The Fiftieth Anniversary Exhibition of MMCA Korea
The Square: Art and Society in Korea 1900–2019
1900–2019

The Fiftieth Anniversary
Exhibition of MMCA Korea
The Square: Art and Society in Korea
1900—2019

The Fiftieth Anniversary Exhibition of MMCA Korea
The Square: Art and Society in Korea 1900-2019

Chief Curator
Kang Seungwan

Team Management
Part I: Park Mihwa
Part II: Kang Soojung, Park Sujin
Part III: Lim Jade Keunhye, Lim Dae-geun

Part I - Part III
Registration: Kwon Sungoh, Koo Hyeyeon, Yi Yeongju,
 Choi Seoyoung
Conservation: Kim Yeongmok, Park Sohyun, Beom Daegeon,
 Seong Yeongrok, Yoon Bokyung, Choi Jeombok,
 Choi Hyesong, Han Yebin
Promotion: Communication and Media Team
Education: Department of Education Team

Part I. 1900-1950

Exhibition Period: Oct. 17, 2019 - Feb. 9, 2020
Exhibition Venue: MMCA Deoksugung

Curator: Kim Inhye
Curatorial Assistants: Kim Sangeun, Park Youngshin
Transportation and Installation: Myeong Yisik, Lee Kyoungmi
Exhibition Design: Lee Minhee
Graphic Design: Kim Dongsu
Space Construction: Youn Haeri
Archiving: Park Narabora, Lee Jieun, Moon Jungsook
Video: D&A izzmi system
Photography: Hwang Jungwook, Myeong Yisik

Acknowledgement
Gallery Hyundai, Gyeonggi Provincial Museum, Kyung-in Museum
of Fine Art, Keimyung University, Kukjae Museum, Korea University
Museum, National Palace Museum of Korea, Jeonju National
Museum, National Library of Korea, The National Institute of
Korea History, Modern Design Museum, Kim Chong Yung Museum,
Daegu Art Factory, Debec Plaza Gallery, National Museum of Korean
Contemporary History, The University Art Museum, Tokyo University
of the Arts, Pressum, Ruki Matsumoto Collection, Machida City
Museum of Graphic Arts, Manhae Museum, Korea Racing Authority
Equine Museum, Mongyang Memorial Hall, Milal Fine Art Museum,
Busan Museum, Arirang Association, Leeum Samsung Museum of Art,
Sogang University Loyola Library, Seoul National University Museum,
Seoul National University Library, Seoul Auction, Songgwangsa
Museum, Suwon Museum, Suwon I'Park Museum of Art, Sunchon
National University Museum, University of Chicago Library Special
Collection Research Center, Adan Mun'go, Arko Arts Archive, Arirang
Museum, Museum of Face, Seoul Calligraphy Art Museum of Seoul
Arts Center, Lee Hoe-yeong Memorial Society, Yoon Dongju Memorial
Society, Leesangil Culture Foundation, Lee Yuksa Literary House, Lee
Ungno Museum, Lee Juhong Literary House, Ewha Womans University
Museum, Chagang Seonbi Museum, Cheonggyecheon Museum , Paju
Book City Letterpress Workshop, Kurashiki City Art Museum, Korean
Film Archive, Daegu&Gyeongbuk Branch, Bank of Korea, The National
Audio Visual Information Service, Ohara Institute for Social Research,
Hosei University, Whanki Museum, Kwon Hyeok-song, Kim Myoung-
ryeol, Kim Yeongab, Mu Sejung, Moon Youngdae, Park Jae-young, Park
Jong-seok, Song Haeng-geun, Oh Eun-ryeol, Oh Young-sik, Lee Jiwoong,
Lee Mina, Jeon Chang-gon, Jung Chang-gwan, Jung Hyun, Cho Hyo-
jae, Choi Hakjoo, Han Sang Eon, Hong Seonwung and private collectors
who wish to remain anonymous.

Organized by 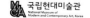 국립현대미술관 National Museum of Modern and Contemporary Art, Korea

Sponsored by LEESANGIL CULTURE FOUNDATION

Supported by ASIANA AIRLINES

Part II. 1950-2019

Exhibition period: Oct. 17, 2019 - Mar. 29, 2020
Exhibition place: MMCA Gwacheon

Curator: Kang Soojung
Curatorial Team: Bae Suhyun, Yoon Sorim, Lee Hyunju,
 Chang Sunkang, Chung Dahyoung
Curatorial Assistants: Suh Joohee, Lee Minah, Lee Yeilim
Transportation and Installation: Park Yang-gyu, Bok Yeongung,
 Choi Sangho
Space Design: Kim Yong-Ju
Graphic Design: Kim Yuna
Graphic Design Assistant: Yang Soojin
Space Construction: Song Jaewon, Yun Haeri, Han Myonghee
Video: The Docent

Acknowledgement
Gana Foundation for Arts and Culture, Gallery Hyundai, Gyeonggi
Museum of Modern Art, National Folk Museum of Korea, Kukje Gallery,
Kimdaljin Art Archives and Museum, Kim Chong Yung Museum,
Mokchon kim jung sik foundation, The Korean Aesthetics Institute,
Vietnam National Fine Arts Museum, Suncheon City Deep Rooted Tree
Museum, Samsung Trasportation Museum, Leeum Samsung Museum
of Art, Samsung Innovation Museum, Seoul Metropolitan Library,
Seoul Museum of Art, The Seoul Shinmun, Sungkyunkwan University
Modern Architecture History Lab, SPACE K, CDR Associates, Arario
Gallery, Chang Ucchin Museum of Art Yangju City, DESIGN HOUSE,
Lee Ungno Museum, Lee Han Yeol Memorial Museum, incorporated
foundation The Deep Rooted Tree, Choi Inhun Research Institute,
Tongyeong City Museum, Pace Gallery, Hakgojae Gallery, KBS, KTV,
The Museum of Photography, Seoul, Han Hyang Lim Museum, Fukuoka
Asian Art Museum, the bereaved of Sung Dookyung, Djong Yun, Rhee
Sangchol, Yi Sunju, Hyun Seung Hoon

Part III. 2019

Exhibition period: Sep. 7, 2019 - Feb. 9, 2020
Exhibition place: MMCA Seoul

Curators: Lee Sabine, Sung Yonghee
Curatorial Assistant: Song Juyeon
Transportation and Installation: Jeong Jaehwan, Choi Sangho
Exhibition Design: Choi Youjin
Graphic Design: Jeon Hyein
Space Construction: Yun Haeri

Acknowledgement
Frame Finland: Frame Contemporary Art Finland
Dutch Performing Arts
The Embassy of the Kingdom of the Netherlands in Seoul

1. The Style of this catalog is primarily based on *The Guide for the Publication of the National Museum of Modern and Contemporary Art* (Seoul: MMCA, 2018).

2. Proper nouns, including persons' names and place names, are transliterated based on the collection list of the National Museum of Modern and Contemporary Art as a primary reference and the Korean Art Multilingual Glossary of the Korea Arts Management Service as a secondary reference.

3. The images in this catalog do not cover all the works in the exhibition. The complete list of all the entries in the exhibition is available in "The list of works for the exhibition".

Contents

The 50th Anniversary Exhibition:
The Square: Art and Society in Korea 1900-2019

Youn Bummo

Director, National Museum of Modern and Contemporary Art, Korea

In 2019, the National Museum of Modern and Contemporary Art (MMCA) is thrilled to be celebrating not one, but two major milestones: the 50th anniversary of the museum's opening and the launch of our newest branch in Cheongju, signaling the dawn of a new era with four MMCA sites (Deoksugung, Gwacheon, Seoul, and Cheongju). To commemorate these historic occasions, MMCA is proud to present *The Square: Art and Society in Korea 1900-2019*, a special exhibition jointly held at three of our locations in Deoksugung, Gwacheon, and Seoul.

Comprehensively examining the theme of art and society in Korea, the exhibition has been divided into three installments. Part I at MMCA Deoksugung covers the first half of the twentieth century, a time of great turbulence after Korea opened its ports to the world, including the Japanese colonial period (1910-1945), independence (1945), and the Korean War (1950-53). Part II at MMCA Gwacheon focuses on the rapid changes that occurred from the postwar era to the present, during which Korea transformed itself from a war-torn rural country into an industrial power, while also reinventing itself as a democracy. Part III at MMCA Seoul tells contemporary stories of Korea today in the fresh voices of young artists working with new media. The scale of this exhibition is truly immense, with almost 300 participating artists and 400 exhibited works, along with more than 320 other materials related to the theme. While many of the featured items come from the existing MMCA collection, quite a few are newly discovered. As a massive undertaking covering the full range of modern and contemporary Korean art, this exhibition truly is a curatorial triumph.

During the twentieth-century, Korean peninsula suffered the Japanese colonial rule in the first half and the division between North and South Korea in the second half. The national tragedy that was the Korean War left deep scars and perpetuated the division that continues today. Through the course of these events, Korea has developed a unique social environment. Thus, when it came time to organize our 50th-anniversary exhibition, we were especially eager to explore the topic of art and society. What did Korean artists think about during these troubling times and how did they express their thoughts?

Of course, due to the Cold War ideology and fervent anti-Communist rhetoric of the time, South Korean artists were often denied freedom of expression. With that in mind, the Korean title for this exhibition is *Gwangjang*, which means 'public square.' For Koreans, this title immediately summons thoughts of Choi Inhun's landmark novel *The Square* (1960), one of the most important works in modern Korean literature. The novel's protagonist Yi Myeongjun contemplates the difference between the '*gwangjang*' and the '*milsil*' (secret room or closed room). Yi Myeongjun refuses the imposed choice between South and North Korea and boards a ship to a neutral territory, where he never disembarks. After having been freed, some Korean war prisoners did indeed denounce both sides and uproot their lives to settle instead in a third country. Korea spent most of the latter half of the twentieth century struggling to recover from the physical and psychological wounds of the Korean War. This trauma deeply affected the lives and works of Korean artists, reminding us that war is the antithesis of art. Many lives and artworks were lost in the war, and even the survivors suffered terribly and had to make great sacrifices. In the aftermath, new terms were even coined to specify artists who had crossed over to either the north or the south.

Hearing stories of the exile and defection of master painters of the 1930s and 40s, we cannot help but feel renewed pain and sorrow for the divided Korea. For example, after being imprisoned in the Geoje POW Camp, Lee Qoede chose to go to North Korea, even though his family was in Seoul. Pen Varlen grew up in a Korean community in Russia before being dispatched to Pyongyang, where he became one of the leading North Korean artists of the 1950s. But he eventually left Pyongyang and never returned to Korea again. Jo Yanggyu, born in Jinju, South Gyeongsang-do, went to Japan after Korea's independence, and later became renowned in the Japanese art world around the 1950s. In the 1960s, Jo chose to be repatriated to North Korea, but he went missing after his return, never to be seen again. Furthermore, the tragic displacement stories of artists like Lee Jungseob and Park Soo Keun, who lost their homes to the Korean War, exemplify the jagged history of Korean art, which for many years seemed to be kept in the *milsil* (i.e., the back room).

Public squares are a symbol of modernisation and democracy. The phrase 'from the back room to the public square.' describes well the Korean society during the twentieth-century. In the past, even public squares were closed rooms where the ruling powers operated. In Yeouido, for example, the "May 16 Square" was named to commemorate the coup of May 16, 1961, through which General Park Chunghee took power. With its desolate, desert-like atmosphere, this square came to symbolize the entire era of Park's dictatorship. Recognizing the power of public imagery, the military government preferred to fill public squares with large statues and

monuments. Today, however, public squares no longer serve to praise those in power or a prominent political figure. , Instead, as the protesters in Gwanghwamun Square have demonstrated in recent years, they are open, public agorae occupied by the people with their voices. From the square, the Korean people showed the world that even the highest power could be overthrown with nothing more than candles. Just like water can either float or capsize an enormous ship, the public square can be the foundation of a government and society, or the cause of its downfall. Today, we are witnessing the birth of the people's public square as a fundamental building block of the Korean society.

In his later years, Lee Ungno produced his *People* series of works depicting a wide square filled with people, which he said was inspired by the May 18 Democratic Uprising in Gwangju, 1980. Painted with swift brushstrokes, the people in Lee's works seem to be dancing. Indeed, Lee once claimed that the people were doing the "reunification dance." But whether they are at an anti-nuclear protest or a rally for reunification, the people in the painting only represent the Koreans who live south of the 38th parallel. And their roar might be a prayer for reunification, or their anticipation of the joy of reunification. Unfortunately, Lee was an artist who was quite familiar with the "back room." In 1967, he and composer Yun Isang were arrested and imprisoned in what became known as the 'East Berlin Incident' or 'East Berlin-North Korean Spy Ring Incident'. This incident reminds us that dictators prefer back rooms to public squares.

As Lee's series shows, dance and performance were crucial elements of gatherings in public squares during the 1980s. To convey their community spirit, various groups would come together in public squares to dance and share performances of the traditional *madang nori* theater. Unlike Western theater, which is characterized by the strict division between the performers and the audience, *madang nori* was typically performed in the *madang* (yard) of local neighborhoods where the stage was open to all. Such performances were truly ideal examples of community art.

Like Lee Ungno, another artist inspired by Korean dance was Oh Yoon, one of the central figures in the *Minjung* ("People's art") movement of the 1980s. Oh Yoon is best known for revolutionizing the Korean tradition of woodblock prints, which is exemplified by the *Tripitaka Koreana* woodblocks of the Goryeo Dynasty (now housed at *Haeinsa* Temple in Hapcheon), as well as by works such as *Sutra on Deep Indebtedness to Parental Love* in *Yongjusa* Temple, Suwon. Inspired by shamanistic rituals (especially the tradition of the crane dance from Dongnae, Busan that was handed down in his own family), Oh Yoon produced many prints depicting scenes of dance. Through such works, Oh showed us that dance required the square for its stage-but it

is equally true that the square needed dance. Alive with dance and adorned with the new medium of *geolgae* paintings (hanging paintings), the public squares of the 1980s were vibrant sites radiating with heat, movement, and passion.

The turmoil of the twentieth century has passed, and we are now well into the twenty-first century. This new era of hope comes with its own lexicon of terms and concepts, such as 'artificial intelligence,' 'virtual reality,' and the 'fourth industrial revolution.' At one point, another such term was the 'crisis of painting,' or even the 'crisis of art.' Just as people once thought that photography would cause paintings to disappear, many in the art world (especially visitors to international biennales) felt certain that the rise of media art and installations would sound the death knell for painting. However, from ancient times to today, painting has remained the world's predominant art form. But even so, aesthetic styles, formal vocabularies, and artistic contents are infinitely expanding. Every moment, contemporary artists are erasing boundaries, thus infusing art with more power than ever before. At a time when artworks are instantaneously circulating around the world, art is becoming increasingly significant as the international language. Once confined to exclusive salons, contemporary art has now come to occupy the public square.

Like Korean society as a whole, MMCA has had its share of ups and downs in the past fifty years. Now boasting a world-class collection of contemporary art on display at four sites, our museum has endured and emerged as a shining symbol of Korea's self-empowerment. From this moment forward, we must strive to become an approachable and accessible museum that provides moving experiences and provokes active discussions amongst our visitors. More than a mere spectacle or memorial, today's museums must be reinvented as a beloved place that evokes limitless imagination in their visitors' minds. In this regard, *The Square: Art and Society in Korea 1900-2019* is more than just another exhibition; it is a turning point propelling us into a new decade. The twentieth century saw the traditional idea of art as painting and calligraphy dismantled and replaced by the idea of 'fine art'. As the boundaries blurred and horizons broadened, art exited the back room and stepped in to the public square. This exhibition looks back at such an amazing transition to contemplate on the symbolism and significance of the public square in the twenty-first century.

Now, without further ado, let's enter the square.

On *The Square: Art and Society in Korea 1900-2019*

Kang Seungwan

Chief Curator, National Museum of Modern and Contemporary Art, Korea

This year marks the 100th anniversary of two key moments in Korea's fight for liberation from the Japanese colonial government: the March 1st Movement (March 1, 1919) and the establishment of the Provisional Government of the Republic of Korea (April 11, 1919). Moreover, 2019 is also the 50th anniversary of the National Museum of Modern and Contemporary Art (MMCA), which opened in *Gyeongbokgung* Palace on October 20, 1969. In the twentieth century, Korea overcame the trauma of the colonial rule and the Korean War to regain its independence and rapidly achieve modernization and economic growth. Nonetheless, these accomplishments have come in the shadow of the ongoing division between North and South Korea. The fight for freedom is now an everyday reality for nations, ethnic groups, minorities, and individuals around the world who are actively resisting countless forms of economic, political, and cultural subjugation. Despite the initial optimism attached to globalization, the resulting neoliberalism and neocolonialism have only exacerbated peoples' anxiety and insecurity for the future.

Meanwhile, in the last fifty years, MMCA has grown from a tiny government department with one basic function—to host the annual National Art Exhibition of Korea—into one of the world's premiere artistic and cultural institutions. At the time of its founding, the museum had no collection of its own and no curatorial staff. Today, MMCA boasts an outstanding collection of around 8300 works that are exhibited in four sites (Deoksugung, Gwacheon, Seoul, and Cheongju), and has also developed a wide range of programs in conservation, education, research, publication, and international exchange.

The Square: Art and Society in Korea 1900-2019 is not merely about looking back at our history. Ruminating on the past has little value unless it helps us understand our current position, with the ultimate goal of teaching us to creatively imagine and navigate our uncertain future. For Korea, the twentieth century was a maelstrom of tragedy and triumph: the loss of sovereignty, colonial rule, regaining independence, the Korean War, the North-South division, and the experiment in capitalism and democracy. Even in the twenty-first century, the age of globalization, the division of Korea continues to have a profound and complex influence on contemporary history, not only in Korea, but around the world.

The Korean title for this exhibition—*Gwangjang*, or "Public Square"—derives from Choi Inhun's literary masterpiece *The Square* (1960), a novel that deals with issues of Korea's division and ideological conflicts from the perspective of an intellectual. Protagonist Yi Myeongjun struggles to choose between the ideologies of North and South Korea, which he respectively associates with the *"gwangjang"* (i.e., the "public square," representing collectivism and the public sphere) and the *"milsil"* (i.e., the "closed room" or "back room," representing individualism and the private sphere). In the end, after realizing that neither side has the answers he seeks, Yi decides to leave Korea for a "third country," opting for the ideal (or death) of the "blue square" (i.e., the ocean).

For this exhibition, we have chosen the "square" as the central word and concept at the heart of modern and contemporary Korean history. Indeed, the turbulence of the last century has been more deeply imprinted on the square than on any other place in Korea. For every major event of contemporary Korean history—the April 19 Revolution (1960), the June Democracy Movement (1987), the national team's run while hosting the World Cup (2002), the deaths of Miseon and Hyosun (two Korean girls killed by a US military vehicle in 2002), the unfair deal for American beef imports (2008), the tragic sinking of the *Sewol* ferry (2014), and the impeachment of President Park Geunhye (2016-2017)—the public squares of Korea have been filled with people gathering to hold candles, sing songs, raise chants, and cry out to express their anger, joy, grief, or festivity. The essence of the contemporary history of South Korea is in its people's struggle and resistance, with the square at center stage.

In charting the flow of that history, with all of its sufferings, hardships, recoveries, triumphs, and transformations, *The Square: Art and Society in Korea 1900-2019* examines the myriad interactions and relations among art, artists, and society to determine if their description of history can lead to changes in the future. In revisiting fundamental questions about the social function of art and "art for art's sake," the exhibition confirms that, through the chaotic course of modern history, Korean artists have been steadfastly pursuing the values of human freedom, dignity, and coexistence. The true significance of the exhibition is to show that these values are by no means limited to Korea, but are in fact the universal goal of artistic creation.

This exhibition consists of three parts: Part I (held at MMCA Deoksugung) covers the years 1900 to 1950; Part II (at MMCA Gwacheon) covers 1950 to 2019; and Part III (at MMCA Seoul) covers 2019 to the future. Despite the chronological arrangement (which is mostly for convenience), the exhibition does not simply trace the one-way development of Korean art. Instead, it synchronously explores many themes that have unfolded around the public

square since the start of the twentieth century. The three parts of the exhibition are independent, not only because they deal with different time periods, but also because they were executed by different curators in different spaces. But all of the different perspectives and methods that Korean artists have used to reflect, interpret, and change history and society are organically linked by the unifying concept of the square. To properly showcase the achievements of the first fifty years of MMCA, this exhibition is organized three-dimensionally, with diverse displays containing works in various media from the museum's collection, new works commissioned especially for this exhibition, loaned works, and various audio-visual materials.

Held at MMCA Deoksugung, Part I considers the role and relationship of Korean art with the liberation movement during the Japanese colonial period. Considering the overall theme of how historical conditions influence the art of a given era, this part is divided into four sections: "Records of the Righteous," "Art and Enlightenment," "Sound of the People," and "Mind of Korea." "Records of the Righteous" recalls the individuals who found their own ways to bravely uphold the nation's honor and autonomy during Japan's initial encroachment into Korea and eventual colonial rule: literati scholars who vehemently asserted the need to maintain Confucian tradition and the isolationist policy; members of the resistance militia; people who risked everything to join the front line of the independence movement; people who chose to go into hiding to nurture future generations; and the martyrs who made the ultimate sacrifice by giving their life to the cause. Through Chae Yongshin's magnificent portraits of these patriots, as well as their own excellent works of calligraphy and painting, this section looks back at how the thwarted dream of building an autonomous modern state led to resistance activities and dreams of enlightenment. This leads to the next section, "Art and Enlightenment," which presents educational resources, illustrations from newspapers and magazines, and works by the *Gaehwapa*, a group dedicated to the reform and empowerment of Korea. Visitors can also trace the changing coverage of independence activities in art magazines published before and after the March 1st Movement of 1919. "Sound of the People" reviews how various international art trends were introduced through posters, magazines, and prints, while also examining Korea's relations with global socialist and proletariat art movements. Notably, this section includes works by Pen Varlen and Yim Yongryun, two master artists who were exiled from their homeland due to colonial rule. Finally, "Mind of Korea" presents works by the pioneers of Korean modern art, such as Lee Qoede, Kim Whanki, and Lee Jungseob, showing how their passion for life and attitude towards art shone through their art, even during times of the darkest despair.

Although many of Korea's first modern cities had public squares from the time of their establishment, the contemporary concept of the square had

not yet arisen in this period. In the early twentieth century, the social and political role of the square was typically filled by the streets or marketplaces instead, where most people met and conversed. However, the artists and freedom fighters who resisted the loss of national sovereignty and struggled to enact a new era never abandoned the collectivism of a public space for the individualism of the back room. There were many possible paths between the back room and the square: some were narrow and winding, some were wide straight boulevards, while others led to a dead end. But no matter which path they chose, they were headed towards the 'square' of freedom and liberation, sharing the same vision of restoring Korea's identity and autonomy.

Held at MMCA Gwacheon, Part II deals with the era of modernization, democratization, and globalization, from the Korean War to the present. Rather than a straight chronological presentation, this part has a mixed arrangement to allow for the intersection and coexistence of the back room, street, and square. To highlight the overarching theme of the exhibition, the title of each section is based on keywords from Choi Inhun's novel *The Square*. In particular, this part invokes Choi's symbolic and metaphorical use of color, especially black, gray, blue, and white. The displays are divided into a total of seven sections: six to the right of the main ramp and one to the left. The six sections on the right are "Blackened Sun", "Han-gil(One Path)", "Gray Caves", "Painful Sparks", "Blue Desert", "Arid Sea" In addition, the right side includes a square dedicated to the May 18 Uprising in Gwangju. Finally, the section on the left is "White Bird," a space for mourning and placing a wreath. Visitors are encouraged to move from right to left, following a roughly chronological path from the 1950s to the present with the square in the center.

Focusing on the 1950s, "Blackened Sun" begins with works by Jeongju An and Kang Yo-bae depicting wounds from the Korean War and the North-South division. Next, "Han-gil(One Path)" explores how the rapid economic development of the 1960s was instigated by the military regime's imperious push for progress and restoration, prioritizing national production at the expense of individual freedom and expression. By enforcing a uniform standard, the military government effectively denounced both the back room (individual freedom) and the square (autonomy of community). Featuring abstract works by Chung Kyu, Yoo Young-Kuk, and Kim Chong Yung, and experimental works by Kim Ku Lim and Lee Kun-yong, this section also includes separate corners for Yun Isang and Lee Ungno, both of whom were imprisoned for ideological conflicts. "Gray Caves" revisits the "gray" period of the 1970s, when Korea continued its incredible economic growth, even while suffering from extreme social oppression under the *Yushin* regime. In the novel *The Square*, the "gray cave" was a back room which became the only refuge where protagonist Yi Myeongjun and his lover Eunhye

could hide. This period, when Koreans were forced to remain in the back room and could not enter the square, is represented by hyperrealist works, documentary paintings of the Vietnam War by military correspondent artists, and "*Dansaekhwa*" ("Korean monochrome") paintings by Park Seo-Bo, Ha Chong Hyun, and Yun Hyong-keun.

"Painful Sparks" is based on a political gathering in a square filled with citizens fueled by the flaming desire for democratization. Thus, this section introduces the 1980s, the decade defined by the rise of *Minjung* art ("People's art") and the tight interweaving of ideology, politics, and culture. Notably, it was also in this period that the square came to be seen as the site for realizing the ideal of community, with a proliferation of group activities based on collective identities of class, nationality, and ideology. This spirit was evoked by poet Bak Chunseok in her book *I Gathered in the Square*, when she wrote, "In order to leave the square, I went to the square every single day."[1] Containing works by artists such as Shin Hak Chul, Kim Jung Heun, Lim Ok-Sang, Oh Yoon, Yun Suk Nam, and Bae Youngwhan, as well as *Liberation of Work*, a *geolgae* painting (hanging painting) by Choi Byungsoo, this section transfers an actual square into the museum. Meanwhile, artists Kang Honggu and Im Minuk used their works to disclose the social and structural contradictions that were hidden in the shadow of urban growth and economic development, even after the achievement of democracy.

Moving closer to contemporary times, "Blue Desert" covers the 1990s, while "Drought-colored Sea" takes us into the twenty-first century. First, the 1990s were the decade in which Korea leapt onto the international stage while initiating many profound domestic changes. Beginning from the 1988 Summer Olympics in Seoul, Korea successfully transitioned from a military government to a democracy, while also riding the wave of globalization. This wave made great ripples in the Korean art world, starting with the launch of the international art biennales in Gwangju and Busan in the mid-1990s. A sharp increase in international art exchanges and communications helped many Korean artists enter the global spotlight. These developments corresponded to major social changes around the world, particularly the fall of the Soviet Bloc that began 1989 and the end of the Cold War, which brought on a global paradigm shift. Suddenly freed from its binary conflict with socialism, capitalism strengthened its hold on the world order and social structure. However, just a year after joining the Organisation for Economic Co-operation and Development (OECD), Korea suffered a crippling financial crisis that resulted in an IMF bailout in 1997.

1. Bak Chunseok, *I Gathered into the Square* (Seoul: Hyeondae Poetics, 2016), 56.

Hence, the "blue square" (represented by the sea) that offered the last bastion of hope in the novel *The Square* no longer exists, having been replaced by a "Blue Desert" and a "Arid Sea." The transition from a sea to a desert, and from blue to the color of drought, would seem to be a dark foreboding for the future, but signs of optimism can still be detected in works from these two sections. In the 1980s, the public square of Korea was filled with ideological protests and displays of defiance, but in the 1990s, many of those disputes fell by the wayside, enabling artists to focus on other issues. "Blue Desert" features works by the new crop of 1990s artists–such as Choi Jeonghwa, Lee Bul, and Ahn Sang-soo–who were part of the first Korean generation to experience the expansion of popular consumer culture and the liberation from ideological conflicts. Starting in the 1990s, more Korean artists began focusing on issues related to pluralization and the micro-oppression of daily life, showing an increased interest in human rights, social minorities (e.g., women, the disabled, immigrants, and homosexuals), and crises caused by neoliberalism and globalization (e.g., labor conditions, poverty, and the environment). This section contains works by Kim Youngchul and Lee Yun-yop, who used their art to resist the cultural monopoly and empowerment of capitalism. In the "Drought-colored Sea" section, the shadow of fear and anxiety inherent to a post-capitalist society is cast over works by Kim Sunghwan, Im Heungsoon, Gimhongsok, and Kim Sora.

In the novel *The Square*, Yi Myeongjun is led to the "blue square" by two white birds–his lover Eunhye and their unborn child–who tragically die together. "White Bird," the last section of Part II, is a memorial to the victims of Korean contemporary history, whether they met their fate in the back room, the street, or the public square. These victims include the comfort women; the expelled; independence activists; victims of the Korean War, the Vietnam War, and the May 18 Democratic Uprising; Miseon and Hyosun, who were killed by a US military vehicle; and finally, the unjustified and concealed deaths of the *Sewol* ferry. Perhaps these victims can experience a moment of healing by having their wounds tended by the works of Oh Jaewoo, jang minseung, Che Onejoon, and Nikolai Sergeevich Shin.

Finally, at MMCA Seoul, Part III confronts the here and now, addressing the contemporaneity of ourselves while simultaneously pondering the future significance of the square. Touching upon fundamental issues of the individual, community, and society, this part is organized along the following themes: I and the Other; portraits of community; the online square (time becomes space); changing communities; and the museum as the square. Presented in Galleries 3, 4, and 8, as well as in the hallway and outdoors, the works comprise various formats and media, including photography, video, performance, and even a collection of seven short stories, (also entitled *The Square*) written especially for this exhibition by seven writers.

In an era when *anderheit* ("otherness") is supposedly dissolving, the portrait photographs of Oh Heinkuhn and Yokomizo Shizuka remind us of the unfamiliar experience of meeting and recognizing the Other. The people in the photographs remain inside their own private space–their back room– while the artists look at them from the street, the middle ground between the back room and the square. By maintaining such distance and refusing to form a mutually exclusive relationship, the photographers newly objectify their subjects, thus restoring *anderheit*.

Today, we are witnessing a new type of square where time becomes space, as virtual squares with no spatial dimensions now have a deeper impact on our lives than any physical space. The power and spirit that once summoned people to a public square has moved onto the internet and social media, where we can now instantaneously exchange our daily interests in political problems and public welfare. While Hong Jinhwon enacts a violent collision between the back room (private sphere) and square (public sphere), Kim Heecheon creates a digital interface where our self is integrated with the Other, and the boundary between reality and non-reality is erased. Such complexities are accumulating into a new augmented reality; as the walls of the back room are torn down, the private self is lost and exposed, until everyone is me, and I am everyone.

The overlying theme of this section is the museum's potential to serve as the future square. Investigating how our communities are changing, Ham Yangah and Eric Baudelaire urge us to address global issues that threaten the very future of humanity, such as violence, natural disasters, economic crises, and climate change. Aiming to break down the closed nature of communities in favor of an open square, Chung Seoyoung presents a fence that opens in any direction, while the team of Shinseungback Kimyonghun transform data from visitors' facial expressions into mesmerizing sounds and waves. Finally, Juha Valkeapää and Taito Hoffrén transform the back room into the square by inviting everyone into their private space for an outdoor tent performance.

Through the structure of the exhibition, the creation and activity of the artists meets the participation and criticism of the audience. If the back room and square can cooperate and coexist in a museum as a public sphere, can the museum replace the square as the primary site for the dynamic dilemma sparked by the fusion and clash between reality and the imagination? Can the back room and square dismantle their barriers, exchange ideas and values, elicit communication and significance to find harmony? This may be possible if, in the words of Boris Groys, art exhibitions "Here, art exhibitions play a crucial political role by at least partially compensation for the lack of a global public space, and global politics."[2] In the novel *The Square*, the

protagonist fails in his quest to enter the "time when a person's back room is interconnected with a square." Are we now living in that time? That is the question that the exhibition poses to all of us.

2. Boris Groys, "From Worldview to World Expo" in *Divided We Stand* (2018 Busan Biennale catalogue), eds. Jörg Heiser, Christina Ricupero, and Park Gahee (Busan: Busan Biennale, 2018), 513.

I.
The Square:
Art and Society in Korea
1900–1950

The Role of Artists in Times of Darkness

Kim Inhye

Curator, National Museum of Modern and Contemporary Art, Korea

I

The Joseon Dynasty, also known as the "Land of the Morning Calm," almost withstood the age of imperialism, maintaining its closed-door policy through most of the nineteenth century. It was not until the signing of the Treaty of Ganghwa in 1876 that Joseon finally opened its ports and began conducting international trade with Japan, the US, UK, Germany, Russia, and France. At that time, few could have imagined the profound repercussions that the decision to open the ports would have on the Korean peninsula. Looking back, however, it is fascinating to re-examine the various stances and attitudes that different groups took with regards to these changes. On one hand, literati scholars and officials vehemently urged that the kingdom be upheld, maintaining its isolationist policy towards the West and its duty to Qing. On the other hand, some younger men of the aristocratic yangban families advocated constitutional monarchy. Finally, the *jungin* (i.e., middle-class professionals) quickly gained influence, arguing for the need to enlighten Joseon by actively adopting applied sciences around the world.

In 1897, in an effort to defend the nation's sovereignty against foreign powers, King Gojong declared the birth of "Korean Empire," and thus became "Emperor Gojong." However, his dream to build an independent and neutral state was eventually thwarted when Japan forcibly annexed Korea in August 1910.

This exhibition begins with the story of literati scholars who displayed their reverence for their king and country by actively petitioning to maintain the closed-door policy and exclude foreign powers, at the crossroad of isolation and enlightenment. These scholars have often been denounced as antiquated figures who stubbornly clung to the Confucian tradition and failed to adapt to modern times. Nonetheless, many of them risked or even surrendered their lives to defend their beliefs, demonstrating the persistence that deserves our consideration and respect in a way. As literati scholars, most of them were of noble background and wealthy. Despite their elevated status and relative affluence, they answered the call of their time with determination, by either taking their own lives as a form of protest; raising Righteous armies (*Uibyeong*) and took up arms in resistance; or going into seclusion while preparing for the future. To document and remember their abiding spirit, artist Chae Yongshin painted numerous portraits of these patriotic activists.

During the Japanese colonial period, some activists from privileged families spent their entire fortune to fund *Uibyeong* activities and the independence movement. Consigned to poverty in their later years, they sometimes took to painting the "four gracious plants," symbolizing dignity, integrity, righteousness, and honor. Such paintings played multiple roles in their lives. For themselves, panting served as an act of self-cultivation and a reminder to their resolutions. For their friends, the paintings represented friendship and companionship. In their role as pro-independence activists, the paintings sometimes were sold to raise funds for resistance activities. Many of these activists spent their entire lives being chased by the Japanese authorities, moving frequently and covertly through a wide territory encompassing China, Manchuria, and the entire Korean peninsula. Since few records documenting their nomadic lives have survived, their extant paintings of the four gracious plants serve as crucial evidence of an essential chapter in Korean history.

With the start of the new era, these literati inevitably saw their power and status decline, while the *jungin* began to acquire more influence. The *jungin* openly embraced foreign culture and technology, and strongly believed that equal education would produce enlightenment, the true source of patriotism. Many members of the *jungin* were followers of new religious movements, such as Christianity, Cheondoism, and Daejongism, which promoted the equality of all people. The middle class also supported Buddhism, which had been suppressed by the Neo-Confucianists of the Joseon period. To promote education, the *jungin* imported foreign printing presses, enabling them to design and publish new newspapers, textbooks, magazines, and popular novels, as well as to reissue many Korean classics. With their publishing capabilities, the *jungin* would go on to play a leading role in the March 1st Movement by writing, printing, and distributing the Declaration of Independence.

Notably, most artists were members of the *jungin*. Around this time, the general conception of an artist began to change in Korea, starting with the introduction of the term "*misul*" (美術), in response to the Western concept of "fine arts." The two Chinese characters in "*misul*" are "美," meaning "beautiful" or "fine," and "術," meaning "skill" or "technique." The rise of this term represents people's new appreciation for the specialized skill or technique of art. Most professional artists from this period were associated with the *Gaehwapa*, a group of reformers. One of the key leaders of the *Gaehwapa* was Oh Se-chang (1864-1953), an artist whose father was Oh Gyeong-seok (1831-1879), an important government interpreter. The interactions among artists such as Oh Se-chang, An Jungsik (1861-1919), Ko Huidong (1886-1965), and Choe Namseon (1890-1957) have great significance as the primary force guiding the opening of this new era in art and culture.

After the nonviolent March 1st Movement, the Japanese colonialists increased their suppression of the Korean populace and began hunting

independence activists. Thus, the movement entailed a major sacrifice for all Koreans, but it also resulted in a slight loosening of restrictions in certain areas. For example, to try to mitigate its harsh military rule, the Japanese Government-General of Korea implemented the so-called "cultural rule," which provided some opportunities for education and publication projects led by Koreans. Although there was still severe censorship and many constraints, the ensuing system led to an increase in printing and publishing projects from 1920 to the early 1930s. Many artists participated in these projects, which included the publication of newspapers such as *Dong-a Ilbo* and *Chosun Ilbo*, and magazines such as *La Kreado, White Tides, Ruins*, and *Student World*. In the years between the two World Wars, while Surrealism and Dadaism were emerging in Europe, Korean literature and art enjoyed a brief flourishing with the appearance of diverse styles and voices.

2

The 1920s was a period of cultural and ideological florescence around the world, and Korea was no exception. First, following the development of anarchism and socialism, and stimulated by the Russian Revolution (1917), communism rose to great prominence. Many Korean intellectuals participated in the communist movement and maintained a close relationship with the independence activists who were leading the armed struggle in Manchuria and China. Under the captivating slogan of "Workers of the world, unite!" proletarian activists of Korea, Russia, China, and Japan formed an international network, based on their belief that the liberation of the working class took precedence over national liberation or state-building.

In the late 1920s and early 1930s, proletarian literature and art enjoyed a brief but explosive peak in Korea. Intentionally avoiding the notion of "art for art's sake," the proletarian art movement sought to directly engage and interact with the public through easily reproducible media, such as prints, flyers, and other illustrations, as well as theater and film. The sharp division of classes that had characterized Korean society throughout the Joseon Dynasty had been all but abolished. As the new concept of the "public" came to be understood, masses of unspecified individuals began to participate in cultural phenomena, assisted by the development of new media, such as radio and the phonograph. Both imported and domestic films became very popular, while various performing arts-including a new type of theater called "*singeuk*" (New Theater)-began to flourish, leading to the construction of new performance venues where large crowds of people could attend such events.

Artists are naturally drawn to places where people gather to enjoy culture. It is little surprise that the founding member of the *Towolhoe* theater group, the representative singeuk group of the 1920s and 30s, was Kim

1. Records of the Righteous

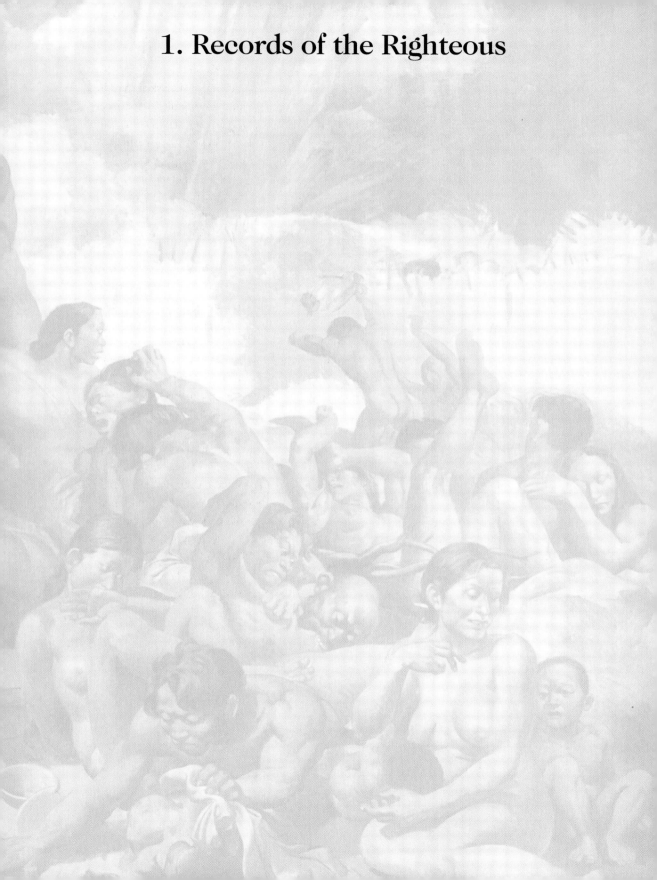

The Struggle of Symbols:
The Patriot's Soul and the Flame of Modern Times

Choi Youl*

Art Critic

Three Roads to Take When the Country is Ruined

When a nation's territories and its people are invaded and fall under the control of other nations, intellectuals are presented with three options. This sentiment was expressed by the *uibyeong* (Righteous Army) leader Euiam (毅庵) Yu Inseok (柳麟錫, 1842-1915) to comrades and followers at the national crisis of Eulmi incident (1895). It was written in the record of *uibyeong* entitled *Changeui Gyeonmunrok* (倡義見聞錄) by his chief of staff and warrior Ok-san (玉山) Lee Jeong-gyu (李正奎, 1864-1945). The record states that, "there are three options for facing the extreme hardship: first, we can gather soldiers and clear the enemy, second, leave the country and maintain our integrity, and third, stay out of the torments and keep ourselves innocent." In the following year, they chose the first option, marking the beginning of the armed struggle that was to last the next fifty years.

At the moment of national ruin, long-established intellectuals in China and Korea faced three paths to keep their integrity and innocence; first, raising an army (擧義), second, committing suicide as a form of protest, (自決), and third, retiring from the world (隱居). Countless scholars chose their own way. Besides them, other classes of people, including farmers, merchants, and others of the lowest class, joined the struggle as their communities became slaves to other nations. Among them were scholars who shouted out their iron will and hope into paintings and calligraphy, using ink and brush, which were their tools of expression before they took up arms. For this reason, their calligraphy and painting were fundamentally different from those of comfortable times. Almost all of the images that they passionately poured onto paper presented the "four gracious plants" and oddly shaped rocks. Those images were all but the weapons of war, clashing spears and swords for the struggle.

Reinstatement of the Modern Spirit

After liberation and independence, the 'patriot painters' became extinct in history and art history. Their disappearance was not their own choice. It was a result of the collaborators of the invading empire taking power, in both the newly formed state and art scene, rather than those who chose one of the

*

Art critic. Choi Youl was the editor-in-chief of *Gana Art* and president of the Art History of Figure Society. He is currently a lecturer at Korea University, Dongguk University, and Seoul National University. He wrote *History of Korean Modern Art Criticism*, *Critical Biography of Lee Jungseob*, and *Dialogue for the Introduction of Art History*. He also edited *Complete Works of Kim Bokjin*, *Complete Works of Go Yuseop*, and *Complete Works of Kim Yongjun*. He won the Prize of Writing on Korean Art and the Publication Culture Grand Prize. Recently, Choi is exploring and presenting on the woman artists who worked as a *gisaeng* as well as the patriot painters from the Korea Independence Army.

1. There is a controversy over the ones who did not leave behind many works. The dispute is as follows: due to a lack of works, it is difficult to confirm the existing work or even show a representative work, and the authenticity of new work is questionable-in addition, it is not clear if we can define these figures as artists or how we can assess their value. However, the identity of these patriot painters is not determined by the number of works. Even if there is only one work left, we have to discuss its history, artistic quality, and its intensity. Besides, I think that the criteria to determine the value of art are history, scarcity, and formativeness.

three roads above to maintain their integrity. Part I of *The Square: Art and Society in Korea 1900-2019*, the exhibition at Deoksugung commemorating the fiftieth-anniversary of MMCA Korea, positions "Records of the Righteous" at the beginning of the show. It is remarkable that this is the first time that the nation, which the patriot painters so longed to protect, put these very same painters on the first page of history. In other words, they have regained their lost position in art history, although it does not mean a glorious return for each one of them. Of course, it is not something awarded according to their individual merits. Instead, such positioning in this event at the MMCA realizes more fundamental and broader values of the 'reinstatement of the modern spirit' in art history. The core of the modern spirit meant *tangpyeong* (fairness, 蕩平), *kyoonyeok* (equality in mandatory labor, 均役), and *daedong* (solidarity, 大同) in the history of Joseon. That is liberty, equality, and fraternity in Western history. The foundation of these three spirits is the consciousness of human rights.

The Avant-garde of the Symbolic Struggle against the Times

There were also those who defended the path of royalism against the threat of the Japanese empire. Their names are Seokchon (石邨) Yoon Yong-gu (尹用求, 1853-1939), Kyejeong (桂庭) Min Yeonghwan (閔泳煥, 1861-1905), and Unmi (芸楣) Min Young-ik (閔泳翊, 1860-1914), Udang (友堂) Lee Hoe-yeong (李會榮, 1867-1932).[1] Leading the Gojong Era, Yoon Yong-gu chose to seclude himself at the national ruin; Min Yeonghwan, known for the 'bamboo from the blood' that grew out of his floor after his death, abandoned his life when the national sovereignty was ceded to the Japanese empire; Min Young-ik, a hero of troubled times, endured the times of crisis full of vicissitudes; Lee Hoe-yeong, a Korean anarchist, terrified the Japanese Empire by using force to avenge the invasion. As the 'imperial four,' their written and painted works were the weapon to pierce the heart of the enemy.

Those who took arms as *uibyeong* and the army for the national independence include the following: Chagang (此江) Park Gijeong (朴基正, 1874-1949), Geungseok (肯石) Kim Jinman (金鎭萬, 1876-1934), Iljoo (一洲) Kim Jinwoo (金振宇, 1883-1950), Gaseok (可石) Kim Do-sook (金道淑, 1872-1943), Hwasan (華山) Kim Il (金鎰, around 1880-after 1944), Byeoksan (碧山) Jeong Daegi (鄭大基, 1886-1953), Yoowoon (悠雲) Han Hyeong-seok (韓亨錫, 1910-1996), Okbong (玉峰) Cho Gisoon (趙基順, 1913-2010). They were the avant-garde of the symbolic struggles that overcame the cruel times in the form of spears and swords alongside the four artists of the empire. Also, the names of those who went out into the world full of aspiration only to return to their hometown because of the national crisis, and then led a life of education and writing in regional villages as scholars, include Yeomjae (念齋) Song Tae-hoe (宋泰會, 1872-1940), Shimjae (心齋) Kim Seok-ik (金錫翼, 1885-

1956), and Shinong (信翁) Cho In-jwa (趙仁佐, 1902-1988). Their paintings are remarkably beautiful, imbued with the fragrance of a modest scholar.

The records on Park Gijeong are unclear, but he was a member of the *uibyeong* of Euiam Yu Inseok. The spirit of the times expressed in his ink paintings of bamboos was inherited by Cheonggang (青江) Chang Il-soon (張壹淳, 1928-1994) and passed down to Kim Ji-ha, a disciple of Chang Il-soon, Oh Yoon, and Park Young-ki, a grandson of Park Gijeong. Kim Jinman was a member of the Korea Liberation Corps, the largest organization in Daegu. He was the central figure in the pistol robbery incident to raise military funds and won renown as an artist who inherited the legacy of Unmi Min Young-ik. Kim Jin-woo fought from a young age in the *uibyeong* led by Yu Inseok and later joined the Shanghai Provisional Government before he was arrested. While in jail, he painted bamboos with this sword-sharp strokes, using rainwater. With his brush technique of spears and knives, called Il-joo style, he took the colonial-era painting scene by storm. He also taught Byeoksan Jeong Daegi, who was a member of the army for the national independence, as well as Okbong Cho Gisoon.

Kim Il was a warrior who first fought in the *uibyeong* of Hwanghae-do and continued the armed struggle as a member of the Korea Independence Corps. After his release from prison, he started to build his own original world of painting. Han Hyeong-seok fled to China when he was young, where he studied music. He fought in the People's Liberation Army and the Korea Liberation Corps before returning to his hometown where he developed his painting style full of musicality, while actively engaging in educational activities. Cho Gisoon became a disciple of Kim Jinwoo at an early age, and carried out her resistance activities with her teacher alongside the figures of the Korean Independence Movement. She became a Buddhist nun after the Korean War, but continued her involvement in the Korean art scene while leading a life resembling that of a reclusive scholar. Jeong Daegi who fled to Shanghai to join the Independence Movement and Cho In-jwa who led the March 1st Movement later settled in Jinju and Gyeongju, and led respectable lives as scholars. They were admired and loved for their excellent painting.

Respecting and remembering the righteous lives

While there were great and brave ink painters who devoted their bodies and minds to confronting the times, there were also artists who respected the life of the *uibyeong* and patriots even though they could not be at the forefront of the struggle. They are Seokji (石芝) Chae Yongshin (蔡龍臣, 1850-1941), Woocheong (又清) Hwang Seongha (黃成河, 1891-1965), Seokyeon (石然) Yang Gihun (楊基薰, 1843-1911), and Shimjeon (心田) An Jungsik (安中植, 1861-1919).

Chae Yongshin painted many copies of the portraits of the respectable figures and dedicated them to shrines all over the country. The portraits include those of Myeonam (勉菴) Choi Ikhyun (崔益鉉, 1833-1906) and Songsa (松沙) Ki Woo-man (奇宇萬, 1846-1916), the *uibyeong* leaders who raised the *uibyeong* at the Korea-Japan Treaty in 1905; national patriot Kanjae (艮齋) Jeon Woo (田愚, 1841-1922); Maecheon (梅泉) Hwang Hyeon (黃玹, 1855-1910) who left the last poem at the 2nd Japan-Korea Treaty in 1905 (also known as the *Eulsa* Treaty or Protectorate Treaty) and suicided by taking poison; and Ko Neungseon who went to the same school as Yu Inseok and was a teacher of Kim Gu. These portraits at the shrines shone out and invigorated community spirit. In 1929, Hwang Seongha produced prints that illustrated Choi Ikhyun's life in the biography of Choi titled *Ilseongrok* (a diary, 日星錄). The book was published in secret to avoid Japanese surveillance and spread quietly throughout the world; it has been passed down to present times. Yang Gihun and An Jungsik painted 'blood bamboo' that came to symbolize Kyejeong Min Yeonghwan who had protested the Japanese invasion by taking his own life at the 2nd Japan-Korea Treaty in 1905. The painting, Bamboo from the Blood was produced in prints as well as paintings and published in the press, including *Daehan Maeil Shibo* (Korea Daily News) and *Daehan Jaganghoe Monthly*. It was intended to be distributed widely. Indeed, a bamboo from the blood was summoned as an image of the symbolic struggle of visual media.

Shimjeon (心田) An Jungsik (安中植, 1861-1919) and Uichang (葦滄) Oh Se-chang (吳世昌, 1864-1953), successors and disciples of Jang Seung-eop, who dominated the art scene of the Emperor Gojong era, and Gwanjae (貫齋) Lee Doyoung (李道榮, 1884-1933) continued the struggle, confronting these times of crisis. An Jungsik and Oh Se-chang joined *Gaehwadang* (Enlightenment Party) together, devoting themselves to the revolution. Crossing the bureaucratic and civilian positions, they fervently strove to make the nation stronger. From calligraphy and painting to genre painting, in particular with Lee Doyoung, they practiced the most potent art struggles in history by publishing a daily satirical cartoon until 1909, right before Japan forcibly annexed Korea in 1910. Their cartoons often did not pass the censorship and were printed over with black ink. Every time that happened, however, the paper would print the big black block in the middle of the front page, attracting even more attention and popularity.

Writing the modern art history right

As I discussed, there are two kinds of records on the righteous. One is produced directly, with all their heart, by those who led the righteous life, and the other is the work produced and distributed by painters who witnessed the life and iron will of those who led a righteous life. The

works painted by a patriot are the symbol of his own life and the times he confronted struggle. They therefore hold great value in themselves, brilliant with the zeitgeist. On the other hand, the paintings that depict the patriots themselves or the traces of the events in which they were involved are a record of remembrance for their courage and will that saw them through the times of hardship. Either way, these two kinds of works are not art that battle the enemy directly. Rather, they work in such indirect ways as symbolizing the will of those in battles with plants like bamboos that resemble spears and swords. They also acted as a mirror that reflects the patriots' appearances, sublimating their passionate lives into the flame of resistance. Of course, satirical paintings also existed but were not enough in intensity to be used as propaganda.

I hope that the righteous art-in defense of human rights against the violence of the empire that destroys the spirit of modern times-secures its legitimacy and finally establishes itself as the mainstream of art history. And I am sure of the fact that this exhibition, "Records of the Righteous," is the first attempt and the beginning of rightful historiography of modern art, bringing passionate patriots and the works of their soul to the forefront of history.

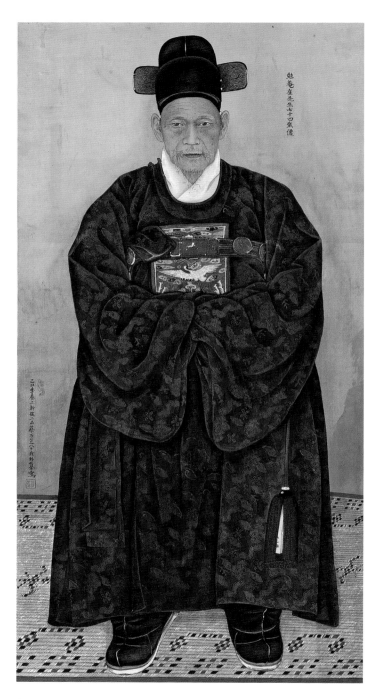

勉菴崔先生七十四歲像

Chae Yongshin, *Portrait of Choi Ikhyun*,
1925, Color on silk, 101.4 × 52 ㎝. MMCA collection.

Edited by Cho Woosik, *Illustrated Life of Choi Ikhyun*, Illustrations: Hwang Seongha, 1932, Woodcut on paper. Private Collection.

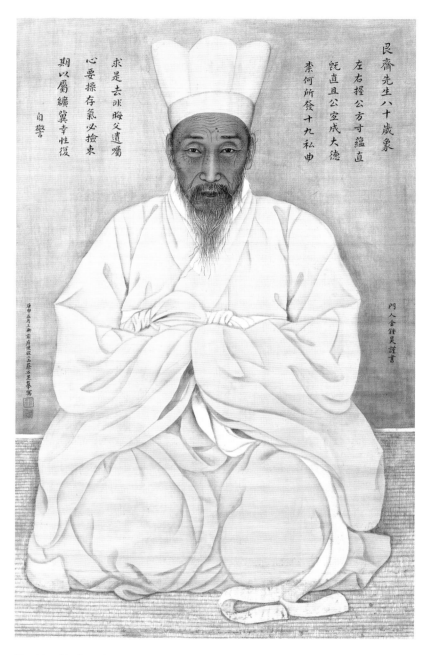

Chae Yongshin, *Portrait of Jeon Woo*,
1920, Color on silk, 95 × 58.7 ㎝. Private Collection.

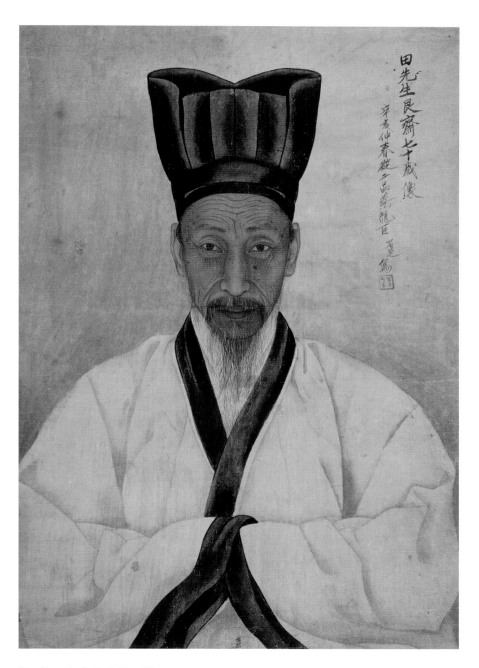

Chae Yongshin, *Portrait of Jeon Woo*,
1911, Color on paper, 65.8 × 45.5 ㎝. MMCA collection.

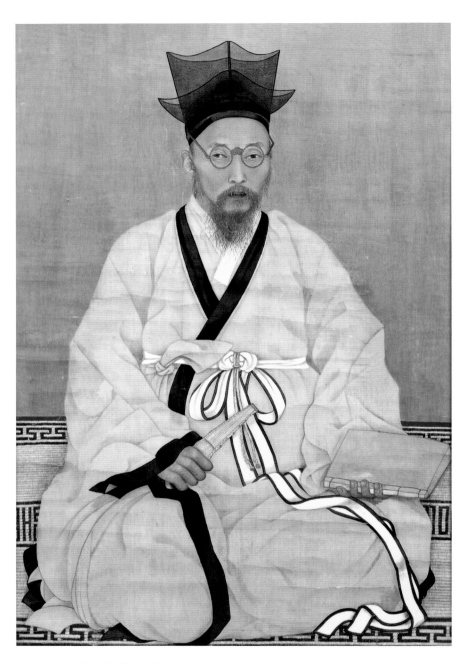

Chae Yongshin, *Portrait of Hwang Hyeon* (reproduction),
1911, Color on silk, 120.7 × 72.8 ㎝. Private Collection.

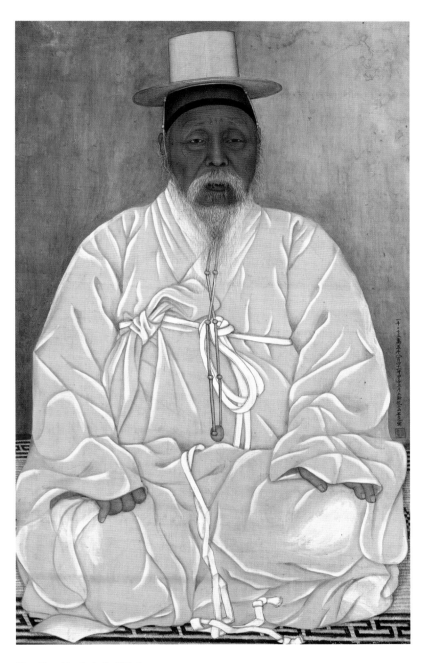

Chae Yongshin, *Portrait of Oh Junseon*,
1924, Color on silk, 74 × 57.5 ㎝. Private Collection.

Chae Yongshin, *Yongjin Jeongsa Academy*,
1924, Color on paper, 67.5 × 40 ㎝. Private Collection.

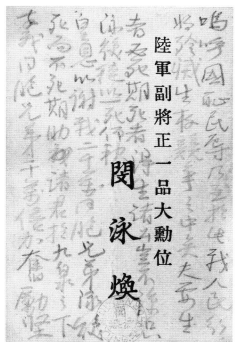

Min Yeonghwan, *Last will and testament of Min Yeonghwan* (reproduction),
1905, Pencil on paper, 9.2 × 6 cm. Korea University Museum Collection.

Oh,
The shame of the nation and its people reached right to this point
Our people are about to perish while competing for survival.
Those who hope to live must die, and anyone who would die will gain
life.

Why don't you realize?
Yeonghwan died only once, repaying King's grace,
And made an apology to our twenty-million brothers thereby.

Yeonghwa died, but he also did not die, pledging to help you all.
Hopefully, our countrymen will intensify strenuous effort,
Strengthen the will and the spirit to pursue learning,
Unite our hearts and work together to restore our independence,
Then the deceased will undoubtedly smile even in the darkest
underworld.

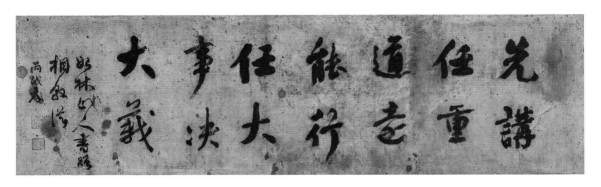

Lee Siyeong, *Calligraphy of Lee Siyeong*,
1946, Ink on paper, 29.5 × 98.5 ㎝. Lee Hoe-yeong Memorial Society Collection.

先講任重道遠 能行任大事決大義
You should first learn that the mission is great and that you have a long
way to go. Then you can carry on crucial tasks and decide on the noble
cause.

始林山人 書贈相敦從
Shirimsanin wrote to his cousin Sangdon.

丙戌夏
In summer, the year of Byeong-sul.

Lee Siyeong, Jeong Inbo, *Stamped Seals of Lee Hoe-yeong*,
1946, 1949, Ink on paper, 65 × 32.5 ㎝. Lee Hoe-yeong Memorial Society Collection.

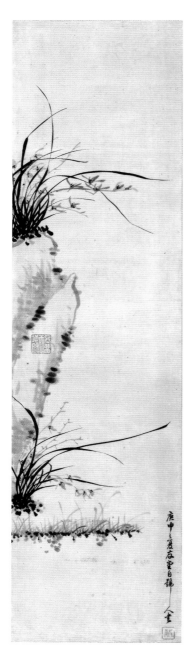

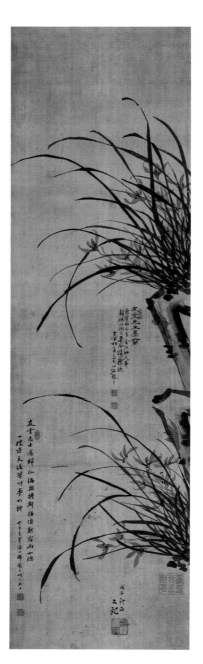

Lee Hoe-yeong, *Orchid*,
1920, Ink on paper, 140 × 37.4 ㎝.
Private Collection.

Lee Hoe-yeong, *Orchid*,
1920s, Ink on silk, 115 × 32.8 ㎝.
Lee Hoe-yeong Memorial Society Collection.

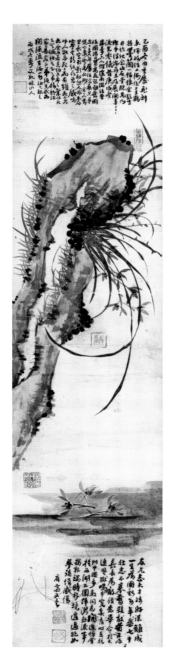

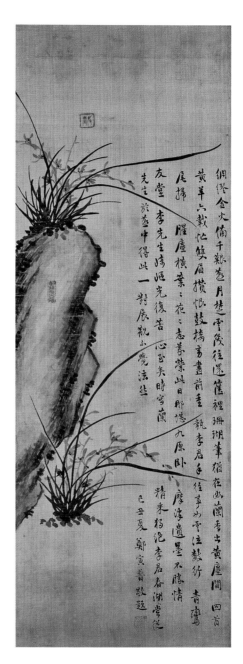

Lee Hoe-yeong, *Orchid*,
1920s, Ink on silk, 114 × 26.8 ㎝.
Lee Hoe-yeong Memorial Society Collection.

Lee Hoe-yeong, *Orchid*,
1920s, Ink on silk, 123.8 × 41.9 ㎝.
Lee Hoe-yeong Memorial Society Collection.

Weaponry of Uibyeong ("Righteous Armies"),
Late Joseon, Each length 128 ㎝, 84 ㎝. Kyung-in Museum of Fine Art Collection.

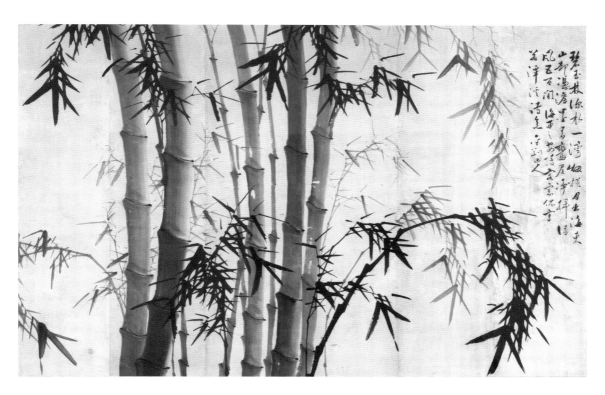

Kim Jinwoo, *Bamboo*,
1940, Ink on paper, 146 × 230 ㎝. Daegu&Gyeongbuk Branch, Bank of Korea Collection.

Park Gijeong, *Plum Blossoms in Snow*,
1933, Ink on silk, 145.5 × 384 ㎝. Chagang Seonbi Museum Collection.

Park Gijeong, *Ten-Panel Folding Screen of Gold-painted Five Gracious Plants*,
Undated, Gold-painted on paper, Each panel 102.5 × 32 ㎝. Chagang Seonbi Museum Collection.

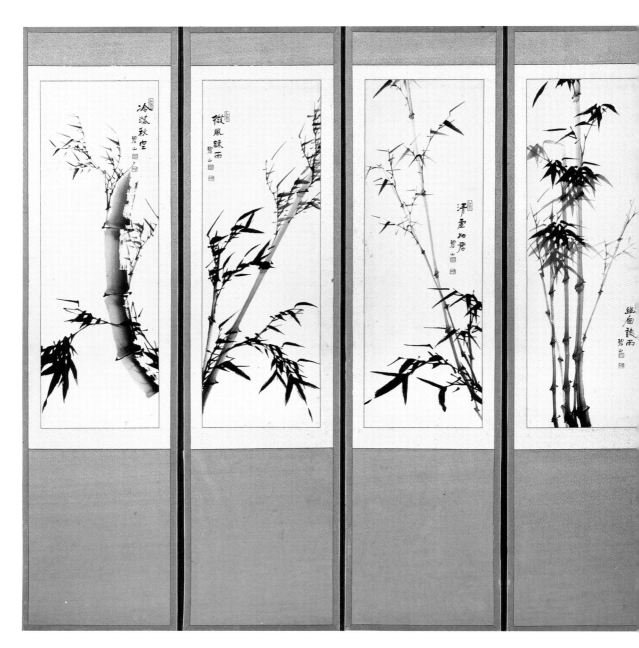

Jeong Daegi, *Eight-Panel Folding Screen of Bamboo*,
Undated, Ink on paper, Each panel 94.5 × 31 ㎝. Private Collection.

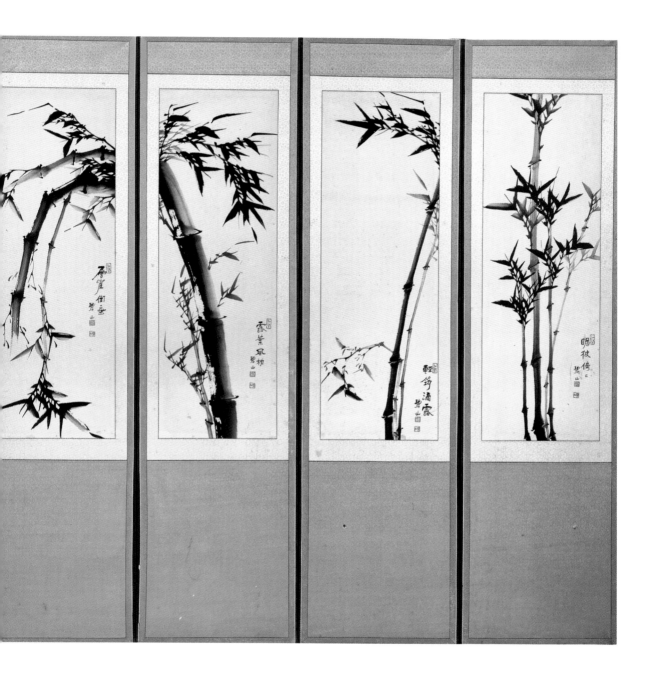

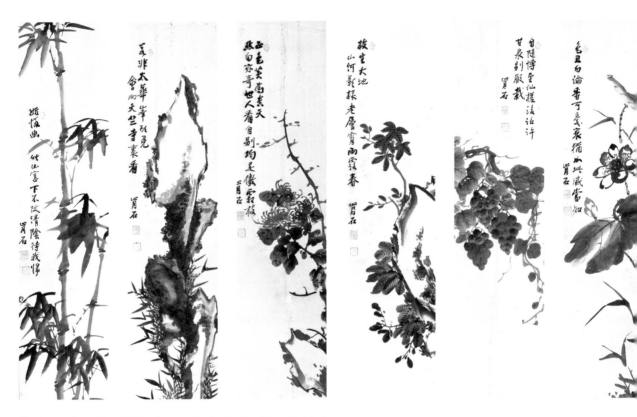

Kim Jinman, *Twelve-Panel Folding Screen of Twelve Gracious Plants*, Undated,
Ink on paper, Each panel 118.5 × 27.5 ㎝. Private Collection.

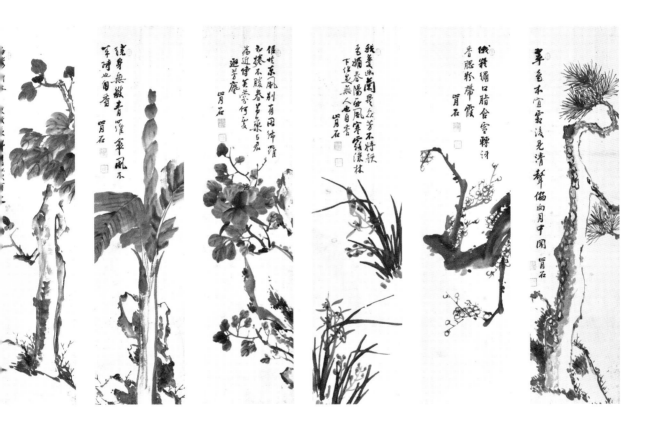

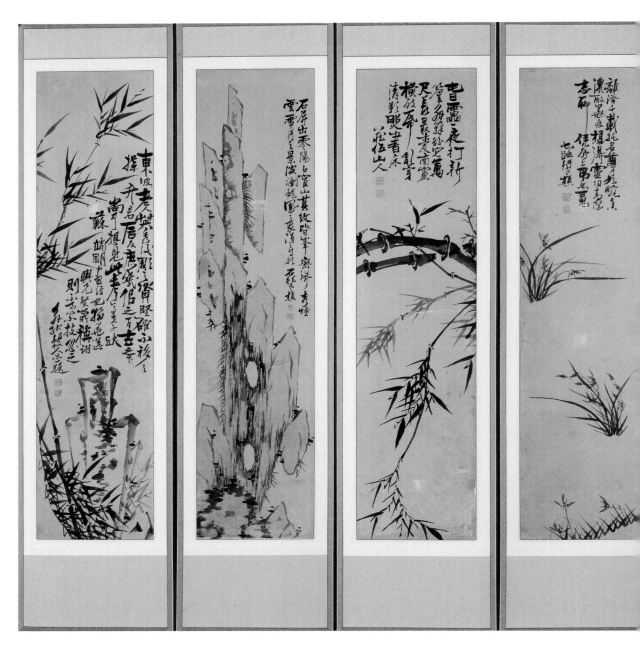

Yoon Yong-gu, *Eight-Panel Folding Screen of Orchid and Bamboo*,
Undated, Ink on paper, Each panel 135.2 × 32.7 ㎝. Suwon Museum Collection.

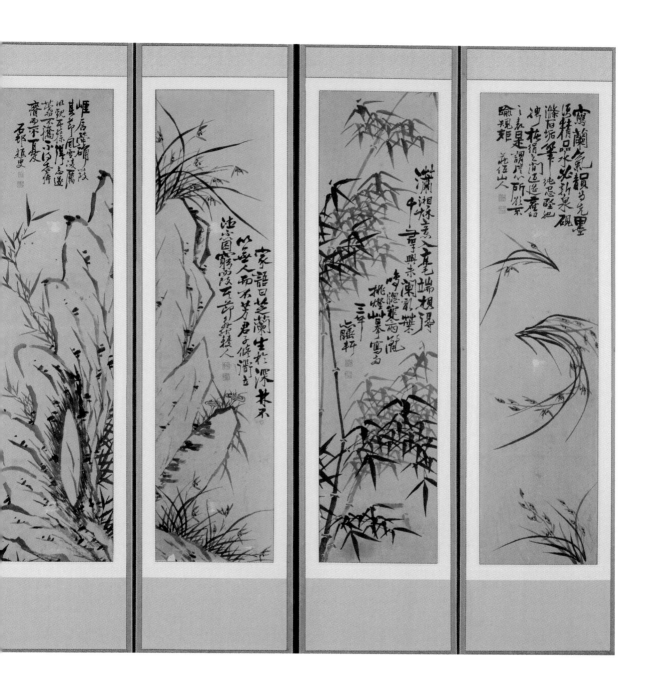

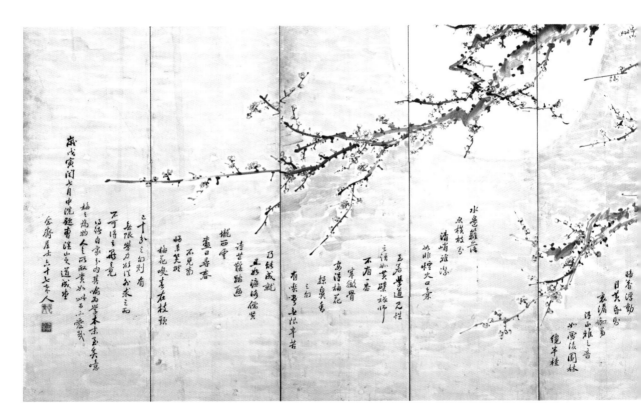

Song Tae-hoe, *Plum Blossoms*,
1938, Ink on paper, 99.5 × 320 ㎝. Songgwangsa Museum Collection.

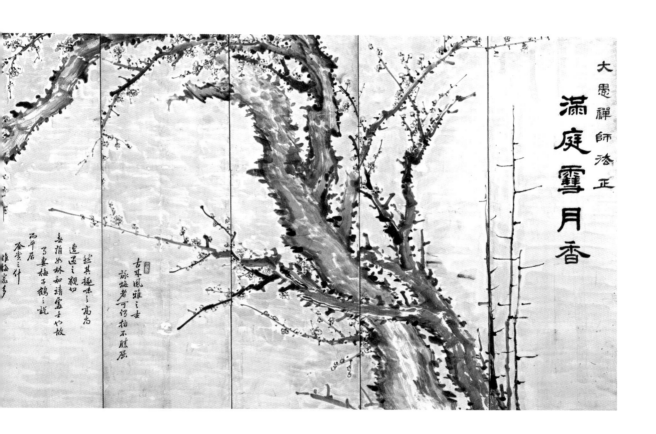

大愚禪師添正

滿庭雪月香

Song Tae-hoe, *Ten-Panel Folding Screen of Bamboo*,
1939, Ink on paper, Each panel 114 × 34.5 ㎝. Jeonju National Museum Collection.

Song Tae-hoe, *Songgwangsa Temple*,
1915, Ink and color on silk, 100.5 × 57 ㎝. Songgwangsa Museum Collection.

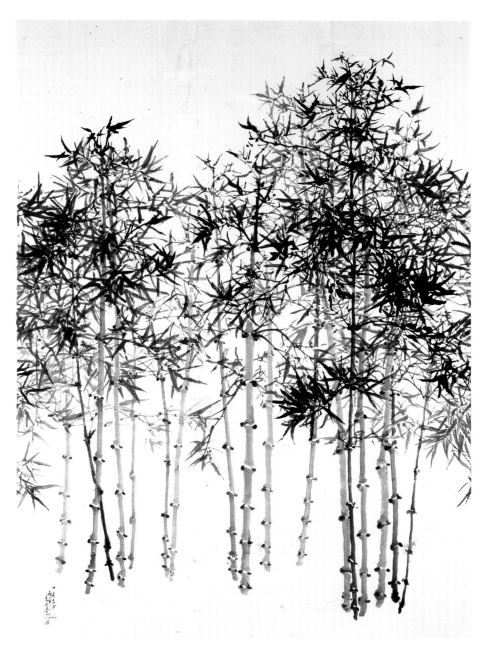

Lee Ungno, *Bamboo*,
1978, Ink and color on paper, 291 × 205.5 ㎝.
Lee Ungno Museum Collection. ⓒ Ungno Lee / ADAGP, Paris - SACK, Seoul, 2019

2. Art and Enlightenment

Challenge and Resistance:
Korean Art and Culture after
the March 1st Movement until the 1930s

Kim Mee Young*

Professor, Hongik University

Born in Busan in 1965, Kim Mee
Young received her BA and Ph. D.
from the Department of Korean
Language and Literature at Seoul
National University. She has been
active as a literary critic since
1998, when she won an award at
the Spring Literary Contest by
JoongAng Ilbo newspaper. Having
taught previously at Seoul National
University, Chungbuk National
University, Soongsil University,
and Chung-Ang University, she
is currently a professor in the
College of Liberal Arts at Hongik
University. She has extensively
researched Korean novels and
criticism from the Japanese
colonial period, focusing on topics
such as the links between Korean
modern literature and fine arts,
the literature of Yi Sang within
the context of fine arts, and the
relationship between the paintings
and essays of Chun Kyung-
ja. Most recently, she has been
researching the history of Korean
modern and contemporary essays
and nonfiction. Her publications
include *Hybrid Society and Future
of Novels* and *Interactions Between
Modern Korean Literature and Fine
Arts*.

On March 1, 1919, the Korean people on and beyond the Korean peninsula staged a massive, nonviolent protest against the Japanese colonial government, declaring to the world that Korea was a sovereign nation that had been wrongfully annexed by Japan. What became known as the "March 1st Movement" had both immediate and lasting effects on the country, first and foremost by prompting the establishment of the Provisional Government of the Republic of Korea. The movement also led to the founding of many labor unions and non-governmental organizations in the 1920s, including Seoul Youth Organization (1921). Beyond these specific results, the March 1st Movement had an even more profound impact in inspiring Koreans both at home and abroad to continue fighting back against the tyranny of the Japanese colonial rule.

After the March 1st Movement, having witnessed firsthand Koreans' strong will for independence, the Japanese colonizers proclaimed a shift from military rule to so-called "cultural rule." Supposedly, under the new cultural rule, every subject of the Japanese emperor–whether born in Korea, Manchuria, or Japan–would be equal, which would put an end to the harsh discrimination against Koreans. To support this claim, in 1920, the Japanese Government-General of Korea allowed Koreans to begin publishing their own newspapers and magazines, such as *Chosun Ilbo*, *Dong-a Ilbo*, and *La Kreado*.

In reality, however, the discrimination against Koreans became even more nefarious and systematic. The "cultural rule" was not about simply using culture to propagate and indoctrinate colonial policies; it was rather to distort Korean culture, restructure the Korean reality in a particular colonial way, and ultimately "Japanify" the Koreans. In short, it was a policy that aimed to make Koreans culturally conform to the system of the Japanese colonial rule. To this end, the "Ministry of Police" was changed into the "Bureau of Police," which was then placed in charge of censoring all Korean publications (e.g., newspapers and magazines) and other media (e.g., film, art, radio, theater, and music). On the surface, cultural rule was intended to promote the assimilation of Koreans, but this was a fallacy. Although Koreans were allowed to begin producing their own media and publications, the colonial authorities tightly managed and controlled Korean art and culture through strict censorship.

Throughout the colonial period, the Japanese Government-General of Korea remained committed to the goal of the annexation: to incapacitate the Korean resistance and annihilate the nation. In the 1930s, the Japanese Empire increased its censorship in Korea. In 1936, under the false pretense of preventing public disorder and demoralization, the Censorship Code was installed to censor all newspapers, magazines, books, and films published or produced in Korea. With the outbreak of the Second Sino-Japanese War in 1937, Japan continued its colonial encroachment into the lives of Koreans, taking full control over all education, media, and press materials, including popular music and even folk religion. From the March 1st Movement in 1919 to around 1940, Japan strongly suppressed every conceivable form of educational, administrative, or cultural expression in Korea.

Despite these woeful conditions, Korean artists somehow managed to promote the modernization of Korean art, while also leading the ongoing effort to maintain Korea's cultural capacity and identity. In the 1910s, pioneering writers such as Choe Namseon, Yi Gwangsu, and Kim Eok laid the foundation for modern Korean literature with their writings in magazines like *Boy*, *Youth*, *Hakjigwang*, and the *Journal of Western Literature*. In the early 1920s, poets such as Kim Sowol, Hwang Seok-woo, and Lee Sang-hwa stirred people's romantic and folk sensibilities with lyrical poems in magazines like *Creation*, *Ruins*, *White Tides*, *Town of Roses*, *Gold Star*, *Yeongdae*, *Student World*, *La Kreado*, *Dongmyeong*, *Joseon Jigwang*, and *Joseon Mundan*, as well as newspapers such as *Chosun Ilbo* and *Dong-a Ilbo*. To capture the seeming futility of the colonial period, many of their poems evinced the sorrowful emotion known as "*han*(恨)", often associated with the fatalistic sentiments of a social minority. In the mid-1920s, however, a new breed of novelists emerged, led by Kim Dong-In, Yeom Sangseop, Na Do-hyang, and Jo Myeonghui, to depict Korea's new reality in works imbued with socialism and nationalism. Despite their differing ideologies, these writers were united in their determination to use their literature to oppose and ultimately end Japanese colonial rule and restore Korea's independence.

The literary experimentations that had begun in the 1920s fully blossomed in the 1930s. Capturing the unique sensibility of Koreans while documenting the social conditions of the time, Korean writers shrewdly subverted the Japanese attempts to take credit for bringing modernization to Korea. In poetry journals such as *Poetry Literature*, *Samsa Literature*, *Village of Poets*, and *Dancheung*, writers such as Jeong Jiyong, Kim Girim, Yi Sang, and Han Yong-un published poems in various contemporary styles. Meanwhile, novelists such as Lee Taejun, Chae Mansik, Yi Sang, Lee Hyoseok, and Park Taewon presented an array of compelling fiction works in magazines such as *Sindonga*, *Jogwang*, *Jungang*, *Singajeong*, *Samcheolli*, *Munhak*, *Munjang*, and *Inmun Pyeongnon*, as well as daily newspapers such as *Chosun Ilbo*, *Dong-a Ilbo*, and *Joseon-Jungang Ilbo*. In the meantime, women also were actively writing and publishing. Starting in the 1920s, magazines such as *Woman*

World (est. late 1910s) and *New Woman* (est. 1923) published important works written by women authors such as Rha Hye-seok, Kim Myeongsun, and Kim Ilyeop. Then in the 1930s, Ji Haryeon and Kang Gyeongae led the further development of Korean women's literature. Overall, Korean literature of the 1930s was a shining symbol of the nation's cultural independence under Japanese rule.

Just prior to the March 1st Movement, a number of artists who had studied Western-style painting in Japan returned to Korea and began laying the foundation of Korean modern art. These pioneers included Ko Huidong (returned in 1915), Kim Gwanho (in 1916), Kim Chanyoung (in 1917), and Rha Hye-seok (in 1918). But despite the individual activities of such artists, the overall field of Korean modern art did not really begin to coalesce until after the March 1st Movement, led by members of the Calligraphy and Painting Association, Korea's first major art group. After forming in 1918, the Calligraphy and Painting Association began holding its own group exhibitions in 1921. In 1922, the Japanese Government-General of Korea launched the Joseon Art Exhibition, which immediately became the most important art event of the time. Various other groups then began hosting their own exhibitions, including the alumni group of the Tokyo School of Fine Arts, the *Dongyeonsa* Group, the *Towol* Art Group, the *Goryeo* Art Group, the *Changgwanghoe* Group, and the *Nokyanghoe* Group. These exhibitions were often reviewed by well-known writers in daily newspapers, which is how the Korean public gradually became versed in Western-style oil painting.

Indeed, during the Japanese colonial period, many Korean writers were actively engaged in the world of fine arts, maintaining close relationships with artists and nurturing the overall growth of the art field. In the mid- and late 1920s, writers and painters carried out debates on various art-related topics, such as aesthetics or proletariat art. In particular, in the 1930s, a special relationship developed between the *Guinhoe* Group of writers (including Lee Taejun, Kim Girim, Jeong Jiyong, and Lee Hyoseok) and the *Mogilhoe* Group of painters (including Gu Bonung, Gil Jinseop, Kim Yongjun, and Hwang Suljo). In 1939, the writer Lee Taejun and the artist and critic Kim Yongjun collaborated to publish the first issue of *Munjang*, an art magazine dedicated to traditional painting and Eastern spirituality. In addition to Lee Taejun and Kim Yongjun, contributors to this magazine included writers such as Yi Byeonggi and Jeong Jiyong, and painters such as Gil Jinseop and Kim Whanki.

Until the early 1930s, the close relationship between writers and painters was primarily based on the traditional unity of the "three arts" (i.e., poetry, calligraphy, and painting). This tradition dated back to the Joseon period, when literati scholars were expected to show proficiency in these three arts, and would regularly gather in each other's studios to appreciate and circulate artworks. In modern times, this deep tradition began to be pulled apart, with literature being channeled into magazines and newspapers

and fine art being restricted primarily to exhibitions. Deeply involved in such a separation process was the Japanese occupation, the ordeal of the Korean nation. Thus, as the three arts were being compartmentalized into separate fields, with greater emphasis being placed on the autonomous aesthetics of works by a single artist, the strong solidarity between Korean writers and artists was a powerful statement linked to nationalist and socialist ideologies. At the time, writers and painters were the most prominent leaders of the Korean intelligentsia, and their works played a crucial role in the collective enlightenment of the nation.

In the early phases of modern Korean art, before the emergence of professional art critics and theorists with a formal education in art (such as Yoon Hee-Soon, Kim Yongjun, and Lee Kyung-sung), most exhibition reviews were written by established literary writers. Such writers included Yi Gwangsu, Jang Jiyeon, and Choe Namseon in the 1910s, followed by Yim Hwa, Yoon Kee-Jung, Byeon Yeongro, Gwon Goohyeon, and Lee Taejun in the 1920s and early 1930s. Their involvement in exhibition reviews was due partly to the fact that they resembled the former gentry-scholar class and had greater exposure to foreign cultures. Most of all, the tradition of considering the three arts of poetry, calligraphy, and painting as one allowed the writers to easily crossover to the fine art scene. In writing their reviews and articles, these writers actively promoted the development of the modern Korean art scene, putting forth their own art theories. By the late 1930s, however, the first generation of professional critics and theorists emerged, helping modern Korean art take a new creative leap. With their arrival, the writers went back to their profession of literature.

Thus, after the mid-1930s, most Korean writers stopped reviewing art exhibitions or producing illustrations for newspapers and magazines. Not coincidentally, this led to a golden age for Korean modern literature, which saw the publication of landmark novels such as *Earth* by Yi Gwangsu, *Muddy Stream* by Chae Mansik, *Scenes by a Stream* by Park Taewon, *Spring* by Kim Yujeong, *Crazy Painter* by Kim Dongin, *When Buckwheat Blossoms* by Lee Hyoseok, *Moonlit Night* by Lee Taejun, *Female Shaman* by Kim Dongri, *Wings* by Yi Sang, and *Evergreens* by Shim Hun. Many famous poems were also written in the mid- to late 1930s, such as "Sea" by Jeong Jiyong, "Til the Peonies Bloom" by Kim Yeongrang, "Flower Snake" by Seo Jeongju, "Flag" by Yu Chihwan, along with renowned books of poetry such as *Weather Map* by Kim Girim, *Lantern at the Roof-tiled Shop* by Kim Kwang-kyun, and *Old House* by Lee Yong-ak. All of these literary works are evocative of a painting that exudes a very Korean atmosphere in that they depict, with a Korean lyricism, the sorrow of Korea under Japanese colonial rule, as well as the scenes from modernizing Seoul.

Also in the mid-1930s, more Korean painters stopped experimenting with Japanese or Western styles (such as Impressionism and Expressionism) in order to pursue aesthetics that were unique to Korea. This shift resulted

in works characterized by flowing lines, colors associated with Korea, and bold, almost tumultuous compositions that filled the canvas. Representative works include *One Spring Day* by Lee Insung, *White Flower* by Kim Bokjin, and *Spring Girl* by Lee Qoede, all of which combine Western and traditional Korean styles. Other key artists who emerged at this time include Kim Kichang, Lee Ungno, Park Soo Keun, and Lee Jungseob.

In the late 1920s and 1930s, the overall discourse in Korean art and culture centered around seeking the inherent aesthetics of Korea and finding new directions for Korean art. This was particularly true among painters, who were then dealing with the incursion of Western oil painting, a style that completely differed from Korean traditional painting in terms of aesthetics, techniques, and materials. In fact, oil painting became a shorthand symbol for the whole of modern culture. In Park Taewon's novel *Owner of Bangnangjang Café* (1936), for example, a group of artists gather in a café that is decorated on all four walls with oil paintings, where they listen to Western music from a portable phonograph. As exemplified in this scene, oil paintings came to represent the new culture, as well as the difference between tradition and modernity. Western-style oil paintings-both those from Europe and Japanese interpretations-were introduced to Korea through the Japanese colonialists, and were thus widely seen as the "Other" in a binary opposition. While some considered such paintings to be models for Korean artists to imitate and aspire to, others viewed them as another threat to Korean culture that had to be overcome. Thus, any Korean artists who practiced this foreign style—even if they were seeking to develop Korean modern art—were subject to intense resistance and debate.

Although the pursuit of the quintessential Korean aesthetics in modern art intensified in the 1930s, it began with Kim Bokjin (1901-1940), who first raised the issue around 1926. For Kim, local characteristics and distinctive Korean traits were essential to contemporary aesthetics; as such, he felt that the search for such authenticity had nothing to do with antiquarianism or revivalism. Meanwhile, the poet and literary critic Yim Hwa (1908-1954) argued that Korean art would not attain authenticity unless artists abandoned imitation and fully committed to depicting the true reality of contemporary Korea. The writer and painter Gwon Goohyeon (1898-1944) claimed that, rather than striving to find the essence of "Korean-ness," artists should stop imitating foreign works in order to invent their own styles. The writer Lee Taejun, leader of the Munjang group, proposed the art theory of Eastern spiritualism, which associated Korea's inherent aesthetics with improvisation, bold subjectivity, a sentimental ambience (recalling the Southern School of literati painting), and techniques for making elements of nature subjective, symbolic, and fantastical. This theory was supported by Kim Yongjun and Ahn Seokju, who proclaimed that Korean modern artists could infuse their works with local sentiments and rhythms by drawing from the legacy of Eastern traditional art.

After originating within the field of fine art, this quest for authenticity eventually spread to Korean literature and film. Starting around 1926, there was a movement to revive traditional three-line poems, which led to discussions about the inherent features of Korean modern literature. At that time, Hyun Jingeon (1900-1943) emphasized that Korean literature must capture both the Korean spirit and the spirit of the contemporary era. Stressing the need to achieve originality, Park Younghee criticized the overall trend of developing countries imitating the literature and philosophy of more advanced countries. Kim Eok expounded on the Korean mind and spirit, while Lee Taejun advocated the creation of a fundamental Korea sensibility and aesthetics based on Eastern tradition. Lee Hyoseok sought to integrate local sentiments with a cosmopolitan awareness.

Likewise, early Korean filmmakers sought to differentiate their works from Western or Japanese films. By the late 1930s, they had succeeded in producing popular Korean films with distinct nationalist characteristics, although these were often limited to a nostalgic depiction of the rural landscape of the country. Hence, many Korean films of the 1930s were based on a simple dichotomy between the urban, representing the Japanese colonizers, and the rural, symbolizing the true nature and spirit of the Korean people.

Nonetheless, the wide-ranging discussions and explorations of Korean aesthetics in the 1930s demonstrated that Korean artists of all types were actively resisting the Japanese imperialist attempt to portray Korea as a barbaric, primitive, rural nation in need of modernization. As such, these discussions and the related works have great historical significance in evidencing the establishment of independent cultural identity as well as the cultural resistance against the Japanese Empire.

Oh Se-chang, *Rubbings of Korean Artifacts*,
1948, Ink on paper, 119.5 × 38.7 ㎝.
Seoul Calligraphy Art Museum of Seoul Arts Center Collection.

Ko Huidong, Kim Donhui, Park Hanyeong, Oh Se-chang, Lee Gi,
Lee Doyoung, Choe Namseon, *Album of Poetry Gathering*,
1925, Ink and color on paper, 18 × 12 ㎝. National Library of Korea Collection.

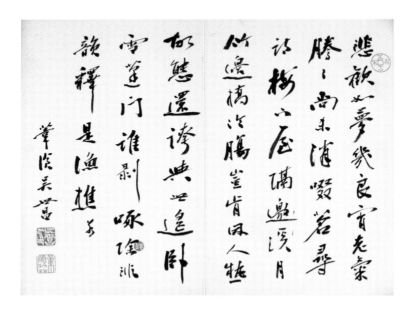

Oh Se-chang, *Seven-Character Regulated Verse*,
1925, Ink on paper. (from *Album of Poetry Gathering*).

Lee Doyoung, *The Sound of the Tungso Falls as the Frost of Heaven / The Sound of the Geomungo Sways in the Waves of the Sea*,
1925, Ink on paper. (from *Album of Poetry Gathering*).

Ko Huidong, *Flowers*,
1925, Ink and color on paper. (from *Album of Poetry Gathering*)

Yang Gihun, *Wild Geese* from *Album of Korean Paintings*, Compiled by Oh Se-chang,
Undated, Ink on paper, 17.6 × 28.3 ㎝. Seoul National University Museum Collection.

Cho Seokjin, *Carp* from *Album of Korean Paintings*, Compiled by Oh Se-chang,
1918, Color on paper, 23.7 × 33 ㎝. Seoul National University Museum Collection.

Lee Doyoung, *Crabs* from *Album of Korean Paintings*, Compiled by Oh Se-chang,
1929, Color on paper, 20.8 × 33 ㎝. Seoul National University Museum Collection.

Kim Yongsu, *Pond* from *Album of Korean Paintings*, Compiled by Oh Se-chang,
Undated, Color on paper, 23.7 × 35.7 ㎝. Seoul National University Museum Collection.

Kim Eung-won, An Jungsik, Oh Se-chang, Yoon Yong-gu, Lee Doyoung,
Jeong Hak-gyo, Cho Seokjin, Ji Un-young, *Collaborative Painting by Seven Masters*,
1911, Ink and color on paper, 17.5 × 128 ㎝.
Seoul Calligraphy Art Museum of Seoul Arts Center Collection.

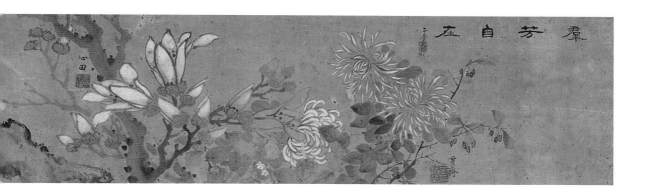

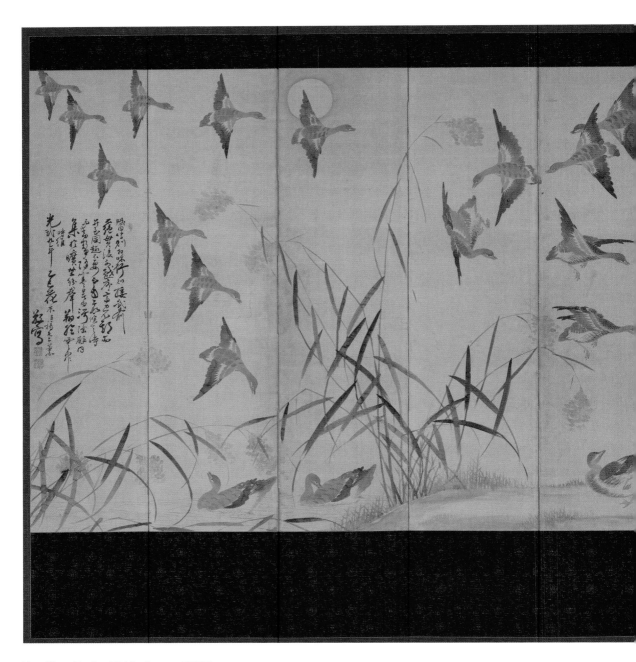

Yang Gihun, *Ten-Panel Folding Screen of Wild Geese*,
1905, Ink on silk, Each panel 160 × 39.1 ㎝. National Palace Museum of Korea Collection.

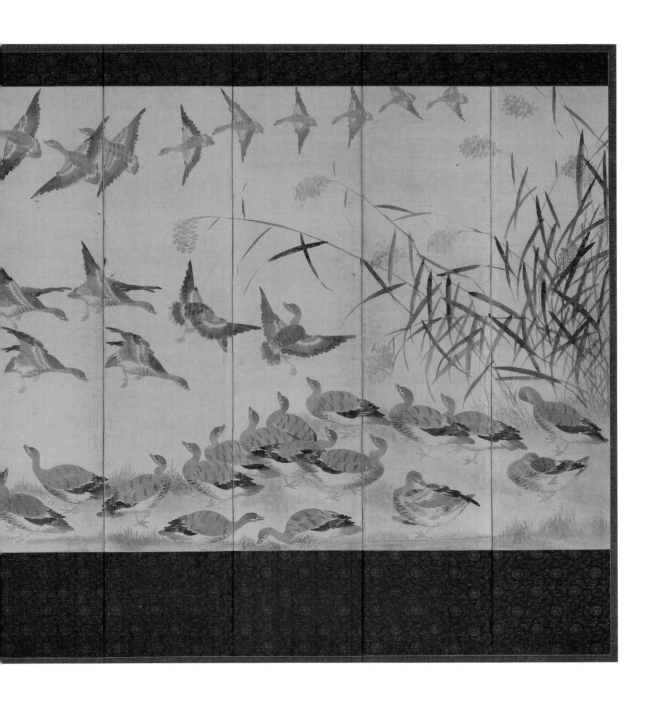

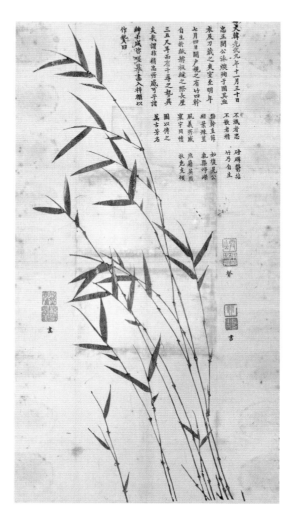

Yang Gihun, *Bamboo from the Blood of Patriot Min Yeonghwan*,
1906, Woodcut on paper, 97 × 53 ㎝.
Art Research Center, MMCA collection.

Daehanjaganghoe Monthly (issue 8),
1907.2. Hong Seonwung Collection.

An Jungsik, "Bamboo from the Blood of Patriot Min
Yeonghwan" from *Daehanjaganghoe Monthly* (issue 8),
Hong Seonwung Collection.

Primary School Textbook 1 (revised edition),
1896. National Library of Korea Collection.

Edited by Jeong Inho, *Primary School Textbook* 4 (new edition),
1908. Hong Seonwung Collection.

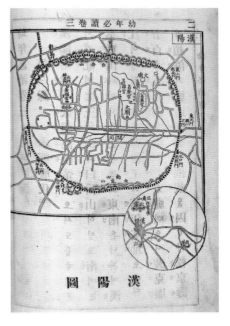

Edited by Hyeon Chae, *Yunyeon Pildok* (children's textbook), Illustrations: An Jungsik,
1907. Art Research Center, MMCA collection.

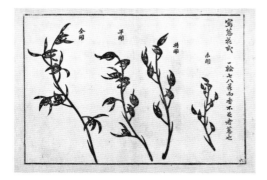
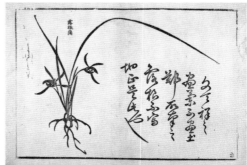

Kim Gyujin, Orchid Painting Manual 1, 2,
1920. Art Research Center, MMCA collection.

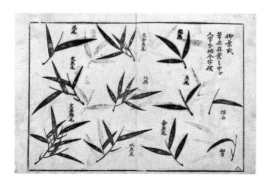
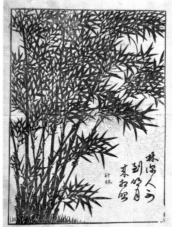

Kim Gyujin, *Bamboo Painting Manual* (new edition),
1920. Art Research Center, MMCA collection.

Kang Jinhee, *Fish* and Kim Eung-won, *Orchid*
(Edited by Baek Dooyong, *Collection of Letters in Cursive Script* (new edition)),
1921. Hong Seonwung Collection.

하는不安恐怖로서脱出케하는것이며또東洋平和로重要한一部를삼는世界平和人類幸福
에必要한階段이되게하는것이라이엇지區區한感情上問題ㅣ리오

아아新天地가眼前에展開되도다威力의時代가去하고道義의時代가來하도다過去全世紀
에鍊磨長養된人道的精神이바야흐로新文明의曙光을人類의歷史에投射하기始하도다新
春이世界에來하야萬物의回蘇를催促하는도다凍氷寒雪에呼吸을閉蟄한것이彼一時의勢
ㅣ라하면和風暖陽에氣脈을振舒함은此一時의勢ㅣ니天地의復運에際하고世界의變潮를
乘한吾人은아모蹰躇할것업스며아모忌憚할것업도다我의固有한自由權을護全하야生旺
의樂을飽享할것이며我의自足한獨創力을發揮하야春滿한大界에民族的精華를結紐할지
로다

吾等이玆에奮起하도다良心이我와同存하며眞理가我와幷進하는도다男女老少업시陰鬱
한古巢로서活潑히起來하야萬彙群象으로더부러欣快한復活을成遂하게되도다千百世祖
靈이吾等을陰佑하며全世界氣運이吾等을外護하나니着手가곳成功이라다만前頭의光明
으로驀進할따름인뎌

公約 三章

一、今日吾人의此擧는正義、人道、生存、尊榮을爲하는民族的要求ㅣ니오즉自由的精
神을發揮할것이오決코排他的感情으로逸走하지말라

一、最後의一人까지最後의一刻까지民族의正當한意思를快히發表하라

一、一切의行動은가장秩序를尊重하야吾人의主張과態度로하야금어대싸지던지光明
正大하게하라

朝鮮建國四千二百五十二年三月　日

朝鮮民族代表

孫秉熙　吉善宙　李弼柱　白龍城　金完圭
金秉祚　金昌俊　權東鎭　權秉悳　羅龍煥
羅仁協　梁甸伯　梁漢默　劉如大　李甲成
李明龍　李昇薰　李鍾勳　李鍾一　林禮煥
朴準承　朴熙道　朴東完　申洪植　申錫九
吳世昌　吳華英　鄭春洙　崔聖模　崔　麟
韓龍雲　洪秉箕　洪基兆

Declaration of Independence (March 1, 1919; reproduction),
1919, Print on paper, 20.5 × 38.5 ㎝. Choi Hakjoo Collection.

宣言書

吾等은玆에我鮮朝의獨立國임과朝鮮人의自主民임을宣言하노라此로써世界萬邦에告하
야人類平等의大義를克明하며此로써子孫萬代에誥하야民族自存의正權을永有케하노라
半萬年歷史의權威를仗하야此를宣言함이며二千萬民衆의誠忠을合하야此를佈明함이며
民族의恒久如一한自由發展을爲하야此를主張함이며人類的良心의發露에基因한世界改
造의大機運에順應幷進하기爲하야此를提起함이니是ㅣ天의明命이며時代의大勢ㅣ며全
人類共存同生權의正當한發動이라天下何物이던지此를沮止抑制치못할지니라
舊時代의遺物인侵略主義强權主義의犧牲을作하야有史以來累千年에처음으로異民族箝
制의痛苦를嘗한지今에十年을過한지라我生存權의剝喪됨이무릇幾何ㅣ며心靈上發展의
障礙됨이무릇幾何ㅣ며民族的尊榮의毀損됨이무릇幾何ㅣ며新銳와獨創으로써世界文化
의大潮流에寄與補裨할機緣을遺失함이무릇幾何ㅣ뇨
噫라舊來의抑鬱을宣暢하려하면時下의苦痛을擺脫하려하면將來의脅威를芟除하려하면
民族的良心과國家的廉義의壓縮銷殘을興奮伸張하려하면各個人格의正當한發達을遂하
려하면可憐한子弟에게苦恥的財産을遺與치아니하려하면子子孫孫의永久完全한慶福을
導迎하려하면最大急務가民族的獨立을確實케함이니二千萬各個가人마다方寸의刃을懷
하고人類通性과時代良心이正義의軍과人道의干戈로써護援하는今日吾人은進하야取하
매何强을挫치못하랴退하야作하매何志를展치못하랴
丙子修好條規以來時時種種의金石盟約을食하얏다하야日本의無信을罪하려안이하노라
學者는講壇에서政治家는實際에서我祖宗世業을植民地視하고我文化民族을土昧人遇하
야한갓征服者의快를貪할뿐이오我의久遠한社會基礎와卓犖한民族心理를無視한다하야
日本의少義함을責하려안이하노라自己를策勵하기에急한吾人은他의怨尤를暇치못하노
라現在를綢繆하기에急한吾人은宿昔의懲辦을暇치못하노라今日吾人의所任은다만自己
의建設이有할뿐이오決코他의破壞에在치안이하도다嚴肅한良心의命令으로써自家의新
運命을開拓함이오決코舊怨과一時的感情으로써他를嫉逐排斥함이안이로다舊思想舊勢
力에羈縻된日本爲政家의功名的犧牲이된不自然又不合理한錯誤狀態를改善匡正하야自
然又合理한正經大原으로歸還케함이로다當初에民族的要求로서出치안이한兩國併合의
結果가畢竟姑息的威壓과差別的不平과統計數字上虛飾의下에서利害相反한兩民族間에
永遠히和同할수업는怨溝를去益深造하는今來實績을觀하라勇明果敢으로써舊誤를廓正
하고眞正한理解와同情에基本한友好的新局面을打開함이彼此間遠禍召福하는捷徑임을
明知할것안인가또二千萬含憤蓄怨의民을威力으로써拘束함은다만東洋의永久한平和를

Photo of a building for Sinmungwan Publishing Company,
Choi Hakjoo Collection.

Boy (issue 1),
1908.11. Choi Hakjoo Collection.

"Taebaek Tiger" from *Boy* magazine (November 1909),
1909.11. Adan Mun'go Collection.

Youth (issue 1), Cover image: Ko Huidong,
1914.10. Institution of Modern Bibliography Collection.

Ko Huidong, "Contemplation in a Park"
from Youth (issue 1)

Youth (issue 4), Cover image: Ko Huidong,
Illustrations: An Jungsik· Ko Huidong, 1915.1.
Institution of Modern Bibliography Collection.

Ko Huidong, "Autumn Day" from Youth (issue 4)

Map of Korea As a Tiger,
early 20th century, Color on silk, 80.5 × 46.5 ㎝.
Korea University Museum Collection.

Red Jeogori (children's magazine, issue 2),
Illustrations: Lee Doyoung, 1913.1.15. Pressum Collection.

Children's Readings (children's magazine, issue 7),
Cover image: An Jungsik, 1914.3. Hong Seonwung Collection.

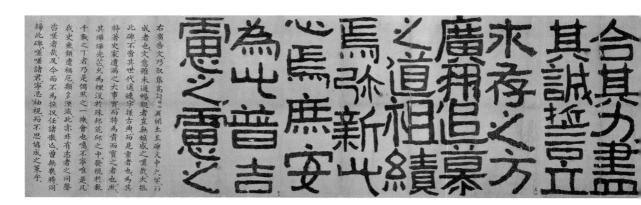

Advertisement of Joseon Gwangmunhoe,
ca. 1910, 39 × 265 ㎝. Paju Book City Letterpress Workshop Collection.

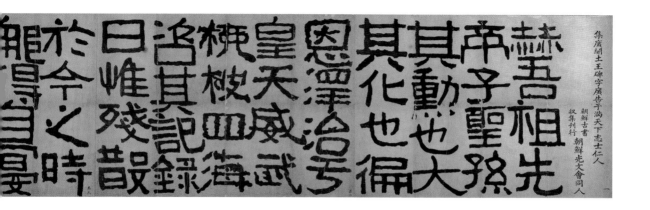

Collecting the letters of Gwanggaeto Stele, we announce to scholars
with noble beliefs as well as generous men.
(Written by) the members of the Joseon Gwangmunhoe who collect
and publish old books of Joseon.

Our bright ancestors
As a descendant of the holy son of heaven
The merits are great
The enlightenment reaches all around.
The grace is satisfying to heaven
The dignity and valiancy are widely in the world.
While we hope to consult the records,
It is just broken and scattered.
In these times
How can we stay comfortable ourselves?
Our future generations
Joining forces and exerting to the utmost
Should establish a method to preserve
And open a way to commemorate them widely
Then the achievements of ancestors shall be renewed more
And this mind shall be almost at ease.
It will be auspicious to seek this
Think and think well.

The above announcement was completed by collecting letters from
Gwanggaeto Stele. Although the sentences do not make sense
fluently, how can it not impress anyone who reads it? This stele comes
far from the old generation, and the shape of letters is regarded as a
classic. Because it especially shows the significant facts that historians
missed, it is considered and treasured particularly preciously. However,
the shining brilliance had long been buried in the desolate hills of
another country. It is now revealed after thousands of years, and it
was one fortuitous opportunity. Ah! It is not all. Many of our members
have often experienced disasters and misfortunes, and it let the ones
with noble beliefs sigh together. If we do not gather them, letting
them scatter and disappear, we will be like this stele in a short time.
Alas! How can't you consider a measure cooperating instead of doing
nothing and just bearing?

Creation (issue 2),
1919.3. Institution of Modern Bibliography Collection.

White Tides (issue 1), Cover image: Ahn Seokju,
1922.1. Seoul National University Library Collection.

Student World (issue 1),
Cover image: Kim Chanyoung,
1920.7. Seoul National University Library Collection.

Student World (vol. 1, no. 5),
Cover image: Kim Chanyoung,
1920.12. Kwon Hyeok-song Collection.

No Soohyeon, "Pioneering" from *La Kreado* (issue 1),
1920.6. Art Research Center, MMCA collection.

Rha Hae-seok, "Pioneer" from *La Kreado* (issue 13),
1921.7. Institution of Modern Bibliography Collection /
Art Research Center, MMCA collection.

Rha Hae-seok, "Dawn" from *Mutual Aid* (issue 1), 1920.9. Sogang University Loyola Library Collection.

Joseon Jigwang (tr. Light of Korea, issue 1), Cover image: Oh Ilyoung, 1922.11. Hong Seonwung Collection.

Edited and Translated by Kim Eok,
Dance of Agony (book of poetry),
Designed by Kim Chanyoung,
1921. Private Collection.

Jeong Jiyong, *Lake Baengnokdam*,
Designed by Gil Jinseop, 1941.
Institution of Modern Bibliography Collection.

Lee Yuksa, *Collection of Lee Yuksa's Poems*,
Designed by Gil Jinseop, 1946.
Institution of Modern Bibliography Collection.

Yang Ju-dong, *Pulse of Korea*, Designed by Yim Yong-ryun,
Illustrations: Yim Yong-ryun(left)· Baek Namsoon(right), 1932.
Institution of Modern Bibliography Collection.

Yim Hwa, *Korea Strait*, Designed by Gu Bon-ung,
1938. Institution of Modern Bibliography Collection.

Park Taewon, *A Day in the Life of Kubo the Novelist*,
Designed by Jeong Hyeon-ung, 1938.
Institution of Modern Bibliography Collection.

Munjang (vol. 1, no. 4), Cover image: Gil Jinseop,
Illustrations: Kim Yongjun, 1939.5.
Art Research Center, MMCA collection.

Munjang (vol. 1, no. 5), Cover image: Kim Yongjun,
Illustrations: Kim Whanki, Gil Jinseop, 1939.6.
Art Research Center, MMCA collection.

Munjang (vol. 1, no. 10), Cover image: Kim Yongjun,
1939.11. Art Research Center, MMCA collection.

Munjang (vol. 3, no. 3), Cover image: Kim Yongjun,
1941.3. Art Research Center, MMCA collection.

Lee Taejun, *Museorok: Essays of Lee Taejun*, Designed by Kim Yongjun,
1941. Institution of Modern Bibliography Collection.

Jeong Jiyong, *Collection of Jeong Jiyong's Poems*, Designed by Kim Yongjun,
1946. Institution of Modern Bibliography Collection.

Kim Yongjun, *Essays of Kim Yongjun*, Designed by Kim Yongjun,
1948. Institution of Modern Bibliography Collection.

Park Taewon, *Scenes by a Stream*, Designed by Park Munwon,
1947. Institution of Modern Bibliography Collection.

Kim Yongjun, *Hong Myeonghui and Kim Yongjun*,
1948, Ink and color on paper, 63 × 34.5 ㎝. Milal Fine Art Museum Collection.

Pen Varlen, *Portrait of Kim Yongjun*,
1953, Oil on canvas, 53 × 70.5 ㎝. MMCA collection.

Rha Hae-seok, *Self-portrait*,
1928, Oil on canvas, 62 × 50 ㎝. Suwon I'Park Museum of Art Collection.

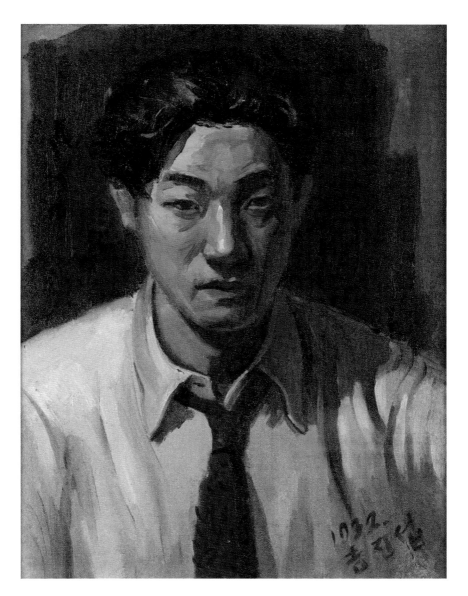

Gil Jinseop, *Self-portrait*,
1932, Oil on canvas, 60.8 × 45.7 ㎝.
The University Art Museum, Tokyo University of the Arts Collection.

3. Sound of the People

1. "Accused (Kim Bokjin) Investigation Report (2nd) on September 27, 1928," in Youn Bummo, *Kim Bokjin: Art Movements and Sculpture during Japanese Colonial Period* (Seoul: Dongguk University Press, 2010), 496.

2. Kim Gijin, "Enlightening the Ruling Class and Enlightening the Ruled Class," *La Kreado* no. 43 (1924): 13.

3. According to Choi Youl, Kim Bokjin was the highest ranked member of the Central Committee and he wrote the draft of KAPF's codes and principles. Choi Youl, *History of Korean Modern Art: 1800-1945* (Seoul: Yeolhwadang, 1998), 192.

4. Lee Bukman was a member of the Tokyo branch of the ML Party. Kim Yunsik, *History of Korean Contemporary Literature as Discovery* (Seoul: Seoul National University Press, 1997), 178.

*

Hong Jisuk received his BA and PhD from the Department of Art Studies at Hongik University. Having previously lectured on art history, art criticism, and art psychology at Dankook University, Hongik University, Sungshin Women's University, the University of Seoul, and Mokwon University, he is currently serving as a visiting professor at Dankook University and on the academic committee of the Korean Modern and Contemporary Art Society. In addition to various articles about Korean modern art, he is the author of *Art Historians and Art Critics Who Defected to North Korea* (Seoul: Gyeongjin, 2018), and *Taste of a Field Trip* (Seoul: Moyosa, 2017), and the co-author of *Conversations for Beginners in Art History* (Seoul: Hyehwa 1117, 2018).

Ideology and Development of Korea's Proletarian Art Movement in the Japanese Colonial Period

Hong Jisuk[*]

Visiting Professor, Dankook University

In August 1925, the two left-wing groups *Yeomgunsa* and *Paskyula* merged to form the Korea Artista Proleta Federacio (KAPF), marking the beginning of Korea's proletarian art movement during the Japanese colonial period. After the March 1st Movement (1919), the increasing animosity towards Japanese colonial rules and concerns about the "ongoing collapse of Korea's economy"[1] led many Korean artists and intellectuals to align themselves with socialism. The emergence and development of the proletarian art movement was also greatly influenced by the Bolshevik Revolution (October 1917), the formation of the Communist International (i.e., Comintern, March 1919), and the creation of the Soviet Union (1922). Inspired by these events, many new sculptors and painters who appeared in the 1920s and 1930s pursued proletarian art, aspiring to national liberation as well as building a working class culture to counter ruling class culture.[2]

Two of the central figures of this movement were Kim Bokjin, who entered the Sculpture Department at the Tokyo School of Fine Arts in 1920, and Ahn Seokju, who studied at the Tokyo School of Oil Painting. After working closely together as members of both the Towolhoe theater group (founded in 1922) and the Towol art group (founded in 1923), Kim Bokjin and Ahn Seokju formed Paskyula in 1923, along with Park Younghee, Kim Gijin, Lee Iksang, Lee Sang-hwa, Kim Hyeongwon and Yun Haknyeon. Through an array of progressive cultural activities, ranging from stage productions to satirical cartoons and art education, Kim and Ahn established themselves as the primary leaders of the proletarian art movement.

In particular, Kim Bokjin was the driving force behind the establishment of the KAPF in August 1925.[3] As the only member of the Marxist-Leninist (ML) Party within the KAPF,[4] Kim Bokjin wrote the draft of the group's codes and principles, in which he stated that the goal of KAPF was to "use art as a weapon for attaining the class liberation of the Korean people."[5] In 1928, however, Japan carried out its third series of arrests against the Communist Party of Korea, and Kim Bokjin was arrested and imprisoned for five and a half years. In the late 1920s and early 1930s, a number of new artists-including Gang Ho, Lee Sang-choon, Lee Gapgi, Lee Juhong, Yi Sangdae, Bak Jinmyeong, Jung Habo, and Chu Min-joined the KAPF and took over the leadership of the proletarian art movement.[6] Even after KAPF was officially disbanded in May 1935, Gang Ho, Lee Sang-choon, Kim Ilyeong, and Chu

5. Kim Bokjin apparently got this phrase from his younger brother, Kim Gijin. Kim Gijin, "My Memoirs: Early Member and Later Bloomer" (originally printed in Generation vol. 2, no. 14, July 1964) in Collected Writings of Kim Gijin II (Seoul: Moonji, 1988), 198.

6. On April 20, 1930, KAPF reorganized its structure, with the four divisions of Literature, Film, Theater, and Fine Arts being placed under the Technology Department. The standing committee member of the Fine Arts division was Yi Sangdae, and the other committee members were Ahn Seokju, Jung Habo, and Gang Ho. Chosun Ilbo, April 29, 1930. At the time, Bak Jinmyeong, Lee Sang-choon, Yim Hwa, Lee Gapgi, Lee Juhong, and Chu Min participated in the Fine Arts division of KAPF. Choi Youl, History of Korean Contemporary Art Movements (Paju: Dolbegae, 1991), 61.

7. Gang Ho, Kim Ilyeong, Park Seokjeong, Park Palyang, Song Yeong, Shin Gosong, and Chu Min, "Art Activities During KAPF Period: Symposium," Korean Art no. 4 (1957): 12-13.

8. ibid., 8.

9. Gang Ho, "Organization and Activities of the Fine Arts Division of KAPF," Korean Art no. 5 (1957): 12.

10. Youn Bummo, Kim Bokjin: Art Movements and Sculpture during Japanese Colonial Period (Seoul: Dongguk University Press, 2010), 358.

11. Kim Bokjin, "Paskyula," Chosun Ilbo on July 1, 1926.

12. Kim Gijin, "Anti-Capitalist and Un-Patriotic: Postwar French Literature," La Kreado no. 44, (February 1924).

Min formed the *Gwanggo Misulsa* Group[7] and determinedly persisted in their proletarian art activities despite Japanese oppression.

The proletarian art movement of Korea was based on international solidarity. For example, the Japanese Federation of Proletarian Culture (KOPF), formed in 1931, established its Korean Council to act as a mediary between the respective proletarian movements of Korea and Japan. Korean proletarian artists received information about the art of revolutionary Russia from the Japanese magazine *Comrades of the Soviets* (*Sobeito no tomo*; ソヴェートの友), and also learned socialist art theory through the art criticism of Ohira Akira.[8] The 1st Proletarian Art Exhibition, held in Suwon in March 1930, included works by many Japanese proletarian artists, including Okamoto Toki, Yabe Tomoe, Huta Seiji, Yanase Masamu, and Hashimoto Yaoji. These works were brought to Korea by Jung Habo, who worked for the Japanese Federation of Proletarian Arts (PIPI). Gang Ho later recalled that the "exhibition demonstrated the realistic expressions of the international proletariat, emerging from the solid alliance among the proletariat of different countries and the solidarity of revolutionaries."[9]

But what exactly is proletarian art? In the early days of the movement, the leaders of the proletarian art movement were primarily concerned with answering this question. They studied new art from Europe and Japan, and paid special attention to any news from Russia. They also took it upon themselves to keep the Korean public informed about development in the international art world, as demonstrated by Kim Bokjin's article, "A Year of the International Art Field: Japan, France, and Russia," (*Sidae Ilbo* on January 2, 1926) and Park Younghee's article, "10th Anniversary of Soviet Russia (5): Cultural Development" (*Dong-a Ilbo* on November 11, 1927).

Many of the Korean artists who pursued proletarian art during the Japanese colonial period were initially drawn to the destructive power of contemporary art. The Paskyula group, formed by Kim Bokjin and Ahn Seokju in 1923, showed great interest in Dadaism from Europe and the Mavo movement of Japan, established by Murayama Tomoyoshi in 1923. Like Dada and Mavo, Paskyula used its own name to signify its resistance to the existing order. In this case, "Paskyula" was an acronym consisting of the initials of the founding members ("PA" for Park, "S" for Sanghwa, "K" for Kim, "YU" for Yun, "L" for Lee, and "A" for Ahn).[10] According to Kim Bokjin, Paskyula was a peculiar meeting of misfits with only one thing in common: their disdain for existing conditions.[11]

The proletarian art movement at the time consisted of two groups: one favoring Bolshevism, and the other favoring Anarchism. Although both factions shared a desire to overthrow the existing order to lay the foundation for a new society, they began to show some disagreement and dissension around 1924. In particular, some inside the movement began to criticize Anarchism, Dadaism, and Futurism as "deformed and transitional phenomena that occurred in cities."[12] Based on such realizations, some KAPF

13. Kim Bokjin, "New Art and Its Target," *Chosun Ilbo* on January 2, 1926.

14. Kim Bokjin, "A Year of International Art Field: Japan, France, and Russia," *Sidae Ilbo* on January 2, 1926.

15. Yim Hwa, "Establishment of *Juche* Ideology in Art," *Chosun Ilbo* from November 20 through 24, 1927.

16. "On the Proletarian Art Movement (Draft by the Headquarters)," *Art Movements* no. 1 (November 1927): 2-3.

17. Kim Yongjun, "Proletarian Art Criticism: for Salvaging Pseudo-art" (originally printed in *Chosun Ilbo* from September 18 through 30, 1927), in *Collected Works of Kim Yongjun V: Theory of Art of the Korean People* (Seoul: Yeolhwadang, 2010), 57.

18. Yoon Kee-Jung, "Yearly Review of Korean Literature of 1927," *Joseon Jigwang* no. 1 (1928): 100.

19. According to Lee Gapgi, the Zero-Gwajeon exhibition organized by Lee Sang-choon, Lee Gapgi, and Shin Gosong in 1927 in Daegu was intended to completely reject the bourgeois art represented by the Joseon Art Exhibition and the Nokyanghoe Group in Seoul. The organizers thus declared the "Zero-Gwa Manifesto," which was filled with anarchist rhetoric. Lee Gapgi, "Memories of Lee Sang-choon," *Korean Art* no. 6 (1957): 15-16.

20. Shin Gosong, "KAPF Artist Lee Sang-choon," *Korean Art* no. 6 (1957): 14.

21. Chu Min, "Militant Genres and Revolutionary Activities of KAPF Art," *Korean Art* no. 4 (1957): 13-14.

artists began turning away from the destructive attitude of Dadaism and instead embraced Russian Constructivism. For example, in a 1926 article, Kim Bokjin conceded Cubist, Futurist, and Dadaist art as "joyful destruction", but also argued that those movements had been formed in a "bourgeois greenhouse," and thus inherently lacked the ideological capacity to pursue "something more".[13] He then cited Constructivism, the industrialist art of Russia, as the optimal type of art for rebuilding after destruction. Having been developed in revolutionary Russia with the clear goal of serving the common good, Constructivism embodied the ideal form of proletarian art for Kim.[14]

Seeking to realize this ideal, Kim Bokjin encouraged the KAPF artists to get out of their studios and start producing propaganda art that could help instigate the proletarian revolution.[15] Under the slogan "From the weapon of art to art as a weapon," KAPF artists jumped into the midst of political struggles.[16] Some within the group tried to attest that German Expressionism represented an anarchist form of art with "unique aesthetics that were inherent to the proletariat,"[17] but this view was quickly dismissed as an "impermissible error of perception."[18] In the 1920s, while studying in Japan, Lee Sang-choon dedicated himself to anarchist and expressionist art.[19] But after returning to Korea in 1930, Lee completely changed his political beliefs and became a Marxist. Instead of painting, he focused on producing posters, illustrations, and stage art, including the cover of *Seven KAPF Artists* and illustrations for the novel *Nitrogenous Fertilizer Factory*.[20]

Like Lee, after 1927, the KAPF artists focused primarily on illustrations, bindings, posters, and stage art. Lee Gapgi, Lee Sang-choon, Lee Juhong, and Gang Ho were in charge of illustrating and binding the KAPF bulletins (*Art Movements and Groups*) and magazines (*Theater Movements, Film Troops, Joseon Jigwang, World of Stars, New Boy, Criticism, Daejung Gongnon*, and *Sidae Gongnon*). The KAPT artists produced stage art for New Construction, the KAPF theater (Lee Sang-choon, Chu Min, Gang Ho, etc.), as well as other theaters associated (both directly and indirectly) with KAPF, such as Aengbonghoe, Children's Theater, Theater Megaphone (Chu Min), Cheongbok Theater, and a small traveling theater (Chu Min). They also produced stage art for progressive performances held in different regions, including the Choi Seung hee Dance Company in Seoul (Jung Habo); Gadu Theater in Daegu; Daejung Theater in Gaeseong; Dongbuk Theater in Hamheung; Yeongeuk Theater in Haeju; and Machi Theater, Myeongil Theater, and Sinyesuljwa Theater in Pyongyang (Yi Seokjin).[21]

After the mid-1930s, however, the proletarian art movement quickly declined. *Gwanggo Misulsa Group*, the last bulwark of the movement, was disbanded in 1938 following the arrest and imprisonment of Gang Ho, Kim Ilyeong, and Chu Min. What little wind remained in the movement's sails was taken by the premature deaths of Lee Sang-choon (1937), Kim Bokjin (1940), and Bak Jinmyeong (1941). Under the complete control of the Japanese war

22. Choi Youl, "Socialist Art Movements and Kim Bokjin," *Inmul Art History* no. 5 (2009): 175.

machine, Korea's left-wing art movement faded into the mists of history, not to reappear again until after the restoration of Korean independence in 1945.[22]

Battle Flag (vol. 2, no. 10),
Cover image: Ootsuki Genji,
1929.10. MMCA collection.

Battle Flag (vol. 3, no. 1),
Cover image: Yanase Masamu,
1930.1. MMCA collection.

Makimoto Kusuro,
Red Flag-Proletarian Children's Song Collection,
1930. MMCA collection.

Formative Pictorial (issue 1),
Cover image: Okada Tatsuo, 1928.10.
Machida City Museum of Graphic Arts Collection.

Ono Tadashige, Cover Page from *Death of Three Generations*,
1931, Woodcut on paper, 12.1 × 10.6 ㎝.
Machida City Museum of Graphic Arts Collection.

Ono Tadashige, *Death of Three Generations* (number 1),
1931, Woodcut on paper, 11.8 × 15.3 ㎝.
Machida City Museum of Graphic Arts Collection.

Ono Tadashige, *Death of Three Generations*
(number 11), 1931, Woodcut on paper, 11.6 × 8.4 ㎝.
Machida City Museum of Graphic Arts Collection.

Ono Tadashige, *Death of Three Generations*
(number 13), 1931, Woodcut on paper, 12.4 × 9.9 ㎝.
Machida City Museum of Graphic Arts Collection.

Ono Tadashige, *Death of Three Generations*
(number 24), 1931, Woodcut on paper, 12 × 7.8 ㎝.
Machida City Museum of Graphic Arts Collection.

Ono Tadashige, *Death of Three Generations*
(number 30), 1931, Woodcut on paper, 12.3 × 9.8 ㎝.
Machida City Museum of Graphic Arts Collection.

Ono Tadashige, *Death of Three Generations* (number 37),
1931, Woodcut on paper, 12.5 × 15.8 ㎝.
Machida City Museum of Graphic Arts Collection.

Ono Tadashige, *Death of Three Generations* (number 46),
1931, Woodcut on paper, 12.4 × 15.7 ㎝.
Machida City Museum of Graphic Arts Collection.

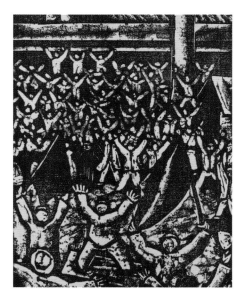

Ono Tadashige, *Death of Three Generations* (number 49),
1931, Woodcut on paper, 16 × 12.1 ㎝.
Machida City Museum of Graphic Arts Collection.

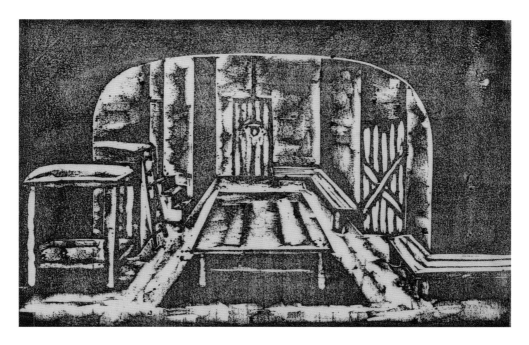

Ono Tadashige, Stage Design for Maxim Gorky's *The hotel by night*,
1932, Woodcut on paper, 14.3 × 20.2 ㎝. Machida City Museum of Graphic Arts Collection.

Luo Qingzhen, *Qingzhen Woodcuts* (vol. 3),
1935, Woodcut on paper, 16.6 × 13.1 ㎝.
Machida City Museum of Graphic Arts Collection.

Luo Qingzhen, *Three Farmer Women* from *Qingzhen Woodcuts* (vol. 3),
1935, Woodcut on paper, 16.6 × 13.1 ㎝.
Machida City Museum of Graphic Arts Collection.

Luo Qingzhen, *Under a Street Light* from *Qingzhen Woodcuts* (vol. 3),
1935, Woodcut on paper, 12.2 × 10.9 ㎝.
Machida City Museum of Graphic Arts Collection.

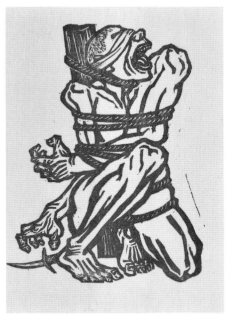

Edited by Li Hua, *Modern Prints* (issue 14),
1935.12., Woodcut on paper, 27.4 × 23.7 ㎝.
Machida City Museum of Graphic Arts Collection.

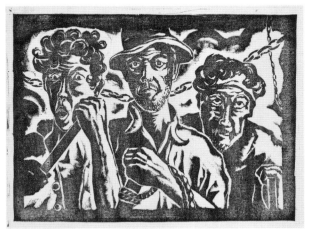

Edited by Li Hua, *Modern Prints* (issue 15),
1936.1., Woodcut on paper, 28.8 × 24.6 ㎝.
Machida City Museum of Graphic Arts Collection.

New Boy (vol. 7, no. 12), Cover image: Lee Juhong,
1929.12. Lee Juhong Literary House Collection.

New Boy (vol. 8, no. 2), Cover image: Lee Juhong,
1930.2. Lee Juhong Literary House Collection.

New Boy (vol. 8, no. 3), Cover image: Lee Juhong,
1930.3. Lee Juhong Literary House Collection.

New Boy (vol. 8, no. 8), Cover image: Lee Juhong,
1930.8. Lee Juhong Literary House Collection.

New Boy (vol. 8, no. 10-11),
1930.11. Lee Juhong Literary House Collection.

New Boy (vol. 9, no. 3), Cover image: Gang Ho,
1931.3. Lee Juhong Literary House Collection.

New Boy (vol. 10, no. 4), Cover image: Choi Gyesun,
1932.4. Lee Juhong Literary House Collection.

New Boy (vol. 10, no. 9),
1932.9. Lee Juhong Literary House Collection.

New Boy (vol. 11, no. 3), Cover image: Lee Juhong,
1933.3. Lee Juhong Literary House Collection.

New Boy (vol. 11, no. 5),
1933.5. Lee Juhong Literary House Collection.

New Boy (vol. 11, no. 7), Cover image: Lee Juhong,
1933.7. Lee Juhong Literary House Collection.

New Boy (vol. 11, no. 8), Cover image: Lee Juhong,
1933.8. Lee Juhong Literary House Collection.

World of Stars (vol. 5, no. 9),
Cover image: Jung Habo, 1930.10.
Lee Juhong Literary House Collection.

World of Stars (vol. 8, no. 10),
Cover image: Lee Juhong, 1933.12.
Lee Juhong Literary House Collection.

World of Stars (vol. 9, no. 4),
Cover image: Lee Juhong, 1934.9.
Lee Juhong Literary House Collection.

World of Stars (vol. 10, no. 1),
Cover image: Lee Juhong, 1935.2.
Lee Juhong Literary House Collection.

The Public (issue 1),
1933.4. Institution of Modern Bibliography Collection.

Criticism (vol. 6, no. 8), Cover image: Lee Juhong,
1938.8. Lee Juhong Literary House Collection.

Criticism (vol. 6, no. 10), Cover image: Lee Juhong,
1938.10. Lee Juhong Literary House Collection.

Eastern Light (January 1932), Cover image: Ahn Seokju,
1932.1. Sogang University Loyola Library Collection.

Eastern Light (November 1932),
1932.11. Sogang University Loyola Library Collection.

Jung Hasu, Lee Sang-choon's illustrations
for the novel *Nitrogenous Fertilizer Factory* (reproduced by Jung Hasu),
2019, Woodcut on paper, Each size 60 × 79 ㎝. Courtesy of the Artist.

Jung Hasu, Illustrations for *Korea's New Theater Movement*
from *Theater Movements* (reproduced by Jung Hasu),
2019, Rubber print on paper, Each size 45 × 40 ㎝. Courtesy of the Artist.

Korean Farmers (vol. 3, no. 8),
Cover image: Ahn Seokju, 1927.8.
Hong Seonwung Collection.

Lee Gwangsu, Joo Yohan, Kim Donghwan,
Collection of Poems by Three Poets,
Cover image: Ahn Seokju, 1929.
Art Research Center, MMCA collection.

Yangjeong (issue 7), Cover image: Lee Byeonggyu,
1930. Hong Seonwung Collection.

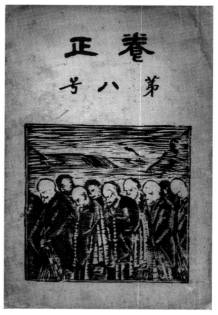

Yangjeong (issue 8), Cover image: Lee Byeonggyu,
1931. Hong Seonwung Collection.

Lee Jeong, Print of cover design for *Sky, Wind, and Stars* by Yun Dongju, 1948, Woodcut on paper, 18.3 × 24 ㎝. Private Collection.

Lee Jeong, *Landscape with Utility Poles 1*, ca. 1947, Woodcut on paper, 11 × 16 ㎝. Private Collection.

Lee Jeong, *Landscape with Utility Poles 2*, ca. 1947, Woodcut on paper, 13.3 × 14.5 ㎝. Private Collection.

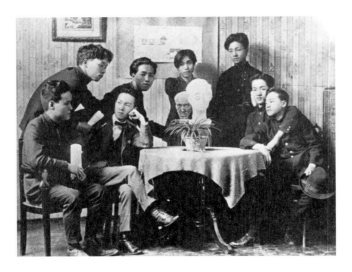

Photo of "*Towolhoe*" theater group,
1922. Art Research Center, MMCA collection.

Literary Movements (issue 1), Cover image: Kim Bokjin,
1926.2. Adan Mun'go Collection.

Theater Movements (vol. 1, no. 2),
1932.7. Adan Mun'go Collection.

Theater Curtains (issue 1),
1936.12. Adan Mun'go Collection.

Theater Curtains (issue 2),
1938.3. Institution of Modern Bibliography Collection.

Theater Curtains (issue 3),
1939.6. Adan Mun'go Collection.

Vacuum tube radio,
ca. 1930s, 22.5 × 50 × 22.7 ㎝. Busan Museum Collection.

Photo of musicians of Nipponophone Company,
1913. Han Sang Eon Cinema Institute Collection.

Lee Jongmyeong, Directed by Kim Yu-young, *Wandering* (film script),
Cover image: Yim Hwa, 1928. Han Sang Eon Cinema Institute Collection.

Flyer for *Floating Weeds* at Joseon Theater,
1928. Han Sang Eon Cinema Institute Collection.

Flyer for *Dark Street* at Joseon Theater,
1928. Han Sang Eon Cinema Institute Collection.

Dansung Weekly (no. 300),
1929. Han Sang Eon Cinema Institute Collection.

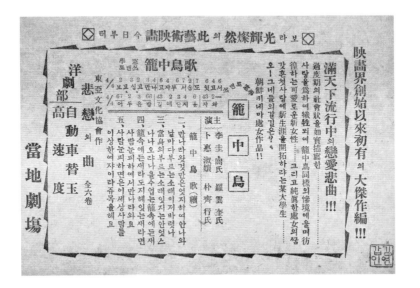

Directed by Lee Gyu-seol, Flyer for *Bird in a Cage*,
1926. Arirang Association Collection.

Na Woongyu, Edited by Mun Il, *Arirang* (film script, 1 and 2),
1930. Arirang Association Collection.

Directed by Kim Sobong, Film poster for *Arirang*,
1957. Korean Film Archive Collection.

Poster for Choi Seunghee's new dance performance, 1930s. Modern Design Museum Collection.

Poster for Choi Seunghee's new dance performance, 1930s. Modern Design Museum Collection.

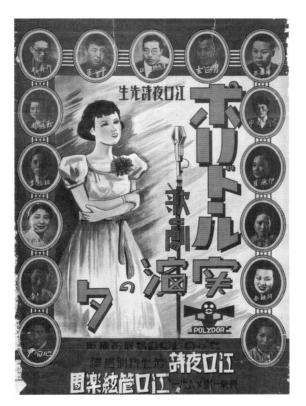

Poster for *Night of Operetta of Polydor Records*,
1930s. Modern Design Museum Collection.

Poster for Kim Yeonsil musical troupe, 1940s.
Modern Design Museum Collection.

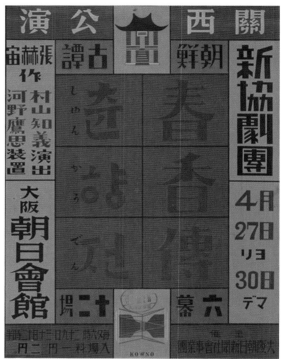

Directed by Bang Han-jun, Film poster for
Seonghwangdang (Altar for a Tutelary Deity),
1939. Korean Film Archive Collection.

Poster for *Story of Chunhyang* by
Sinhyeop Theater Company in Kansai, Japan,
1930s. Ohara Institute for Social Research, Hosei University Collection.

Directed by Kim Sobong, Film poster for
Story of Hong Gildong, 1934. National Museum of
Korean Contemporary History Collection.

Film poster for *Story of Hong Gildong* directed by Lee Myeongwoo
and *Story of Janghwa and Hongryeon* directed by Hong Gae-myeong,
1936. Busan Museum Collection.

Jeong Jeum-sik, *Landscape of Harbin*,
1945, Pen and watercolor on paper, Each size 16.2 × 21.5 ㎝, 14 × 18.5 ㎝. Private Collection.

Jeong Jeum-sik, *Landscape of Harbin*,
1945, Pen and watercolor on paper, Each size 13 × 15 ㎝, 12.5 × 19.5 ㎝. Private Collection.

Pen Varlen, *Kalinino*,
1969, Etching on paper, 50.8 × 84.2 ㎝. Private Collection.

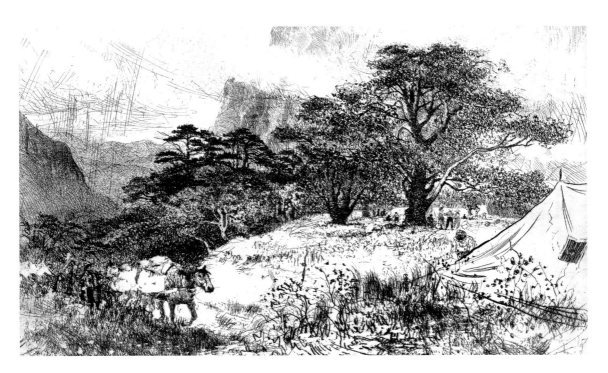

Pen Varlen, *Yuzhno-Sakhalinsk*,
1967, Etching on paper, 32 × 49.5 ㎝. Private Collection.

Pen Varlen, *Nakhodka Bay in the Evening*,
1968, Oil on canvas, 100.5 × 79.5 ㎝. Private Collection.

Pen Varlen, *Family*,
1986, Oil on canvas, 68 × 134 ㎝. Private Collection.

Park Youngchik (Charles Park), *Untitled*,
Undated, Oil on plywood, 24.5 × 19.5 ㎝. MMCA collection.

Park Youngchik (Charles Park), *Portrait of a Woman*,
1950s, Oil on canvas, 39.4 × 28.7 ㎝. MMCA collection.

Yim Yong-ryun (Gilbert Phah Yim), *Crucifixion*,
1929, Pencil on paper, 37 × 32.5 ㎝. Private Collection.

Yim Yong-ryun (Gilbert Phah Yim), *Landscape of Herblay*,
1930, Oil on hardboard, 24.2 × 33 ㎝. MMCA collection.

Pai Unsoung, *Self-portrait in Hat*,
1930s, Oil on canvas, 54 × 45 ㎝. Jeon Chang-gon Collection.

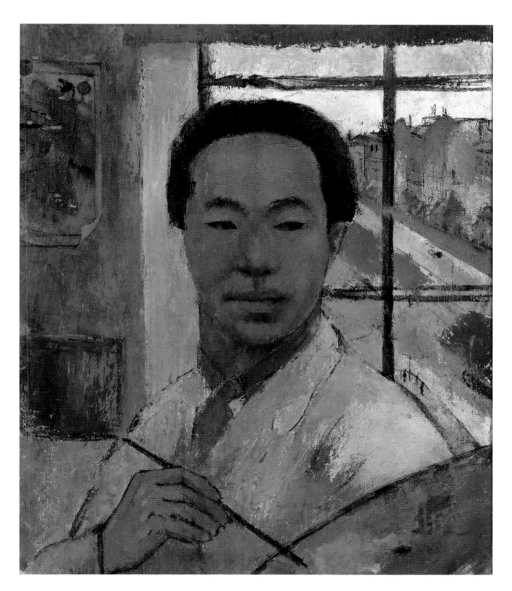

Pai Unsoung, *Self-portrait*,
1930s, Oil on canvas, 60.5 × 51 ㎝. Jeon Chang-gon Collection.

4. Mind of Korea

The Trajectory of the Paintings Presenting Joseon

Kim Hyunsook*

Director, KISO Art Research Center

Doppelgangers of Joseon

We grow into independent individuals as well as adults through the process of asking ourselves who we are and what kind of people we want to become, struggling to find an answer. Finding our own identity means not observing oneself in a mirror but undergoing the process of questioning, challenging, experiencing failure and success, and realizing ourselves in it. In the process, we acquire our own voice. If the ultimate goal is determined externally or only one path of life is offered, forming an identity is impossible from the beginning; in which case we may choose to return to the past and stagnate. The identity crisis experienced by the Koreans during the early 20th century was caused by the problematic situation of the latter. In such a situation, 'I' was referred to not in the present tense but in the past tense by the ruling colonial power of Japan, and only the empty shell of "us" was allowed while the community of 'we' was denied. We neither existed, nor not-existed. Instead, we were just said to have been so in the past.

Japan meticulously gathered a large amount of information and knowledge about Joseon and led the discourse of the identity of Joseon and its people in a way that benefited, and created profit for, Japan. This so-called 'fabricated identity' was suggested and planted, and 'Joseon-ness' was visualized with doppelganger images infused by "local color of Joseon." Those images of doppelgangers who are poor, ignorant, and naïve people roamed around a mirror, such as a woman carrying a water jar on her head, a long-bearded man in white with a tobacco pipe, a collapsing thatched house, a bare and hungry sister wandering in an empty field, a girl carrying a baby on her back, women doing laundry, a woman pounding grain in a mortar, and a burden carrier. Far away, the flag that read 'Great Gyeongseong' fluttered, but it was just a story of a cold, cruel, and distant nation, as in Yom Sang-sop's short story *A Green Frog in the Specimen Room*.

In the framework of civilization versus barbarism, Joseon was placed in the realm of barbarism. Although categorized as barbaric, the people of Joseon were encouraged to taste and desire the new civilization that was modernity, only to be exploited economically. Of course, desiring does not guarantee that the gap is bridged. The most successful example of modern products was the artificial flavor enhancer which was written as '味の素,' read 'Ajinomoto,' and later became 'Miwon' in South Korea. Advertised as the 'taste of civilization,' Ajinomoto tamed and "civilized" the people's palate in Joseon,'

Kim Hyunsook received her Ph. D. from the Department of Art History at Hongik University with the dissertation *Orientalism in Korean Modern Art: with Focus on Western-style Painting*. She worked as a guest curator or contributor for Korean and Japanese exhibitions on modern art including *100 Years of Korean Art (Part 1)* (MMCA, Gwacheon, 2006); *Toward the Modernity: Images of Self & Other in East Asian Art Competitions* (Fukuoka Asian Museum and traveling venues, 2014); *Korean and Japanese Modern Artists in the Korean Peninsula, 1890s to 1960s* (The Museum of Modern Art, Hayama, and traveling venues, 2015). She was the chairperson of the Association of Korean Modern and Contemporary Art History as well as the Korean Art History, and worked as a research professor at the Humanities Research Center of Duksung Women's University and an adjunct professor at Sungkyunkwan University; as a guest researcher at the Fukuoka Asian Art Museum (2014) and the Los Angeles County Museum of Art (2014). Kim currently works as the director of the KISO (綺疏) Art Research Center.

1. Byeon Young-ro, *The Heart of Joseon* (Seoul: Pyeongmoongwan, 1924).

2. Byeon Young-ro, "The Theory of Eastern Painting", *Dong-A Ilbo* (July 7 1920)

3. Lee Yeosung, "Joseon Traditional Costume," *Shingdonga* (1935).

eventually lining the pockets of a Japanese colonial company. Without guns and knives, it occupied Joseon's table only by promoting images of capital and civilization, finally dominating the consciousness of the noble Koreans who did not make decisions without a justifiable purpose. Joseon in the first half of the 20th century was a multilingual space where not only Korean and Japanese but also English and Chinese were used. Cultural hybridism and variety were breeding. In contrast, doppelganger images of Joseon were promoted and programmed—mainly by Japanese artists and the government—patronized artists of Joseon-to keep the Korean people inside the threshold of the old days. In this situation, as the poet Byeon Young-ro (卞榮魯, 1898-1961) grieved in his book of poetry titled *The Heart of Joseon*, we could ask "where can we find the heart of Joseon."[1] As soon as the doppelgangers came out of the boundary of the glass layer, would they cease to exist? Did the nature of Joseon even exist? Extremely difficult and pressing issues were left as the task of the time.

Awakening the Spirit of the Times

Only four to five years before Byeon Young-ro cried that the heart of Joseon was a "grievous mind!" he had translated the March 1st Declaration of Independence into English with his brother Byeon Young-tae, typing it all night and sending it abroad through a foreign missionary. He claimed that the conservative and lethargic Joseon ink painters who could not do away with corrupt customs should have the spirit of the times. In *The Theory of Eastern Painting*, he wrote the hard truth as follows:

> Look at the current paintings on the walls of the Paris Salon Exhibition! All the pictures are the painters' own expressions. All of them are created with free imagination, bold expression ignoring old ways, and original ingenuity (although there are some flaws). Also, all the themes come from the real world that we see everyday. Therefore, there are miserable war paintings and also pictures that vividly depict the disabled, beggars, whores, fighting people, drunkards, and rabid dogs. But what kind of paintings did our artists paint?[2]

Byeon Young-ro had called for the enlightenment of here and now, but after a few years, he expressed his grievous mind that could not find the heart of Joseon. After a decade or so, the nationalist journalist Lee Yeosung (李如星, 1901-?) also criticized Joseon artists, saying "Joseon artists are immersed in cigarettes, alcohol, women, irregularity, and intemperance with a thin body, pale complexion, downhearted behavior, and sleepy eyes. He insisted that "the artists should observe the reality of Joseon in a scientific way" with "energetic sincerity, diligent efforts, as well as serious and noble attitudes."[3] Publishing a

series of articles under the title of *Joseon Traditional Costume* in a newspaper, he attempted to research and restore historical materials on traditional clothes of Joseon that were disappearing. In the 1930s, Lee started to paint oversized portraits of historical figures based on his research. Such works included *Commissioner of Cheonghaejin Jang Bo-go, Kim Yu-shin Cutting the Horse's Head, Creator of Daedongjeojido Gosanja, Ancestor of Music Park Yeon*, and *Gyeokgu* (擊毬, a Korean game similar to polo), with the only surviving piece today being *Gyeokgu* housed in the Equine Museum Collection. On the other hand, he published *Research on the Numbers of Joseon* to grasp the reality of Joseon which was distorted by the Japanese Resident-General of Korea. Lee's efforts to find Joseon correspond with the spirit of *Shilsagushi* (實事求是, the quest for the truth from actualities). As the Silhak scholars of Joseon, including Chusa Kim Jeong-hui (金正喜, 1786-1856), accepted the bibliographical study of the Qing Dynasty, Lee Yeosung endeavored to avoid distorting or abandoning reality by embracing the three-dimensional depiction and the perspective of the West.

When the phantom of the reproduced images called the 'local color of Korea' was popular, the empirical realism of Lee Yeosung was exceptionally innovative. The artist who sympathized with his philosophy of art was his brother Lee Qoede (李快大, 1913-1965). Lee Qoede attempted an accurate understanding and description of the object, and then took the path of romantic realism to enhance the effect of the theme with the composition and expression that resulted in an emotional uplift. In particular, he studied the works of Renaissance artists including Sandro Botticelli (1445-1510), Michelangelo di Lodovico Buonarroti Simoni (1475-1564), and Raffaello Sanzio da Urbino (1483-520) as well as Romantic masters like Ferdinand Victor Eugene Delacroix (1798-1863) and Théodore Géricault (1791-1824). Based on this study, he constructed his work using the physical proportions and facial appearance of Koreans and pioneered a new horizon of group figure painting that presents allegorical iconography and historical narratives. His representative work, *People* series, is a group figure painting that presents the reality, historical spirit, and future vision of the Korean society. It boosted the conviction that a new history could be created with people as its subject.

Reaching the State of Dignity and Elegance

While the art theory of Lee Yeosung emphasized reality based on bibliographical study and empirical evidence, Kim Yongjun (金瑢俊, 1904-1967) sought to inherit the convention of ink painting that captured the essence of the subject matter and expressed the inner world of the artist, reaching a state of dignity. Contrary to the expansion of art after modern times-that divided poetry, calligraphy, and painting (詩書畫)-he recognized

anew the artistic value of calligraphy and rediscovered qualities that surpassed Western modern art in a stroke of ink and brush or in the elegant drawing of lines. He disagreed with the idea of the time that Eastern painting modes of expression are out of date compared to Western realism or expressionist art. Instead, he thought that it was possible to attain a higher aesthetic and practical achievement with the coexistence of a description of the appearance (形似, *hyeongsa*) and an expression of the inner world (寫意, *saui*). Kim's art theory is opposed to Lee's because Lee Yeosung emphasized the expression of the inner world over the description of the outer appearance, accepting the technique of Western painting. Kim said it was not necessary to compromise with Western painting techniques because it was possible to acquire a sense of reality close to Western realism within the tradition of *hyeongsa*. He also argued that by simultaneously pursuing *hyeongsa* and *saui*, Eastern painting can reach its own particular state which is superior to that of Western painting.

The method of combining *saui* and *hyeongsa*, not dividing the two, is not the invention of Kim Yongjun, but the legacy of Eastern literati painting and ink painting. The idiom 'hills and valleys in the heart (胸中丘壑)' means that there is an ideal landscape in one's heart, made out of the real world. However, the ideal landscape is not a surreal or abstract world that escapes reality, or does it leave the formality of a real landscape altogether. It reminds us that the unique horizon of the Eastern image of mind lies in the comprehensive state of existence and non-existence.

The inheritance of tradition also played a significant role in the abstract paintings and the porcelain paintings of the 1950s by Kim Whanki (金煥基 1913-1974). The image of white porcelain, in particular "moon jar," sublimated into natural objects and became a symbolic existence of 'emptiness with non-thinking mind,' transcending the relationships of our world that only pursue profits. The world of spirit responds to a modern society dominated by capitalism with Eastern transcendence, deflecting the reality claimed by Lee Yeosung and Lee Qoede, and defending the values of nature, transcendence, and non-thinking mind, which are the core the Eastern discourse.

In this essay, I discussed a series of thoughts and the trends of works that sought to be the paintings 'presenting Joseon.' Confronting or complementing each other, these works created a clear flow that enhanced Korean traditions and the self-consciousness as Korean artists. They are also believed to have contributed to establishing the foundation of national art and to vitalizing the universal values as well as the assets of an aesthetic mind of humanity.

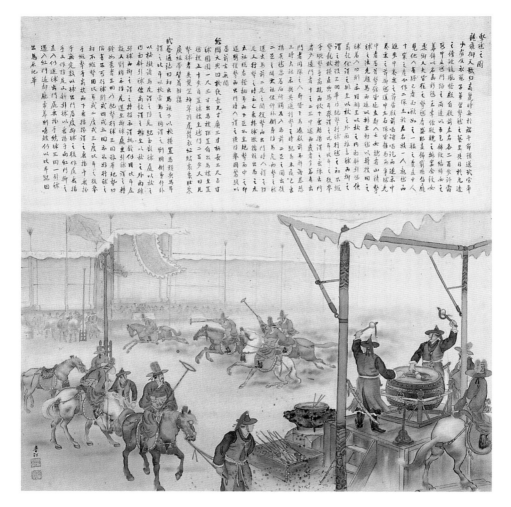

Lee Yeosung, *Gyeokgu* (a Korean game similar to polo),
1930s, Color on silk, 92 × 86 ㎝. Korea Racing Authority Equine Museum Collection.

Spring and Autumn (vol. 2, no. 8), Cover image: Lee Yeosung,
1941.9. Art Research Center, MMCA collection.

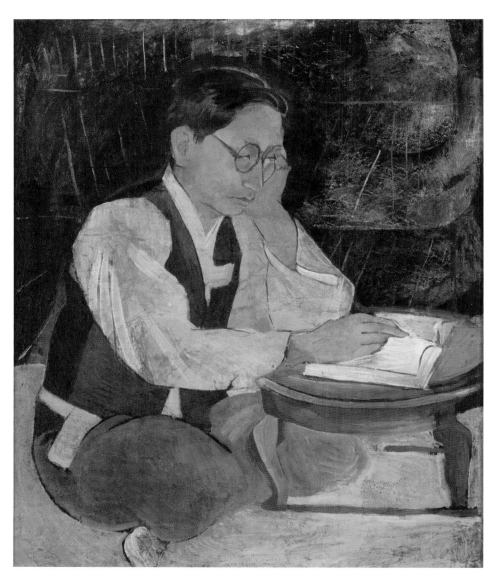

Lee Qoede, *Portrait of Lee Yeosung*,
1940s, Oil on canvas, 90.8 × 72.8 ㎝. Private Collection.

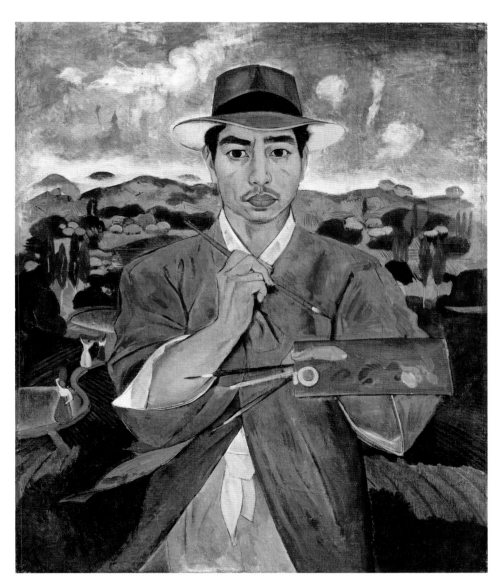

Lee Qoede, *Self-portrait*,
late 1940s, Oil on canvas, 72 × 60 ㎝. Private Collection.

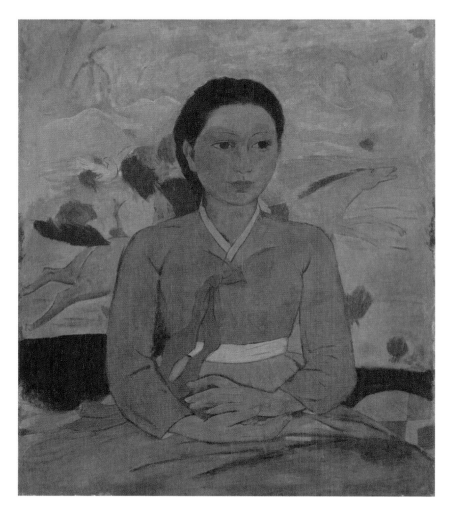

Lee Qoede, *Portrait of a Woman*,
1943, Oil on canvas, 70 × 60 ㎝. Private Collection.

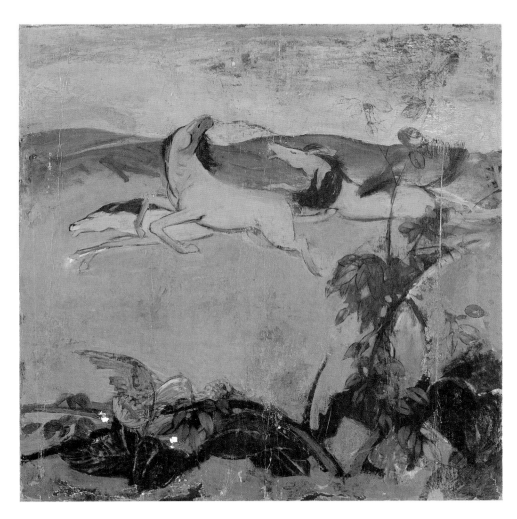

Lee Qoede, *Horses*,
1943, Oil on canvas, 60.8 × 59.5 ㎝. Private Collection.

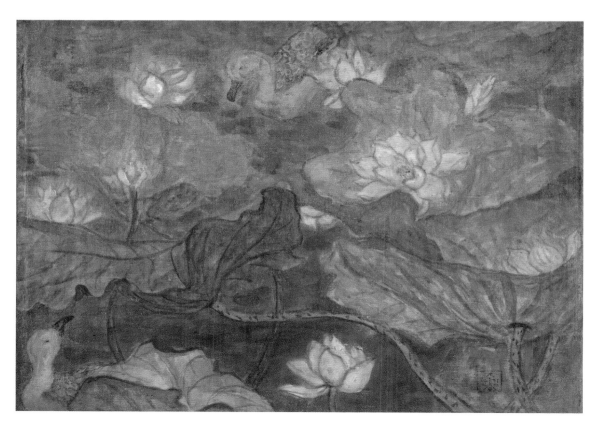

Kim Jongchan, *Lotus*,
1941, Oil on canvas, 33 × 46 ㎝. MMCA collection.

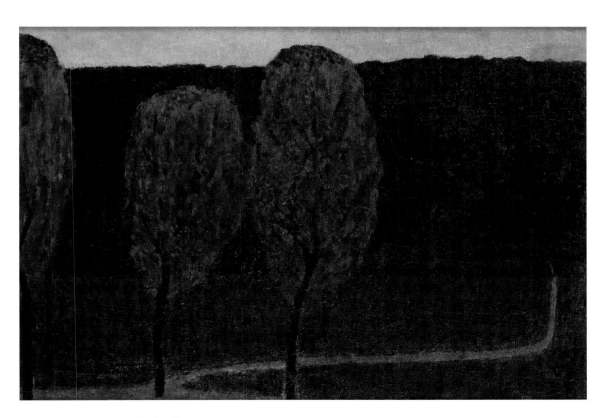

Choi Jaideok, *Poplar Trees by the Han River*,
1940s, Oil on canvas, 46 × 66 ㎝. Private Collection.

Choi Jaideok, *Lookout Hut on Stilts*,
1946, Oil on canvas, 20 × 78.5 ㎝. Private Collection.

Jin Hwan, *Heavenly Peaches and Children*,
1940s, Crayon on hemp cloth, 31 × 93.5 ㎝. MMCA collection.

Lee Insung, *Sweet-briars*,
1944, Oil on canvas, 228.5 × 146 ㎝. Private Collection.

Kim Whanki, *Fruits,*
ca. 1954, Oil on canvas, 90 × 90 ㎝. Private Collection.
© Whanki Foundation · Whanki Museum

Kim Whanki, *White Porcelain Jars*,
late 1950s, Oil on canvas, 100 × 80.6 ㎝. Private Collection.
© Whanki Foundation · Whanki Museum

Kim Whanki, *Jar and Plum Blossom*,
1958, Oil on hardboard, 39.5 × 56 ㎝. Private Collection.
© Whanki Foundation · Whanki Museum

Kim Whanki, *Jar*,
1958, Oil on canvas, 49 × 61 ㎝. Private Collection.
© Whanki Foundation · Whanki Museum

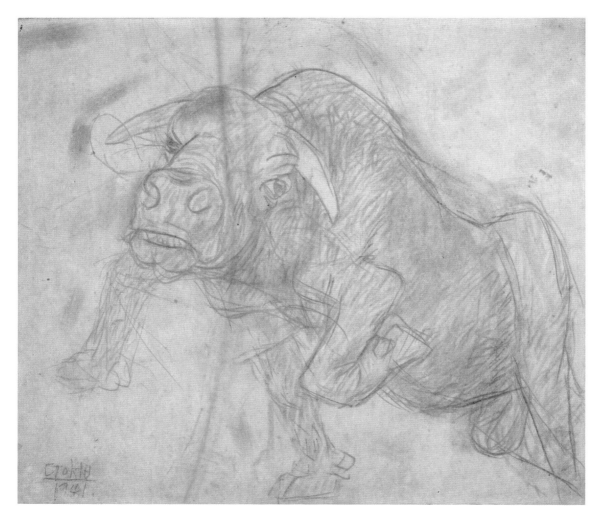

Lee Jungseob, *Drawing*,
1941, Pencil on paper, 23.3 × 26.6 ㎝. Private Collection.

Lee Jungseob, *A Boy*,
1944-45, Pencil on paper, 26.4 × 18.5 ㎝. MMCA collection.

Lee Jungseob, *Three People*,
1944-45, Pencil on paper, 18.2 × 28 ㎝. MMCA collection.

Lim Gunhong, *Traveler*,
1940s, Oil on paper, 60 × 45.4 ㎝. Private Collection.

Lim Gunhong, *Birds in a Cage*,
1947, Oil on paper, 21 × 13.5 ㎝. Private Collection.

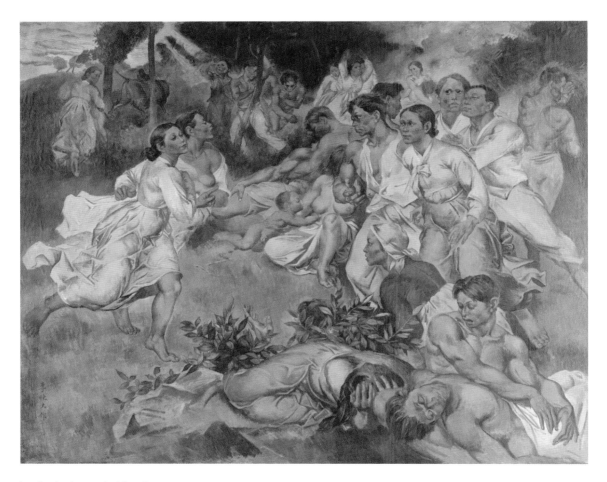

Lee Qoede, *Announcing Liberation*,
1948, Oil on canvas, 181 × 222.5 ㎝. Private Collection.

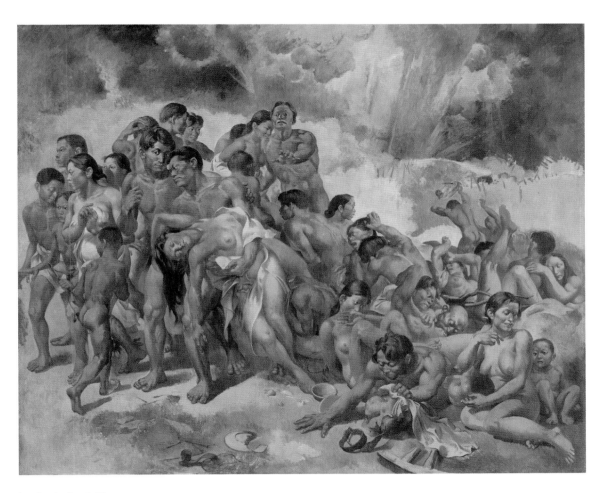

Lee Qoede, *People IV*,
late 1940s, Oil on canvas, 177 × 216 ㎝. Private Collection.

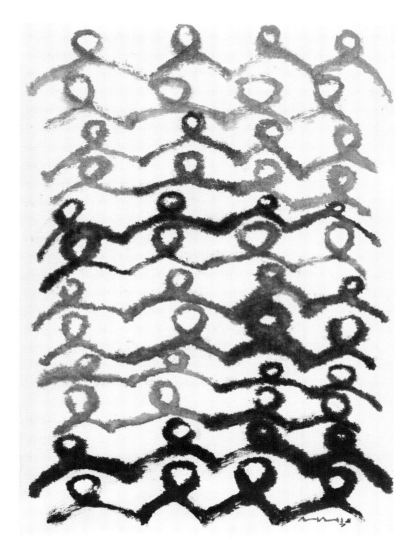

Suh Seok, *People*,
1990s, Ink and color on paper, 91 × 63 ㎝. MMCA collection.

Suh Seok, *People*,
1990s, Ink on paper, 173.3 × 183.3 ㎝. MMCA Collection.

Kim Chong Yung,
Sketch for *Monument for Declaration of Independence* (March 1, 1919),
1963, Watercolor on paper, 53 × 37 ㎝. Kim Chong Yung Museum Collection.

Kim Chong Yung, Part of the Sculpture *Monument for Declaration of Independence* (March 1, 1919),
1963, Bronze, 22 × 38 × 45 ㎝. Kim Chong Yung Museum Collection.

Hong Seonwung, *Centennial Anniversary of the March 1st Movement*,
2019, Woodcut on paper, 68 × 187 ㎝. Courtesy of the Artist.

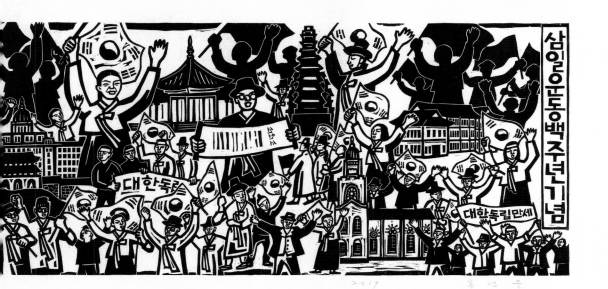

II.
The Square:
Art and Society in Korea
1950–2019

The Square: Art and Society in Korea 1900-2019
Part II. 1950-2019: Opposing Chronic Historical Interpretation Syndrome[1]

Kang Soojung

Senior Curator, Head of Exhibition Department 1, National Museum of Modern and Contemporary Art, Korea

I
—

As the National Museum of Modern and Contemporary Art, Korea (MMCA) commemorates its 50th anniversary, let us take this opportunity to consider the relationship of correspondence between Korean society and contemporary art. For this purpose, I have attempted to ensure a narrative in which artists and artworks cycle and connect together within the context of social life. I have also worked to visualize the chronological currents of abstract time through artworks produced at the time and archival records, diversifying the approach through juxtaposition, editing, and reinterpretation of these works with works of literature and theater or commissioned pieces. This format, which Joseph Frank referred to as "spatial form," was borrowed by the novel *The Square* (1961, Jeonghyang Press) by Choi Inhun (1936-2018)[2]. Choi's "square-private chamber-sea" framework metaphorically represents the relationships among "society," "the individual," and "ideals." Beyond the realm of literature, this is a perspective regarding essences that provides a means to explain the efforts and artworks through which artists sought to critique the powers that be and pursue ideals in new forms within the "square" that is Korean society. The square was a source of profound inspiration for the planning of this exhibition. Different eras were configured as small squares unto themselves, with folktales and everyday objects positioned together with the major artwork to illustrate ways of life. The aim here was to show the organic relationship between the "public square" and the "private chamber," while also conveying the explosive societal passion and tears of frustration as people aspired to the "sea." As such, the exhibition does not include the sort of heroic portraits that so chronically appear whenever we speak of "history." Instead, it seeks to revive the "today" of yesterday–summoned back through the artists' recollections and sensibilities–as well as the people of today.[3]

1. The title of this piece is taken from *Chronic Historical Interpretation Syndrome*, a work by Kim Sora & Gimhongsok that appears in this exhibition.

2. Park Miran, "A Discussion of Space in *The Square*," *Korean Language & Literature* 53, 2004, 586.

3. The events selected as major turning points in South Korean society were "the Korean War," "the April 19 Revolution of 1960 and May 16 coup d'état of 1961," "the *Yushin* government and the May 18 Democratization Movement in Gwangju," "the June Democratization Movement of 1987 and the 1988 Seoul Olympics," and "the IMF crisis and new millennium." Art history was recontextualized along these lines to examine the relationship of correspondence between society and art/culture.

2

Since its foundation in 1969 as a public art museum for the masses, the MMCA has been consistently part of the development of contemporary art history in Korea. For this reason, the art museum space was envisioned as two squares, with the exhibition organized around items in its collection. The first space presents Korean art history together with trends in social history from the outbreak of the Korean War in 1950 until the present. Each era here is presented in Gallery 1 and 2 and the Main Hall through five subtopics organized around keywords taken from The Square. At the same time, artworks newly discovered with this exhibition have been placed alongside advertisements, postage stamps, earthenware, pottery, posters, architectural models, blueprints, and so forth to provide a richer understanding of the era. Further enriching one's understanding are special corners bringing together major events within each era. For the second space, an actual "square" has been created through a circular exhibition venue. In Korean history, the public square has been a place of noble sacrifice where nameless members of the groups referred to as "the public," "the masses," and "the citizenry" have assembled to achieve social progress. The circular venue is presented as a space of "remembrance" and "mourning" for them. The artworks from this time serve as a sort of floral offering, which is to achieve its completion through the participation of visitors.

3-1 Blackened Sun

Blackened Sun, which concerns the Korean War and the 1950s, was designed to transcend generations and space through works that address fragments of the everyday destroyed by the war. While the war was a tragedy in and of itself, the resulting division was the chief factor responsible for impeding experiments and developments in Korean art within a society steeped in Cold War ideology. The first work, Jungju An's *Ten Single Shots* (2013), was envisioned as a "bullet of tragedy" penetrating society and history. The dancers fall down to the sounds of gunshots, but are then revived through the use of rewinding. The repetition of life and death alludes to issues within reality that persist as a result of division. Just after this appear works with value as witnesses to their time, including Pen Varlen's *The Panmunjeom (JSA) for Ceasefire Talks in September 1953* (1954) and Lee Cheul-yi's *Massacre* (1951). Meanwhile, the series *The Camelia Has Fallen* (1989-1991) by Kang Yo-bae and the work *Sung Si (Jeju Symptom and Sign)/Jeju Note* (2011) by Im Heungsoon address the events in the wake of the Jeju April 3 Uprising, which represented both a result of division and a precursor to the Korean War. Kim Heryun and Kim Jae-hong present the landscape of the DMZ with a painterly touch. The works *History and Time* (1958) by Lee Seung-taek and *Returning to Hometown* (1981) by Jeon Seontaek give expression to the longing of those who have lost their homeland. Jaewook Lee's *Red Line* (2018) uses a red laser to capture the current landscape of Jeju, visualizing the ideology of division that continues to exist in our

unconscious. The special corner shares the lives of artists within refuges and war, together with paintings by Lee Jungseob and Park Soo Keun expressing the joys and sorrows of the working class and a photograph by Han Youngsoo showing the Bando Hotel, where the first art gallery was located.

3-2 Han-gil (One Path)[4]

Han-gil refers to the path taken to reach the square. With an economy based on US aid, the 1960s saw efforts to rebuild from the ruins of war. Meanwhile, the dictatorship of Rhee Syngman fell with the April Revolution of 1960, while this revolutionary passion was succeeded by the ordeal of the May 16 military coup d'état of May 16, 1961. Art and culture also underwent major changes in response to these societal upheavals. To begin with, the experiments with abstract art that took place after the war can be observed through Chung Kyu and Yoo Young-Kuk's *Work* (1957), Kim Whanki's *Two Moons* (1961), and Lee Kyusang's *Composition* (1959). Park Rehyun and Lee Ungno in particular experimented with abstract works in the area of Korean painting (*hangukhwa*). Members of this generation shared works that incorporated aspects of abstract art from Europe and North America, which coexisted with traditional tastes rooted in Confucian education.[5] Other artistic creation was inspired by Moon Jars[6] and Celadon Prunus Vases[7], which are presented in this exhibition alongside the works of Kim Whanki. *Informel* was triggered both by the spirit of the April Revolution and a movement in artistic forms that was critical of the established generation. Opposing the academism of the time and the National Art Exhibition, young artists like Kim Chonghak and Youn Myeong Ro answered the zeitgeist by placing irregular works of abstract art on the walls of Deoksugung Palace. The trend is also reflected in works of metal sculpture such as *Legend* (1958) by Kim Chong Yung and *Mechanism and Humanitarianism* (1964) by Kim Youngjung, as well as *hangukhwa* works such as Suh Seok's *Midday*

4. This refers to a broad path or road used by many people or vehicles. Before the construction of a public square in Seoul's Yeouido neighborhood (then May 16 Square) in 1971, it was chiefly paths (roads) that served the role of public squares in South Korea as places where people congregated and public opinion was shaped. In other words, "paths" here can mean "squares."

5. This was analyzed in terms of cognitive systems passed down through education as a kind of "taste." Here, the concept of the "habitus" was borrowed from the sociologist Pierre Bourdieu. Referring to a kind of system of tendencies acquired or internalized over years of education, it is significant in explaining the ways in which artists pursued works with an aesthetic rooted in tradition even as they adopted the new abstract forms of the time. Kang Soojung, "An Exploration of Pierre Bourdieu's Theory of Culture: The Concepts of Misrecognition and Habitus," *The Korean Journal of Art Studies*, Korean Society of Art Studies, 2005, 206-207.

6. Moon Jars are traditional Korean white porcelain vessels made during the Joseon Dynasty, with their round mouths slightly larger than the base. They are in general not perfectly symmetrical due to minor distortion during baking. A transparent glaze is applied, and long, thin cracks are formed on the glazed surface.

7. Widely praised for its translucent jade-colored glaze and unique inlaid designs, Goryeo celadon ware was first produced between the late 9th and early 10th centuries and reached its pinnacle in the 12th. This style of vase with a wide upper body narrowing toward the foot is called a maebyeong, from the Chinese meiping (梅瓶, "plum vase").

(1958-1959) and Song Youngbang's *Heaven and Earth* (1967). The April Revolution is recorded as having been shaped by the societal discourse of intellectuals, with social opinion directed through political journals such as *Sasanggye* (World of Thought). In contrast, the urban poor who led the nighttime demonstrations have been excluded from history. With this exhibition, the work *Elegantly* (2019) by Lee Wonho focuses on the stories of the forgotten urban poor in an attempt to summon them forth as agents of history.

The political system formed through the May 16 coup d'état of 1961 was one of economic development and social controls with an anti-communist focus. The societal situation was a paradoxical one of successful economic development through the *Saemaul* ('New Village' or 'New Community') Movement combined with the bleak *Yushin* era of the 1970s. Indeed, the bestowing of the National Art Exhibition Chairman's Award on Kim Hyungdae's *Restoration B* (1961) signaled *informel*'s official recognition as a mainstream art form.[8] Shortly after, young artists proclaimed the new subversion of forms, critiquing the older generation via The Exhibition of the Young Korean Artists' Union (1967). They took to the streets, calling for the establishment of the National Museum of Modern and Contemporary Art, Korea.[9] They absorbed the transformation of their era and began to represent and critique industrialized society.

In works such as *Kiss Me* (1967) by Jung Kangja and *Amusement of Visual Sense* (1967) by Kang Kukjin, fashion and industrial goods representing the 1960s' consumer society appear in the form of "Pop Art" and "collage/objets."[10] Artists also staged happenings such as *Second Han-River Bridge* (1968)—which critiqued the older generation—and presented their own comments on society. Kim Ku Lim drew attention through "fashion shows as popular lifestyle art" on the streets of Seoul's Myeong-dong, Gwanghwamun, and Ewha Womans University neighborhoods.[11] He also produced *The Meaning of 1/24 Second*, Korea's first experimental film, and staged various performances. This trend was succeeded by the group *Space and Time* (ST) to which Sung Neungkyung, Lee Seung-taek, and Lee Kun-yong belonged. For lack of understanding from the public and the rigid societal situation of the time, their artistic activities ended up forgotten as an isolated, brief phenomenon. Even at the time, they earned only cursory mention in Sunday Seoul and newspaper articles.

8. Kim Mikyung, "In Search of another Perspective on Korean Contemporary Art: The Significance of the 1960s and 1970s Avant-Garde and the Position of Experimental Art," *Sourcebook of Korean Contemporary Art Trends 1*, Seoul: Hongik University, 43.

9. The street demonstrations included two demands concerning the creation of a contemporary art museum: 1) the renovation of the Gyeongbokgung Art Museum for use as a contemporary art museum after the National Art Exhibition ended, and 2) the use of the Gyeongbokgung Art Museum as both a venue for permanent exhibitions and a contemporary art museum. Two years after the demonstration, the National Museum of Modern and Contemporary Art, Korea was opened in *Gyeongbokgung* Palace on October 20, 1969.

10. See Kim Mikyung, "Korea: The Significance of the Late 1960s Group Movement-A Look Back on the Young Artists Coalition Exhibition," Era of Transition and Dynamism, MMCA, 2001, 168.

11. "Fashion show appears on the streets," *Weekly Chosun*, Dec. 6, 1970.

The reason for this had to do with the political authorities, who suppressed proactive statements and expression regarding issues and areas of social interest. An example of this was the East Berlin incident in 1967.[12] That episode resulted in overseas musician Yun Isang and Lee Ungno being arrested and imprisoned as alleged spies. International artists embarked on a large-scale campaign to call on the Korean government to stop its suppression of art. This exhibition includes a special corner showing work produced in prison by two artists whose creative will could not be broken even amid their hardship. Yun Isang's score for *Image* (1968) is presented alongside the work that inspired it, *Sasindo* ("Four Guardians," year unknown),[13] as well as Lee Ungno's works *People* (1967-1968) and *Composition* (1968). Also on display are Park Chan-kyong's *Flying* (2005) and *Yun Isang-Colloid:28538* (2019), a documentary theater reconstruction directed by Hyoung-jin Im, which illustrate solidarity among artists that transcends time, space, and medium.[14]

3-3 Gray Caves

The "miracle on the Han" that occurred around the 1970s ushered in various changes in social and cultural terms. Earthenware disappeared with courtyards as large apartment complexes were built; televisions, refrigerators, and other industrial designs were increasingly developed for apartment living. A multi-level balcony structure is presented here to illustrate the situation at the time-blending design, crafts, and architecture like the advertising photographs of Kim Hanyong, the special *Saemaul* Movement postage stage designed in 1976 by Lee Geunmun to commemorate the *Saemaul* Movement, the architectural model for the Yeouido public square, and images of the Guro Industrial Complex. Aesthetic tastes at the time are also represented through Chang Hwajin's *Modern Taste* (at the Corner). Yet this was also a paradoxical era in which vast "private chambers" became entrenched through the *Yushin* regime.[15] The death of worker Chun Taeil[16] was a tragedy that brought to the surface the hidden undercurrent of labor exploitation within Korea's splendid economic development achievements. Art movements with experimental art and avant-garde orientations were suppressed and disbanded alongside acoustic

12. In July 1967, the Korean Central Intelligence Agency (KCIA) forcibly repatriated culture/arts community figures Yun Isang and Lee Ungno along with 194 professors, artists, physicians, and government employees whom it claimed to have been involved in espionage activities at the North Korean embassy in the East German capital of East Berlin. In the subsequent trial, they were finally acquitted and released. The fabricated incident resulted in a chilling effect on demonstrations denouncing election improprieties, and South Korea devolved into a state of backwardness in human rights terms.

13. The "four guardians" in the title refers to the blue dragon, white tiger, black turtle, and red phoenix. A reproduction of wall paintings from the ancient Goguryeo tombs of Gangseo, it is believed to have been produced in the 1950s. The white tiger and red phoenix are presented here.

14. In this essay, experimental art and the East Berlin incident are presented in chronological order as part of "*Han-gil*" in the 1960s. In the gallery, however, they are combined with the "Painful Sparks" section as visual images underscoring the experimental spirit and passion seen among young people.

guitar and youth culture. *Last Sound*, a play by the *Fourth Group*,[17] left a final indicator of cultural resistance before its dispersal. The public squares came to a standstill. It was at this time that *dansaekhwa* (Korean monochrome) emerged. Its artists sought to segregate themselves from reality, indulging in the flow of nature within their hideaways and rediscovering themselves. They also devoted themselves to exploring the essential "materiality" of nature.[18] *Dansaekhwa* sought a de-materialized, spiritual world through the shedding of the self, using methods such as "repeated drawing," "awareness of two-dimensionality," "integrating supports and illusion," "displaying patterns and emphasizing the materiality of surfaces," "neutralizing materials and restoring two-dimensionality," and "infiltration and awareness of space."[19]

Park Seo-Bo's Écriture series (1981) and the works of Ha Chong Hyun and Yun Hyong-keun were created as aesthetic achievements rooted in the ideas of Laozi and Zhuangzi. A crucial underpinning of their activities lay in their relationships with Quac Insik, Kwak Duckjun, and Lee Ufan, who were then active in Japan.[20] Their relationship has been represented here through a special section. During the late 1970s, works of hyperrealism were also presented, chiefly through the Non-Government Juried Exhibition, including *Door* (1978) by Kim Hong Joo and *Daily Life* (1985) by Lee Sukju. Many documentary images were also produced during this period under state leadership to promote policies. This exhibition focused in particular on the records of war in images by artists accompanying troops in Vietnam. This was intended to use the artists' records to look back on the tragedy that befell both sides when Korea—which had endured its own tragedy in the Korean

15. On October 17, 1972, the Park Chunghee administration pronounced an emergency martial law decree and issued a "special presidential statement" disbanding the National Assembly, prohibiting political parties and political activities, and partially suspending the validity of the Constitution; the following December 27, it promulgated the "*Yushin* Constitution." The *Yushin* Constitution stripped the legislature of its authority to conduct parliamentary audits and reorganized the Constitutional Court (a judicial organization to ensure adherence to the Constitution) into a "Constitution committee," while granting extralegal authority to the President (including authority to declare emergency measures and disband the National Assembly) to underpin the dictatorial regime. While the National Assembly was disbanded and political parties and activities prohibited under the emergency martial law degree, the end result was the emergence and expansion of an anti-dictatorship campaign throughout the South Korean public. The system ended up coming to an end with Park's assassination on October 26, 1979.

16. On November 13, 1970, Chun Taeil, a garment cutter at a clothing factory in the Pyeonghwa Market area of Seoul's Dongdaemun neighborhood, doused himself in gasoline and set himself on fire. "Obey the Labor Standards Act! Don't let my death be in vain!" he cried before his suicide. As a result of his death, the lives of workers sacrificed amid the process of rapid industrialization emerged as a major societal issue. Jeon's self-immolation marked the starting point for a Korean labor movement to demand compliance with the Labor Standards Act and improvements to working environments.

17. Spearheaded by Kim Ku Lim, the Fourth Group aspired to "comprehensive art" and experimented with collaborations in theater, music, film, dance, and other genres. It was of profound significance as an early attempt at convergence-style projects within Korea.

18. See Kim Bokyoung, "Origins of Monochrome Two-Dimensional Painting in the 1970s: Interpreting Its Unitary Surface Forms," *Sourcebook on 100 Years of Korean Art, Part 2*, MMCA, 2008, 370-371.

19. Oh Gwangsu, "Korean Monochrome and Its Identity," *Age of Contemplation and Feeling: The Progression of Korean Art from the Mid-1970s to Mid-1980s*, MMCA, Aug. 2002.

20. Kim Bokyoung, "Korean Monochrome Two-Dimensional Painting of the 1970s and 1980s: A Social History of Nonrepresentational Understanding of Objects and Others," ibid., 41-43.

War—sought the economic rewards of the so-called "Vietnam premium" with its participation in the Vietnam War. The sketchbooks of Park Youngsun and other materials preserve the artists' interpretations of the war, which go beyond mere records. Also featured here are works by Vietnamese artists Lê Quốc Lộc, Lê Thanh Trù, and Trần Hũu Tê. Beyond the background behind their production, the artists, who were present on the actual battlefields from both sides, served as witnesses recording the horrors of war through media including *Hangukhwa*, sketches, posters, lacquered paintings, and silk paintings. Today, their hope is to achieve reconciliation and healing through art.

3-4 Painful Sparks

In the 1980s, Korean society entered a new stage with the arrival of the new military regime and the Gwangju Democratization Movement. Suppression of the democratization movement had the ultimate effect of stoking the embers of democracy. The public squares would eventually blaze with the 1987 Democratization Struggle as it gained further momentum with the deaths of Park Jongchol and Lee Han-yeol. Yet there was also a paradoxical state of affairs as the economy flourished amid the so-called "three lows."[21] This was used as a basis for the administration to pursue a brutal urban development push to ensure the success of the 1988 Summer Olympics in Seoul, leaving behind innumerable evictees from forced urban demolitions. Seoul was opened up to the world wearing the face of the successful capital city that had achieved the "miracle on the Han River."

Amid this set of political and economic circumstances, art responded with a movement of realism, expressing a socially critical message in the most assertive of ways. The social statements of art were expressed in new ways alongside the various scenes of oppression and the demands being made by demonstrators. *The Old Mangwol-dong* (1985-1995) by Lee Sangil, who had been a member of the martial law forces during the Gwangju Democratization Movement in 1980, presents documentary photography not simply as a record, but as an act of atonement in a sense. During the first half of the decade, the group Reality and Utterance, broadened from realist art activities centering on artists into a diverse range of media and themes rooted in an awareness of issues within Korean society. Shin Hak Chul's *Modern History of Korea-Synthesis* (1983), Kim Jung Heun's *Land I Should Cultivate* (1987), and Lim Ok-Sang's *Newspaper* (1980) joined critics in presenting a spirit of more structural and analytical realism vis-à-vis Korean society, as opposed to an emotional critique of it. Working chiefly in prints, Oh Yoon succeeded in broadening the field through his work with literature and *minjung* theatricals. This exhibition includes masks created for the original *madanggeuk* work *Gangjaengi, Darijaengi*,[22] along with prints that were distributed in poster form. Also featured are large paintings produced as backdrops for dance pieces. The latter part of the decade saw attempts to communicate actively with the public through activities rooted in practice, including in factories as well as scenes of demonstrations.

Attempts were also made to consider a new artistic language regarding the identity of national art. The *Dureong* Group in particular stepped outside of the art gallery to pursue creative activities with workers and ordinary citizens in labor settings, seeking to interrogate the role of art within life. Lee Giyeon's *Back against the Wall* (1984) and Jung Jungyeob's *Body Ache* (1994), which were featured in *Dureong's* inaugural exhibition, directly confront the reality faced by women in working environments. This movement would erupt into a fiery blaze in the squares where the Democratization Movement unfolded in 1987.

The MMCA Main Hall has been presented as a recreation of a public square from the time. Choi Byungsu's large banner paintings (1987) and *Liberation of Labor* (1989), Bae Youngwhan's *Pop Song 3: Farewell to My Youth* (2002), a sneaker belonging to the martyred Lee Han-yeol,[23] and a taxi[24] provide a visual recreation of the spaces in which demonstrations took place at the time. The artworks and objects presented here hold great significance as symbols of their era. The public squares were a setting where great strides were made towards democracy through the hard-fought battle to win a direct presidential election system. The pro-democracy camp, however, was defeated in the election that they brought about. The 1988 Summer Olympics in Seoul the next year were a crucial milestone, transforming the very axes of society and culture.

The 1988 Olympics brought about internationalization and openness; in a bid to improvce Seoul's image as a global cultural capital, the MMCA was relocated to a new building in Gwacheon with a warehouse and galleries.[25] Images of Korea were transmitted throughout the world through the Olympic broadcast. Lee Manik, who served as artistic director for the opening and closing ceremonies, produced a series of 20 print works that were presented on stadium electronic displays. The works included variations on Korean traditional patterns and its five *obangsaek* colors

21. Having achieved economic development through a reliance on overseas exports, South Korean enjoyed a boom from 1986 to 1988 as it benefitted from the "three lows": a low dollar, low oil prices, and low interest rates. The South Korean economy would later enter a period of stagnation amid changing conditions in the global economy, wasting of the "three lows" gains on real estate and stock speculation, and a slowdown in export competitiveness.

22. *Madanggeuk* works were created to critique the oppressive political situation in the 1970s and 1980s, which they did through satire and humor. This work, which tells the story of a village suffering a water shortage while preparing for a wedding, lampooned the social conditions with authorities and policies at the time. Oh Yoon produced masks suited for each role, which continue to be used in performances.

23. On June 9, 1987, Lee Han-yeol was taking part in a Yonsei students' rally ahead of a citizens' rally scheduled the following day to denounce the concealment of Park Jongchol's death during torture and call for the withdrawal of efforts to protect the Constitution, when he was struck by a tear gas canister fired by a riot police officer, suffering a skull fracture as a result. He lingered until finally passing away on July 5. A photograph of Lee after his injury was taken by Reuters and shown not only in Korea but throughout the international community. The young university student's death triggered outrage among the Korean public, leading ultimately to the nationwide movement of June 1987. The sneaker is the same one that Lee was wearing at the June 9 demonstration.

24. In a choice inspired by the movie *A Taxi Driver* (2017), a KIA Brisa (frequently used as a taxi at the time) has been included in the exhibition. Signifying the vehicle-based demonstrations at the time, it was included to bring the scene more vividly to life.

25. Around this same time, a number of specialized art journals also entered publication, including *Wolgan Misul* (Monthly Art Magazine) and *Gana Art*.

(white, black, blue, yellow, and red) together with the Olympic rings-a cultural rendering of the 1988 Olympics' message. With the staging of the games, design and architecture underwent explosive development. But there was also an underbelly to this in the form of forcible evictions from buildings slated for demolition and the development of new towns. Alongside the records of the 1980s in Koo Bohnchang's *One's Eyes 1980 Series* (1985-1989/2010), Kang Hong-goo's *Greenbelt Series* (2000-2002), and Minouk Lim's *New Town Ghosts*, the gallery contextualizes the products of grim ideology lurking on the underside of the 1988 Olympics through Olivier Debré's *KAL* (1986) and Song Sanghee's *Shoes/243.0Mhz* (2010-2011).[26]

3-5 Blue Desert

The arrival of the Kim Youngsam administration and the collapse of the socialist world in 1993 signified the weakening of Cold War-based social controls. With "globalization" and "internationalization" as its slogans, Korea's transition from an underdeveloped to an advanced economy was finally recognized with its admission to the OECD. The Whitney Biennial Seoul exhibition, held by MMCA to commemorate the Expo in Daejeon, announced the possibility of real-time interchange with the international art community.[27] The art world, for its part, interpreted the conflict between "apolitical modernism" and "political realism" in the 1970s and 1980s in terms of a semantic or hermeneutic dictatorship.[28] Conceptualization of the newly arriving "post-modernism" had also begun, and young artists advocating a "break with modernity" conducted various artistic experiments, creating groups such as *Metavox* and *Nanjido*. Kim Chandong's The *Floating Signifier* (1990) and Do Ho Suh's *Untitled* (1990) were produced in this context.

At the same time, a new generation-made up of people who knew how to enjoy the mass society and consumer culture that had just arrived in societal terms-was emerging as agents. The sensibilities of the time are represented in Choi Jeonghwa's *Made in Korea* (1991/2019), which consists of cheap market objects, as well as in Lee Bul's performances and works *Cyborg W5* (1999) and *Live Forever* (2001). Meanwhile, Ahn Sang-soo and Gum Nuri opened *the Electronic Café* (1988), a space of medium

26. On November 29, 1987, Flight KAL858, a Korean Air Boeing 707 traveling from Baghdad to Seoul, exploded in midair after a bomb was planted by North Korean operatives Kim Hyon-hui and Kim Seungil. All 115 people on board were killed in the tragic incident. Staged to sabotage the 1988 Olympics, the episode became a crucial variable in the 13th presidential election in 1987 when Kim Hyon-hui was deported just before voting.

27. Staged at the MMCA in Korea three months after the Whitney Biennial (1993) was held in New York, this event dealt thematically with issues including ethnicity, politics, minorities, and women in media, performances, and other art forms. It attracted attention with its adoption of new media and themes considered taboo even in the US, and it would prove influential in terms of the adoption of a broader range of themes and new media in the Korean art world and the establishment of the Gwangju Biennale.

28. See Yoon Jinseop, "The Post-Modern Movement and Post-Modernism," *Research on Korean Modernist Art*, (Seoul: Jaewon, 1997) 199-200.

experimentations linking the newly arrived PC communications with art. Although it was quite small, the space was significant for the involvement of IT engineers and for predicting the social networking services (SNS) of the future. The instantaneous communication and sharing of information transcend the space, announcing the formation of a new relationships between the "private chamber" and the "square." This became a foundation for easier and more frequent gatherings by more people later on in the public squares, including World Cup cheering and candlelight cultural festivals (demonstrations). Ham Jin's *Encounter* (2005) and Dongwook Lee's *I Wished* (2004) are works in clay baked in a mini oven in their small studio apartments, reflecting an interest in the smallest of beings. These are meaningful works that signal the importance of the small narratives of individualized actors after the grander narrative is dismantled.

Meanwhile, ongoing experimentation was taking place in the area of *Hangukhwa*. Yoo Geun-Taek's *Long Fence Series* (2000) broke with the traditional concept of the landscape painting to depict the subtle energy of objects observed in private spaces. Park Yoonyoung broadened the scope thematically with *Pickton Lake* (2005), a silk folding screen work concerning a murder that took place in Canada. But into this context of societal and cultural growth erupted the foreign exchange crisis known locally as the "IMF crisis." ium's *The Highway* (1997) adopts a format similar to a music video to show the extreme pace of Korean society just before the IMF crisis hit. During the IMF crisis, numerous company employees were fired amid the threat of national bankruptcy and corporate restructures. Designer Kim Youngchul (AGI Society) produced the series *IMF Story*, adopting the slogan "behavioral graphic imagination" and a practice of using design to speak out about the world. This was significant as marking the beginnings of a form of design espousing political modernism. Lee Yun-yop used the print media to represent the struggle of workers at Cort Guitars/Cor-Tek[29] and the issue of irregular workers from the front lines.

Faced with the realization that they had arrived not at the sea, but simply at a "blue desert," the new generation faced a harsh reality, dealing simultaneously with abundance and impoverishment.[30] Artists in particular stood at the very edge, living the bleakest of lives.

3-6 Arid Sea

Pursuing neoliberal values and globalization with the arrival of the new millennium in the 2000s, Korea announced its new era with the emergence of "netizens who act" and "cultural festivals" (demonstrations). The public squares became filled as spaces for World Cup cheering and social statements. The Sunshine Policy was ushering in improvements to inter-Korean relations, and improving women's status became a focus of societal attention. Korean contemporary art took on aspects of realist art rooted in "alterglobalization," with practice involving social relationships and the aesthetic practice of a post-boundary discourse stemming from global

mobility.[31] This was soon expressed through an interest in areas such as migration, nomadism, minorities, and "publicness." Artists represented this in their work with different media narratives transposing the "boundaries" and "relationships" of literature, publishing, and history. Within alternative spaces in particular came an expansion of discourses and publishing and exhibition approaches.

Produced amid this trend, Meekyoung Shin's *Translation Series* (2006-2013) consists of a total of 16 soap sculptures resembling pottery, along with wooden crates. The pottery here represents the "Chinese style" sought by the West; presented alongside the crates as symbols of their relocation and transportation process, the work addresses matters of cultural interchange and the clashing of different cultures. *Temper Clay* (2012)[32] by Sung Hwan Kim (in musical collaboration with David Michael DiGregorio a.k.a. dogr) interprets modern and contemporary Korean history through the narrative structure of Shakespeare's *King Lear*, drawing upon a mirror structure in its reinterpretation of space. The deaths and tragedy that occur within a family across generations caused by desire for power and wealth are likened to the conflicts and absurdities of Korean society, presented through the intercutting of symbolic images and performance.

At the same time, issues of labor and Asian identity began to establish themselves as key themes. This signified an attempt by Korean art to establish a new position outside of Europe and North America. Im Heungsoon's *Factory Complex* (2014) deals with the women's labor that was exploited in the process of Korea's rise from an underdeveloped nation to join the ranks of advanced economies. It also presents a history without constraints of ideology, spanning multiple areas including the past and present of women's labor, attitudes and memories, reality and the unconscious, documentary and performance, cinema and art. At the end, it trenchantly addresses aspects of labor and capital within the context of everyday emotions, connecting the lives of women working for Korean companies in Southeast Asia to those of the previous workers of Seoul's Garibong-dong neighborhood. The work offers insights into ironies of Korean society in terms of the global circulation of capital and the essence of human power and labor.

Finally, the work *Chronic Historical Interpretation Syndrome* (2003) by Kim

29. After earning an average of KRW 9 billion in net profits between 2000 and 2006, the guitar makers Cort/Cor-Tek closed their factory in Daejeon, citing management struggles. Their entire workforce was let go as the factory was relocated to China and Indonesia in a notorious case of unjust layoffs. Labor unions and artists banded together to fight them, proclaiming that the "instruments that create art should be produced through fair labor." The laid-off workers themselves formed what became known as the "Cort/ Cor-Tek Guitar Workers' Band." In 2019, a provisional agreement was reached between labor and management to reinstate the workers 12 years after they had been let go.

30. A reference to the song "Sea" by BTS (*Love Yourself: Her*, Big Hit Entertainment, 2017).

31. See Bae Myungji, "Korean Contemporary Art Exhibitions of the 2000s as Seen from a Globalization Topography Map," *Reviews on Art History*, 2013, 9-10.

32. In addition to its sense of clay being tempered with water, the title also references a line of dialogue from *King Lear*.

Sora & Gimhongsok expresses both a yearning for history and a *cri de coeur* toward a society of skewed desires, while at the same time serving as a confession of sorts for the exhibition. Combining statues of heroes in the public square with everyday objects, the artists present something resembling comical monsters. Their aim is to deconstruct the grand narratives forged by past glories and strip away the heroic aura. In the process, they are attempting to critique political interpretations within the histories of humanity and art, and the potential "taming" that occurs as a result. For this exhibition, that is the square–the "sea"–that artists sought to reach with works of art as products of their era.

4 White Bird

The circular exhibition setting has been envisioned as a public square–a ritual space for reflecting on the role of the museum and for joining the artists in remembering and comforting those who were lost to history. With Oh Jaewoo's *Downsized Square* (2019), the novel and literature by Choi Inhun that served as inspiration for the exhibition has been taken as a theme to create a setting for communion with YouTubers and other young people. Works of art similarly adopting the "homage" form are located throughout the venue, serving as devices to call both past and present to mind. The artwork also serves as the artists' floral dedication of mourning for the *Sewol* ferry sinking–the greatest tragedy of the present era and an incident that brought candles into Korea's public squares.

Weaving Life, Weaving Nature's *Yellow Light* features an audience-participation program in which the act of weaving serves as a means of healing and sharing suffering. jang minseung's *Voiceless series* (2014) is a recollection of tragedy shared by a hearing-impaired person. Everyday Practice's *There is No Reason Anyone Should Die Because They Were on that Ship* (2014) is a somber remembrance of the strategy that unfolded on the day of the sinking. The caress of loss leads "north" to the actual square posited by Choi Inhun, a place that had to be forgotten to go on living. With *International Friendship*, Che Onejoon presents an installation work showing information and images related to North Korea. Finally, Sunmu's performance *Blossom* is an artist's exorcism, presented alongside the flowers as an offering and a whispered wish of peace for all the victims of the gunfire that has occurred through 70 years of history–all of the killing, intimidation, and suspicion. The ritual of grieving for all this pain and loss reaches its culmination with third–generation Kareisky Nikolai Sergeevich Shin's *Mother and Son* (1984) and its evocation of a *pietà* image. The anguish of a mother who has lost her son is the same in every time and place. It is eternal suffering, which art serves to remember and assuage.

5

This exhibition looks from a viewer's perspective at the ways in which artists have witnessed history through their eyes and recorded it in works of art. At the same time, it attempts to revive and share this through our lives today. It is for this reason that Jung Jungyeob's mirror-based workers are positioned, decontextualized, in various spaces. Visitors will catch a glimpse of themselves among the works of art. And so it is: the greatest artist, the greatest work of art, is yourself as you discover your own value as it exists within the long span of history. This exhibition is, in the end, a dedication to you who are alive today.

The Public Square Set Forth in *The Square*: Firm Individuals and Flexible Community

Kwon Boduerae

Professor, Department of Korean Language and Literature at Korea University

"Humans cannot live without entering the Square", wrote the writer Choi Inhun, when his novel *The Square* (1960) was expanded upon and republished as a monograph (1961) just a year after the April Revolution in 1960. While the novel's emphasis on "the Square" has its counterpart in the "Private Chamber," Choi is not concerned about how to preserve the latter. As evident in its title, the novel focuses on how to stabilize the Square and thus remedy the closed, severed relationship between the Square and the Private Chamber. Choi proposes a society in which the Square and Private Chamber constitute a continuously connected space: a society where members can enter the Square directly from the Private Chamber without wearing a different face, a society in which a firm individual consciousness lays the groundwork for a flexible sense of community. While more than half a century has passed since the publication of *The Square*, Korean society has yet to realize these dreams. In fact, the passageway described as an "alley leading from the Private Chamber to the Square" is has become even more distorted and treacherous.

In the context of Korean history, the public square is more of an imported concept. Whereas the Western public square boasts a long history dating back to the ancient Greek agora and the Roman forum, the Korean public square is a product of the state constructed hastily during a process of modernization. The word "public square" did not even exist in pre-modern Korea. It first appeared in the *Joseon wangjo sillok* (The Annals of the Joseon Dynasty) in 1926 around the time of Emperor Sunjong's funeral. Perhaps this owes to Korea's lack of pluralistic centers; while city-states had flourished in Europe, Korea and its neighboring states had been governed by highly centralized monarchies. Public squares gave rise to European cities and states, whereas the squares in the Balkans, Asia, Latin America, and Africa emerged as a product of state-led modernization. In general, these non-Europan squares were created adjacent to train stations as part of the construction of early modern railways. The state-led nature is also evident in two examples from Korea's recent

Kwon Boduerae is a professor at the Department of Korean language and literature at Korea University. She obtained her Ph.D. from Seoul National University, where she started her career as a researcher of the cultural history of modern Korea. Her books include *The Origin of the Modern Korean Novel, Age of Romance: Culture and Fashion of the early 1920s, Questioning the Year of 1960: Cultural Politics and Intellectual Transition of the Park Chunghee Era* (co-authored with Cheon Jeonghwan), and *Night of the March 1st: Imagining Peace in the Century of Violence.*

past, Yeouido Square (formerly named the May 16 Square) built in the 1970s and Gwanghwamun Square that opened in the 2000s.

This is not to say that public spaces for civilians did not exist. On the Korean peninsula, where public squares were underdeveloped, a neighborhood communities flourished by a network of marketplaces and street spaces. Streets brimmed with conversation in lieu of debates carried out in public squares. Indeed, Koreans are known for their fond attachment to alleyways. Foreigners in early modern Joseon were surprised to find people sharing food and even napping on the streets. These foreign travelers were also struck by the so-called "house stalls" that developed in place of shop buildings. Street-side houses would have eaves lengthened toward the alley, under which goods for sale were displayed. Many spent their days not in their homes but in alleyways. Aptly reflecting such spatial arrangement, relationships among neighbors and kinfolk flourished. Rather than seeing the separate development of the Square and the Private Chamber, Korea saw a strengthening of passageways in between. The street—not the public square—remained a more familiar backdrop during the growth of democracy. Korean democracy was a "democracy of the streets" more so than a "democracy of the square."

This held true during the People's Assembly of 1898, which saw crowds gathered in the middle of Jongno street. The second-floor loft of *Baekmokjeon* (the store dealing in cotton cloth) served as a podium, and the people would make bonfires to keep warm during many sleepless nights in midwinter. Crying out for the abolishment of unjust foreign privileges and demanding the establishment of a national assembly, commoners-turned-citizens raised their voices for the first time on behalf of national concerns. Butchers, children, and others—who heretofore never dared to discuss such public matters in public spaces—took turns mounting the podium, and women also joined by organizing support groups. They could have chosen to protest in front of the Royal Palace, where appeals were made to the king; instead, the citizens chose the commercial district of Jongno as the place for their first popular political demonstration in modern Korea. . Likewise, during the March First Independence Movement of 1919, marketplaces served as preferred meeting grounds. On market days, leaders would read the Declaration of Independence and wave the Korean flag as the throng of crowds—numbering hundreds and even thousands—would respond with cries of *"manse"* ("long live [Korean independence]"). As formations of demonstrators mounted attacks on *myeon* (municipal) offices and raised rallying cries before police substations, the marketplace became at once a political sphere and a carnivalesque space.

Choi Inhun must have been familiar with this history, and yet he attempts to universalize the concept of a public square in his novel *The Square*. Based on his experiences in both South and North Korea amid division and war, the novel's protagonist Yi Myeongjun characterizes the South as a society consisting of only Private Chambers and the North as a society consisting of only Squares. With the

civic balance distorted, the 'Squares' in both North and South Korea are merely nominal and inauthentic in their own particular ways. In South Korea, bloated only with individual desires, its Square is a neglected dumping ground. In North Korea, where the pretext of serving the proletarian people dominated, its Square is a theater of deception that belongs to no one. Wishing to "live a worthy life that will make his heart swell to the point of cracking his ribs," Yi Myeongjun remains dissatisfied with both societies. South Korea's politicians are shameless, "picking roadside flowers that should be admired by all to fill a vase in their home, removing faucets from fountains to use them in their private bathrooms, and digging up public pavement to cover their kitchen floors." On the other hand, North Korea's politicians are terrifying, being "not humans but marionettes." Amid the political turmoil of the post-liberation era, Korean peninsula experienced the publicness in a unique way that failed to inform meaningful collaborative response to its situations. In these circumstances, *The Square* suggests referring to the experience of the West that has long been managing Squares.

As a product of the "new republic brought forth in brilliant April," *The Square* propounded a historic new beginning. Just as the April Revolution of 1960 opened an era beyond colonialism and war, *The Square* hailed the end of the traumas of war in Korean literature. *The Square*, in that sense, is a work that marks the conclusion of post-war literature and the birth of new, post-April Revolution literature. The April Revolution was a series of mass protests that once again demonstrated Korea's yearning for democracy. The Revolution announced the people's demand for popular sovereignty that had survived the preceding decades of chaotic turmoil, since it had manifested through the March 1st Movement (1919). Minds bound by survivalism and familism were freed by the April Revolution onto a wider horizon where they found new political and metaphysical existence. The participants of the April Revolution, including nighttime rioters (violent molecular movements that attacked police stations to seize guns and destroyed theaters), reignited a movement that demanded survival, safety, and dignity all at once.

Throughout the 1950s, South Korea lagged far behind North Korea economically, socially, and culturally, but the April Revolution finally provided the impetus for renewed self-determination. Prior to the April Revolution, South Korea had been in a mire of confusion and stagnation after having failed to channel its openness and hybridity (which embraced even traitors, power brokers, and swindlers) into potential strength for driving the country. The sensation caused by the 1956 film *Madame Freedom*, attested to a culture of urban consumerism that was prevalent already in the 1950s; still, the memories of human existence brutally violated by the war lingered in the Korean minds. North Korea opted for a collective illusion of "Fatherland Liberation War" to paint the Korean War in a different light, but with which new cause or ideology was South Korea to escape from the shadows of the war? People had witnessed through the war how fragile human bodies are, and how much more so the minds are. They were also disillusioned by politics, ideologies,

and history, which had deceived and betrayed them time and time again. Even so, the April Revolution, and the novel *The Square*, contend that humans can prevail over this past and become historically conscious beings once again. *The Square* dismantled the customary narrative characterizing the Korean War as a disaster; people tormented by distrust and contempt were roused to stand before history and metaphysics once again. Thus rises the problematic of *The Square*: How does one rewrite a history of colonialism, division, and war? How does one reconstruct the Square in reference to other histories? *The Square* places the Korean War upon the historical horizon while setting forth "neutrality" as a vision or an axis for perspective. Moving aside the horrors of war that had preoccupied literature of the 1950s and departing from its practical realities, the work proposes a field of vision encompassing world history. What is more, *The Square* openly rejects survivalism and familism, the unmistakable stigmata of the Korea War. Yi Myeongjun, the protagonist of *The Square*, is a young man who yearns for a wider, vaster Square while also insisting on a self-centered Private Chamber from beginning to end. "Father . . . cannot be my substance. Mother . . . cannot be my own. In my room, there is only Myeongjun." Resembling Choi Inhun's other heroes, Yi Myeongjun from *The Square* dares to desire as a subject. Such desire comprises his own scars, childishness, and yearning, held above concerns for his survival, family, and even nation.

While deciding to leave for a neutral third country, Yi Myeongjun's mind briefly turns to his father, but he thinks "reality weighs down far too heavily for filial duties." If carried out in real life, such behavior as Myongjun's would earn him dire censure as an immoral man comparable to Meursault in *The Stranger*. Similar censure was meted out to prisoners of war (POWs) bound for neutral countries, which served as a key motif in *The Square*. In February of 1954, seventy-six POWs of the Korean War sailed off for India, choosing to go abroad rather than choosing a side between South or North Korea. Newspapers ran headlines of their sailing, claiming that the POWs were forcibly abducted by the Indian army and hence not leaving their homeland voluntarily. The Anti-Communist Youth Corps and other social organizations waved Korean flags while urging them to return over loudspeakers. This had the effect of reducing the number of neutral-country-bound POWs from the original eighty-eight to the final seventy-six, with twelve already on board changing their minds.

The POWs who sought a neutral country were inevitably deemed unfortunate, cowardly beings. Lee Oyoung, Choi Inhun's senior by a few years, once referred to these POWs as a byword for seclusion, evasion, and cowardice. "Having refused to take a stand on either side of history, they are the most heretical clowns and fugitives of our era." Prior to the April Revolution and *The Square*, POWs who opted for neutral countries thus represented "eternal losers who attempt to flee from their times." *The Square* took a stand against this common notion by interpreting the POWs' departure as an active pursuit of challenge. As a character who "always seeks

out the scene instead of relying on hearsay," Yi Myeongjun grapples with problems of Korea's reality even while dreaming of a secluded life in a neutral country. It is only natural that, in the end, Yi Myeongjun takes his own life instead of settling down in a neutral country. In rejecting the reality of his homeland, he had put his whole existence at stake, rather than simply evading or deferring the problem. Even without memories of the woman/women he loved, he would have been incapable of turning his back on his love for his motherland, which burned as passionately as his hatred.

Rather than summoning an exceptional hero, *The Square* uses the subject of POWs bound for a neutral country to realize a process of situating even the most unheroic spirit within history. Through the character Yi Myeongjun, these POWs–hitherto called abductees or fugitives–are reborn as modern heroes of sorts. Granted, Yi Myeongjun remains flawed as quasi-adolescent hero. He judges the world according to his self-centered views and allows his ideas to obscure the specifics of reality. Even while stating that "people cannot live without producing excrement," he does not explore ways to treat sewage in his own, individual life. Even while insisting on the continuity of the Private Chamber and Square, he, himself, surrenders readily to a dichotomizing logic. In the end, he refers to the "round space created by a set of arms" as the "last Square" and a "small Square of primitive times," thus revealing his regression.

Since the April Revolution, Korean society has encountered various Squares. There were Squares governed by symbolic structures and monuments, spontaneous Squares flowing over from streets, and even the "small Square of primitive times" luring those who became disillusioned by common causes. While there were Squares upholding the causes of state, nation, or democracy, the same causes led to divisions that tore them apart. Finally, there were even counter currents of complete distrust in Squares. Given that the relationship between communal prosperity and individual survival, safety, and dignity has gained in complexity, it appears that the Square must be reimagined in our time. In *The Square*, Yi Myeongjun proposes the arrangement of sewers and cleaning trucks rather than denying the fact that humans cannot help but defecate even while entering the Square. He requests that one acknowledge existential history and the air of the Private Chamber while also learning how to adjust such personal preferences and interests in relation to the communal Square. He declares that such is the way to enter the Square without disguising one's true face as worn in the Private Chamber, hence becoming a true actor in the Square. Almost 70 years have passed since the publication of *The Square*-what will we make our Square?

1. Blackened Sun

Jungju An, *Ten Single Shots*,
2013, Six-channel video, B&W, sound, 8min. 56sec. MMCA collection.

Lee Cheul-yi, *Massacre*,
1951, Oil on plywood, 23.8 × 33 ㎝. MMCA collection.

Kim Song-hwan, *Korean War Sketch - September 12, 1950 A Hiding Place: Jingol Inn in Gaeseong*, 1950, Watercolor on paper, 20.1 × 27.5 ㎝. MMCA collection.

Jeon Seontaek, *Returning to Hometown*,
1981, Oil on canvas, 136 x 230 ㎝. MMCA collection.

Kim Jae-hong, *Father-Iron Curtain 1*,
2004, Acrylic on canvas, 162 × 331 ㎝. MMCA collection.

Pen Varlen, *The Panmunjeom (JSA) for Ceasefire Talks in September 1953*,
1954, Oil on canvas, 28.1 × 47 ㎝. MMCA collection.

Lee Seung-taek, *History and Time*,
1958, Wire, painted on plaster, 153 × 144 × 23 ㎝. MMCA collection.

Park Ko-suk, *Landscape in Bumildong*,
1951, Oil on canvas, 39.3 × 51.4 ㎝. MMCA collection.

KIm Ku Lim, *Death of the Sun II*,
1964, Oil and object on wood panel, 91 × 75.3 ㎝. MMCA collection.

Lee Jungseob, *A Couple*,
1953, Oil on paper, 40 × 28 ㎝. MMCA collection.

Park Soo Keun, *Grandfather and Grandson*,
1960, Oil on canvas, 146 × 98 ㎝. MMCA collection.

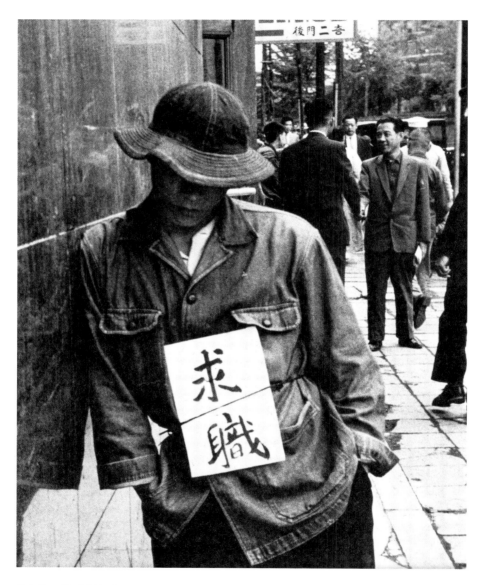

Limb Eung Sik, *Job Hunting*,
1953, Gelatin silver print, 50.5 × 40 ㎝. MMCA collection.

Joo Myung Duck, *Mixed Names(Holt Orphanage)-Biracial Orpha*n,
Photographed in 1965, printed in 1986, Gelatin silver print, 27.9 × 35.5 ㎝. MMCA collection.

Lee Hyungrok, *The Shoe Vendor in the Street, Namdaemun Market, Seoul*,
1950s/2008, Gelatin silver print, 49.3 × 59.5 ㎝. MMCA collection.

2. Han-gil (One Path)

Yoo Young-Kuk, *Work*,
1957, Oil on canvas, 101 × 101 ㎝. MMCA collection.

Oh Jong-uk, *Widow No. 2*,
1960, Steel, 72 × 15.5 × 31 ㎝ (2). MMCA collection.

Kim Whanki, *Two Moons*,
1961, Oil on canvas, 130 × 193 ㎝. MMCA collection.
ⓒ Whanki Foundation·Whanki museum

Lee Sook Ja, *Work*,
1980, Color on paper, 146.5 × 113.2 ㎝. MMCA collection.

Youn Myeong Ro, *Tattoo 64-I*,
1964, Oil on canvas, 116 × 91 ㎝. MMCA collection.

Kim Hyung-Dae, *Restoration B*,
1961, Oil on canvas, 162 × 112 ㎝. MMCA collection.

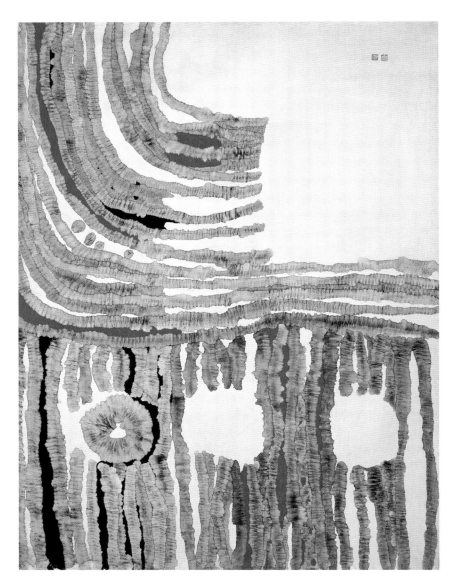

Park Re-hyun, *Work*,
1960, Color on paper, 174 × 129.3 ㎝. MMCA collection.

Suh Se Ok, *Twilight on Address No. 0*,
1955, Ink and color on paper, 99 × 94 ㎝, MMCA collection.

3. Gray Caves

Ha, Chong Hyun, *White Paper on Urban Planning*,
1970, Oil on canvas, 80 × 80 ㎝. MMCA collection.

Suh Seung-Won, *Simultaneity 67-1,*
1967, Oil on canvas, 160.5 × 131 ㎝. MMCA collection.

Kim Chungsook, *Half Moon*,
1976, Marble, 30 × 96 × 46 ㎝. MMCA collection.

Chung Chang Sup, *Tak No.86088*,
1986, Paper on canvas, 330 × 190 ㎝. MMCA collection.

Shim Moon-Seup, *Wood Deity 8611*,
1986, Wood and steel, 114 × 44 × 38 ㎝, 39.3 × 128 × 34 ㎝. MMCA collection.

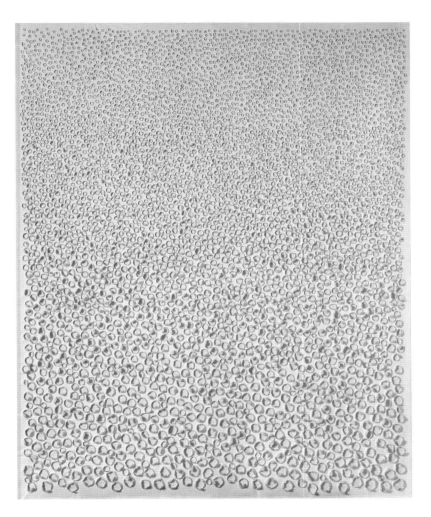

Kwon Young Woo, *Untitled*,
1980, Punched paper, 163 × 131 ㎝. MMCA collection.

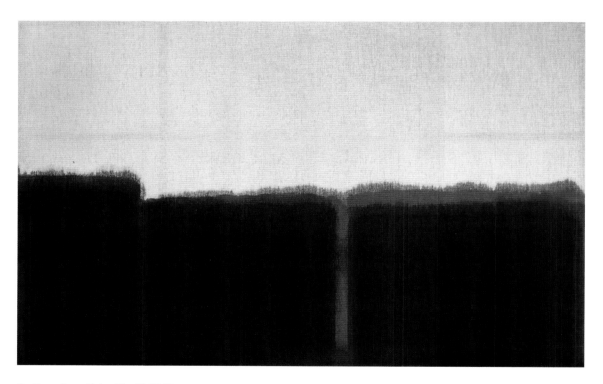

Yun Hyong-keun, *Umber Blue 82-86-32*,
1982, Oil on canvas, 189 × 300 ㎝. MMCA collection.

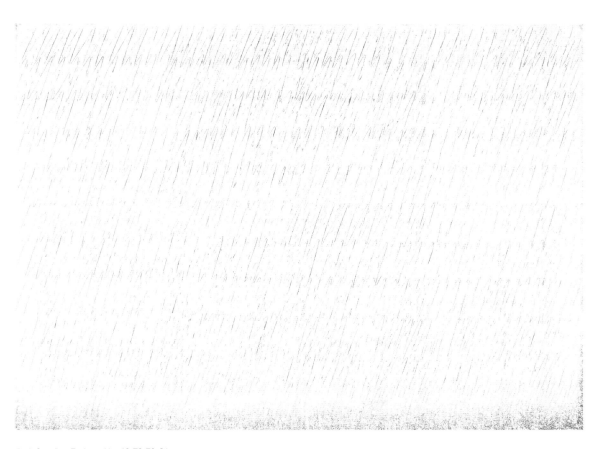

Park Seo-Bo, *Ecriture No. 43-78-79-81*,
1981, Oil and graphite on canvas, 193.5 × 259.5 ㎝. MMCA collection.

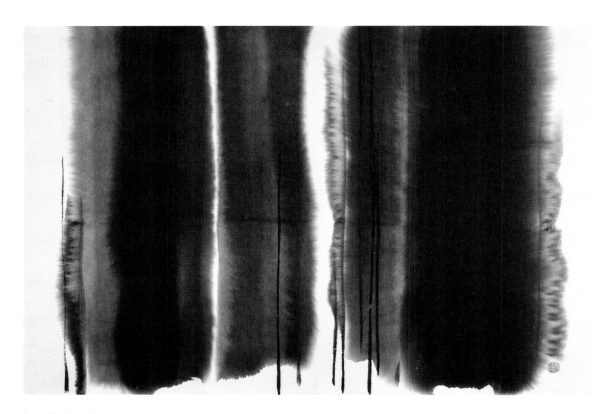

Song Soo Nam, *Tree*,
1985, Ink on paper, 94 × 138 ㎝. MMCA collection.

Quac Insik, *Work 63*,
1963, Glass on panel, 72 x 100.5 ㎝. MMCA collection.

Lee Ufan, *From Line*,
1974, Stone pigment on canvas, 194 × 259 ㎝. MMCA collection.

Kwak Duck Jun, *Meter Series*,
1970/2003, Meter, stone, 125 × 38 × 58 ㎝. MMCA collection.

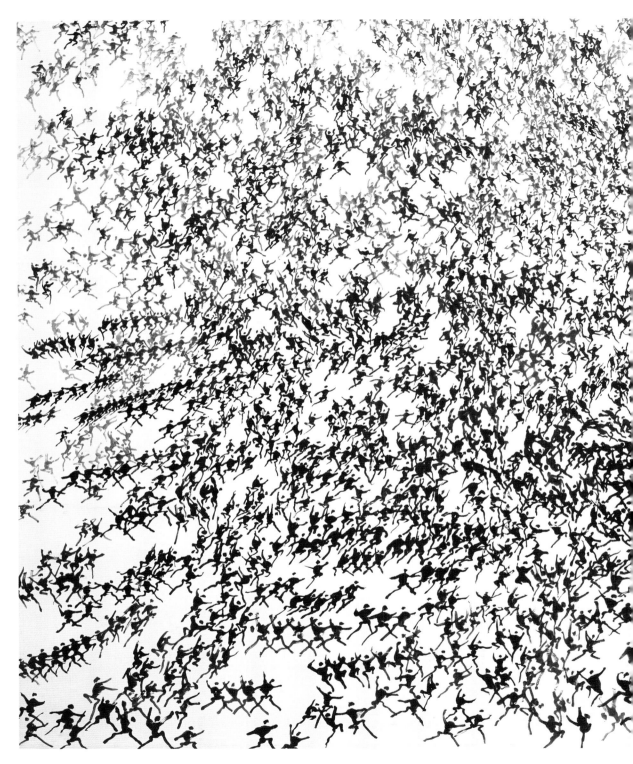

Lee Ungno, *Crowd*,
1986, Ink on paper, 211 × 270 ㎝. MMCA collection.
© Ungno Lee / ADAGP, Paris - SACK, Seoul, 2019

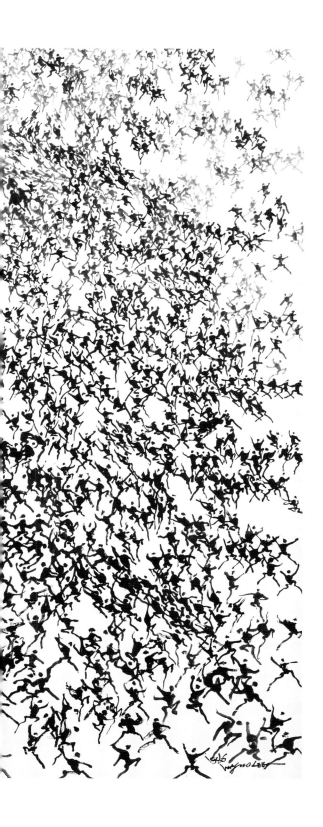

4. Painful Sparks

Kim Ku Lim, *The Meaning of 1/24 Second*,
1969, Single-channel video, color, silent, 10min. MMCA collection.

Kang Kukjin, *Amusement of Visual Sense*,
1967, Glass bottle, desk etc, 165 × 155 ㎝. MMCA collection.

Lee Kun-yong, *The Method of Drawing 76-6 (Drawn with Both Arms)*,
1976, Marker pen on plywood, 71.3 × 118 ㎝ (3). MMCA collection.

Lee Kun-yong, *The Method of Drawing 76-2 (Drawn with the Artist's Back toward)*,
1976, Marker pen on plywood, 118 × 71.3 ㎝ (3). MMCA collection.

Moon Bokcheol, *Situation*,
1968, Oil and objet on canvas, 120 × 93 × 17 ㎝. MMCA collection.

Lee Seungjio, *Nucleus No. G-99*,
1968, Oil on canvas, 162 × 130.5 ㎝. MMCA collection.

Kim Hong Joo, *Door*,
1978, Oil on door frame, 146 × 64 ㎝ (2). MMCA collection.

Lee Sukju, *Daily Life*,
1985, Acrylic on canvas, 97 × 129.7 ㎝. MMCA collection.

Choi Byungsoo, *Save Han-yeol*,
1987, Woodcut on Korean paper, 40 × 30 ㎝. MMCA collection.

Lee Sangil, *The Old Mangwol-dong*,
1985-1995, Gelatin silver print on fiber-base, 35.5 × 27.6 ㎝ (8), 50.5 × 40.5 ㎝ (33), 60.4 × 50.6 ㎝ (9). MMCA collection.

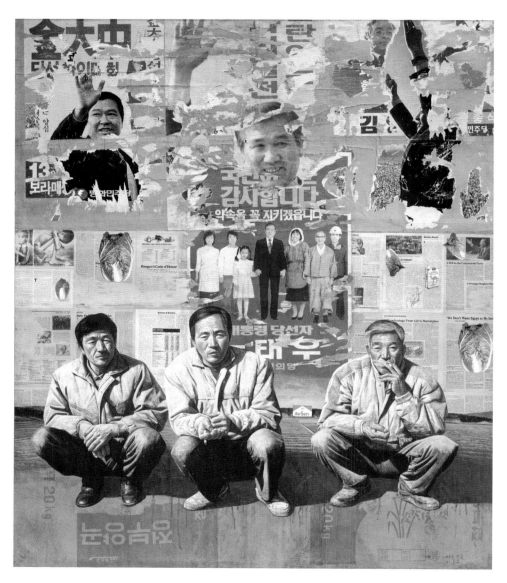

Lee Jong-gu, *Earth-At Oziri (Oziri People)*,
1988, Acrylic and paper collage on paper, 200 × 170 ㎝. MMCA collection.

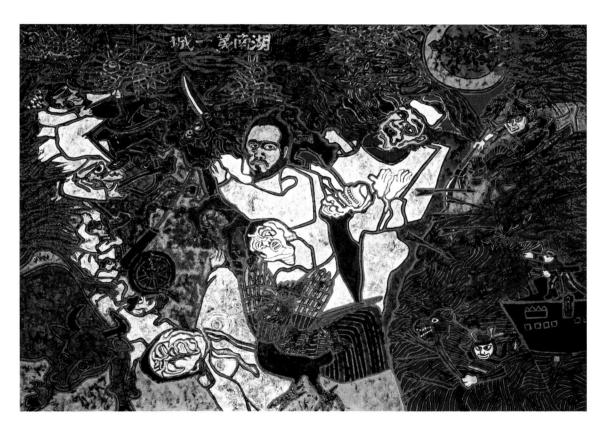

Park Saeng-Kwang, *Jeon, Bong-Jun*,
1985, Color on paper, 360 × 510 ㎝. MMCA collection.

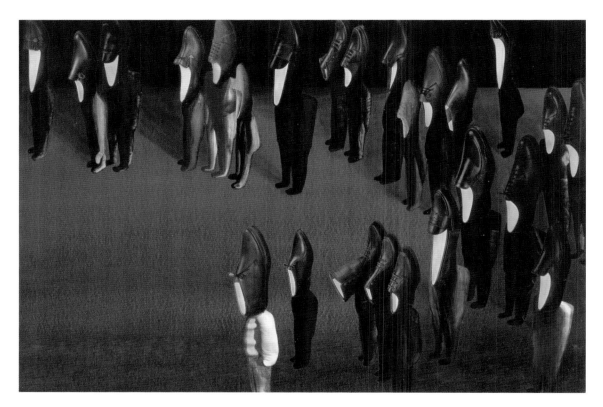

Shin Hak Chul, *Connivance 802*,
1980, Collage on canvas, 60.6 × 80.3 ㎝. MMCA collection.

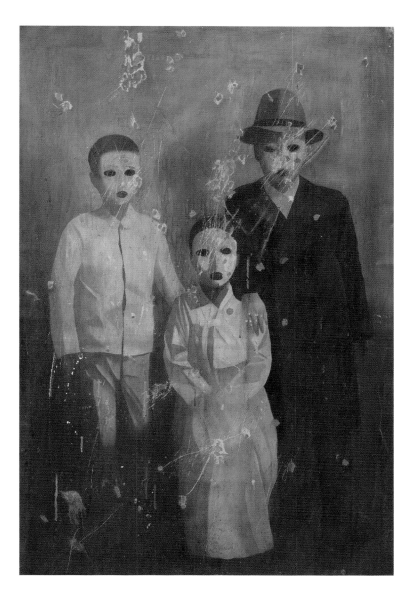

Ahn Chang Hong, *Family Photograph*,
1982, Oil on paper, 115 × 76 ㎝. MMCA collection.

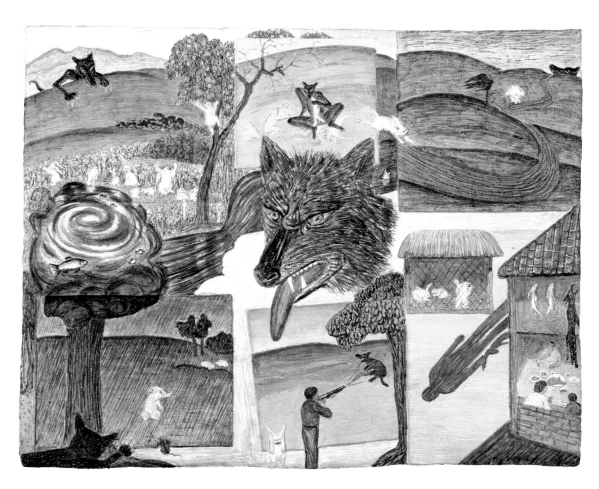

Lim Ok-Sang, *Rabbit and Wolf*,
1985, Ink and color on embossed paper, 85.5 × 106 ㎝. MMCA collection.

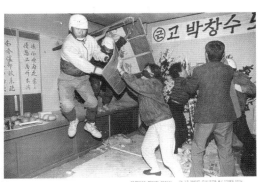

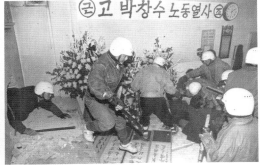

Joo Jaehwan, *Wonwangseang*,
1991, Print on paper, 52 × 76 ㎝. MMCA collection.

Ahn Kyuchul, *Chung-dong Landscape*,
1986, Color on plaster, 24 × 46 × 42 ㎝. MMCA collection.

In Search of a Language of Necessity:
Korea's Art Discourses during the Second Half
of the Twentieth Century

Shin Chunghoon

Assistant Professor, Department of Painting at Seoul National University

I.
—

In the latter half of the twentieth century, Korean art harbored despair interwoven with hope as it faced a new beginning. Such was the state of Korean art when, upon Korea's liberation in 1945, South and North Korean artists took up the task of imagining the independent nation's art anew. The conditions for artistic production remained bleak in the immediate aftermath of the war. Kim Whanki (1913-1974) bewailed the state of affairs upon viewing paintings at the third National Art Exhibition's Western Art Division drawn on pieces of canvas, scraps of muslin, and wood veneer, which prompted him to imagine "flipping all the paintings upside down."[1] Kim added that "such materials were probably not chosen for their expressive effect." Nevertheless, the material deprivation he described as "poverty dressed in rags" could be overcome with the passionate "high spirits" prevalent in the exhibition hall. The fact that Korean art lacked an inheritance from the past caused greater despair.[2] With an art history lacking a period of modernity and with extant art philosophy and aesthetics outdated, passion alone could not dispel its challenges. Such was the problem that fell upon Korean art, conditioned as it was by the physical, spiritual, and "art historical" ruins left by the Japanese colonial era and the Korean War. With nothing passed down, what did they have to embark on their beginning? However, the situation was not without hope. In pointing out the problematic conditions of Korean art, one held a certain anticipation. There was the expectation of new Korean art drawn upon a blank canvas; a will to forget the recent past's entanglements went hand in hand with this yearning for a new start.[3]

Given this context, the pervading anxiety that Korean art was temporally "delayed" and spatially "isolated" in relation to the world held within itself the very solution for its new beginning. By no coincidence, Lee Kyungsung (1919-2009) voiced such unease before proposing "imitation as a creative process."[4] Though neither desirable nor commendable, post-war urgency rendered it permissible.

Shin Chunghoon is currently an Assistant Professor in the Department of Painting at Seoul National University and also teaches the Interdisciplinary Program in Art Management. He received his BA and MA from Seoul National University, and his PhD from State University of New York at Binghamton. He was a Postdoctoral Fellow in the College of Humanities at Seoul National University, and a Research Professor at the Korea National University of Arts. He writes extensively on contemporary art, architecture, and urbanism in Korea, with recent essays on Han Mook, Kim Swoo Geun, Kim Ku Lim, Reality and Utterance, Choi Jeonghwa, Park Chan-kyong, and flyingCity.

Whether phrased as "reception" or "imitation," this rather frank proposal owed to the unique situation in which one could not simply scorn such course of action. No longer required to receive what was filtered through Japanese preferences to undertake "imitation at second remove," Korean art could now "open its doors directly to the world."[5] The cultural Cold War offensive mounted by the Eisenhower administration (1953-1961) brought examples of American art to Korean shores, providing an ideal model of a latecomer that "sprinted across the entire course of art history in no time at all and reached the contemporary age."[6] Armed with the ability to select what was suitable for Korea while benchmarking a similar case of success, Korean art was justified in its "bold imitation" by more than sheer urgency.

As the keyword of Korean art in the 1950s, the term "contemporary" encompassed both the desire for a new beginning and a plan for its achievement. It's not simply because of their dictionary meaning that phrases such as "contemporary aesthetics," "contemporary art," "contemporizing," and "contemporary people" proliferated. Indeed, the term "contemporary" implied what was not of the "current age"-not in the sense of the unknown but in the sense of what was current in the West; it designated what was not yet realized here but already known elsewhere, and thus available to pursue, reach, and absorb. The problem behind this yearning for what was contemporary did not necessarily lie in its one-sided reference to the Western art. The bigger problem was the internalization of a single time scale for world history, in which case historical time is understood as a progression, thereby replacing cultural difference with temporal order.[7] Hence Korean art's present was not considered different from Western art but behind, and it was Western art's present that determined Korean art's future. Laden with such connotations, the term "contemporary" served as a keyword among Korean artists, displacing the terms *minjokjuui* (Korean nationalism) and *minjok* (the Korean ethnos or people) that served as keywords before the Korean War.[8] As the words and thoughts of the earlier post-liberation period lay dormant amid the Cold War's politically hostile atmosphere, the pursuit of the "contemporary" that is colonized temporality met with little restraint.

1. Kim Whanki, "The High Spirits of Painting: On Viewing the Oil Paintings of the *Third National Art Exhibition*," *Kyunghyang Shinmun*, Nov. 7, 1954.

2. "Lacking a period of modernity in its art history, Korean artists were required to make a logical leap. . . ." Lee Kyungsung, "Art based on Everyday Life," *Saebyeok* (1955); "Historical dialectics does not apply to Korean art. Hence the difficulty of establishing contemporary art upon situation, the negation of modern history. . . ." Kim Yeongju, "Challenges Facing Korean Art (Part 1)," *Yonhap Shinmun*, Jan. 24, 1957.

3. Leela Gandhi's argument regarding the emergence of independent nation-states and their concomitant will to forget the colonial past helps elucidate the postcolonial amnesia present in Korean art. Leela Gandhi, *Postcolonial Theory: A Critical Introduction*, Trans. Lee Yeonguk (Seoul: Hyunsil Book, 2000).

4. Lee Kyungsung, "A Profile of Korea's Western Painting," *Art Bulletin*, May 26, 1954.

5. Lee Kyungsung, "Melancholia of the Art World," *Yonhap Shinmun*, June 19, 1953.

6. Lee Kyungsung, "The Significance of American Contemporary Art: Lessons from the Exhibition *Eight American Artists*," *Dong-A Ilbo*, Apr. 17, 1957.

7. For a postcolonial criticism of modernity's historicist temporality that replaces spatial difference with temporal order, see Dipesh Chakrabarty, *Provincializing Europe: Postcolonial Thought and Historical Difference* (Princeton and Oxford: Princeton University Press, 2000).

That is not to say that the pursuit remained entirely one-sided. With passionate desires for the "contemporary" in art came a sharpened awareness of the gulf between its realization and the "here and now." Did a given artwork constitute "adherence" or "experience?" Such was the question repeatedly raised with new artwork as they met with well-worn expectations rather than surprise due to their clear reference to foreign trends. The question of "necessity" in the relationship between foreign visual language and the aesthetic taste, temperament, social reality, tradition, and history pertaining to "us Koreans" or the "here and now" had direct bearings upon the compelling and moving effects of an artwork. An account of Korean art history must highlight the appearance of new artistic trends in conjunction with what followed: namely, what may be called the test of necessity.[9] In this light, the trajectory of Korean contemporary art-founded upon early conditions of a hierarchical relationship with Western art and launched with a will to forget the past-is comprised of a history of reception and no less so by a history of measuring the necessity of such reception.

2.

"Contemporary art has a form of its own. That form consists of contemporary art's abstract tendency."[10] As stated by Kim Byungki (b. 1916) in 1953, abstraction emerged as the definitive method for pursuing contemporary art in post-war Korea. In breaking away from naturalistic depictions of external objects as well as the narrativity of literature, the non-objective plane became necessary for starting anew by rejecting traditional painting. As a prerequisite, however, artists had to overcome a deeply ingrained resistance to abstract art. Indeed, discussions of abstract art had taken place before in Korea. In the late 1930s, elite students who had studied abroad introduced and demonstrated both abstract and surrealist paintings as examples of avant-garde art. The abstract art of that time relied on intellectual sensibilities and geometric shapes as it simplified form by combining points, lines, and planes, purified the surface of paintings, and drew upon the essence of objects. In the words of Jung Hyunwoong (1910-1976), abstract art resonated with materialistic modernity as the "pursuit of sensibilities and formal aesthetics tied to mechanisms of abstract form and composition" corresponded to a "handshake with the modern, mechanical civilization."[11] Artistically contemporary while also serving as an art of the contemporary age, abstract art offered undeniable merits-but these very merits

8. For a discussion of the post-liberation period's keywords and thoughts, see Choi Yeol, *History of Korean Contemporary Art: A Dictionary of Korean Art, 1945-1961* (Paju: Youlhwadang, 2006).

9. The present paper's discussion regarding the mechanisms of imitation and necessity, as well as the test of necessity, summarizes a previous article by the author. Shin Chunghoon, "Imitation and Necessity in Korean Art Criticism during the 1950s and 1960s," *Art History and Visual Culture* 19 (2017): 126-151.

10. Kim Byungki, "The Problem of Abstract Painting," *Sasanggye* 6 (1953): 170-176.

11. Jeong Hyeonung, "Abstract Painting," *Chosun Ilbo*, June 2, 1939. A similar argument can be found in an article by Kim Whanki. Kim Whanki, "An Essay on Abstract Art," *Chosun Ilbo*, June 11, 1939.

also hindered its wholesale adoption. Its supposedly intellectual aspects were deemed strangely unfamiliar whereas its geometric forms were disparaged as mere designs or decorations.[12]

In this context, the call to practice abstract art in the early 1950s required concomitant proposals on how to overcome such resistance. Artists such as Kim Byungki and Han Mook (1917-2002) presented a new model for a more familiar abstract art.[13] Under this model, abstract art bore an affinity to Korean temperament as it was expressionistic rather than geometric, spontaneous rather than intellectual, and reflective of Kandinsky rather than Mondrian. Furthermore, as a practice in capturing essence rather than depicting external appearance, abstract art was deemed to share the preexisting logic of Eastern art that sought to reveal essential meaning or spirit rather than outer form. This new model of abstract art based on a perspective that equated Eastern "energy" with Western "expression" attracted the attention of Eastern and Western artists alike.[14] Yet this growing interest in expressionistic art in the mid-1950s was propelled not only by such affinity, but also by demands of exigence. While the modest refinement and simple dignity found in paintings by Kim Whanki and Chang Uc-chin soothed the psychological wounds of post-war Korea, those who expected art to confront the post-war trauma found them wanting. They demanded that art be more relevant and embody zeitgeist, with a stronger sense of reality. Kim Youngjoo (1920-1995) urged on the production of expressionistic art, thereby hoping to cope with contemporary anxiety.[15] Kim's insistence on treating the contemporary era in terms of anxiety, confusion, and irrationality rendered former conceptualizations that linked contemporality with intellectual sensibilities as outdated.

Bearing affinity to what was deemed to be Korean temperament and Eastern sensibilities while capturing the zeitgeist of anxiety, expressionistic abstract art gained traction. This context facilitated the emergence (or reception) of art *informel* in the late 1950s. Admittedly, the appearance of art *informel* was not as startling as it was anticipated. Not only were Korean artists aware of the European and American vogue of gestural abstraction, they were already discussing the suitability of adopting the model. Its appearance in the third and fourth Contemporary Artists Association Exhibition of 1958 thus faced an immediate test of necessity. Lee Kyungsung, Kim Byungki, Kim Youngjoo, and other artists born in the 1910s contended that art *informel* was not yet fully assimilated, whereas Kim Tschang-

12. For the resistance to abstraction per se, see Oh Jiho, "Theory of Pure Painting: Towards Painting Rather than Art," *Dong-A Ilbo*, serialized Aug. 1938; for the resistance to geometric forms of abstraction, see Kim Whanki, "The Sought-Out Year," *Munjang*, Dec. 1940, 184.

13. Kim Byungki, "The Problem of Abstract Painting," *Sasanggye* 6 (1953): 170-176; Han Mook, "Reflection on Abstract Painting: Essence and Objectivity," *Literary Art* 2.5 (1955).

14. For the identification of "energy" with "expression," see Jeong Mujeong, "Kwon Youngwoo's Works of the 1950-70s and the Transformation of the Concept 'Eastern Painting,'" *Journal of Korean Modern and Contemporary Art History* 32 (2016): 322.

15. For Kim Youngjoo's appraisal of Kim Whanki and Chang Uc-chin, see Kim Youngjoo, "Kim Whanki's Exhibition in France," *Hankook Ilbo*, Feb. 8, 1956; Kim Youngjoo, "Intention and Result: On the Second *Baekuhoe Exhibition*," *Chosun Ilbo*, June 29-30, 1956.

yeul, Park Seo-Bo, and others born in the 1930s retorted that wartime experiences validated the necessity of their art.[16] These conflicting views were resolved only in the late 1960s when the older generation of artists finally withdrew their doubts. This belatedness does not suggest that the younger generation hesitated to embrace the new visual idiom. More so than the compelling effect of necessity per se, the characteristically militant, heroic, uncompromising, and nonconformist attitude of the *informel* movement was what won the hearts of the younger generation. It was the term "avant-garde" that accounted for this attitude, which gained exigency amid the political upheavals ushered in by the April Revolution of 1960 and the May 16 military coup d'état of 1961.[17] As artists sought out contemporary art in the aftermath of the Korean War, explored abstract art as its form, and emphasized the avant-garde as its attitude, what may be called a trinity of contemporary, abstract, and avant-garde art came into being at the turn of the 1960s. However, rather than standing upon firm ground, this structure stood precariously, supported by each of the three components leaning on one another.[18]

3.

The trinity of contemporary, abstract, and avant-garde art did not last long. Although the abstract art of the '60s remained contemporary, there was less certainty over its avant-garde nature; by the '70s, the avant-garde came to be more decadent than advanced. With the spread of art *informel*, abstract art appeared to be enjoying its golden age. As a testament to the power of its campaign, abstract art began to claim a place in the National Art Exhibition itself. In 1961, the National Art Exhibition's Western Art Division was separated into the figurative, semi-abstract, and abstract categories. For the 1969 exhibition, the Western art works were subsequently reorganized into the figurative and non-figurative categories.[19] Despite the growth of abstract art, the quality of works regressed; they were often stereotypical and banal. Kim Whanki pointed to the dubious nature of such new abstract art in the self-mocking lamentation, "I marvel at the genius of established painters who can enable first-year art students to create works of *informel*."[20] Indeed, abstract art was even disparaged as a field for those lacking skills in detailed depiction, given such derogatory labels as "imitation," "poor copies," "contrived,"

16. The conversation between Kim Byungki and Kim Tschang-yeul highlights their generational differences. Kim Byungki and Kim Tschang-yeul, "Contemporary Art Advancing Forward: A Conversation Dispelling Korean Modern Art," *Chosun Ilbo*, Mar. 26, 1961.

17. For the relationship between political change and art *informel*, see Kim Mijung, "Art *Informel* and the National Art Exhibition: Focusing on the Political Changes of the Early 1960s," *Journal of Korean Modern and Contemporary Art History* 12 (2004): 301-342.

18. For the contemporary-abstract-avant-garde trinity of Korean art in the 1950s, see the brochure, *Korea Arts Management Service*, "Korean Art: Again, Aright, Together," Vol. 2, 2018.

19. For a discussion of Korean figurative art, see Kim Yisoon, "Denotation and Connotation of Korean Figurative Sculpture," *Journal of Korean Modern and Contemporary Art History* 15 (2005): 89-116.

20. Kim Whanki, "The Challenge of Avant-Garde Art," *Lectures on Contemporary Humanity* 3 (1962): 83-93.

"fetish," and a mere "trend."[21]

The devaluation of abstract art did not occur in Korea alone. In fact, one could view it an international phenomenon that influenced Korean art. The latest works out of the US and Europe seemed to return to figurative art. Along with the Neo-Dada and pop art of the US, the optico-kinetic tendencies and nouveau réalisme of French art in the early '60s served to reinstate figuration and narrative in art.[22] As Korean artists began to participate regularly in the Paris Biennale and São Paulo Biennial in the 1960s, they grasped these changes through information unprecedented in its immediacy, as well as their firsthand experience. As a result, interest in figurative art grew explosively in Korea. Proponents of naturalism who had been under heavy attack of abstract art welcomed the reinstatement of figurative art. Meanwhile, proponents of abstractionism warned against the abuse of figurative art, stressing that such figurative art signaled a movement forward from abstract art rather than a return to pre-abstract naturalism.[23] The revival of figurative art also threatened the very raison d'être of art *informel*. After the early to mid-'60s vogue for *informel* subsided, "a hefty silence fell over the art community for several years," which, according to Park Seo-Bo, is due to "artists formerly engaged in the *informel* movement not being able to find the necessary momentum for proceeding to the next stage."[24]

The concern over the art community's silence prevalent around 1964 led to a demand for the adaptation of foreign trends. Bang Geuntaek (1929-1992) exclaimed, "elsewhere, artists are clamoring after junk art, pop art, assemblage, mobile art, happening, Neo-Dada, op art, and the like. . . . Why should we stop upon confronting *informel*?"[25] Nevertheless, hewas to discover soon that importing trends is not a panacea. The Western art movements had been born as a response to the Western civilization, accepting it or rebelling against it..; yet Korean artists "lacked the societal, civilizational ground on which to carve out the aesthetics that followed art *informel*."[26] The diagnosis that artistic trends of Europe and North America in the '60s were unsuited for Korea's "here and now" had the converse effect of suggesting the retrospective suitability of art *informel* in the '50s. By no accident, the narrative that art *informel*'s agitated, non-objective plane rose from post-war

21. Park Seo-Bo, "Similar Forms of Abstract Painting in the First Half of '62," *Dong-A Ilbo*, July 5, 1962; Kim Youngjoo, "Korean Contemporary Art Ailing: Questioning Our Direction," *Chosun Ilbo*, July 20, 1962; Lee Kyungsung, "The Paradox of Korean Contemporary Art," *Chosun Ilbo*, July 27, 1962.

22. Lee Yil explains, "Clear themes-this impure literature persecuted so severely of late-has returned to the scene." Lee Yil, "A Testing Ground for New Art: On-Site Views of the Paris Biennale," *Chosun Ilbo*, Oct. 28, 1965.

23. Kim Byungki, "The Confrontation of Figurative Abstract: A Testimony," *Dong-A Ilbo*, Oct. 12, 1962; Park Seo-Bo, "Figurative and Fact," *Dong-A Ilbo*, May 29, 1963; Lee Yulmo, "Contemporary Art and the Avant-Garde: On Reading Park Seo-Bo's 'Figurative and Fact,'" *Dong-A Ilbo*, June 14, 1963; Lee Il, "Dialectics of Abstract and Figurative Art: Around Current Figurative Art, *Space*, July 1968, 62-69.

24. Park Seo-Bo and Kim Youngjoo, "A Decade of Abstract Movement: Legacy and Prospects," *Space*, Dec. 1967, 88.

25. Bang Geuntaek, "Theory of Avant-Garde Art," *Hyundae Munhak* 129 (1965): 268.

26. Bang Geuntaek, "Contemporary Art by Koreans," *Sedae* 3.9 (1965): 352.

experiences of confusion and anxiety gained official approval around this time. In this context, the ruins of the Korean War-formerly considered a condition for non-synchronous "delay" and "isolation" in relation to the West-had served as a condition for synchronicity by resonating with the physical and psychological wounds of post-WWII Europe and America. In fact, it was only as hopes for achieving synchronicity ran high in the late '60s that Korean artists realized it had become impossible in their time.

The new trends of the late 1960s appeared against the backdrop of widespread skepticism about adopting artistic models from the West. Thus, negative reception laid in wait. In December of 1967, the Young Artist Coalition Exhibition headed a storm of pop art, op art, kinetic art, environmental art, and happenings. Though initially welcomed as boldly spirited attempts that broke the art community's "hefty silence," they soon met with criticism that they were "rootless flowers."[27] Chung Chanseung (1941-1994) would confess in the 1970s, "I admit that I was caught up entirely in foreign trends. I feel ashamed," hinting at what was to follow: art of the late '60s would be disparaged and forgotten.[28] The oblivion lasted until the works garnered attention for their social commentary while receiving new consideration as the origin of the installation and performance art that came into vogue during the mid to late 1990s; the late '60s were restored in academia as a period of experimentation, rather than mere transition or exploration. Given the inextricable relationship between art and experience, the disparaging treatment was, in part, undeserved. Under the Park Chunghee administration, as well as Kim Hyunok's city government, modernization took on unprecedented levels of visibility through industrial development and urban transformation. Futuristic discourse on urbanization, science and technology, and consumerist society lent to the understanding of changes that overtook everyday environments. These discursive as well as real shifts facilitated the arrival of foreign architecture and techno-utopian art on Korean shores. Against this backdrop, the "happeners" became linked to Seoul's underground youth culture. Members of AG (Korean Avant Garde Association) referred to their abstract art as "art of the city," thus explaining the works' cold atmosphere and geometric forms.[29]

In assailing such artwork as "rootless flowers" regardless of the facts, critics appeared predisposed toward censure. Whether in the form of reflections by Lee Yil and Oh Kwangsu (b. 1938), or denunciations mounted by Kim Jiha (b. 1941) and Kim Yunsu (1935-2018), the transitional period leading to the 1970s produced a deluge of critical reflections upon Western-oriented art (in such terms as "non-sequential sequence," "history of clashes," "series of irregularities"); paradoxically enough, such

27. For the expression "rootless flowers," see Lee Kyungsung, "Trends and Prospects of Visual Arts: As Seen Through the *Exhibition of Contemporary Artists*," *Space*, June 1968, 69; Lee Kyungsung, "Dynamic Avant-Garde Art: Exploring Directions without Noteworthy Results," *JoongAng Ilbo*, Sept. 22, 1969.

28. "Symposium on Recent Avant-Garde Art and Us Artists," *Space*, Mar. 1975, 63.

29. Ha Chong Hyun, "On Welcoming the '70s in Korean Art," *AG* 2 (1970); Choi Myoungyoung, "New Aesthetic Consciousness and its Figurative Settings," *AG* 2 (1970).

accounts did not owe entirely to the gulf between Korean and Western art, which appeared wider than ever.[30] In facing this familiar fundamental inferiority complex by putting it to public debate, Korean artists expressed a sense of confidence. The rediscovery of tradition prompted by discussions of "internal development," the accumulation of artwork and theory related to the aesthetics and literary theories of realism, the deeper understanding of European and American contemporary art, and, above all, the hope that Korean art would finally stand upon firm ground, paved the way for the Korean art of the '70s.

4.

Korean art of the 1970s departed significantly from the past. As a clear sign of change, such expressions as "Koreanness" and "tradition" gained currency within the art community. Those values-abandoned as the fount of underdevelopment amid post-war yearnings for the "contemporary" and subsequently mentioned only out of necessity to warn against the dangers of isolationism and chauvinism-now served as the core of artistic production. As an important case in point, one can turn to the representative tendency found in 1970s Korean art, alternately called Korean monochrome, *dansaekjo* painting, or *dansaekhwa*.[31] Just as abstract art prioritized the visual over the verbal (by removing referentiality from its surface), thereby rendering meaning tenuously vague and thus prompting verbal proliferations seeking to ensure meaning, art of the '70s engendered a plethora of words because the paintings were not particularly allusive or allegorical on the surface.[32] The identity discourse surrounding such terms as "inactivity," "nature," "white," "spirituality," and "Eastern" served as a frame for understanding tactile sensibilities, delicate shades of color, repetition of visual elements, multi-layered permeations, and diffusions.

A number of forces served to drive these changes. One could mention the ideology of nationalism rising from the "Korean democracy" of the 1970s, demonstrated by the *Yushin* System and emergency rule that departed from the formalistic democracy of the 1960s, the psychological resistance or compensation mechanism prompted by breakneck industrialization and urbanization, or the exoticism and self-orientalism that followed from exposure to foreign (especially Japanese) audiences and consumers. However, in terms of the internal structure of Korean artistic discourse, "Koreanness" and "tradition" operated as signifiers of necessity. Refusing to be read as a socioeconomic index as in the case of '60s art and

30. Lee Yil, "Ethics of Transition: Where Art Stands Today," *AG* 3 (1970); Oh Kwangsu, "The Critical Outlook of Korean Art," *AG* 3 (1970); Kim Jiha, F*irst Manifesto of the Reality Group: Upon the Reality Group Exhibition*, Exhibition catalog, 1969.

31. Kim Youngna, "The Two Traditions: Monochrome Painting of the 1970s and *Minjung Misul* of the 1980s," Korean Studies Quarterly 23.4 (2000): 33-53. Meanwhile, Lee Il refers to these artists as "artists of the '70s." Lee Il, "Artists of the '70s: Returning to What Is Primordial," *Space*, Mar. 1978, 15-21.

32. For the paradoxical situation in which abstract artists increasingly turn to the verbal to ensure meaning, see Leah Dickerman's "Introduction." Leah Dickerman, ed. *Inventing Abstraction*, 1910-1925 (New York: The Museum of Modern Art, 2013).

selecting a monochrome canvas nowhere in vogue at the time, Korean art of the '70s proceeded without requiring the test of necessity repeatedly administered since the 1950s. Its effects were immediate as in the Korean art community's self-reflection over irregular development in the late 1960s.

Nevertheless, the circumstances were far from simple. Not unlike before, foreign art played a decisive role in Korean art production of the 1970s. The role played by Japanese contemporary art is well known. The Exhibition of Contemporary Korean Paintings held at Tokyo's National Museum of Modern Art in 1968 provided the impetus–mediated through Lee Ufan, who, upon the occasion, began associating with the Korean art community–for a rising tide of influence that exerted greater force in discursive (more so than formalistic) spheres. The influence was not limited to specific art movements, as it reached the entire range of art production by penetrating several trends. As an example, the Korean art community of the 1970s adopted the view that art entails a revelation (an "encounter") of the world per se as it exists apart from meaning assigned by humanistic frames of reference or as it exists before objectification via human perception. This concept of art led to the consideration of production methods that erased the artist's subjective or arbitrary decision-making process, carrying out repeated actions that minimized the role of the agent or allowing the visual event rising from natural characteristics of a medium or material to stand as an artwork's final form. By principle, to appreciate such works, one had to stop turning to presumed meaning, intention, or purpose; appreciation lay in mere perception or in a mere act of sensation. Park Seo-Bo's claim that he "did not draw anything" or tautological actions deemed "logical" by Lee Kun-yong (b. 1942) bore affinity to these anti-hermeneutical, anti-illusionist, or anti-humanistic tendencies. These tendencies lay at the core problematic of North American art movements such as Neo-Dada, pop art, and Minimalism ahead of being adopted by Japanese art. Given that painting remained a mere physical object wherein pigment was applied to a canvas surface, the illusionist view of art production and acceptance that sought out the nature of humankind, the world, and the entire universe in painting met with increasing resistance; this resistance promoted the literalist or "anti-interpretation" attitudes maintaining that painting was nothing other than itself, considered as advanced, politically liberating views.[33]

In light of this context, one can say that literalist art trends from the US and Japan were operating behind the eye-catching identity discourse that governed the 1970s Korean art scene. Based on precise discernment of these underlying trends, the critic Park Yongsook (1935-2018) questioned the necessity of such foreign models of art. Were Korean artists driven by an exigence to halt the suffocatingly dangerous accumulation of knowledge, meaning, and images of the world, simply revealing the world as it is, in and of itself? To this question, Park replied, "I do not sense the fear of hollow images" present in European and American civilizations.[34] Reminiscent of Kim Jiha's sharp criticism in the late 1960s, the remark censured Korean artists for adopting and making use of art that emerged from places urgently "disposing excess" even as Korean art faced urgent needs of "addressing deficiency."[35] Rather

than being shackled by excess knowledge, was Korean art not liberated by a lack of knowledge instead?

By giving art a place between the tension of what is sensuous and what carries meaning, the literalist tendencies of 1970s Korean art provided the means for experiencing the ontology of art and the theory of modernist art. In doing so, however, Korean art grew abstruse. Never had art been termed abstruse as often as in the 1970s. In Korea, even abstract art had responded to demands of compositional necessity by evoking things external to a painting's surface, hence bearing figurative, rather than self-referential, attributes. Not surprisingly, the exploration of literalist aspects of art in the 1970s gave rise to widespread criticism regarding the "dehumanization of art" and the "abstrusity of abstract art." The theory of *minjok* art (Korean national art or Korean people's art) propounded by Kim Yunsu and Won Dongseok (1939-2017) came to the fore amid the emergence of *minjok* literary theory based on realism and the developmental dictatorship era's *minjung* discourse; in part, it was also propelled by widespread dissatisfaction over the era's art. The criticism deplored more than art's increasing pedantry. By assigning profound meaning to such cryptic artworks, the Korean art field's belatedly established institutions of high art (i.e., galleries, national art museums, art markets, art magazines) drew criticism for alienating a great majority of the "common people" and even putting up a hostile front against them. The awareness of this problem underlay *Minjung* art's efforts to make art resemble common speech, carried out alongside critical attack on art institutions and attempts at their rectification.[36]

5.

The history of Korean art production and reception from the 1950s to 1970s can be understood as a repeated process of referencing the changing forms and theories of foreign art on one hand and, on the other hand, questioning whether they were necessary for Korea's "here and now." In terms of this mechanism describable as "imitation and necessity," the 1980s clearly served as a key turning point in Korean art history. The period's art movements established a regular current of production and reception in which the debate regarding "whether or not an artwork merely imitated foreign trends or demonstrated immanent necessity" no longer held sway as decisive factors. *Minjung* art deserves considerable credit in putting a halt to this long-lived structure.

33. Susan Sontag, *Against Interpretation and Other Essays*, Trans. Lee Mina (Seoul: Ewho, 2002); Robert Slifkin, *Out of Time: Philip Guston and the Refiguration of Postwar American Art* (Berkeley and Los Angeles: University of California Press, 2013).

34. Park Yongsuk, "Reasons for Conceptual Art," *Space*, Apr. 1974, 8-18.

35. See Kim Jiha, *First Manifesto*. For a similar case made by Cho Yohan, see Cho Yohan, "On the Experimentalism of Contemporary Art: How Far Has Korean Art Reached?" *Hongik Misul* 2 (1973): 60.

36. The argument draws on the forthcoming study, Shin Chunghoon, "Reality and Utterance in and against *Minjung* Art," in *Collision, Innovation, Interaction: Korean Art from 1953*, ed. Yeon Shim Chung et. al. (London: Phaidon, 2020).

Traced back to the establishment of *Reality and Utterance* and the *Gwangju Free Artists Association* in 1979, the art movement restored figuration and narrative in art, depicted the life and history of *minjung* ("common people"), and revealed the contradictions rising from their political, economic, and social structuralization. The movement introduced visual forms of low culture, including Buddhist paintings, Korean folk paintings, barbershop illustrations, and cartoons, bringing art in contact with everyday life and political scenes. Alternately described in the early 1980s as the "new figurative painting," "new art movement," and "living art," the movement eventually earned its general appellation as *Minjung* art in the mid-1980s when the conflict between Korea's military government and pro-democracy forces reached their height: the designation hints at the various currents and interests that were woven into the movement.[37] Insofar as it was linked to *minjung* discourse-a postcolonial project seeking to rectify the supposed failure of Korea's modernity thrashed about amid Japanese colonial rule, North-South division, the Cold War, and oppressive regimes on both sides of the Korean Peninsula by discovering (or perhaps creating) *minjung* as a historical subject-the *Minjung* art movement demanded complete revision of the postcolonial dynamics of "imitation and necessity" founded upon its hierarchical relationship to Western art. Indeed, concepts such as "the contemporary," "the abstract," and "the avant-garde" were all negated during the period of *Minjung* art, replaced with such concepts as *minjok* and history, narrative and figure, neighbors and *minjung*.

Accusations of imitation mounted against individual works, as well as the ingrained self-deprecation over Korean art's irregular development, did not entirely vanish, but in the wake of *Minjung* art in the '80s, concerns over "art without a cause" nevertheless died down considerably. The earnest, postcolonial effort of *Minjung* art played its part in concert with changing conditions of Korean politics, society, economy, and culture. In the several preceding decades, the historical experiences of Korea, Europe, and the US, along with qualitative and quantitative disparities in material development, had served as decisive factors in the repeated dynamics of imitation and necessity. Accordingly, divergent opinions clashed over whether or not "their" necessity could stand for "our" necessity, and specific trends were either approved or assigned to oblivion in the process. However, that sense of disparity gradually diminished in the late twentieth century as similarities in foundation or ground ensured that Western art movements were no longer wholly strange or irrelevant to Korean art.

This belief may have constituted an illusion of synchronicity, a logic for allowing art practice founded upon such illusion to escape responsibility. If synchronicity was indeed to be found, it would have been what Fredric Jameson and Paik Nak-chung described as "the synchronicity of the non-synchronous," created by the coexistence of the first, second, and third worlds of the Korean Peninsula.[38] As such, one could still raise issue with the colonial nature of immediate translation based on such illusions of synchronicity. In fact, this became a controversial issue in the transition to "postmodernism" in the 1990s as well as the transition to the 2000s that gave rise to discussions of "migration," "nomadism," and "flight," along

with respective critical responses. Nevertheless, such fin-de-siècle discussions revealed that Korea was no longer a wholly third-world country as it also contained first-world aspects in its midst. Whether negatively or positively, the sense of underdevelopment or disparity no longer wielded such decisive force.

Indeed, the language of necessity had grown so much as to put Korean art at risk of fetishism or stereotyping. *Minjung* art withered in the early 1990s because its reductive aesthetics and stereotypical rhetoric-hitherto tolerated under the tumultuous era of the 1980s-now lay exposed. This suggests that claims of necessity did not automatically ensure a work's quality or compelling force. What is more, as Korean art entered the post-1990 art circuit driven by globalization and art biennials, the language of necessity was at times actively demanded from "there" rather than being desired from "here." While Korean art gained greater visibility on the world stage, such visibility came at the expense of revealing the unique conditions-whether diachronic or synchronic-pertaining to Korea. As a result, artworks were treated as an anthropological artifact or socio-historical evidence rather than products of artistic discourse or aesthetic considerations; attempts to gain greater visibility also led to cliched or essentialized language of necessity, which caused concern as it threatened to marginalize Korean viewers.

The post-1950s postcolonial conditions of Korean art came with structural demands regarding the pursuit of art with a motive, as opposed to arbitrary art. Following the 1980s, Korean art clearly welcomed a new paradigm that departed from its antecedents. However, one would be naïve to assume that the shift came after Korean art broke free of its deep-rooted postcoloniality. Perhaps liberation would only be possible by disregarding the practice and concepts of what is necessary, what contains motive, and what contains originating cause. When a welter of works unrelated to "us Koreans" and the "here and now" inundate the scene, that is when necessity can be considered a given that no longer requires conscious pursuit.

37. For a general outline of generations and the myriad terms for art movements of the '80s, see Yu Hongjun, *The '80s Field of Art and Artists*, (Paju: Youlhwadang, 1986); Sung Wan-kyung, "Two Cultures, Two Horizons," *Minjung Art, Modernism, and Visual Art, Sung Wan-kyung's Art Criticism: Reflections for a New Modernity* (Paju: Youlhwadang, 1999): 84-105.

38. For "the synchronicity of the non-synchronous," see Fredric Jameson and Paik Nak-chung, "Marxism, Postmodernism, and *Minjok* Cultural Movement," *The Quarterly Changbi* 67 (1990): 290-291.

The Draft of Monsters Biography in Modern and Contemporary Korean Art: "*Jungmi* [精美; Clean and Pure Beauty]", Abstraction, *Hangukhwa*[Korean Painting], *Minjung* Art, and Fine Art?

Kim Hak-lyang*

Independent Curator, Artist, Professor at Dongduk Women's University

Where is fine art? At what moments does fine art move? Will the world collapse without it? What role does fine art play in this world? What does it seek? I have roamed the so-called fine art planet for 37 years, from the year I started my bachelor's degree in fine art, yet I am perplexed every time I ask myself the definition, uses, functions, roles, status, and meaning of fine art. Although I am surrounded in daily life by things related to fine art, I find moments when they feel foreign. What questions do fine artists ask themselves?

Over 100 years have passed since the "monster" called "fine art" in the Western European style landed on the Korean Peninsula. After fine art stealthily took the place of *siseohwa* (integration of poetry, calligraphy, and painting) and *dohwa* (drawing) and began to function within Korean society, it remained something akin to a UFO for some time. (Certainly, it might still be so.) The reason behind this is that although fine art's basic format of drawing or making something is similar to its traditional counterparts, fine art becomes more foreign the more one deliberates on its various aspects, including the material characteristics and limitations of its medium, the language and grammar it commands, its history, the worlds or ideologies it has faced, and religious and philosophical ideas that support it. How could fine art, which was formed against a backdrop of Western life, history, and culture, not be a monster to us? What has the monster done, and how, since entering our lives? What should we ask about fine art, of fine art, and of ourselves now, and what should we have asked in the past? Korea's modern and contemporary art history across the 20th century is, on one hand, the history of our experience of gradually becoming familiar with the monster, and on the other hand, that of the monster becoming familiar with us.

Kim Hak-lyang worked as a curator at Donga Gallery (1995-1999) and Seoul Museum of Art (2003-2006), and has taught in the Department of Curatorial Studies and Art Management at Dongduk Women's University since 2006. He majored in fine art during his undergraduate years and studied Korean modern and contemporaty art history at a graduate school. As life gets more comfortable, people become simple-minded. Artists also from day to day chatter on various theories, discourses, media, techniques, methods and styles. However, standing apart from them for delibration, the more you talk, the more empty you become. Well, what is art? There is a book titled *Aporia Called Modern Times* written by a Japanese scholar. Well, art has as many controversies as modernity. 'Aporia called art'… Over the past 100 years in our lives, what has been art that has engaged with poetry, writings and paintings (*siseowha*)? Whatever they are?

The purpose of this essay is to uncover anew several peculiar situations effectuated by fine art after siseohwa, while retracing how we neglected *siseohwa* and *dohwa*, and instead accepted and revered Western fine art over the past 100 years. Every tool, equipment, machine, and technology ultimately functions as a barometer that helps us understand our lives in each moment. This is also true of art. To the people who believe fine art to be noble and pure, I am sorry to liken fine art to a monster. However, the monster is, in fact, none other than our alter ego, our shadow, our inner self. Thus, the monstrosity of fine art is our self-portrait.

First, what is modern art? "Painting is depicting anything as it appears."[1]

This passage from a textbook published by the government during the Korean enlightenment period reflects a fundamental property of Western-style fine art, which entered our lives and replaced the sensibilities and philosophy of *siseohwa*. Anything goes; depict what you see and experience. This perhaps is the core message of the European modernity since the Renaissance about its view of the man and the world. *Siseohwa*, which centered on literary society, sought to "learn the spirit of objects with certain values and ideologies, which tie in with the tastes of men of letters, with a mind that transcends the individual, become one with the subject, then borrow its form to express the mind." In contrast, modern painting seeks to provide three-dimensional vision by reproducing man's visual experience using one-point perspective.[2] In short, to depict what one sees and feels as realistically as possible was the lesson from Europe, which built human-centered civilizations and cultures several hundred years earlier than we did.

The following is an excerpt from an article that "Chunwon" Lee Gwangsu wrote for *Maeil Sinbo* after viewing the Japanese Ministry of Culture Art Exhibition in 1916, during his studies in Tokyo. Lee suggests a direction for modern painting, "new painting," to replace *siseohwa* customs.

Comparing traditional Joseon painting and new painting, I gleaned two major differences. The first is that while the materials (subjects) of Joseon painting, which have been handed down, are narrow in scope, for example, "four friends of the scholar's studio" and "the nine-bend streams of Wuyi Mountain," in new painting, everything in the universe, and every human ordeal is a subject of painting. A scenic mountain or a small, unremarkable hill, a woman of beauty or a plain woman of humble origin, people washing clothes, students studying, children playing, a blacksmith, a charcoal burner, and a load bearer all make equally good subjects of paintings. From the perspective of the old paintings, which only pursue ideal subjects of excellence, beauty, perfection, purity, and high mind, such ordinary everyday affairs must seem meaningless. However, from the familiar nature of the vivid subject matters (materials) of real society, we feel novel pleasure. Rather than seeing "the four old men on Shang Mountain," with whom we feel no connection, we are pleased to see the state of

a farmer or artisan with whom we are familiar. I expect big changes to occur in Joseon painting in this aspect, and painters of Joseon will do themselves a favor by changing their ways, that is, choosing their subjects (materials) freely.[3]

Lee is advising artists to see, experience, and paint the world around them, with their bodies and senses, at will. When would we respond to this adjuration?

The fine art ideology that imperialists bestowed upon the colony-*jungmi* (精美; clean and pure beauty): painting like/unlike painting, modern like/unlike modern

In the 20th century, the monstrosity of fine art was plainly revealed to Korea under the Japanese occupation, when imperial Japan controlled the Joseon society through a colonial system and modern discipline. As is widely known, it was through the Joseon Art Exhibition, a public contest founded by the Japanese Government General of Korea, that fine art was established in the realm of daily life. In order to establish a cultural governance paradigm, which sought to elicit obedience without the use of force, in the field of fine art, the Japanese Government General of Korea proclaimed and informed the public of ideological conceptions about art, concepts, attitudes, methodologies, the ideal artist, and specific artistic styles through this special system of public contest (submission and screening). The head of the Education Bureau of the Government General of Korea, Shibata, confessed frankly in an interview with a newspaper reporter that the purpose of the Joseon Art Exhibition was to "purify public ideology" and "to aid the edification of society."[4] The imperialist intention to implant modern art and culture in the colony is apparent in the inclusion of the word jungmi, meaning "clean and pure beauty," hand written by the Governor General of Korea, Jiro Minami, in the Joseon Art Exhibition catalogues for the 16th exhibition in 1937 and the 19th exhibition in 1940.[5]

Within the colonial competition system, being selected was evidence of the painting having safely passed the screening process, a formality of censorship. A painting had to be of a nature that could pass the screening process before being something to be appreciated. Paintings were not transported straight from the artist's studio to the gallery but were "arranged" in the exhibition space after undergoing screening. Thus, in the exhibition space of the Joseon Art Exhibition, work was presented only if it was deemed worthy of exhibition by the colonial disciplinary power.

1. *Sinjeong simsang sohak*(Ministry of Education, 1896), in Hong Seonpyo, *Korean Modern Art History*, (Seoul: Sigongsa, 2009), 37.

2. ibid., 36.

3. Lee Gwangsu, "Mungseong Sung Art Exhibition (Part 1-3)," *Maeil Shinbo*, October 28, 31, November 2, 1916.

4. "The Purpose of Launching the Art Exhibition," *Dong-A Ilbo*, December 28, 1921. Right after the first Joseon Art Exhibition, they revealed that "after much deliberation the Japanese Government General of Korea has decided to host this exhibition in order to aid perfect guidance of cultural politics by promoting valuable art." *Maeil Sinbo*, June 6, 1922.

5. He published a calligraphic writing of the phrase "內鮮一體" (Japan-Joseon Unity) in the 1938 and 1939 catalogues.

The product of the public art contest system called the Joseon Art Exhibition displayed what the organizer of the system wanted. Therefore, the creative process and the resulting work within the system cannot be considered art. Rather than as art, they remain as traces in the history of art of a desire to be art. Within the public contest system, governed by colonialist discipline, Korean artists were unable to look squarely at the reality of colonization. Other than nominally recording evidence of visual experiences, they could hardly explore the potential of new painting.

A monster called abstractionism: What is buried under the "ruins," on which abstractionism made an emergency landing?[6]

Abstractionism was a talking point and the zeitgeist of artists in the 1950s, whether they were born during or after colonial times. The Korean War settled the "confusion" of the post-liberation period and allowed artists to "restart" from "square one" in "a blank state," though the National Exhibition, which took command of the institutional hegemony of the art world, remained unaffected. To Korean art, which had been abandoned in the ruins like an orphan after colonization, military rule, the division of the country, and war, abstractionism represented modernity itself, an ideal that Korean art would do everything to reach.[7] Lee Kyungsung argued that radical figurative art, such as abstract painting and abstract sculpture, was the new art that contemporary people wanted desperately, and providing it was the most urgent task that Korean art faced.[8] Under such circumstances, questioning the clear goal and ideal of abstractionism was risky. As soon as the question was posed, it was met with a hostile response-*Aren't you moving into modern times?*

Why was the 1950s so excited about abstractionism? According to Kim Byungki, artists were motivated "to sever ties with the real world and open their windows to the phantasmal." They sought to sever ties with the real world and explore the pure and fundamental reality of humanity's inner world.[9] If this is so, what is the goal of abstractionism? Kim Byungki believed it to be, "directly facing the eternal and rigorous reality that mankind acquires by breaking away from the phenomenal world."[10] According to Kim, composition refers to "determining space" and "organizing the painting surface," "using pure form and color that emerges from the inner reality." Composition is the "only element that can imbue abstract painting with life."[11]

6. This section contains summarized excerpts from the following publication: Kim, Hak Lyang, "What is Abstraction to the Artists of the Colonial Period?" Proceedings of the Symposium in Honor of the 100th Anniversary of Han Mook (Seoul: Seoul Museum of Art and Association of Korean Modern & Contemporary Art History, 2019).

7. Lee Kyungsung, "Korean Eastern Paintings of the 1950s," *Contemporary Korean Art-1950s (Eastern Paintings)*, (National Museum of Contemporary Art, 1980), 181, republished in Lee Kyungsung, *Understanding Contemporary Art* (Art Knowledge, 1989), 82-94.

8. Lee Kyungsung, "Recent Art Trend-Exploration of New Beauty," *Yonhap Shinmun*, December 14, 1953, quoted in Choi Yeol, 306. He also argued that at a time when Korean art could not escape criticism for being underdeveloped due to "Eastern identity" and "shortage of modernity," artists had a duty to work toward "rationalization, modernization, and globalization." Lee Kyungsung, "Cross-section of Beauty," *Sincheonji*, September 1954.

What we meet in the abstract space woven through the act of composition is the "eternal and rigorous reality that mankind acquires by breaking away from the phenomenal world," as described by Kim Byungki. Han Mook published a piece of writing that corresponds to Kim Byungki's concept of "eternal and rigorous reality." He wrote that while early Western abstract painting sought purity of form, abstract painting after the Second World War explored a mysterious abstract world that transcends the dimensions of the visual world, that such a phenomenon could simultaneously be a show of "the human mind's resistance to the mechanization of mankind" and "an admiration for the Eastern mind."

> While the expression of Western abstract painting originally sought to extract form and color from an internal exploration of material structure, that of the East sought to break away from what is and to suggest the mental state of nothingness, in other words, to use all experiences accumulated up to the present to extract the form that arises naturally (abstraction). It is a method of escaping material to suggest material. This indicates that contemporary painting moved from the visible world to the invisible world, where it explores higher meaning.[12]

However, when we accepted and held the mirror of abstractionism, which is considered the peak of the history of Western formalism and modernism, all we saw reflected in it was "I," who appeared very weary.

> Kicking away all rationalistic farce in the perfectionist intellectual system, which was established only yesterday, we resolved to restart in a world where the will to live is derived from and controlled by "I." ... seeing world domination by pioneering the "I," who is overflowing with inspiration.[13]

Here is a self-portrait of the discourse of the 1950s, which is turning its back toward the world, looking into a dusty mirror, and stroking its own blurry image with compassionate eyes. To whom do the "perfectionist intellectual system" and the resulting "rationalistic farce" belong? Did these words come out of the bodies that were abandoned in the ruins after experiencing colonial cultural policies and Japanese orientalism, neocolonial cultural policies of the US military government, the division of the country, and the Korean War over half a century after they accepted fine art?

Looking back calmly, during the post-colonial period, from liberation through the 1950s, should we not have concentrated on understanding and reappraising colonial modernity and the colonial legacy in institutions, discourses, and practices,

9. Kim Byungki, ibid.

10. ibid.

11. Kim Byungki, ibid.

12. Han Mook, "The Issues of Contemporary Painting-Characteristics and Directions," quoted in *Sinmisul 2* (1956); Choi Youl, ibid., 414.

13. *Invitational Contemporary Art Exhibition*, "The First Declaration," 1959, quoted in Kim Yunsu, *History of Contemporary Korean Painting*, Seoul: *Hankuk Ilbo*, 1975, 203-204.

and then asked ourselves how to dismantle and overcome them, with at least as much passion as we devoted to abstractionism? Raising our voices and crying desperately for modernity and abstractionism,[14] while glossing over the problem at hand, seems pathetic and empty. However, this is less an individual choice of aesthetics than the shadow of a collective desire that entwined the postwar Cold War system. As the country underwent US military rule, the division of the country, and the Korean War, the so-called "impurities" that was the left wing were thoroughly eliminated. While the country was in ruins and a blank state, "modernity" appeared in the art world in the guise of "truth," though it is unclear whose gift it was. Unfortunately, this was after numerous proposals and methodologies to expunge the colonial legacy, which poured out of dynamic discussions during the post-liberation period, had been "purged," as the Cold War system was firmly established through the US military rule, the division of the country, and the Korean War. The post-liberation period was a stage for political struggle, with one side seeking to restore autonomy, which had been gravely damaged by imperialist cultural rule, and the other seeking to obstruct that desperate movement from the position of the new occupying forces/ruling class. For this reason, the experience of colonization must crucially be deliberated on in order to cultivate a post-colonial space. Rather than a vestige that must be disposed of hastily, it is a wound (trauma) that we must meditate on gravely.[15]

From this point of view, the US military government, which emerged in the post-liberation period as a new occupying power, was a neocolonialist disciplinary power that politicized nationalist desires, either suppressing and eliminating them or directing them as it desired. The post-liberation period was a ground on which two systems, liberation and occupation, and their respective plans, collided. As a result of this collision, many artists who rejected the system defected to North Korea or fled and sought asylum overseas, and the space for abstractionism finally opened up, with the postwar Cold War system setting in and the influence of the postwar existentialism of the West reaching Korea. In short, abstractionism is the result of a failure to ruminate over and dismantle the experiences and vestiges of colonialism, under the governments of the US military and Rhee Syngman, which distorted the

14. About this issue, the attitude and achievements of Lee Ungno after liberation are notable. Kim Hak-Iyang, "Lee Ungno after Liberation (1945-1950s): Post-colonial Modernity of Drawing from Life and *Ji-pil-muk* (paper, brush, and ink)," *Misulsahakbo* (Korean Bulletin of Art History) 44 (2015), 43-64. While abstractionism avoided contact with the skulls, rags, and all kinds of shredded objects and beings scattered all over the ruins and was preoccupied on one hand with only oneself, freedom, individuality, and life, and on the other hand with anti-communism, nation, people, and identity, what we abandoned was perhaps our sorrowful lives, a vivid death.

15. According to Leela Gandhi, postcolonial remembrance is the act of putting the pieces of one's past back together, while enduring the pain of remembering, in order to understand one's trauma. Leela Gandhi, *Postcolonial Theory: A Critical Introduction*, trans. Lee Young wook, Paju: Hyunsil Book, 2000, 23. This problem is linked to the issue of who should remember/forget colonial experiences and legacies, how and why. It is also linked to specific trends and resources in art history, and the forces that manage and control discourses.

various desires and visions that poured out of the post-liberation period by the light of the rules of the Cold War system.

The monster called *hangukhwa*: the politics of loss and longing

The term *hangukhwa* (Korean painting) is not a common designation for all paintings of Korea. It refers to the concept that replaced *dongyanghwa* (Eastern painting).[16] It is common knowledge that the term Eastern painting was used officially to refer to a concept that counters Western painting, to a genre of painting, for over sixty years, from the time it was institutionalized through the ideologies of the cultural policies of the Japanese Government General of Korea and the system and aesthetic paradigm of the Joseon Art Exhibition, until its near-identical successor, the Korean Art Exhibition, closed after its final (30th) exhibition in 1981. People criticized, "Using the term Eastern painting is denying our people's distinctive characteristics. The expression is one of disregard and contempt."[17] Reflecting the grim resolve to recover the identity of Korea's painting, which was on the verge of disappearing under the umbrella of the colonial concept of Eastern painting, the term Korean painting emerged.[18]

"From the late 1950s to the early 1960s, as artists experimented energetically with Eastern painting," they called in unison for Korean painting "as a product of an experimental drive," and they performed a wide range of experiments with form in order to attain the "stylistic requirements of Korean painting."[19] In this process, artists maintained pride in *ji-pil-muk* (paper, brush, and ink) as an extremely "spiritual" medium with the legitimacy of an art form that represents the Korean people, while making consistent attempts to expand on the traditional techniques of paper, brush, and ink. However, looking closely at this process, as exemplified by the *sumuk* (ink and wash painting) movement, which showed off the collective identity of Korean artists and became widespread in the 1980s, artists were mindlessly repeating the rhetoric of the idealism of paper, brush, and ink, which adapted the literary ideologies of the Chinese painting of the past, even as they experimented aggressively with new styles of paper, brush, and ink. The following passage

16. Pioneering arguments on this issue include the following two articles by Kim Cheong-gang (Kim Youngki): "Korean Painting Rather than Eastern Painting-A Call to Establish a New Tradition of the Nation's Painting (Part 1-2)," *Kyunghyang Shinmun*, February 20-21, 1959.

17. Kim Cheong-gang, ibid.

18. The Grand Art Exhibition of Korea, which launched in 1982, adopted the term *Korean painting* in place of *Eastern painting*. In the art textbooks revised in 1983, the term *Eastern painting is replaced with Korean painting*. Many young, unestablished artists at the time adopted the term. At the same time, as exemplified by the writing by Song Sunam, "Setting the Direction of Ink and Wash Experimentation" (*Space*, Sept. 1983, 83-85), these artists distinguished themselves from the "Eastern painting generations," even perceiving themselves as some kind of radical artists.

19. Oh Kwangsu, "Is Korean Painting Possible?," *Space*, May, 1974, 8.

dramatically illustrates how the generation at the forefront of the Korean painting "movement" perceived paper, brush, and ink.

> The world of ink and wash painting on mulberry paper is profound. Each point and each stroke contain the heart that paints the falling flower and the crowing chicken. The ink expresses the fundamental principles of the birth and death of all things. Ink painting embraces this Eastern, therefore Korean, view of nature and the world. Ink painting is valuable as a spiritual world that can heal the wounds of a contemporary society born of material civilization, and as a figurative language. The subtle power felt in Namcheon's ink and wash paintings carries within it our spirit, and our energy that seeks to overcome Western material civilization. This spirit can be unified into a life of restraining from desires and becoming one with nature.[20]

In this way, discourses on Korean painting depended on a dualist formula, i.e. traditional-modern, Eastern-Western, past-present, mind-matter (body), natural-artificial (man-made), viewing the former way to be right, and the latter as a force that ruins the former. This attitude was an extension of the "preference for the old ways, seeking the ideal world in the East of the past," which was prevalent in the discourses of Asia-centrism in the 1930s.[21] Artists were generally under the influence of these ideas, and alternative routes and methodologies to make traditions current were practically off limits. Early on, during the post-liberation period, Yoon Hui-sun advised that artists should "stay away from robotic imitation" and explore and review the classics with a "critical eye founded on the historicity of reality." She warned, "Only sentimental moaning and imitation can come of idolizing classics with simple reactionism, thus making them objects of nostalgic reminiscence. This is no better than a love of curios." However, most artists and art institutions disagreed.[22]

Korean painting and its discourses suffered greatly from a sense of loss and longing, as if they had been afflicted with some kind of fever. That sense of loss and longing was great enough to erase the present. The object of this sense of loss and longing was the past, or traces of the past. It seems that people who justified Korean painting considered the past and traditions to be "innocent primitive." To them, the past and traditions represented an untainted, pure place, an aesthetic utopia to which they ultimately had to return. The present had been corrupted, and in order to cure the signs and symptoms of illness that the hideous present possessed, they had to refer endlessly to the primitive innocence of the past. The present was

20. This quote is from an advertisement for Song Sunam's art book, published in an art journal in the late 1990s. While the author is anonymous, this passage clearly reflects how discourses on Korean painting in the twentieth century perceived East-West, traditional-modern, and past-present as dichotomies.

21. Kim Hyunsuk, "Modernist art and Asia-centrism," quoted in *100 Years of Korean Art*, vol. 1, by Kim Yunsu et al., edited by National Museum of Contemporary Art, Korea, Paju: Hangilsa, 2006, 259.

22. Yun Heesun, "The Practical Meaning of Classical Art," *Kyunghyang Shinmun*, December 5, 1946.

a debauchee that had run away from the past. In short, the discourses of Korean painting did not seek to simply commemorate the past-and the East, tradition, nature, and spiritual expression-but to "recover" it. In other words, they repeatedly redefined and monopolized fundamental principles, central concepts, and truths (or what was considered truth) that had been determined intuitively, which is typical of politics and metaphysical philosophy.

Another monster, *minjung* art

From the end of the Joseon Art Exhibition until the 1980s, the de facto driving force of Korean art was a "fine art system"[23] that observed the doctrine of purism and aestheticism, and all rules observed by artistic processes, theories, and histories were based on Western modern art history.[24] *Minjung* art was the monster that emerged to challenge this trend squarely. *Minjung* art and artists sought to connect with specific contexts of reality/world to redefine their roles and meaning. After the discourses of abstractionism and *informel* in the 1950s, the so-called modernists separated themselves from the world, or soared to heights out of reach from the breath of the earth, asserting a modernity that was as mutable as the drifting clouds, while overusing the transcendental rhetoric of mystery and magic. Possibly for the first time in art history after *siseohwa*, *minjung* art saw, touched, searched, felt, read, dug, and poked at the truth of the living world and people's lives–and society and history–and asked endless questions while examining its own position and function.[25] In short, *minjung* art was a cultural movement that sought to rectify the fine art (*jungmi*) paradigm, which began with colonial modernism, and normalize the relationship between life and art.

As I pointed out earlier in the discussion on abstractionism, while going through military rule, the division of the country, war, and the neocolonialism of the Cold War system, when the ways of doing away with the colonial legacy were blocked, a new, independent, non-Western nation had little room to maneuver, leaving an embarrassing combination of worldliness and internationalism with conservative nationalism and traditionalism as the only option. Nevertheless, it is extremely regrettable that what Lee Ungno achieved through a decade of hard work after liberation, as described below, was not picked up by artists for 30 years, until Hwang Jaehyeong and *Dureong* appeared on the scene.

23. Lee Young wook, "100 Years of Fine Art, the Topic of Postcolonialism," *Wolgan Misul*(Monthly Art), December 1999.

24. Shin Jiyoung, "Why Do We Have No 'Great' Woman Artists?: The Establishment of 'Koreanness' and the Masculinity of 'Korean' Abstractionism," *Journal of History of Modern Art* 17 (2005): 69-103.

The people that Lee Ungno depicted in the styles of genre painting and figure painting are people whose livelihood depended on manual labor. They are completely outside of the contemplative frame and institutionalized definition of figure painting–othering the subjects and turning them into a spectacle; placing features in certain types of clothes in certain poses along with objects that evoke the past in spaces resembling a theatre stage, using them as a prop, etc.–as prescribed by the government-controlled public contests of the Joseon Art Exhibition and the National Art Exhibition. Lee Ungno's figures are not "models," but people who are doing their work in specific places. They are not depicted in an artistic, theatrical scene "designed" for aesthetic contemplation, but in their living environment where they engage in arduous labor [...] Lee Ungno defines the devastating deprivation and poverty of the 1950s through a heavy yet cheerful "*golbeop* (Kim Young-ju)," a brush technique for depicting structure. Lee's images are cheerful to the point of clashing with the times, and even humorous on occasions.[26]

From a macroscopic view of 100 years of art since *seohwa*, *minjung* art tackled the age-old challenge of addressing the entire modern era, which had been deferred constantly, and reached much further than the specific cultural and political context of the 1980s.[27] Firstly, this signifies that the artist completely shed the appearance of superficial modernity (colonial modernity based on the tourist gaze of the colonizer), which acted throughout the era of the Joseon Art Exhibition as a proxy for producing a colonial archive, and finally came to taste the vibrant enthrallment

25. "Looking back, existing art, whether conservative and time-honored, or radical and experimental, has flattered the snobbish tastes of leisured classes, blocked out the outside world from art spaces, and insisted on highbrow idealistic amusement, thereby alienating and secluding the reality of their true selves and their neighbors, and worse, failed to even discover the inner truth of the isolated individuals." *Reality and Utterance Inaugural Declaration*, 1979. "Looking back, institutional art has avoided the awareness of a life of intense segmentation, conflict, and contradiction, which is essential within the reality of our divided country. Rather, it functioned to hinder all serious efforts to liberate self-awareness. . . . In this way, institutional art separated true life and artistic functions, maximizing isolation and severing acceptance. Castrating criticism from the process of beautifying reality, it was busy constructing a framework of self-protection through the logic of every kind of formal aesthetic, including purism, aestheticism, art-for-art principle, and modernism." Inaugural Declaration of the *Minjok* Art Association, 1985.

26. Kim Hak-lyang, "Ungno Lee after Liberation (1945-1950s): Post-colonial Modernity of Drawing from Life and *Ji-pil-muk* (paper, brush, and ink)," *Misulsahakbo* (Korean Bulletin of Art History) 44 (2015): 247-270.

27. In Korea's modern history, modernity in the art sector, whether it is through a foreign medium such as oil painting or a familiar medium such as ink and wash, can perhaps be finally achieved when we can give it a definitive shape after soaking it fully in our lives. Modernity is not achieved through absolute ideology or transcendental metaphysics but is in fact a process of establishing the backbone of a culture wherein individuals and communities become the masters of their own lives and honorably observe, record, and express themselves. In the case of Korean art, however, this process has constantly been overpowered by different monsters, such as the ideologies of *siseohwa* and ink and wash painting, and the art-for-art principle called upon by the fine art system that came after the public contest system of art under colonial rule.

of fully soaking the body–the artist's body and his senses–in the everyday ordeals of the mundane world. *Beggar* (1948) by Lee Qoede from the post-liberation period, scenes of crowds on streets and on battlefields depicted by Lee Ungno from liberation to the mid-1950s, and the rare type of realism demonstrated during the Korean War by Lee Ungno, Lee Soo-auck, and Lee Cheul-yi were edged out by postwar contemporary trends, or the fever for abstractionism. This demonstrates how little room there existed to calmly map out postcolonial modernity.

Minjung art accepted everything that was eliminated by the colonial system and the fine art system as subjects of art. These included the lives and the scenes of minorities and the weak, regional contexts and communities (e.g. farm villages, factories, and colleges), popular culture, tradition, capitalism, and even state authority. Artists paid attention to the forces that compose reality and the shadows cast by them. Through discovery and utilization of an abundance of old and new cultural resources from the East and the West, which contributed to contemplation and criticism of reality, *minjung* artists made a concerted effort to renew Korean life and art in the context of global art history. People affiliated with modernism mocked *minjung* art, questioning its worthiness for appreciation from the point of view of purity and art for art's sake. Nevertheless, *Minjung* art served as the foundation for new generations of artists who emerged during and after the 1990s and paved the way for them to blaze a new path, relatively free of the ghost of modernity and the traumas of the late modern era.

Nearly 100 years after the monster of fine art entered our lives, we finally came to heal from the trauma of colonial modernity, to a degree, through the critical mind and practices of *minjung* art. The method used by *minjung* art is, in a way, disappointingly simple: remaining close to reality. After *minjung* art shamed the monsters of colonial modernity and colonial legacy in art and culture, to some degree, since the 1990s, have other monsters appeared in the contemporary art scene? If the monsters were related to the phantom and trauma of the late modern era up until the 1980s, to search for monsters among contemporary art, we must ask more fundamental questions surrounding the institution of fine art. Is the field of fine art itself possibly a monster? For whom does fine art exist? If fine art is truly relevant and related to us, what is it doing now, where, how, and why?

5. Blue Desert

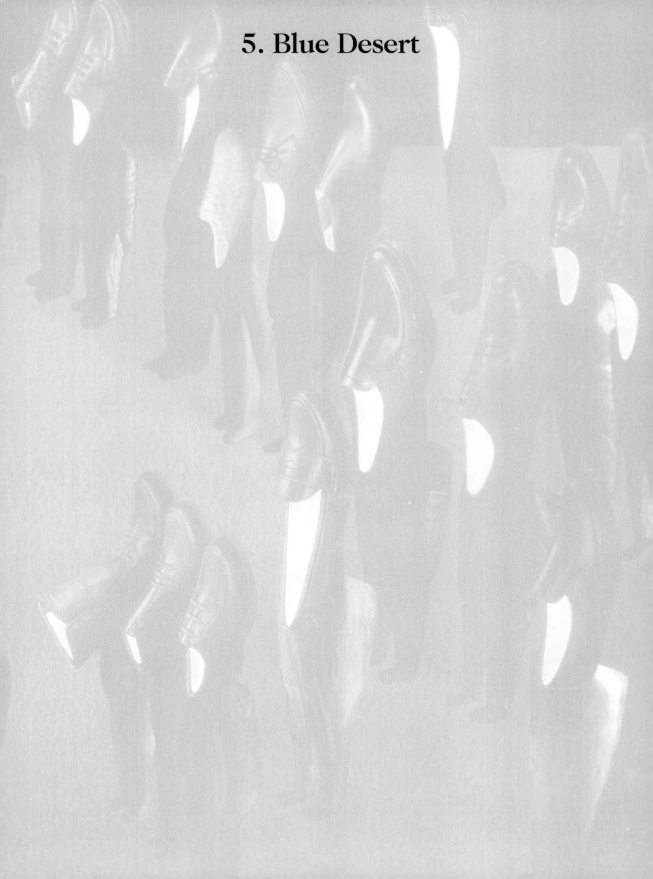

Lee Bul, *Cyborg W5*,
1999, Painting on plastic, 150 × 55 × 90 ㎝. MMCA collection.

ium, *The Highway*,
1997, Single-channel video, color, sound, 8min. 46sec. MMCA collection.

Mlnouk Llm, *New Town Ghost*,
2005, Single-channel video, color, sound, 10min. 59sec. MMCA collection.

Nikki S. Lee, *The Hip Hop project 1*,
2001, Digital C print, 74.8 × 100.2 ㎝. MMCA collection.

Hong Kyoung Tack, *Funkchestra(Funk+Orchestra)*,
2001-2005, Oil and acrylic on canvas, 130 × 163 ㎝ (12). MMCA collection.

Lee Sunmin, *Sang-yeop and Han-sol*,
2008/2012, Inkjet print, 118 × 143.5 ㎝. MMCA collection.

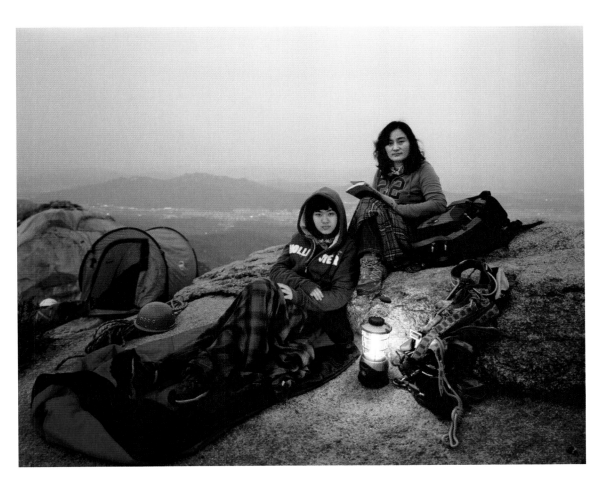

Lee Sunmin, *Su-jeong and Ji-yeong*,
2008/2012, Inkjet print, 118 × 143.5 ㎝. MMCA collection.

Donghyun Son, *Logotype CocaCola*,
2006, Color on paper, 130 × 162 ㎝ (2). MMCA collection.

Lee Dongi, *Atomouse eating noodles*,
2003, Acrylic on canvas, 130 × 160 ㎝. MMCA collection.

Lee Manik, *The Han River Boat Parade*,
1989, Silkscreen, 45 × 65.4 ㎝. MMCA collection.

Lee Manik, *Farewell*,
1989, Silkscreen, 45 × 65.4 ㎝. MMCA collection.

Kim Ki-Chan, *Jungrimdong, Seoul, November. 1988*,
1988, Gelatin silver print, 27.9 × 35.6 ㎝. MMCA collection.

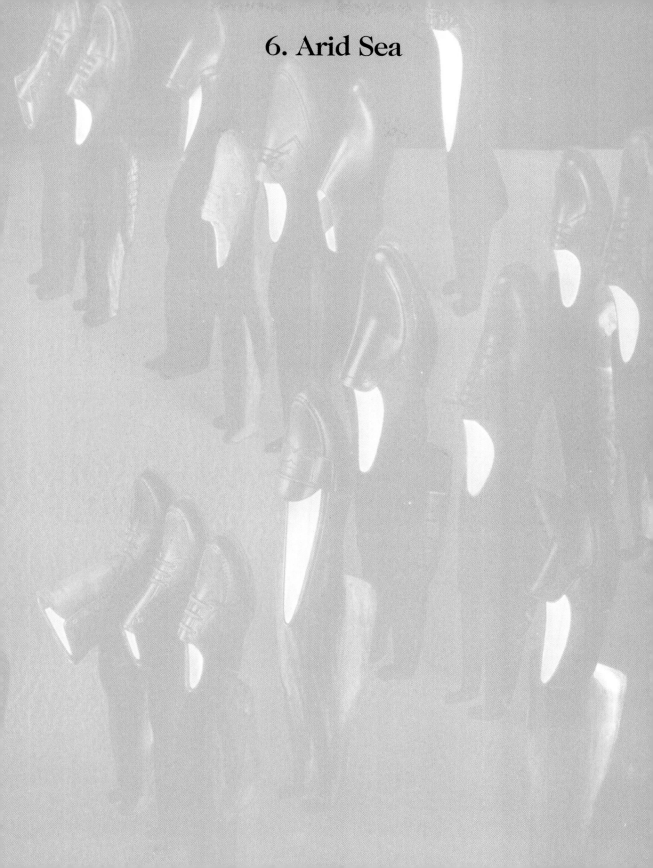

6. Arid Sea

Kang Hong-goo, *Greenbelt - A Virtuous Man Watching Water*,
1999-2000, Digital print (Dust Lamda 130 laser print), 80 × 251 ㎝. MMCA collection.

Kang Hong-goo, *Greenbelt - Sehando*,
2000-2002, Digital print (Dust Lamda 130 laser print), 80 × 220 cm, MMCA collection.

Yoo Geun-Taek, *Long Fence*,
2000, Ink on paper, 162 × 130 ㎝ (4). MMCA collection.

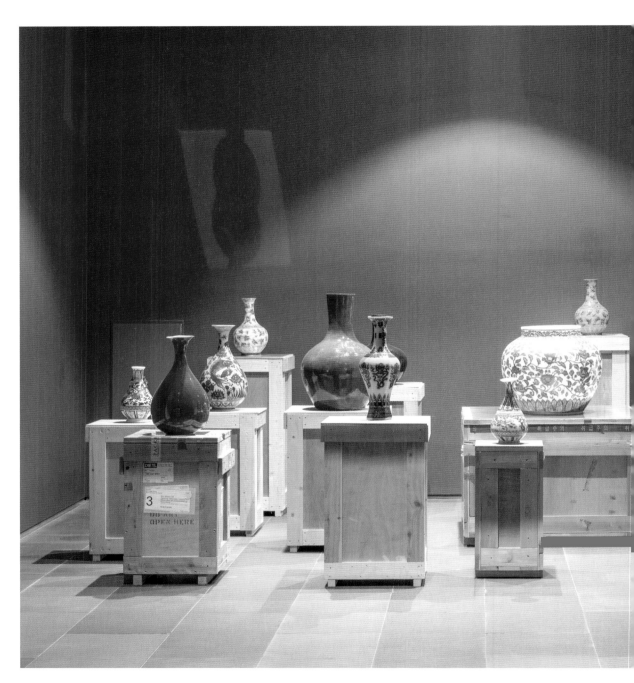

Meekyoung Shin, *Translation Series*,
2006-2013, Soap, 36.5 × 21.5 × 21.5, 56 × 21 × 21, 57 × 29.5 × 30, 69 × 48 × 48, 54 × 30.5 × 30.5, 54 × 31 × 31, 55 × 61 × 61, 39 × 23 × 23,
30 × 16 × 16, 55 × 30 × 30, 52.5 × 29 × 29, 32 × 19 × 19, 84.5 × 34 × 34, 48 × 36 × 36, 42 × 40 × 40, 39.5 × 24 × 24 ㎝. MMCA collection.

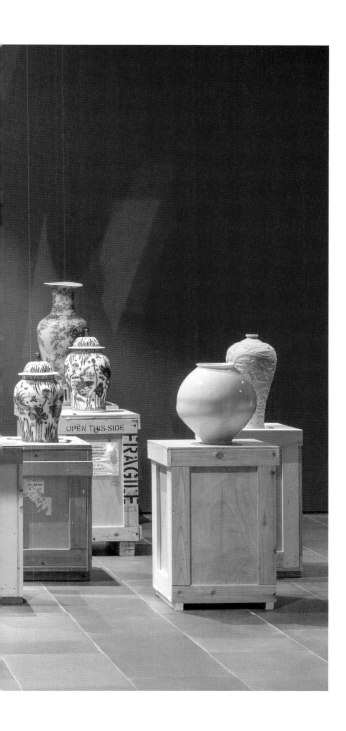

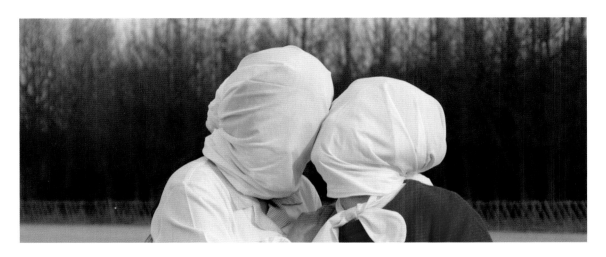

Im Heung-soon, *Factory Complex*,
2014, HD video, inkjet print, Single-channel video, 95min. photo 41 × 100 ㎝. MMCA collection.

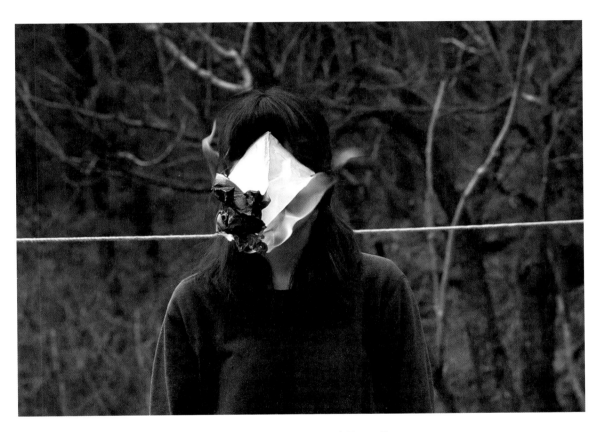

Sung Hwan Kim (in musical collaboration with David Michael DiGregorio a.k.a. dogr), *Temper Clay*,
2012, Single-channel video, color, sound, 23min. 41sec. MMCA collection.

Do Ho Suh, *Floor*,
1997-2000, PVC, glass plate, phenolic sheets, polyurethane resin, 8 × 100 × 100 ㎝ (8). MMCA collection.

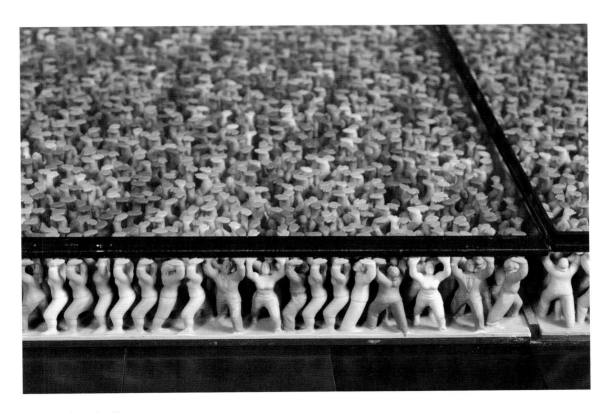

Do Ho Suh, *Floor*, Detail image.

Applied Art: The Zone of Criticism Sparked by Craft, Design, and Architecture

Chung Dahyoung, Lee Hyunju, Yoon Sorim
Curators, National Museum of Modern and Contemporary Art, Korea

Within the institution of a museum, craft, design, and architecture are constantly challenged on their artistic value. People question whether works that fall under these categories have "obtained value as autonomous works of art." At MMCA, the discussion of these genres, grouped under the category of applied art, has widened in scope, regarding them primarily as media that epitomize various changes in society rather than ones of pure artistic value.[1] For this reason, works in these fields have not been easily incorporated into the museum's collection, but they have paradoxically bridged art and society. For *The Square: Art and Society in Korea 1900-2019 Part II. 1950-2019*, which will be held at MMCA Gwacheon as a part of *The Square: Art and Society in Korea 1900-2019*, we have put together works that are at the intersection of art and society in the name of craft, design, and architecture. These works have adopted elements of art in the traditional sense, remained parallel to art, and advanced in the opposite direction from art. Today, as the field of visual arts and the institutional space of the museum have left the disciplines of the past and are interpreted anew, craft, design, and architecture, which are positioned in the complex network of the state and industries, pose important topics for discussion. This article attempts to expose the fragmentary clues that generate such discussions. The purpose of this article is to cursorily explore the zone of criticism sparked by the applied arts division of the museum, through documents presented in the exhibition and episodes in each field that are connected to the works. This exhibition will prompt us to imagine stories together as we consider the next 50 years of the MMCA.

1. MMCA currently operates four research divisions. These divisions are not part of the official organization, but they are intended to aid comprehensive curatorial duties related to collection, exhibition planning, and research. At present, the divisions are Modern Art, Sculpture/Painting, Media/Performance/Photography, and Applied Art (Craft, Design, and Architecture).

Brand image of Korea sculpted by tradition

After the Korean War, which broke out in 1950, Korean society sought progress and development, while calling for a return to traditional Korean culture, which was cut off under Japanese rule. This was key to establishing an identity as an independent nation and to increasing Korea's international presence. Celadon, white porcelain, cloisonné, mulberry paper, and *bojagi* (wrapping cloth) are examples of household objects from the past that exist today as paragons of traditional culture. Architecture played a role as a bridge to and a driving force of social development, and design demonstrated the industrial development of Korea through commodities. On the other hand, craft was a medium that symbolized tradition and the continuation of history, which the rapidly developing Korean society could not protect.

Craft from the 1970s can be explained by two phenomena regarding traditional crafts. First is the phenomenon of summoning traditional crafts in the field of fine art. Craftworks from the Joseon Dynasty in the enlightenment period became motifs that aroused creative desires for modern Korean artists. In particular, the "elegance" and "nonchalant beauty" of Joseon ceramics, as defined by modern Korean art historians, reminded many artists, including Kim Whanki and Kim Kichang, of the sentiments and aesthetics unique to Korea. The trend traces back to the *Drawing on Ceramics Exhibitions*, organized by Choi Sunu, director of the National Museum of Korea, and Lee Kyungsung, director of the MMCA. Through such opportunities, drawing on ceramics remained popular for about a decade from the late 1970s into the 1980s. During this time, artists and ceramicists collaborated, with the ceramists making bodies of white porcelains and Buncheong-ware and the painters drawing or painting on them. For example, Chang Uc-chin, Yoo Young-Kuk, and other modern artists who mainly worked in oil painting collaborated with such ceramic artists as Shin Sangho and Yoon Kwangcho on drawing works. These collaborative efforts provided opportunities to contemplate Korean beauty through the lens of painterly abstraction.

The second phenomenon is the neglect of traditions resulting from the clash between industrial development and nonindustrial folk lifestyles. Amid high economic growth, manual industry no longer had grounds for existence. *Onggi*, cloisonné, and brassware factories faced challenges in securing production efficiency and capital power to keep up with urbanization and industrialization. Beginning in the 1970s, manual industry communities centering on folk artisans disappeared altogether. Consequently, factories that supplied tableware, jars, and other handcrafted household objects were pushed out of city centers by high–density residential spaces such as low and high–rise apartment buildings. As refrigerators, washing machines, and other household appliances spread and changed lifestyles, people began to choose household products that matched their material abundance. As a result, folk crafts began to disappear from life, as shown in scenes from Marty Gross's documentary, and were positioned in the collective memory as objects that symbolized tradition.

From the 1980s through the 2000s, college-educated, artistic craftspeople appeared in large numbers, and contemporary craft found its place in art institutions. The inclusion of craftworks in the MMCA collection started with the point of view that craft is a branch of art. By involving art, the "artistic craftsperson" became a new passageway through which tradition is interpreted and material relationships are explored, according to individual capabilities. On the other hand, craftspeople who inherited traditional craft techniques through the apprentice system testify to the beauty and legitimacy of Korean craft as transmitted from generation to generation. The Intangible Cultural Asset and *Myeongjang* (master artist) designations by the Cultural Heritage Administration have given institutional support to elevating traditional crafts that represent the national image.

Since 2010, craft as experienced by individuals has expanded its realm, building on the various approaches that manifest in either tradition or the field of fine art. Within various aspects of life, including dining, hobbies, and interior spaces, craft activities can be individual or communal. "Making as healing" activities by Weaving Life Weaving Nature, local charity hat knitting projects, and the campaign for proper use of chopsticks are examples of craft playing an intermediary role, triggering actions to share culture. Korean society is shedding the notion that craft is symbolic of the nation's traditional image and moving toward "craft as a process," as suggested by Glenn Adamson. However, this does not mean that craft is completely abandoning tradition. In Korean society, "craft as a process" views tradition not as an end-product, but as an attitude that reflects the spirit and style of traditional culture that has culminated in the present. This attitude is expressed when the focus extends beyond the individual to the community.

The call of the state: desires of the private chamber

In the 1960s, the Korean government realized the importance of promoting design as part of its modernization policy. After liberation, Korean society moved away from the influence of the crafts division of the National Art Exhibition (National Exhibition), and Korea's first design exhibition was launched in 1966. The Korean Commercial and Industrial Arts Exhibition (KCIAE) allowed Korean design to acquire an institutional framework. While the Rhee Syngman administration hosted the National Exhibition as an art promotion measure, to "develop and enhance Korean art," KCIAE was an event held to fulfill the national task of art export. At a time when economic development, industrialization, and national development and growth were considered the only worthy goals, and as the nation cried for modernization, designers responded to the demands of the times and performed their tasks faithfully. The state-led goal of increasing exports through design generated an unwholesome trend of increasing product value through sophisticated "packaging" that tempted the buyers, which people equated with good design.

In this context, architecture served as the largest and most visible political executive tool. With the goal of everyone "eating well and living well" together,

urban redevelopment and demolition perpetuated, and in the process, much was carelessly destroyed and sacrificed. Behind the state slogan of "Let us fight and build," critical practices were not completely absent. Architects and artists did not respond one-dimensionally to the calls of the state. For example, young architects under the Korea Engineering Consultants Corporation (KECC), a national consultancy for which architect Kim Swoo Geun served as the second director under the Park Chunghee administration, completed key projects such as the Gyeongbu Expressway, the Bomun Tourist Complex, the Yeouido Master Plan, Sewoon Plaza, and the Korean Trade Fair. The architects utilized these projects as a strategic platform for futuristic urban experiments. At that time, the state was about the only avenue through which contemporary urban experiments were possible.

The 1960s and 1970s was a period when industrial design appeared and developed in earnest. In 1958, the Goldstar Company (now LG Electronics) hired Park Yonggwi as Korea's first in-house designer and created an industrial design department. Other companies, including Samsung and Taihan Electric Wire Company, followed suit, hiring designers and expanding departments specializing in design. The first domestically produced radio, the A-501 (1959); the first black-and-white television, the VD-191 (1966); electric fans; refrigerators; washing machines; and various other products transformed residential culture and the everyday landscape. Meanwhile, the government that seized power through the May 16 military coup adopted the radio as a key implement of control, distributing radios for enlightenment and propaganda in rural communities. Also, amid competition with North Korea, the South Korean government led the establishment of national television stations, founding Seoul Television (KBS-TV) in 1961 and the Munhwa Broadcasting Corporation (MBC-TV) in 1969. Radio and television caused a big stir in leisure and consumer culture. Rapid industrial development and the spread of mass media acted as major mechanisms that reshaped everyday sensibilities, while stimulating community-oriented self-consciousness and popular culture.

Meanwhile, Mapo Apartments, Korea's first apartment complex, and Hangang Mansion, which introduced the modern concept of the residential complex, were constructed in the 1960s. In the 1970s, the Yeouido, Banpo, and Jamsil apartment complexes were built, transforming the urban landscape as well as individual lifestyles. Private cars, which were the dream of the urban middle class, appeared during this period. In its early years, the Hyundai Motor Company, founded in 1967, manufactured the Ford Cortina through assembly production. Hyundai began producing its own models in 1975 with the Pony, and the automobile manufacturing industry led the growth of the export-centered economy. As producers of consumer goods began to adopt corporate identity (CI) designs, which appeared on large street signs and in newspapers and television ads, the expressions of objects around the house and the overall visual culture changed significantly. It was during this period that the familiar logos of many companies, including Oriental Brewery (OB), Cheil Jedang, Cheil Industries, and Shinsegae Company, were developed and put into use. In Design by Cho Young Jae: DECOMAS, an exhibition held in the Shinsegae Gallery in 1976, the design process and examples were presented to educate

corporate workers and the public about the concept of CI. This exhibition spurred the CI development boom among domestic companies.

A wide range of magazines appeared one after another, offering a space for critical discourse that could not be had out in the open. *Space* and *Quarterly Changbi* were launched in 1966; Literature and Intelligence was launched in 1970; Design and *Art Quarterly* (now *Monthly Art*) were launched in 1976; and *Ggumim* was launched in 1977. Amid the domination and control of nationalism, cultural criticism expanded, reflecting the times, shaking absolute norms, and crossing boundaries between genres. In particular, *Deep-rooted Tree*, published by Han Changgi in 1976, garnered much attention for its content, design, attitude, and format. Introducing logical yet sensual editorial design, which included horizontal printing of *hangeul*, a grid system, cover photos, and layout design, art director Lee Sangcheol led qualitative enhancement of the magazine format. Unfortunately, the new military regime's media consolidation policy forced the discontinuation of 172 periodicals in 1980, a fate that did not spare *Deep-rooted Tree*.

Separation from the state, fragmentation of the public square

As we have seen, state, design, and architecture are in a very close and complex relationship. Each continued to influence one another even after the 1980s, as urban development plateaued. As the nation and corporations continued their rapid growth, the design field and designers enjoyed a boom, being recognized for their expertise and importance. The 1986 Asian Games and the 1988 Seoul Olympics were occasions for a complete overhaul of the national infrastructure. These were the largest international events that the country had hosted since its foundation, and they were broadcast throughout the world. All fields of art and culture, including design and architecture, collaborated on every part of these international events. During this time, design and architecture grew rapidly, much better answering the call of their client, the state, than did traditional fine art. In June of 1982, a design committee was installed under the organizing committee of the Seoul Olympic Games. Architecture and environmental design work went into stadiums and public facilities, and design work went into every semiotic system, street furniture, poster, pictogram, uniform, and souvenir, spurring the enhancement and expansion of Korean design. Tasked with quickly finding ways to "show Korea to the world," the design community chose a method of creating images of Korea based on traditional motifs that embody national identity. Through national-scale promotion and distribution, the resulting icons were engraved as images symbolic of Korea throughout the world as well as among Koreans. *Hodori*, designed by Kim Hyun and whose name was chosen through a public contest, was loved as the nation's first mascot. Critics of the widespread mantra "what is the most uniquely Korean is the most universally global" argued that the idea that reflecting national sentiments is the only way to distinguish one culture from another caused the stagnation of tradition.

Many of the buildings in Jamsil constructed for the Olympics and the design content found inside and outside of those buildings are good examples of the practical aspects of industrial and cultural design and architecture. In addition to facilities directly related to the Olympics, public cultural facilities established during that period, including MMCA Gwacheon (1986), could not have been realized without government support. Korean architecture at this time excelled in demonstrating its ability as a problem solver rather than its inherent artistic value. This reflected the tendency of architects to capture the changing needs of the times faithfully, at the same time utilizing the opportunity as a base for independent experiments. The terms state and avant-garde contradict each other, but they coexisted in Korea at the time because the state was a crucial participant, at least in the fields of architecture and design. It was these conditions that sprouted the places that are represented as civic spaces today.[2]

In the late 1980s, which marked the end of the Cold War, key Korean architects Kim Swoo Geun and Kim Chung-up passed away. Around the beginning of the 1990s when the world embarked on preparations for the 21st century, a generational shift was sensed among architectural circles. Centering on young architects, various projects with the characteristics of movements were carried out. As in the plan to build two million housing units in 1988, the state remained the largest force at work in building cities. As a reaction to this phenomenon, 4.3 Group and other young architects at the time led various projects that looked back on and criticized Korean architecture. They rejected reckless large-scale development and opposed construction that focused on quantitative measures of speed and size. Concentrating on the concepts and languages of architecture, they began to tell stories about Korean cities and architecture through exhibitions, publications, and other media outside architecture.

The explosive consumer culture of the 1990s, when the public took center stage in place of the state, led to new practices in design and architecture as well as in fine art. Designers Ahn Sang-soo and Gum Nuri published a new form of cultural magazine, which garnered attention for avant-garde editorial methods and ideas, as seen in *bogoseo\bogoseo* (1988), and experimented with new forms of expression using hangeul as their medium. This was a novel attempt in the 1980s, when graphic design was thought of as a means of product packaging, promotion, and delivery of information. Architect Chung Guyon worked with a number of cultural critics and launched an exhibition titled *Apgujeong-dong: Utopia/Distopia* (1992), which viewed the Apgujeong-dong neighborhood as a subject of cultural research.

2. For detailed discussion on the nation and the avant-garde movement surrounding modern Korean architecture, refer to the exhibition in the Korean Pavilion at the 2018 Venice Architecture Biennale and to the book by the same title by Seongtae Park, et al., *Spectres of the State Avant-garde* (Seoul: Propaganda, 2018).

After dashing breathlessly forward through a period of rapid economic development bolstered by the Olympic Games, the architecture and design communities entered a period when they were forced to seek change, faced with an economic crisis that led to an IMF bailout. Government-led projects and other large-scale projects diminished in number, and designers had to find new ways to survive. In this environment, those with a strong sense of identity thrived. Discussion became fragmented, focusing on the voices of individual creators. Since the late 1990s, AGI Society has presented graphic works in the form of posters that call for social change, projecting real life and capturing the voice of the people. Since the 2000s, the number of small-scale design studios and independent designers has increased rapidly, and the movement of politically minded designers has expanded. With young designers and collectives in the center, attempts to comment on and intervene in society continued. Everyday Practice is a remarkable design studio that endlessly contemplates its social role and experiments with various ways to implement change.

In the field of architecture, too, empty spaces that the state once occupied are being filled with citizens and civic spaces. Voices are not subsumed, but are spreading with all their differences, filling our urban environment. This phenomenon is not restricted to architecture. To us, who have never experienced a truly civic space, in what form will the public square, a sphere for citizens, be revealed? Today, in 2019, as people discuss refurbishing the Gwanghwamun Square, this question poses very real topics for discussion.

Future museums and new applied art

MMCA Korea, founded in 1969 to operate the National Exhibition and exhibition spaces for hire, has undergone arduous challenges to fulfil its role as a National Museum and reinvent itself. In the process, the museum introduced modern and avant-garde art to the public, and featured applied art, which mediates art and society. The above summary outlines the way in which craft, design, and architecture were applied and operated within the network of art and society. At present, when the format of exhibition is used for many things in daily life, how is applied art, including design, defined within art institutions, and in what context must it be discussed? Are the choices valid and representative? The museum has never ceased to question, imagine, and arrange. As an extension of this process, this exhibition seeks to involve works in the fields of craft, design, and architecture that embody social ideas, individual desires, and the demands and beliefs of the times through their materialization and visualization. This is to allow the memories of our contemporaries and the next generation to intersect through the objects and visual culture of our generation and find a new perspective on the practices and trends of art that have responded to or challenged the social ideas and ideologies of each generation.

Considering the coming 50 years, rather than looking back on the past 50 years, it is easy to see that various conditions surrounding the museum will change drastically from the present. Museums, as one of the few remaining public places and civic spaces in the urban environment, have the responsibility to aid society

in facing the major conflicts of the moment and preparing for the future. At the same time, technology is constantly developing at an impossible pace, weaving new networks between virtual and real worlds. This has toppled the concepts of image, information, and material, with which museums deal. Naturally, the demand is growing for applied art to mediate between museums and the audience, and between museums and creative works.

Within the web of meaning of applied art, craft generates an attitude through the human act of facing a material. Urged to play a new role in the future, craft will function as a new area in which the acts of creation and relationship-forming as imagined by the public can be experimented with. Despite this change, craft is unique in that it reflects production methods and techniques that have not changed since before the foundation of the Republic of Korea. Therefore, the act of crafting, as experimented with in the museum setting, will be revealed as an attitude for seeing individual identity in our daily lives, with a sense of duty to preserve history. Works of design and architecture featured in this exhibition do not break away from the status of objects with materiality, but still raise a question with the advent of the digital era: in what form will they manifest within the museum in the future? Architecture that is not built, designs that are not made into products, and art based on data rather than material are already arriving. In the near future, material design will shrink in scope and will be replaced by digitally based, flexible, variable, intangible things. Accordingly, design and architectural practices, which react to and intervene in social issues, will also be attempted in new ways in the museum setting. In this way, curatorial practices in applied arts involved with the future museum will direct new knowledge and create spaces for useful learning that illuminates the museum's complexifying network, which encompasses society and technology.

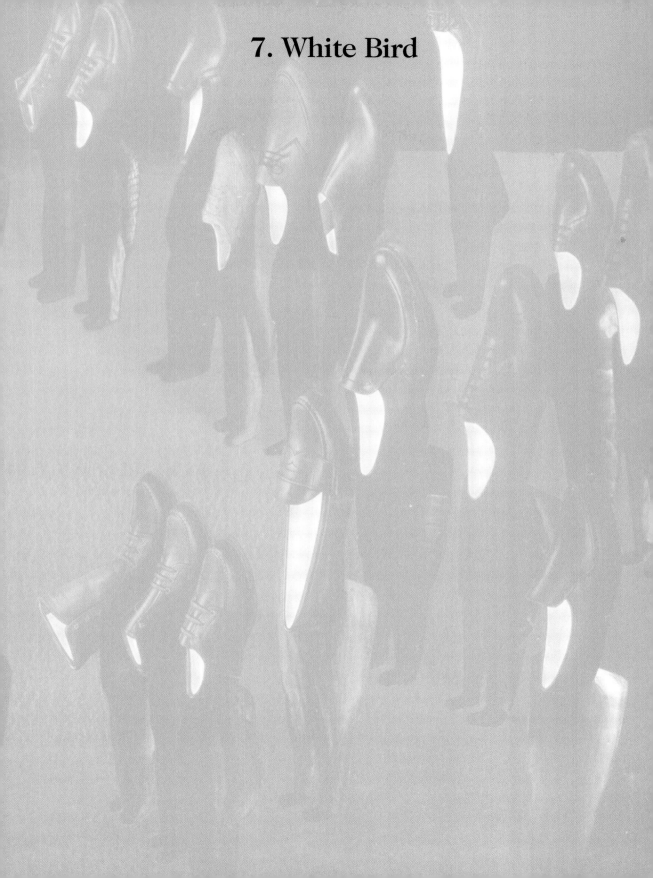

7. White Bird

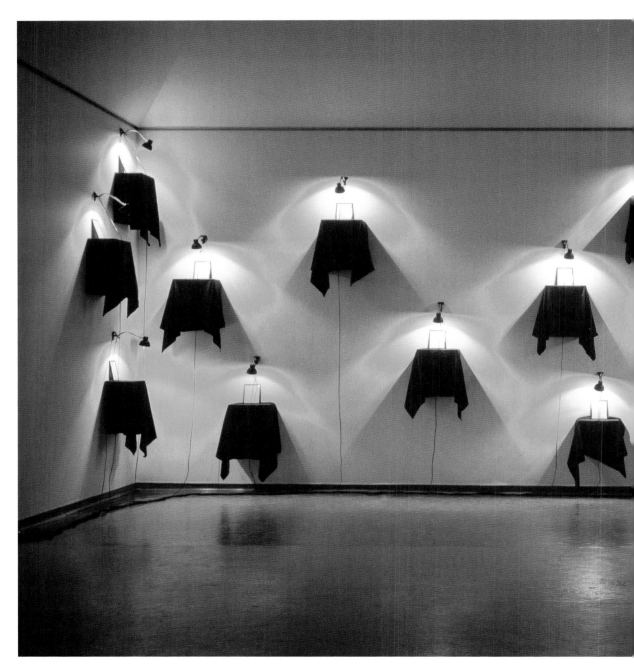

Christian Boltanski, *Monument-Comfort Women*,
1997, Mixed media, 125 × 58 × 36 ㎝ (16). MMCA collection.

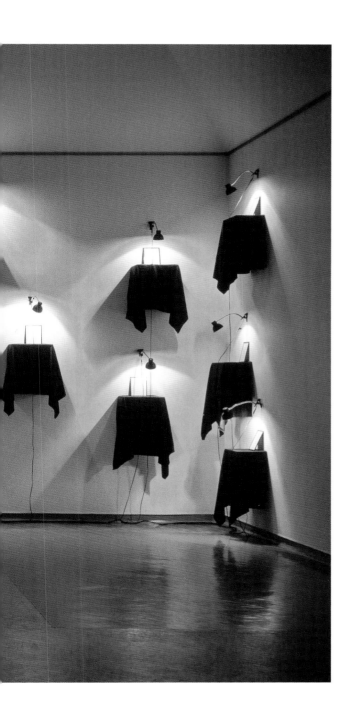

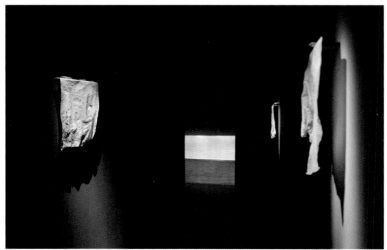

jang minseung, *voiceless-pitch-dark, a withered field*,
2014, Single-channel video, six silk screen on papers, six pebbles, 25min.
silkscreen 29 × 42 × 8 ㎝ (6). MMCA collection.

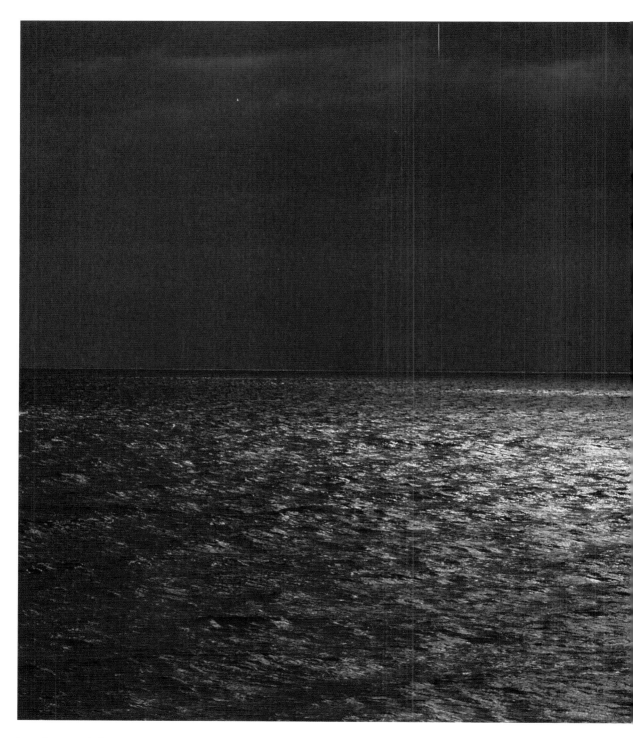

jang minseung, *voiceless-snow we saw*
2014, Single-channel video, color, silent, 89min. 51sec. MMCA collection.

Pen Varlen, *The Amnok Riverside*,
1960, Etching on paper, 32 × 63.8 ㎝, MMCA collection.

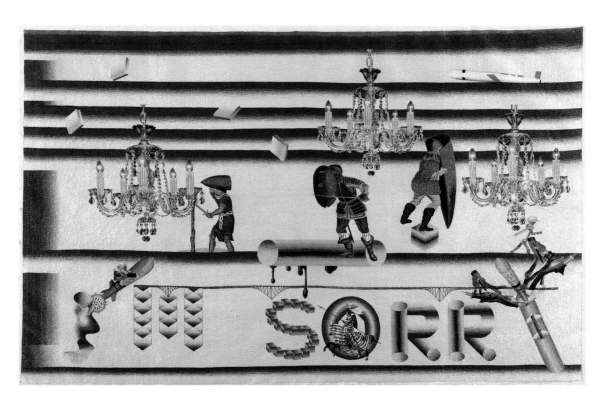

Ham Kyungah, *I'm Sorry*,
2009-2010, Embroidering on fabric, 148 × 226.5 ㎝. MMCA collection.

Memory, Erasure, and Their Complicity:
Forgotten Ghosts and Their Representation

Kim Won

Academy of Korean Studies

1. Introduction

While reading *Minjung Art: Listening to History* (Hyunsil Munhwa A), an oral compilation of recollections of the *Minjung* (literally "The People's") art movement during the 1980s, I encountered an interesting passage. It was a comment about how one of the subjects "missed the smell of tear gas" while recalling Korea of the '80s. I can only guess the speaker had grown nostalgic about the passion for resistance of that era.[1] Another notable passage I encountered was from a transcript of a dialogue between Choi Byungsoo and Kim Jinsong called *Carpenter, Initiate to an Artist*. Kim Jinsong is an art critic and carpenter, and Choi Byungsoo is an artist well known by anyone who lived through the workers' liberation movement around 1987 for his banner paintings such as *Nodbong haebangdo* (Liberation of Labor). Choi recalls how he suggested to his pupils that they go eat some *seolleongtang* (ox bone soup), to which they replied, "You expect us to eat that bourgeois food?" insisting that they would eat two-minute noodles, which they saw as people's food. Choi remarks how it's impossible for workers to sustain their strength on instant noodles, further commenting on the absurdity of students thinking it was the people's food.[2]

With the '80s behind us, there were significant attempts to represent "the forgotten ghosts." As Choi's recollection tells us, however, it requires more than just the commitment of artists and intellectuals. In this regard, Im Heungsoon's documentary *Factory Complex* (2014) is worth noting. The film starts off with the Statue of Export of Guro Industrial Complex, built in the 1960s, flooding the screen with common images of women and migrant workers in a way that makes them unfamiliar, requiring the viewer to reflect more deeply on them. The subjects forgotten and erased in the cultural and cinematic representation of the 1970s and 1980s were represented later with much delay, or only forced into view through dramatic events. The unfamiliarity with, and the erasure of, such subjects was often simplistically attributed to the Cold War, Korea's version of anti-communist

Kim Won is a professor at the Division of Social Sceience in the Academy of Korean Studies. He majored in Korean modern history and oral history, and his recent topics of interest are memory of East Asia and issues surrounding relationships in East Asia seen from below. His representative papers include *Female Factory Worker 1970, the History of Their Rebellion*, *The Uprising in June 1987, The Ghosts of the Park Chunghee Era - Memory, Events and Politics*, "Stowaway, Border and Nationality: Focusing on the case of Son Jindu", "The State and Minority: Thinking of the Way to Recollect", "Reproduction of Koreans in Japan in the 1970s by media - Focusing on the Reproduction of the Korean-Japanese Visitation Project by mass media", and others.

McCarthyism, and the division of Korea. Are we not, though, also a part of the forgotten?

At this point I'd like to refer to Tessa Morris-Suzuki's use of the word "complicit." This word alludes to our conscious relationship to the past and our tacit approval of being an accessory after the fact. For example, I was not involved in the slaughter of civilians by Korean soldiers during the Vietnam War, but I have participated in the destruction of the memory of slaughter. In other words, while I haven't directly persecuted "the other," I live in a contemporary society that has benefited from the persecution of a past that has not received proper attention.[3] The word "complicit" provides a useful compass for reflecting on how we remember or erase people treated like "forgotten ghosts."

2. War, Death, and Erasure

On the Korean Peninsula and in the surrounding region of Northeast Asia, war raged continuously under imperial colonialism and later, since 1945, under the Cold War. The Pacific War, the Cold War and the Korean War, and the Vietnam War have thrust the people of the Korean Peninsula and East Asia into a state where the fear and terror of actual or potential war have become normalized. Even though the wars are over, they still feel like they're in progress due to the US-South Korea-Japan trilateral military alliance that is supposed to counter the threat of communism. The presence of US military bases throughout South Korea is a reminder that war can still break out at any moment.

Following 1945, the Korean Peninsula has endured a continuous state of war, in which states were forged and the process for justifying their existence was constant. Via the Korean War, the state became the terror that wielded the power of national belonging; the state, the Republic of Korea, determined who had the right to be recognized as its people. After the Korean War, South Korea's brand of McCarthyism demanded an "uncontaminated nation" of both blood and ideology. Conversely, "commies," collaborators, and their families were considered "non-nation," who could be rightfully killed, their lives and deaths effectively erased.

Individuals on the Korean Peninsula experienced death in many ways: some died in the whirlpool of war; some had to live in silence as if they were already dead; and some were chased out of memory after death. In the instance of the "commie village" in Icheon, Gyeonggi-do, leftist individuals had to prove that they had been "converted" by turning to religion.[4]

War also demanded death from women, which ultimately resulted in their silence. Women visible and active in the public sphere dominated by men such as workplace and universities were considered "dangerous."[5] The "postwar women"

1. Park Yongju et al., *Minjung Art: Listening to History* (Seoul: Hyunsil Munhwa A, 2018), 51.

2. Choi Byungsoo, *Carpenter, Initiate to an Artist* (Seoul: Hyun Moon Suh Ga, 2006), 111.

3. Tessa Morris-Suzuki, *The Past Within Us: Media, Memory, History*, trans. Kim Gyeong-won (Seoul: Humanist, 2006).

included war widows who were called *Mimang-in* (the 'not-yet-dead,' despite the death of their patriarch), the sex workers around the U.S. military bases labeled "Yankee princesses", who "defiled the national purity", and female university students who were condemned for abandoning their duty to nurture a family. Present in the public sphere away from domestic settings, they were seen to be disrupting social order with their "impure" sexuality of the "corrupted" women.[6]

Around 65 years ago, during the process of postwar reconstruction, the top priority of the state became modernization. South Korea entered the overseas adoption market then and has remained the world's largest "exporter of children" relative to the country's child births. Under the Special Adoption Law for Orphans (1966) formulated to satisfy US demand, "mixed blood" children, of impoverished households, and of single mothers became the victims of orphan manufacturing and adoption agencies. They also were as good as dead, erased from the memory of postwar Korea.[7]

The homeless children deserted in the streets during the war were often placed in orphanages and childcare services in the wake of the war. In the postwar Korea, there were essentially seen as potential criminals, difficult to manage and ought to be banished. We have only recently begun to learn about the children who had been kidnapped and detained in the Seongam Juvenile Reformatory; orphans of the Korean War; children referred to as "shoeshine boys"; and others who were placed within the system, including leper colonies. They were always considered dangerous and were forgotten as if dead.[8] The youth who took to the streets during the April Revolution of 1960 became less numerous after the military coup of Park Chung-hee. After the Gwangju Grand Housing Complex Incident of 1971, the urban poor were branded as "thugs" or "a mob of rioters", of which the stigma weighed heavily. Street kids who had been active during the night protests in the Pusan-Masan Uprising of October 1979, the final blow to Park Chunghee's *Yushin* regime, were targeted in crackdown on urban delinquents. The "junkyard youth" "disappeared" immediately after the Gwangju Uprising of 1980.[9] So called *bappulttaegi*–lower class protesters who were sometimes violent–who emerged during the May Revolution of 1991, which lasted for a month after the death of student activist Kang Kyung-dae, shared a similar fate.[10]

4. Lee Yong-ki, "Ordinary People's Experience and Memories of the Korean War in a 'Red' Village: focusing on the case of a 'Moscow village' in Gyeonggi-do," *Critical Studies on Modern Korean History Vol. 6* (2001).

5. Choi Chungmoo, *Dangerous Women: Gender and Korean Nationalism*, trans. Park Eun-Mi (Seoul: Samin Books, 2001).

6. Kim Jeongja and Kim Hyeonseon, *The Hidden Truth about the U.S. Military Camp Town: The First Testimony of a U.S. Military Comfort Woman* (Seoul: Hanul Publishing Group, 2019); Lee Im Ha, *A War Widow Breaks the Silence about Korean Modern History: The Korean War and the Post-War Society Written in Colloquial Language* (Seoul: Cum Libro, 2015).

7. Arissa H. Oh, *To save the Children of Korea : the Cold War Origins of International Adoption* (Stanford: Stanford University Press, 2015).

8. Ha Geum-cheol et al., *No One Asked Me About My Dreams: Oral Records of Seongam Juvenile Reformatory Survivors* (Paju: Owoleui Bom, 2019).

9. Kim Won, "Defamed Heroes and Testimonies of Violence: The 'Mudeungsan Tarzan Incident,'" *Ghosts of the Park Chung-hee Regime: Memories, Incidents, and Politics* (Seoul: Hyunsil Munhwa, 2011); Kang Sangwoo (Director), *Kim Gun* [Documentary] (2018).

Within and outside the anti-communist Republic of Korea existed those forgotten, living as if dead. During the mass internal migrations around the Korean War, a considerable number of those who migrated from the north to the south joined the front line of the anti-communist campaign. Meanwhile, the families left behind in the south by those who migrated northward had to endure the pain of being labeled "non-nation", condemned guilty by association.

Following the division of Korea, the Korean diaspora such as *Zainichi Chosenjin* (ethnic Koreans residing in Japan; '*Zainichi*' hereafter) and Sakhalin Koreans received continuous suspicion regarding their national identity and loyalty to the Republic of Korea, a situation that hasn't changed much to this very day. The East Berlin-North Korean Spy Ring Incident in 1968 brought a big shock to the Korean community in Germany and further exacerbated the South Korean distrust of overseas Koreans. For a long time, the intellectuals involved in the incident, including Yi Eungro and Yun Isang, were barred from returning to their homeland, while the Korean public were kept away from the artwork that encapsulated their voices.

Another example of the "forgotten ghosts" from the Cold War to recent times are the *Zainichi*. When the colonial rule collapsed, the *Zainichi* were still deprived of their right to citizenship in the process of the fortification of the Cold War in East Asia, despite their newly acquired status as part of a liberated people. As symbolized in *Zainichi* artist Cho Yang-gyu's *Sealed Storage*, exhibited at Tokyo's National Museum of Modern Art, both the Allied Occupation authorities in Japan and the Japanese government shunned the *Zainichi* as a "dangerous race" and denied them their rights.[11] Stripped of any nationality, the *Zainichi* were simply given the mark of "Chōsen-seki (朝鮮籍, "Joseon domicile")", with the word that referred to the pre-colonial Korean Peninsula. Furthermore, following the division of Korea, the South Korean government maintained its suspicions and surveillance of *Zainichi* Chosenjin. In 1955, the General Association of Korean Residents in Japan (Chongryon) was formed, and from 1959 onward, it ran a "repatriation project" to North Korea that sent about 90,000 *Zainichi* for permanent residency. Obsessively preoccupied with its competition with North Korea for legitimacy and influence, the South Korean government viewed the *Zainichi* as a threat.[12] Even after the normalization of South Korea-Japan relations in 1965, the Korean-Japanese visiting South Korea were still viewed as "half-Japanese scum" and parvenus. in the 1970s, several North Korean spy rings consisting of Korean residents in Japan were uncovered; amongst those imprisoned for espionage were the *Zainichi* brothers Seo Seung and Seo Jun-sik who had been studying in South Korea. Such spy cases, however, have since been proved fabricated by the Korean Central National Intelligence Agency.[13] Those associated with *Chōsen gakkō* (朝鮮學校, *Zainichi* schools for national education) and those

10. Kim So-jin, *Open Society and Its Enemies* (Paju: Munhakdongne Publishing Group, 2002).

11. Jin Yongju, *That Which is Remembered Does Not Vanish: My Trip Around Japanese Art Museums* (Seoul: Danchu Press, 2019), 132.

12. Yang Yonghi (Director), Dear Pyongyang [Documentary] (2008); Tessa Morris-Suzuki, *Exodus to North Korea: Shadows from Japan's Cold War* (MD: Rowman & Littlefield), 2007.

with *Chōsen-seki* were indiscriminately considered as supporting the North Korean regime.[14]

After South Korea and Japan normalized their diplomatic relations in 1965, in its competition for influence with the North Korean regime, the South Korean government attempted to convert the *Zainichi* with *Chōsen-seki* to South Korean nationality. Cho Ji-hyun's recent photo exhibition in Seoul, Ikaino: The Small Jeju-do of Japan, contains an interesting scene: two photographs in juxtaposition, both taken in the streets of Ikaino, Osaka's *Zainichi* neighborhood. In one, the banners are urging the *Zainichi* to obtain South Korean nationality; in the other, the messages are strongly against it. What we observe here is "division politics surrounding the issue of nationality."[15] Such politics continued: the South Korean government launched a large-scale "motherland visit campaign" in the mid-1970s, through which the *Chongryon Zainichi* were brought to South Korea and taken on "anti-communist tours" in an effort to encourage them to convert to the South Korean nationality.[16] Even until recently, South Korea has denied entry to *Chōsen-seki* holders looking to visit the country for research and cultural activities. The most notable case was that of novelist Kim Seok-bum, whose novel *Kazantō* (火山島) explores the Jeju Uprising of 1948.

3. Resurrecting the Forgotten: The 1980s and the People's Movement

Following the Korean War, the South Korean society prioritized modernization and development above all else. In the 1980s, it faced major changes: its intellectual, cultural, and art scenes started in earnest to self-reflect, breaking away from the pro-Japanese, conservative, and Western modernity during the period of dictatorship and economic development. Such changes had already been occurring with increasing intensity since the late 1960s: In historiography, internal development theory was introduced; in literature, problems were raised about the Korean reality, employing tools such as the theory of national literature; national art forms were also contemplated, drawing on *talchum* (masked dance), *madanggeuk* (outdoor theater), folk religions, legends, and folktales.

At the same time, people started to pay greater attention to the workers and the urban poor, so-called "*minjung*", whom had been marginalized in the new class society formed during the country's rapid transformation to Capitalism.[17] Even before the 1980s, cultural explorations of this marginalized class occurred in films

13. Kim Hyosun, The People Abandoned by Their Country: Records of the Korean Students in Japan Who Were Convicted of Espionage (Paju: Seohaemunjib, 2015).

14. Park Giseok, *Bokurano Hata: Our Flag 1, 2*, trans. *Jeong Miyeong* (Paju: Poom Books, 2018).

15. Cho Jihyeon, *Ikaino: The Small Jeju-do of Japan* (Jeju: Gak, 2019); Cho Gyeonghui, "Nationality and Politics of Divided Nation after 1965," *Identifying Myself: Nationality, Passport, and Registration in Asia* (Paju: Hanul, 2017).

16. Kim Won, "1970s Media Portrayals of *Zainichi Chosenjin*: Representations of *Zainichi* Homeland Visits in Mass Media," *1970s Social Change and Self-Representation* (Seongnam: Academy of Korean Studies Press, 2018).

through the genre of "hostess melodrama," in literature through peasant/third-world literature, and in art via critical reflections on consumerism. However, it wasn't until the 1980s that there was a fundamental materialization of efforts to represent the people who'd been erased from history. In short, the masses, who'd been asleep and unaware, were thrust into an era where social and political democratization seemed imminent. That was what characterized Korea in the 1980s.[18]

What sparked off this new era of the '80s was the Gwangju Uprising of 1980. As the state power represented by the new military regime slaughtered citizens who organized in opposition to yet another dictatorship, people began reflecting more deeply on the foreign powers over South Korea and the nation's dependence on them. The aspiration for revolution and a new social order materialized as the democratization movement. The petit bourgeois' condescending pity or compassion directed toward the *minjung* during the 1970s gave way to new "theory of *minjung*" inspired by Marxist class theory. The *minjung* theory manifested itself in various forms such as *minjung* history, *minjung* literature, *minjung* art, etc., the last of which began in 1980 with the founding exhibition by Reality and Utterance that advocated humane paintings.[19]

The *Minjung* movement was a massive wave that sought to see Korean society as it really was in the realms of academic research, art, and literature. University students known as the "educated workers" began secretly infiltrating into factories, construction sites, and other blue-collar workplaces.[20] Artists gave up their elitist thrones and dispatched themselves to factories, into the arms of the *minjung*. Collectively created, quick, mobile, and mass-producible, works such as banner paintings, prints, murals, and flags were considered fitting forms of art as weapons of revolution. Writers applied themselves to labor literature; Labor News Production was established; and *minjung* films, such as *The Night Before Strike* (1990), were produced. They created art expressing their beliefs in *minjung*, who would overcome the oppression, rise from their suffering to finally lead the revolution.

However, the effort to resurrect the forgotten people's history via the *Minjung* movement was often exploited for political purposes. In the effort to revive those erased from history, the idea of the *minjung* fighting against suffering and exploitation became an ideological fixture. In reality, however, the marginalized *minjung* did not only exist in their struggles.[21] This idea of the "fighting *minjung*" simplified them and catered to the intellectuals' idea of *minjung*.[22] A *Minjung* artist who made himself known through his banners, Choi Byungsoo commented that he didn't like how *Minjung* art comprised almost entirely of images of *minjung* suffering, asking artists if they had ever even worked as manual laborers. After having learned

17. These people included those featured in Oh Yoon's painting *Family II* (1982): a deliveryman for Chinese black bean noodles, a bar keeper, and construction workers.

18. Park Yongju et al., p. 264.

19. Lee Namhee, *The Making of Minjung: Democracy and the Politics of Representation in South Korea* (NY: Cornell University Press, 2007).

20. Yu Gyeongsun, ed., *Same Era Different Stories: Heroes of the Guro Alliance Strike Sharing their Lives* (Seoul: Mayday, 2007).

that most of them had spent a mere week or two as blue-collar workers, his response was, "It sure is tough for someone who has only worked for a week or two. If you temporarily work at a construction site carrying a heavy load on your back, all you are going to remember is the pain. Ultimately, they have depicted their own selves, not the workers. No wonder I couldn't understand their work."[23]

Additionally, themes like masculinity, violence, and social hierarchies were mechanically applied to highlight "the typical working class," alienating, intentionally or unintentionally, those who did not fit the stereotype. The male *minjung* were viewed as central features in the struggles of the working class, while the female *minjung* in was stereotyped as assisting and sacrificing in the back. *Minjung* was not understood as spontaneous and autonomous beings who may stand up to fight or be organized, but only seen as a homogenous unity of people. Such a view erased any internal contradictions and complexities of the *minjung* "[24].

In this context, it is difficult to deny that the *minjung* represented in the '80s were a community of men, a league of brothers.[25] Even images of women, rather than focusing on the women themselves, focused on the image of a "*minjung-woman*."[26] In short, the representation of *minjung* as a political movement for revolution had its limits in that it privileged the pain and struggles of the working class, rather than embodying diverse experience and the realities of the *minjung*. More people had to take the Square; but the forgotten beings of many genders and races remained unrepresented, as the praxis and the outlook of the 1980s' movements failed to reach them.

4. National borders, Co-existence, and Memory

After the 1990s, when border control and border crossings were relaxed in South Korea, people realized the need to welcome or encourage those outside Korea's borders who showed interest in the country. At the same time, South Koreans started becoming interested in Koreans who had fled overseas during the Japanese occupation and the Cold War whether as asylum seekers, refugees, or stowaways. The interest also extended to those who had relocated to places such as Japan/Okinawa and Sakhalin, to those had been forgotten and erased.[27] Yet, such an

21. Kim Insoon, "*A minjung artist of the '80s, recalls that she had no knowledge of female laborers' clothes*". Park Yongju et al., 344.

22. Kim Won, *Memories of Forgotten Things* (Seoul: Imagine, 2011).

23. Choi Byungsoo, 51-52.

24. Kim Jaeeun, *A Study on the Gendered Subjectivities Constructed in the Pro-Democracy Movement in South Korea (1985-1991): Focused on the Analysis of Symbolic Politics' Discourses*, MA thesis (Seoul: Seoul National University, 2003).

25. Kwon Myeong Ah, *How Stories of Families Come About* (Chaeksesang, 2000).

26. Park Yongju et al., 349.

27. Choi Sanggu, Sakhalin: History and Records of Zainich on a Frozen Island (Ilda, 2015); Oh Sejong, Between Okinawa and Korea: On the History and Narratives of Visualizing / Invisiblizing Koreans, Trans. Son Jiyeon (Seoul: Somyeong, 2019).

interest resembles more a systematic effacement and collective amnesia of the overseas Korean who have led their lives abroad for many reasons including the Korean War, the Cold War, and the anti-communism, as it is not an interest in their distinct experience and history.

Typical cases of overseas Koreans who have been erased from the mainstream historical narrative are Alice Hyun (1903-1956?), an independent woman who had fled to Hawaii during the Japanese occupation and had travelled to both South and North Korea during the Cold War; Ju Sejuk (1898-1953), a socialist activist during the Japanese colonial rule who was never to return home from the Soviet Union where she had taken political asylum; and Sohn Jindu (1928-2014), a victim of the US' atomic bombings of Japan, who fought a confidential legal battle for compensation from the Japanese government.[28] They remained forgotten for long, while the attempts to understand interpret their extra-territorial existence and experiences failed to transcend the limits of the South Korean perspectives.

There are others who have been forgotten outside the Korean borders: those from the Vietnam War. The Vietnam War, which waged for more than 10 years from 1965, is still remembered from an anti-communist perspective—a second anti-communist war following the Korean War—and as a way to earn foreign currency for South Korea's economic development. A great many South Koreans took part in the Vietnam War, including soldiers, engineers, workers, and war correspondents and intellectuals. Still, the problem of civilian massacres by South Korean troops raised during the 1990s is met with silence and efforts to efface the memory. In addition, conscience is rarely seen in South Korea about the Vietnamese women and the *lai dai han* (children born between Korean fathers and Vietnamese mothers) left behind by Korean men in the Vietnam War. After the war came to an end, the reflections on the conflict were expanded to a certain point and referred to as the "Vietnam syndrome." Such reflections included a realization that the Vietnam War was an unjust war, and that such a war should never be repeated. Yet, although over 40 years have passed since the war, we still haven't properly reflected on the Cold War in which South Korea was deeply involved, or on the Korean diaspora that resulted.[29]

In the 1990s, as the Cold War regime was dismantled and Korea's democratization further progressed, issues such as the Japanese military's comfort women and forced mobilization started being addressed. Issues that were erased during the Cold War are resurfacing and people began demanding compensation and a proper investigation into the truth to the Japanese government. Around the same time, amid increasing globalization, Korea went from being a country that

27. Choi Sanggu, Sakhalin: History and Records of Koreans on a Frozen Island (Ilda, 2015); Oh Sejong, *Between Okinawa and Korea: On the History and Narratives of Visualizing / Invisiblizing Koreans*, Trans. Son Jiyeon (Seoul: Somyeong, 2019).

28. Jung Byung Joon, *Alice Hyun and Her Times* (Dolbegae, 2015); Kim Soyoung, *SFdrome* (2018); Kim Won, "Stowaway, Border, and Nationality: In Focus of the Sohn Jindu Accident," *Topos of Events and Politics* (Seoul: Somyeong, 2017).

29. Yoon Chung-ro, *Forgotten War and an Aged Present: Korean Social History in the Vietnam War* (Pureunyeoksa, 2015); Kwon Heonik, *After the Massacre: Commemoration and Consolation in Ha My and My Lai*, Trans. Yu Kangeun (Seoul: Archive, 2012).

once dispatched nurses and miners to Germany and construction workers to the Middle East to a country that began importing foreign labor forces. It is no longer uncommon to see immigrants at universities, in industrial complexes, and in the streets of South Korea.

How, then, are they represented in the South Korean society? Around the mid-2000s, there was a television program called *Asia! Asia!* in which the migrant workers in South Korea were reunited with their families back home. On the surface, it was based on good intentions; in reality, it was a sympathy fest exhibiting the "pitiful" migrant workers from "poor, suffering countries." Over ten years later, South Korea is populated with not only migrant workers but also with multicultural families from international marriages and refugees crossing the border seeking asylum.

In 2018, those who opposed the arrival of Yemeni refugees on Jeju Island argued that Muslim Yemeni men were a potential threat of sexual violence against Korean women. In other words, it was an argument of "our people first," even though the Yemeni refugees were more vulnerable than women who are South Korean nationals. During the 2000s, South Korea's xenophobia towards immigrants was from the lack of contact with them. Since then, however, as with the Islamophobia demonstrated above, the practice of drawing distinctions between 'us' and 'them' has spread widely, in terms of skin color and nationality as well as of clothing, religion, customs, and culture. Such a tendency is evident in those who implicitly consider immigrants of certain race or religion "dangerous," while denying being racist. Also, the South Korean society takes the presence of North Korean defectors as a proof of the superiority of South Koreans to North Koreans. It does not acknowledge them as people with complex identity as refugees and immigrants, beyond a single role of publicly condemning North Korea.

Discrimination, phobia, and racism are all inevitably associated with our past. The South Korean society is metamorphosing into a complex society where people of varying education, races, and religions identifying with nation/non-nation, men/women, heterosexuality/homosexuality, stable/unstable employment are intermingled. It is imperative that the viewers of this exhibition reflect actively on the fact that the discrimination against those marginalized is connected to South Korea's past and that they themselves are capable of such discrimination. When the South Korean art can finally accept even non-Koreans as its object to represent, it will truly become a medium that connects us with the "forgotten ghosts."

III.
The Square:
Art and Society in Korea
2019

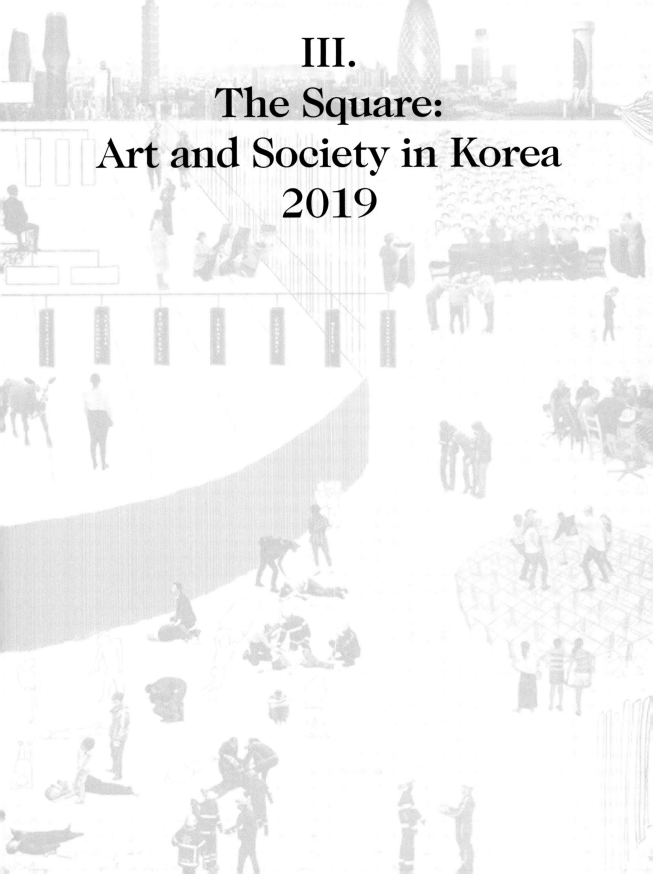

1. I and the Other

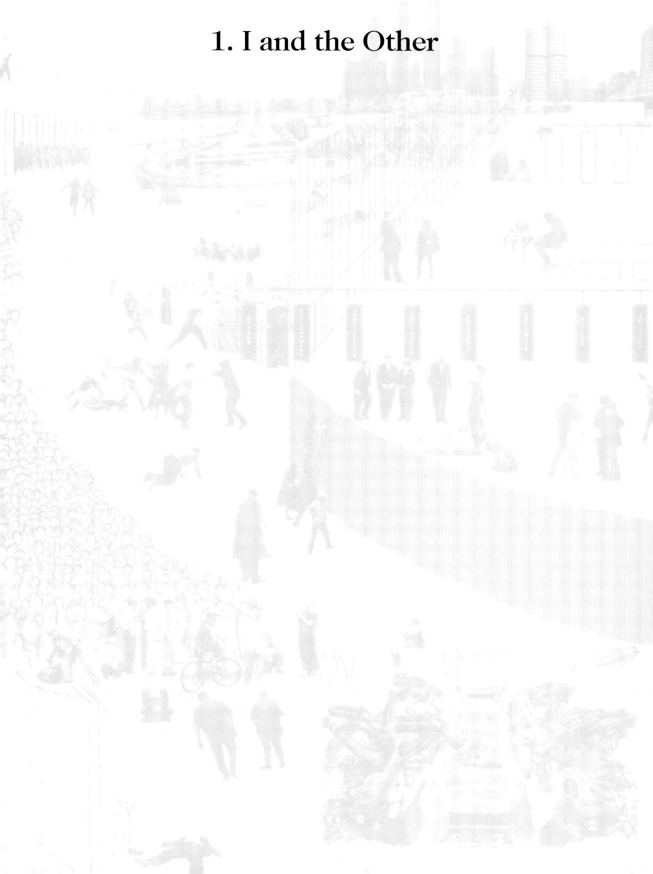

The Square, 2019

Lee Sabine

Curator, National Museum of Modern and Contemporary Art, Korea

1. Isolde Charim, *Ich und die Anderen*, trans. Yi Seunghui (Seoul: Mineum Publishing Co., 2019), 58.

This exhibition began from the question, "What is the meaning of the public square today?" The Korean word for a public square–"*gwangjang*"–has a long historical legacy, simultaneously invoking the fierce pro-democracy demonstrations during the latter half of the twentieth century, the recent candlelight protests, and Choi Inhun's landmark novel *The Square* (1960), which documents the division of Korea and its resultant tragedies. Charged with such compelling associations, "*gwangjang*" is a powerful term that transcends physical space, being capable of both specificity and timelessness.

As social beings, each of us must live together with other people. This necessity becomes a reality in the public square, where people gather to confront their social issues and express their desire for a better community. In this sense, the public square can be the place where the social life of an individual begins. Our attempts to resolve such problems inevitably lead to collisions of conflicting aspirations and desires, which reveal how similar or different we are as individuals. Each of the countless standards that divide us–age, gender, occupation, political inclination, etc.–corresponds to its own view or perspective. Thus, the square is a space that simultaneously embodies solidarity and separation. That is why simply looking across a public square can arouse feelings of fatigue and disillusionment.

Above all, a public square is where we question the meaning of a community. By investigating some of the problems faced by individual members of a community, this exhibition contemplates what it means to live together and the changing role of community in our increasingly pluralistic society.

I and the Others

A public square is where I discover myself–and we discover ourselves– by coming face to face with the Other. While one's relationship with the Other has always been difficult, it has become even more complicated in this pluralistic era of individualism. Isolde Charim has argued that we are now living in the era of "third-generation individualism," where society is less homogenous and the individuals are more pluralized. As Charim explained, the social boundaries that once provided a sense of belonging are loosening, resulting in a split or diminished sense of personal identity.[1] For some, this process can bring tremendous freedom and liberation, while others

experience it as loss, anxiety, or threat. Changes in our individual identity will trigger changes in our relationship with the Other, transforming our ways of belonging in society and our relationship with communities.[2]

The first part of this exhibition showcases works by three artists, all of which can be categorized as portrait photography. At first glance, portraiture seems to focus on an individual subject, but its true power lies in the psychological reaction of the viewers, who inevitably begin to intuit the social identity of the subject through his or her physical appearance.[3]

The portrait photos of Oh Heinkuhn and Joo Hwang focus on individuals, but simultaneously capture the sensibility or social conditions of a certain group or generation. While Oh Heinkuhn typically photographs young adults (in their twenties or early thirties), Joo Hwang's photos depict women who are leaving Korea for various reasons, such as to study or work abroad. In both cases, the photos are ingrained with the tensions between the subjects' external appearances (whether revealed consciously or unconsciously) and their personal and social conditions. As we the viewers, who are dealing with our own personal issues and conditions, look at these photos, the identities of the subjects are newly constituted and performed before our eyes.

One of the key elements of portrait photography is the friction between what the subject wants to show and what the photographer wants to reveal. In other words, the distance and relationship between the subject and photographer are crucial. In her series *Stranger* (1999-2000), Yokomizo Shizuka found a unique way to maximize the sense of comfort and intimacy by maintaining a certain distance from her subjects. Yokomizo wrote to various strangers and asked if she could photograph them through the window of their living room at a certain time, and then wrote to them again for their permission to use the images. Produced with no direct, face-to-face interaction between the photographer and her subjects, the images in this series show how such distance between strangers may offer the possibility of an amicable yet complacent coexistence.

Meanwhile, in *One Pyeong House Between Tides* (2018), Song Sung-jin connects his visit to a Rohingya refugee camp with the social landscape of Korea. Inspired by the ramshackle homes he saw in the camp, Song documented his two-month process of arduously building and preserving a miniature house on a tidal mudflat in Ansan, Gyeonggi-do. Notably, the house is precisely one "*pyeong*" (approximately 3.3 m2) in size, which is the standard unit of measurement in real estate in Korea. Because of the strong tides and weather conditions, the house repeatedly collapsed or washed out to sea, forcing Song to rebuild. The motif of a house (being both a necessity for survival and a commodity for profit) and the special environment of a tidal mudflat (where the land is continuously exposed and concealed) evinces the banality of trauma in an era when news of others' struggle to survive has become commonplace.

2. Charim, ibid., 69. She also pointed out that pluralization can exacerbate conflict and hatred among ethnic groups, races, classes, generations, and genders.

3. Richard Brilliant defined portraiture as the particular statement of the subject and the purposeful composition of the photographer to elicit the viewers' psychological reaction. Richard Brilliant, "The Authority of the Likeness," *Portraiture* (London: Reaction Books, 1991), 23-44.

Where Time Becomes Space

Today, some of the most violent collisions between Others are occurring on the internet. Starting from the point at which the public square transformed from a physical space to a virtual space, Hong Jinhwon created *I Think It's Time I Stopped the Show* (2019). By exploring the role of a public square as a gathering place for public opinions, Hong calls attention to the dissipating notion of the square as the center of democracy. On the other hand, Kim Heecheon's *Sleigh Ride Chill* (2016) examines the social changes engendered by the intrusion of digital interface in our daily lives. Kim's provocative video also evinces the uncomfortable duality in which every individual is both a victim and perpetrator of the diverse forms of violence taking place in group chats and online communities.

These two works are particularly interesting as attempts to visualize how our perceptions of time and space have been distorted by our increasing reliance on digital screens and devices. In an interview about *Sleigh Ride Chill*, Kim noted how the real-time interactions of social media have created a new sense of sharing space with like-minded people, which is sometimes strong enough to penetrate the real world.[4] Today, public opinion originates online, as individuals share their thoughts through social media or chatrooms, before gaining enough momentum to ignite protest in the physical world.

In this era of hyper individualism, this phenomenon of the shared time online actively leading to the occupation of shared physical space has become a new form of political participation. According to Isolde Charim, the new political mode of this pluralistic era is driven by individuals' aspiration for complete participation.[5] Rather than seeking to represent collective qualities (e.g., community, class, or political party), people today are basing their political participation on their own specific individuality. Even so, this sense of participation requires space where such feelings can emerge and find resonance through the attention of Others.[6] Places, sites, and squares acquire greater significance by enabling us to become active participants in democracy.

Changing Communities

Communities are not static entities; they are constantly changing in terms of the relationships among members, the way that members join and belong, and the problems that they must confront. Some of the works in this exhibition stimulate thoughts on the meaning, role, and origin of our contemporary communities, ranging from nation-states to the entire human race, particularly during times of crisis and disaster.

Our economic, political, social, and ecological conditions are now so deeply intertwined that minor mistakes or accidents can quickly spiral into

4. From an interview with the artist on April 10, 2019.

5. Charim, ibid., 149-153.

6. Thus, participation is not derived merely from collective decision, but rather from the actual reality in which one participates. Charim, ibid., 149.

major disasters. In *The Sleep* (2016), Ham Yangah looks into the operation of social systems in times of crisis through images of people taking shelter in a gymnasium, a heartbreaking scene to which we have become accustomed. The exhibition also introduces two new works by Ham–*Undefined Panorama 1.0* (2018-2019) and *Hunger* (2019)–which explore the underlying links between social, economic, and ecological crises, forcing us to question the trajectory of our future.

Indian artist Nalini Malani places contemporary disasters on the axis of time in *The Tables Have Turned* (2008), which intersperses historical, biblical, and mythical images of violence. The images are painted in the style of the "Kalighat School," which originated in West Bengal in the nineteenth century, when painters were first beginning to depict social and political motifs. The turntables that rotate the images were inspired by Buddhist prayer wheels, thus evincing the collective aspiration for change. Meanwhile, *Letters to Max* (2014) by Eric Baudelaire is based on the artist's correspondence with his friend Max Gvinjia in Abkhazia, a de facto republic in northwestern Georgia that has not been internationally recognized as a country. The work contrasts the concepts of tolerance and exclusion while deliberating on the fundamental conditions that constitute communities.

Museum as Square

Finally, some of the works in this exhibition move outside the main galleries, transforming the space of the lobby and hallway into new types of public square. In the hallway between Gallery 2 and 3, *East West South North* (2007) by Chung Seoyoung takes the form of a fence, which typically divides or restricts space. The title of the work invokes the four cardinal directions, a concept that simultaneously helps us comprehend the abstract concept of space while implying the infinity of open space. In this exhibition, Chung's work encourages visitors to imagine a square as a temporary, movable, and infinitely open structure. Moving upstairs from the lobby to Gallery 8 (in the opposite direction of the main gallery space), visitors will find themselves in *Mind* (2019), an ingenious new work by Shinseungback Kimyonghun. Interpreting a square as a sea of people's minds, the artists created this innovative installation that transforms the data of viewers' facial expressions into waves.

Finally, Hong Seung-Hye transformed the hallway in front of Galleries 3 and 4 into an alternative rest space called *Bar*. Like the dual meaning of "square" (i.e., a rectangle having all four sides of equal length and an open public space with that shape), the word "bar" also has two related meanings (i.e., an elongated piece of some solid substance and a counter in a pub or restaurant with that shape). As an alternative to a square, which is imbued

with shared aspirations and chaotic commotion, *Bar* offers a serene space where visitors can comfortably relax, either alone or with others.

A public square is a reflective space that forces us to contemplate the ever-changing meaning and role of communities. In this regard, museums, which use social agendas to shape the discourse of art and culture, should be considered as a type of public square. Although typically associated with the art of the privileged class, a museum still functions as a public space that conjures thoughts of an alternative square. In a museum, natural order is usually maintained without strict regulations. For example, people tend to respect one another's space, and rarely raise their voices or shove their way forward to get a closer look at an artwork. As such, museums afford a general feeling of ease and comfort, whether one is alone or with others. As a space where people can come together or be alone, to think about or talk about social agendas, to converse or convalesce, a museum is a space of coexistence, where we can peacefully exist as both an individual and as a member of a group. Indeed, wouldn't the ideal shared space of a mature individualist society be something like a museum?

Like all public squares, museums are places where various voices converge. With that in mind, the final work that must be mentioned is *The Square*, a collection of short stories that visitors will find on the benches in the aforementioned installation Bar. Produced in collaboration between the museum, Workroom Press, and editor Kim Shinsik, this book contains seven short stories written especially for this exhibition. Other than the keyword "*gwangjang*" ("public square"), the seven writers (Yun I-hyeong, Kim Hye-jin, Lee Jangwook, Kim Choyeop, Bak Solmay, Yi SangWoo, Kim Sagwa) were not given any guidelines or restrictions, so that the final stories are purely the result of their fertile imaginations. We hope that their stories will temporarily transport visitors elsewhere, offering a bit of respite from the barrage of thoughts and visual shouting that are now echoing throughout the new public square of the museum.

Yokomizo Shizuka, *Stranger 2*,
1999, C-print, 124.5 × 105 ㎝. MMCA collection.

Yokomizo Shizuka, *Stranger 23*,
2000, C-print, 124.5 × 105 ㎝. MMCA collection.

Joo Hwang, *Departure #0462*,
2016, C-print, 105 × 70 ㎝. Courtesy of the artist.

Joo Hwang, *Departure #1024 London*,
2016, C-print, 105 × 70 ㎝. Courtesy of the artist.

Oh Heinkuhn, *Rose, August 2017*,
2017, C-print, 130 × 100 ㎝. Courtesy of the artist.

Oh Heinkuhn, *Sue, April 2016*,
2016, C-print, 113 × 85 ㎝. Courtesy of the artist.

Oh Heinkuhn, *Jo, July 2016,*
2016, C-print, 125 × 96 ㎝. Courtesy of the artist.

Oh Heinkuhn, *Min, May 2017*,
2017, C-print, 144 × 109 ㎝. Courtesy of the artist.

Oh Heinkuhn, *Jiwoo, July 2016*,
2016, C-print, 122 × 94 ㎝. Courtesy of the artist.

Song Sung-jin, *One Pyeong House Between Tides*,
2018, wood, mixed media, installation, 280 × 240 × 290 ㎝.
Courtesy of the artist.

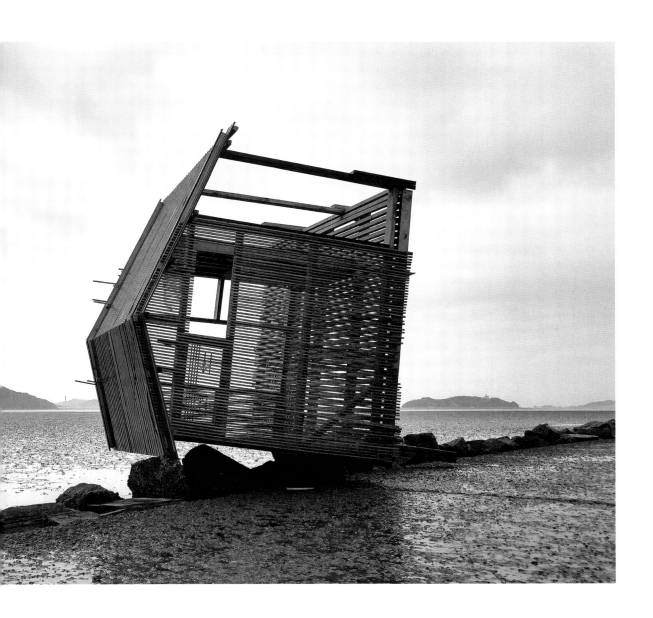

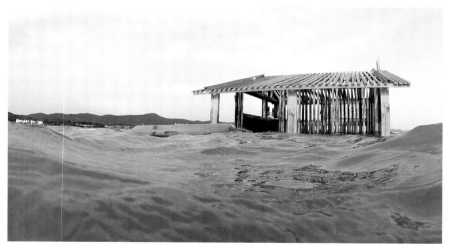

Song Sung-jin, *One Pyeong House Between Tides*,
2018, single-channel video, 24min. 35sec. Courtesy of the artist.

Song Sung-jin, *Non-existent but Existent: Rohingya*,
2018, single-channel video, 2min. 27sec. Courtesy of the artist.

Song Sung-jin, *Camp 16 Block E*,
2018, pigment print, 150 × 100 ㎝. Courtesy of the artist.

Hong Jinhwon, *I think it's time I stopped the show*,
2019, QR code on pigment print, 60 × 80 ㎝. Courtesy of the artist.

Kim Heecheon, *Sleigh Ride Chill*,
2016, single-channel video, color, sound, 17 min. 27 sec. MMCA collection.

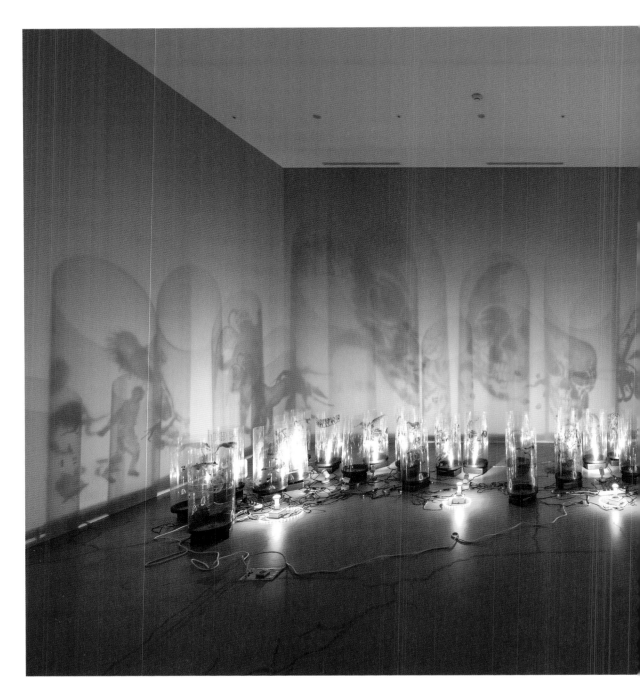

Nalini Malani, *The Tables Have Turned*,
2008, thirty-two turntables, reversed painted Mylar cylinders, halogen lights, sound, 20min. MMCA collection.

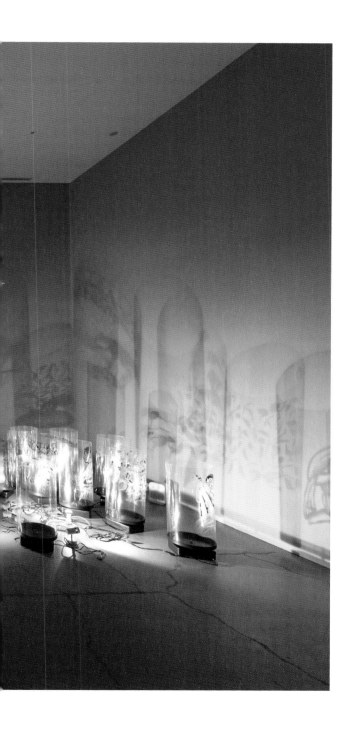

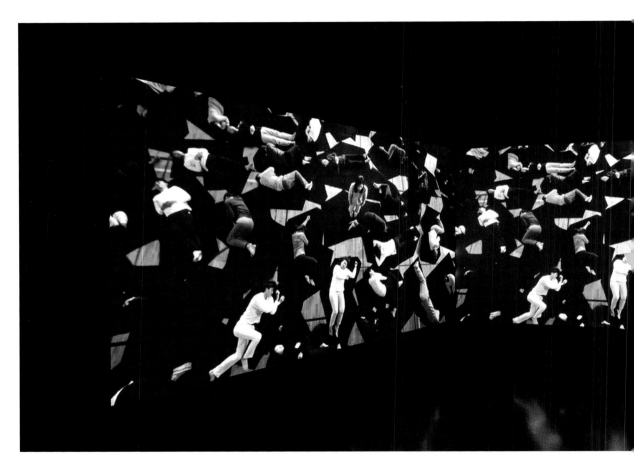

Ham Yangah, *The Sleep*,
2016, two-channel video installation, color, sound, 8min. MMCA collection.

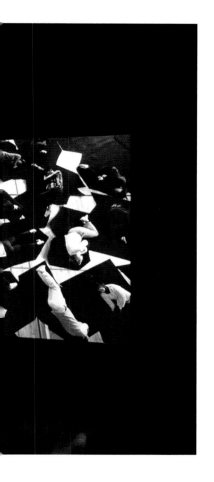

Ham Yangah, *Undefined Panorama 1.0*,
2018-2019, single-channel video, color, sound, 7min. Courtesy of the artist.

Ham Yangah, *Hunger*,
2019, single-channel video, color, sound, 7min. Courtesy of the artist.

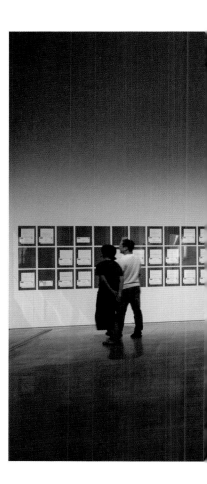

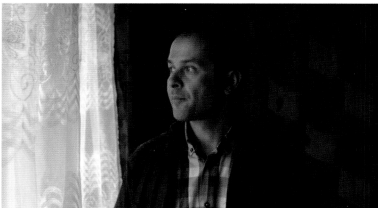

Eric Baudelaire, *Letters to Max*,
2014, single-channel video and 74 letters, 103min. 12sec. MMCA collection.

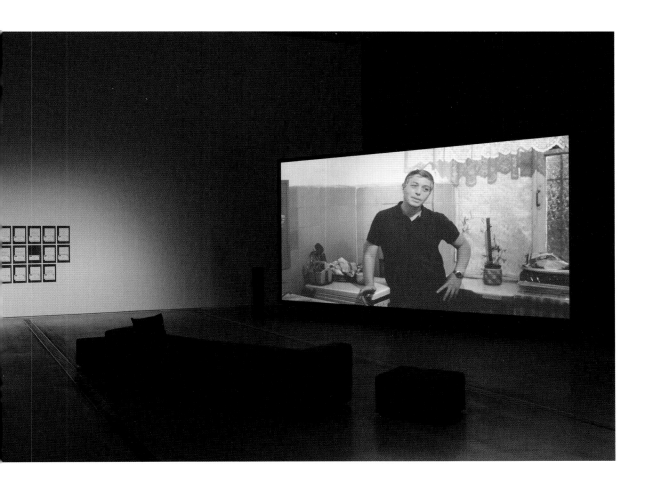

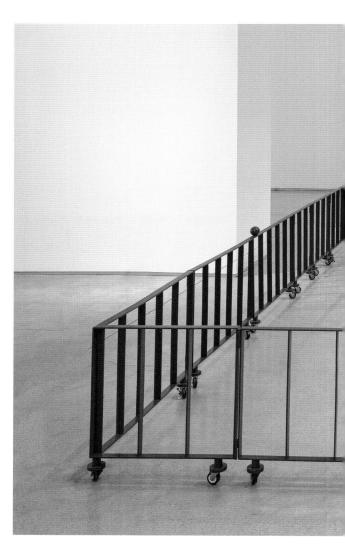

Chung Seoyoung, *East West South North*,
2007, steel, wheel, dimensions variable. MMCA collection.

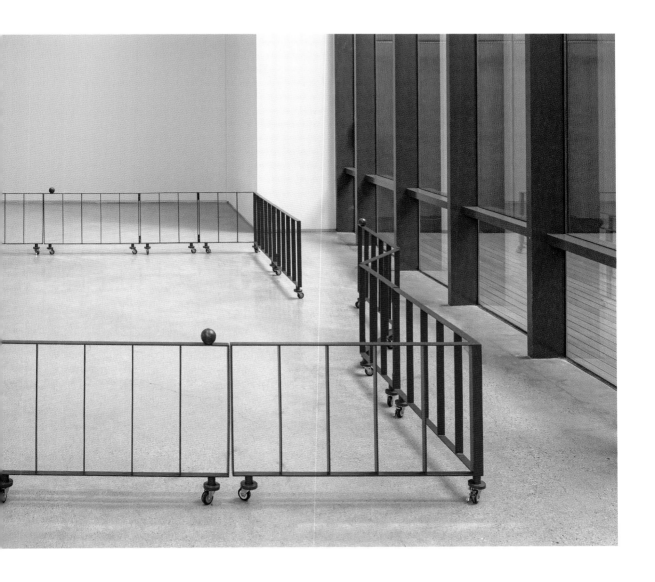

Hong Seung-Hye, *BAR*,
2019, furniture, graphic. Courtesy of the artist.

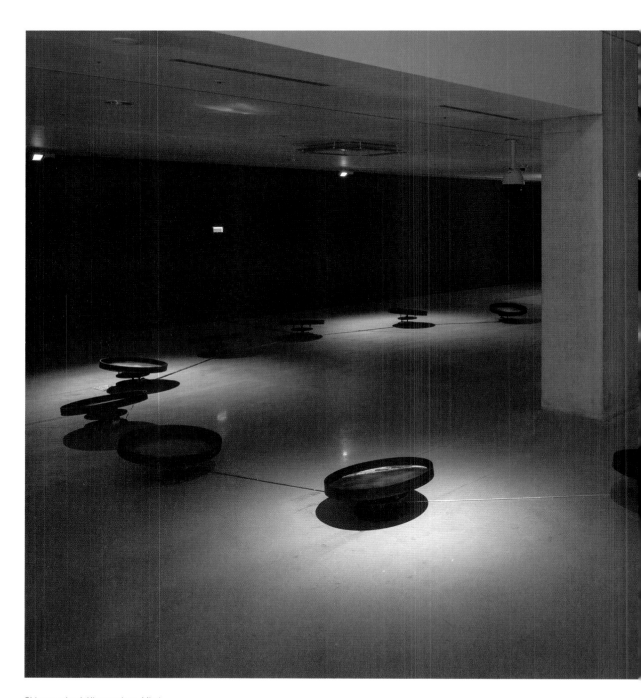

Shinseungback Kimyonghun, *Mind*,
2019, Mechanical ocean drum, microcontroller, sea simulation, facial emotion recognition-network camera, computer,
smartphone, dimensions variable. Courtesy of the artist.

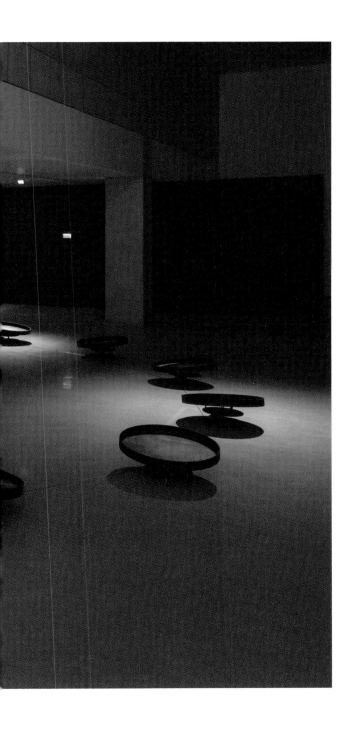

The Square: Emergence of Bodies and Politics of Art

Yang Hyosil*
Art critic

Most public streets and squares are designed and built with the intention of enhancing the mobility of motor vehicles and pedestrians. On certain special days, however, they are transformed to a place for festivals, rallies, and demonstrations, and become a temporary space where various groups- whether conservative or radical-visualize their collective identity and solidarity through specific rituals and in their own styles. Occasionally, ordinary rallies and gatherings are declared illegal, which then emergently occupy the space through violence. For a seemingly random incident to spark an uprising or a revolution like an accelerated version of the butterfly effect, it requires sizeable squares or open streets. Protests and revolutions of our time are made into media spectacles, represented through high-angle shots of a mass of citizens in tens of thousands or millions. By nullifying and erasing the myriad differences between the people involved in these gatherings, such images serve to homogenize the events themselves.

Much like films and novels, recordings of mass protests have now acquired their own recognizable grammar of visual and narrative elements: Hundreds of people gather in a square; excessive force is used against them by the police, which in turn draws even more people to the square; in the midst of it, some people are injured or killed. Through this process, the event loses its status as a natural occurrence; "we" (i.e., the people on our side) are not gathered by nature, but rather as a type of performance. Since repetition inevitably spawns differences, our slogans and marches take on a certain visual and linguistic style. As politicians latch onto the citizens' cause, the capacity to subvert the system increases exponentially. The authorities' use of tanks, tear gas, or water cannons against unarmed citizens is soon to be seen as a foolish or cruel response. In due time, of course, we realize that the new system that has emerged from the revolution is strikingly similar to its predecessor. But in the meantime, we will mindlessly traverse the streets and squares until the next revolution.

Revolutions are well known to us. Representational frames of media once again attest to the similarities and repetitiveness of the revolutions. But in truth, those who vicariously experience such complex events through the filter of media can never begin to comprehend them. After all, media cannot function without simplifying, standardizing, and homogenizing. In our daily lives, we rely almost entirely on our own senses. To indulge our anger or sense of a noble cause, or in order to either empathize with or denounce the situations of others, we are forced to trust the limiting frames of our

Yang Hyosil, lecturer in Aesthetics at Seoul National University, received her Ph.D. with a dissertation titled "A Study on Baudelaire's Modernity". She translated Judith Butler's *Precarious Life, Giving an Account of Oneself: A Critique of Ethical Violence* and *Parting Ways: Jewishness and the Critique of Zionism*. She has written two books: *Imagination Against Power: A Chronicle of Cultural Movement and Crippled Life, Words of Love* as well as co-authored *Red, Blue and Yellow* and *Transition Theater*.

own vision and perception. Rather than directly seeing events or listening to other people, we trust in the media's portrayal of them. The specificities and singularities of an incident, which might refute our assumptions and shatter the frame, are eroded or erased by the violent aestheticization of political matters, exemplified by the beauty of a high-angle shot. Political assemblies and revolutions, as well as any injuries or fatalities they may incur, are taken hostage by concept (reaction), cognition (symbolization), and reason (judgment). By mechanically injecting what we know into such incidents, we effectively tame them, making them comprehensible, perhaps even enjoyable. These attempts to tame and narrativize difficult events are essential to preserving our sense of self, as well as our daily life and survival. The fatigue of politics is nothing but a banal idiom or an alibi of those who cannot perceive the events themselves and who wish to maintain their desensitized daily life.

After a political incident has been safely consigned to history, our streets and squares return to their everyday functions, hosting festivals, sanctioned protests, and other such events. Similarly, history and our collective memory erase all of the people who were involved with the incident: those who were there when it happened, those who directly experienced it through their bodies, those who united as "we" before the authorities regained control of the space, the agents and wheels of history, and all the anonymous others - people who could be anybody. The experiences, the people, and the sites of a historical event are conceptualized according to abstract intellectual notions. When historicism (based on causality or narrativity) becomes the predominant frame for understanding events, and when people lack the means of testifying and documenting their experiences and solidarity, history becomes a cruel but (or therefore?) enjoyable game, in which those in power swap seats and take turns as winners and losers.

As I write this sentence, I'm thinking about when I should introduce and begin to discuss a type of art that attempts to preserve the space of an incident, to record an incident and its space in a way different from the history-narrative, to faithfully depict an incident that cannot be reenacted, and finally, to support and question its specificity as another medium.

I am currently translating Judith Butler's *Notes Toward a Performative Theory of Assembly* (2015). Through that project, I have learned about some of the unconventional, even bizarre modes of protest that took place as part of the anti-government "Gezi Park protests" that occurred in Turkey in 2013. Having played a key role in the birth of the Republic of Turkey, Taksim Gezi Park in Istanbul is a site with great symbolic significance for the nation. In May 2013, after the government announced plans to construct a large shopping mall in the park, environmentalists led a series of performance protests. Adhering to the requisite script discussed above, the police used excessive force against the non-violent protesters, resulting in injuries and deaths. The antigovernment protests spread far and wide, with citizens

across the nation as well as the Turkish diaspora around the world joined in their cause. Through social media, news of the situation reached the world in real time. With a lot of people arrested, injured, or killed, the situation shifted back and forth between advance and retreat, calm and tension. In the midst of this tug-of-war, at 6:00 pm on June 13, a man named Erdem Gündüz (who later became known as the "standing man") appeared in the square (which was now off-limits to protesters) and began an eight-hour performance in which he simply stood and stared at a large poster of Mustafa Kemal Ataturk, the founder of the Republic of Turkey. All alone, he stood quietly with his hands in his pockets, looking at the area that he was not allowed to enter. The police searched him and his backpack, finding nothing. He was just a kind and harmless person. Soon, the people around him took notice of the "standing man" and began documenting his protest on social media, until he was joined by hundreds of others. For his passive resistance, Erdem Gündüz (who is a choreographer and dancer) received the "M100 Media Award," Germany's most prestigious award for human rights. At the Oslo Freedom Forum in 2014, Gündüz explained his actions in a speech, from which I will quote from at length[1]:

> "In the beginning, my concept was not to deliver a performance. . . . My concern is, what you can say with only the body. Sometimes the attitude of a body may be more meaningful than the attitude of a language. My protest arose from my keen disappointment of the bias of the Turkish media and their failure to report the protest in Gezi Park and Taksim Square in a correct and objective way I wanted to demonstrate my respect to the principles and ideas of Mustafa Kemal Ataturk, the founder of the Turkish republic. His concept was 'Peace at home, peace in the world.' . . . Nobody had told me before that this was a form of silent protest that this was a performance, or activism, or 'artivism.' . . . A few hours later, people began to form the reproduction of the Standing Man, like pop art. Soon it became clear that this was . . . a reaction against the media institution. . . . I was there like a medium that transferred the social conscience back to society itself. I felt pain in my chest for my country. I wanted to reach Taksim Square, so I passed the zone forbidden by the police, and I entered alone, as if I were a tourist. . . . And there I realized that it would be a significant action standing there. And from that moment everything worked automatically for me. . . . I did not go there to do something powerful. Only after standing, I realized that this was the right time and right place to do something. At that time I could not imagine how it would grow. People have shared on Facebook and Twitter. . . . Others joined the action of continuing to stand still. . . . Sometimes I have the feeling that I have to do something. We have to do something before the reason comes. Because when the reason comes, it will be already too late to do

something. . . . My individual protest of a dancer was able to remind the world about the power of art and the way it's used. . . . It was a way of creating empathy and awareness of the situation among people. . . . On this day, I felt the need to do something, and my body did. We have to do something before the reason comes."

In this speech, Gündüz seems to be trying to answer the question, "What can art do?" But listening to his description, it sounds as if art is already doing something. According to Gündüz, his performance was enacted not by him, but by his body. It was guided purely by the senses, rather than by reason, as if he were but an unwitting accomplice. Rather than a tool manipulated by consciousness, the body becomes a mere vessel, or a medium, thus veering off the path of judgment, intention, and choice. By simply standing still and calmly breathing, Gündüz presented a human being as an animal or object, resulting in a consoling form of anger and frustration. But this was not an angry protest against prohibition, but rather a demonstration of self-restraint that transformed the space into a performance stage. Thus, what began as the act of one dancer immediately blossomed into a collaboration, as some 300 people joined Gündüz's performance-protest that day.

As described in his speech, Gündüz felt that this response resembled the self-replication of pop art. This interpretation invokes the politicization of pop art, particularly the emergence of bodies that were formerly deemed powerless. The interpretation and translation of a person's previous actions is central to the politics of discourse. But in attempting to explain unconscious actions with words, we must remember that language is not a neutral container, but an implement of power. Thus, such attempts are perpetually in danger of succumbing to standardization and homogenization. This is why we must be vigilant to continuously rewrite the context and conditions of revolutions once their narratives have been deconstructed. In doing so, we must note the difference between the conventional notion of people gathering in a square to fight and win, and the new concept of people gathering in a square to emerge and be together. There are numerous stories to support this difference, but we need more. In both his actions and words, Gündüz provides one such story, while also demonstrating the possible connection between art and politics.[2]

Perhaps he also provides the final answer to that cynical question, "What can art do?" The answer, of course, is that art has always been doing something. For some, however, this leads inevitably to the next question: What good is it for people to just stand together, doing nothing? But that question can only be asked by someone who has never had such an experience, who is inclined to be a passive observer, or who is captivated by conditions, rather than experiences. Such questions can be met with attempts to persuade but can also be dismissed as mere cynicism. By connecting the body as the tool of reason and the body as the area with

2. Gündüz's protest was later replicated by various bodies: a woman who stood at the site where the police had killed a citizen; women and men who stood to commemorate dissidents who had been killed in Turkey; a man who stood and read Kafka; and others.

the right to defy reason, Gündüz revealed the performativity of the body. Thus, the body is transformed from the medium of performance into the medium of protest in the square. The subsequent multiplication of this medium-body represents the emergence of corporeality that escapes from the automaticity or narrativity of revolutions, or the manifestation of the Other and the remnants of revolutions. As both the creator and interpreter of the performance, Gündüz apprehends the novel role of art in the politics of discourse. If art is an experience that cannot be subsumed into the existing narrative of revolution or everyday life, it may mean that art is an exceptional medium, as the actual site through which we receive experience and sensation. If so, the politics of art may have the power to overcome the fatigue of actual politics, the depression of history, and the desensitization of everyday life.[3]

The Square: Art and Society in Korea 1900-2019 is a special exhibition to commemorate the fiftieth anniversary of the opening of the National Museum of Modern and Contemporary Art. It consists of three parts, to be held respectively at the Seoul, Gwacheon, and Deoksugung branches of the museum. The curator of this part (i.e., at the Seoul branch) of the exhibition is Lee Sabine, who is fully aware of the fatigue or sarcasm surrounding "the politics of the square." Nonetheless, she presents several compelling works that demonstrate how, by documenting the performativity of the body, the politics of art can undermine the control of reason and unveil new possibilities for the square. Most of the works in this exhibition lack any built-in grammar of understanding or empathy, and thus resist simple interpretation. In this way, the square is linked with works characterized by ambiguity and ambivalence, rather than clarity and simplicity. Rather than being placed in or subsumed by the square, the exhibited works seem to stand side-by-side with the square, thus reminding us that what we experience in the square is equality (albeit temporary), the extinction of hierarchy, and the sharing of senses.

For example, the people featured in Yokomizo Shizuka's photography series Stranger agreed to participate after receiving a letter from an unknown artist (i.e., Yokomizo), who asked for their permission to photograph them through their front window at an appointed time. The resulting images expertly deconstruct the hierarchical structure of photography, in which the flash of the camera is the pivotal moment. By granting her subjects control of the images, Yokomizo disowns her authorship and puts parentheses around the sovereignty of the artist. In this case, the subject's performativity and control is linked to a classic act of voyeurism, placing us as viewers in an ambiguous position. Through the repeated instances of this uncertain encounter between strangers who are equally exposed, we arrive at the square of only one person: Yokomizo Shizuka.

In her own photography series Departure, Joo Hwang captures women whom she met in airports, waiting for their plane to depart. These women

3. "When the Turkish government in the summer of 2013 banned assemblies in Taksim Square, one man stood alone, facing the police, clearly "obeying" the law not to assemble. As he stood there, more individuals stood "alone" in proximity to him, but not exactly as a "crowd." They were standing as single individuals, but they were all standing, silent and motionless, as single individuals, evading the standard idea of an "assembly" yet producing another one in its place. They technically obeyed the law forbidding groups from assembling and moving by standing separately and saying nothing. This became an articulate yet wordless demonstration." Judith Butler, ibid., 169.

spend their lives shuttling back and forth between different countries (i.e., territories), unable to settle or find attachment in their daily lives. Having already experienced multiple cultures, norms, and times, these women exemplify the obscure and ephemeral existence of art. Forever stuck "in-between," they inherently deny the nationalist demand for individuals to declare a single identity. Unlike the travelers pushing carts overloaded with bags, packages, and luggage–a common sight in any airport today– these women travel light, packing their entire lives into small carriers. As such, they become a compelling symbol of the burdens associated with the contemporary ideology of identity.

Another work of note is *One Pyeong House Between Tides*, in which Song Sung-jin attempts a peculiar cultural translation (rather than a straight reproduction) of a Rohingya refugee camp, addressing a crisis that remains almost unknown in Korea. Song combines the concept of a "*pyeong*", representing the abstract and replaceable nature of economic terms, with the vulnerability of a refugee camp that he directly experienced. As such, the work is susceptible to ethical concerns about thematizing the pain of others. From a distance, the small house on a tidal mudflat looks like an attractive and enjoyable work of art, but anyone who visited the house would immediately realize that it–like life itself– could be swept away at any moment. Balancing poetics and practicality, this temporary structure simultaneously represents the possibilities and the doubts of art. If art is to subsist despite the abundant pain and misery of the world, it must focus on the artist, much like this unstable house, which exists in perpetual limbo between construction and destruction, between appearance and disappearance.

As the curator of this exhibition, Lee Sabine engaged the artists and works in the spirit of the square, promoting a shared strategy of refusing to speak clearly. Thus, the central question of the exhibition–"Where is the square for art?"–remains open. In these works, the politics are vague, the relationship is persistent, the situation is clear, and the senses are desperate. If the current square has been submerged in spectacle, drowning any attempts at shared meaning, then perhaps the time has come to create a new square, rather than continually trying to salvage the old one. At this point, it seems that the inclination towards the supremacy of reason in representation is as powerful as ever. In accordance, most people remain pessimistic or cynical about the capacity of art to challenge the perceived effectiveness or economic feasibility of reason. In the wake of a "History," in which almost everything has been tried and has failed, in which political creatures occupied a square and cried out for justice, art is now an attempt or a medium to manifest the equality of the body and its senses. Indeed, the question (or more aptly, the suspicion) of "what art can do" is inevitably linked to the ongoing appropriation and consumption of art as a monument, commodity, official record, and institution. Nonetheless, we can at least find hope in the fact that

such questions (and suspicions) persist. Moreover, we can draw courage from the existence of these works and artists. Although sensing their imminent failure, they show us how this closed space of a museum can poetically and practically serve as a square, although it may not be named as such. Visitors are sure to experience these works of narrowing and widening the distance between art and the square as instances unto themselves.

New Discourses on Art Museums as the "Square"

Lim Jade Keunhye

Senior Curator, Head of Exhibition Team 2, National Museum of Modern and Contemporary Art, Korea

1. "Creating a new museum definition - the backbone of ICOM," ICOM website, accessed August 15, 2019, https://icom. museum/en/activities/standards-guidelines/museum-definition/

New Definitions of a Museum: ICOM

Having originated in a much different world from our own, museums have evolved according to the demands of their respective time and place. Today's museums must continuously transform themselves to keep pace with advancing technology, compete with new media and institutions, and adapt to our rapidly changing cultural and socio-political conditions. In this environment, the members of the International Council of Museums (ICOM) have started to urge that the fundamental purpose and the roles of the museums/galleries be redefined.

According to ICOM's standing definition, a "museum is a non-profit institution" that "acquires, conserves, researches, communicates and exhibits the tangible and intangible heritage of humanity and its environment for the purposes of education, study and enjoyment." For almost sixty years, this definition, which has been only slightly modified from the original published in 1961, has served as the basic guideline for establishing, operating, and classifying museums around the world. At the 2016 ICOM General Conference in Milan, however, participants proposed the need to review and update this definition. To that end, a new Standing Committee was appointed and charged with collecting and reviewing new definitions from the member museums around the world, to propose a new definition based on its findings. In July 2019, the committee submitted its proposal to be voted upon at ICOM's next Extraordinary General Assembly (EGA) in September. The new definition reads as follows:

Museums are democratising, inclusive and polyphonic spaces for critical dialogue about the pasts and the futures. Acknowledging and addressing the conflicts and challenges of the present, they hold artefacts and specimens in trust for society, safeguard diverse memories for future generations and guarantee equal rights and equal access to heritage for all people.

Museums are not for profit. They are participatory and transparent, and work in active partnership with and for diverse communities to collect, preserve, research, interpret, exhibit, and enhance understandings of the world, aiming to contribute to human dignity and social justice, global equality and planetary wellbeing.[1]

Interestingly, the voting was postponed due to opposition mainly from various Western European nations, including France, Germany, Italy, and Spain, all of which had created the early archetype of modern museums mainly from artworks and artifacts pillaged during the Age of Imperialism. In particular, these Western European member institutions (which represent a core contingent of ICOM) claimed that the new definition was too ideological.[2] Due to their criticism, the voting on the new definition is deferred indefinitely. Nonetheless, this episode shows the collective awareness of the need for change in the future.

This argument about the definition of a museum can be seen as the result of recent contemplations on how museums can perform their public role within our rapidly changing society without losing their social significance. Some in the field have suggested that this debate shows the divide between old and new generations, or between the Anglosphere and Europe. Among museums of contemporary art, with their relatively short history, recent discourse has included criticisms of the branding of large museums (especially in the wake of the 2008 global financial crisis), of the reliance on blockbuster exhibitions that create an unsustainable "bubble," and of the prioritizing of economic concerns over humanity's common problems. By examining the primary topics of discourse among leading museums since the global financial crisis, this article imagines how museums can evolve into new public squares, as polyphonic spaces characterized by diversity and coexistence.

New Discourses on the Museum: Verbier Art Summit and L'internationale

Emphasizing human dignity, social justice, global equality, and planetary wellness, the newly proposed definition seems to be aiming for political correctness. This shift may be the result of ICOM's self-examination and determination to restore certain values that have been neglected in the past few decades, as more museums have focused on economic and neo-liberalist concerns. The museum bubble began in the 1990s, driven by the blockbuster exhibitions and global expansion of museums such as the Guggenheim. Thomas Krens, representing such a trend, however, is no longer considered a model museum leader. Some now recognize the need to carefully reconsider the performance-driven management and evaluation of museums and galleries that rely on architectural expansions and increasing attendance.

That being said, when it comes to facing these issues, museums that primarily deal with contemporary art show a more progressive attitude than traditional museums do. At least many contemporary museums have recognized that certain global problems—such as economic crises, climate change, and the reemergence of nationalism—are direct threats to the survival of humanity, and have formed international organizations and programs

2. Vincent Noce, "What exactly is a museum? Icom comes to blows over new definition," *The Art Newspaper*, accessed August, 15, 2019, https://www.theartnewspaper.com/news/what-exactly-is-a-museum-icom-comes-to-blows-over-new-definition

with the goal of discussing agendas and creating action plans. Despite some differences in the detailed logic and methodology, their direction follows the same overall attitude represented by the new definition proposed by ICOM. In 2013, for example, the Verbier Art Summit (named for its location of Verbier, Switzerland in the Swiss Alps) was established as an "international platform for discourse in a non-transactional context."[3] Founded primarily by art collectors and artists with ties to Verbier, the group's honorary members include architect Rem Koolhaas; artists such as Tino Sehgal, Olafur Eliasson and Anicka Yi; and directors of Western European museums, such as Daniel Birnbaum, Beatrix Ruf, and Nicholas Serota.

The Verbier Art Summit holds an annual conference at the beginning of each year to discuss relevant issues of the art field; thus far, the topics have been "(de)growth" (2017), virtual reality (2018), politics (2019), and the environment (2020). In particular, the 2019 theme was "Art, the Political and Multiple Truths," which focused on the recent right-wing movements represented by Donald Trump's presidency in the US and Brexit in the UK. That summit was organized in partnership with museum director Jochen Volz of Pinacoteca de São Paulo, Brazil, who explained "In these times of increasing uncertainty, [we have seen] the erosion of democratic principles, and manipulation through biased social and conventional media…I propose to explore themes that have been present in artistic and institutional practices for decades, but that have gained additional urgency in recent years: concepts of many histories, of plural forms of knowledge, and of contradicting narratives and multiple truths."[4] This explanation shows Volz's understanding of art's social role in helping to draw attention to global problems and to imagine alternative ways of living.

Another group that has been leading the production and implementation of alternative museum discourses has been L'internationale, which was founded in 2009 by seven modern and contemporary art institutions in non-English speaking regions: Moderna galerija (MG+MSUM, Ljubljana, Slovenia); Museo Nacional Centro de Arte Reina Sofía (MNCARS, Madrid, Spain); Museu d'Art Contemporani de Barcelona (MACBA, Barcelona, Spain); Museum van Hedendaagse Kunst Antwerpen (M HKA, Antwerp, Belgium); Muzeum Sztuki Nowoczesnej w Warszawie (Warsaw, Poland), SALT (Istanbul and Ankara, Turkey), and Van Abbemuseum (VAM, Eindhoven, the Netherlands). Based on the collections and archives of these seven members, L'internationale has been actively producing online platforms for research, debate, and communication.

Notably, the group was named after the workers' International, showing its affinity for the international labor movement and commitment to enact a more equitable and democratic society. According to their official website, L'Internationale "serves as an apparatus for making visible the standardisation of individual and collective beings, and defends the critical imagination of art as a catalyst for concepts of the civic institution,

3. "Connecting Innovators," *Verbier Art Summit*, accessed August 15, 2019, https://www.verbierartsummit.org/mission

4. "2019 *Verbier Art Summit* Reflections and Findings," Verbier Art Summit, February 2019, https://docs.wixstatic.com/ugd/fe121c_884b76503c6d4ef891b994dbf595cce1.pdf

citizenship and democracy.… It defends a concept of common heritage that is based on interconnected archives and collections, and it brings together those who view legacy as an active tool in the processes of individual and collective emancipation.… [It] challenges the way globalising art institutions replicate the structures of multinational powers and the streamlined, centralised distribution of knowledge."[5]

Although Verbier Art Summit and L'internationale operate in different ways with different members and goals, they share a belief that artistic insight and imagination are needed to address the global crises brought on by neo-liberalist globalization. Museums today, as a bridge between contemporary art and society, are realizing that the field of art must take up a new social role beyond driving the market and increasing investment values. This awareness can be seen in the emergence of relational aesthetics, art activism, and collective activities.

5. "About L'internationale", *L'internationale*, accessed August 15, 2019, https://www.internationaleonline.org/about

6. Rosalind Krauss, "The Cultural Logic of the Late Capitalist Museum" (1990) in Claire Bishop, *Radical Museology* (Köln: Walther König, 2014).

New Relationships and Spatial Changes: Tate Modern

Since the 1980s, when the British Prime Minister Margaret Thatcher made major budget cuts to welfare and public funds, museums in the UK have had to rely more on donations and corporate sponsorship. This trend was exacerbated in 2010, when the Conservative Party took power and made further cuts to public funds for art. Given the recent flow of capital, it is becoming more difficult to distinguish between the public and private sphere. Hence, it is not uncommon for curators or directors of renowned museums to move to commercial galleries, or for a former art dealer to be appointed as a museum director. Moreover, it is also becoming difficult to differentiate art fairs, biennales, and museum exhibitions. As Rosalind E. Krauss presciently predicted thirty years ago, we are now seeing museums devolve into "populist temples of leisure and entertainment."[6]

During his term as director of Tate, Nicholas Serota opened Tate Modern in 2000, the museum's Tank performance spaces in 2012, and the new Tate Modern building in 2016. All of the steps were taken with the goal of expanding the museum's space for public programs and collection display. As Serota explained, these changes were made not based on principles aligned with post-capitalism and neo-liberalism, but rather in accordance with the evolving demands of visitors. Discussing these choices, Serota wrote that the "concept of the museum is in constant evolution, driven forward by a combination of curatorial vision, artistic innovation, and the demands of audiences. The first challenge for the museum of the 21st century is to create spaces that accommodate the way in which artists wish to work, and to develop programmes for these spaces that reflect the public's desire for a more active engagement with the art."[7]

Since the economic crisis of 2008, the status of performance art has been steadily rising, such that it now represents the mainstream in the art scene. The rise of performance art exemplifies the combination of "curatorial vision, artistic innovation, and the demands of audiences" that Serota mentioned. Not coincidentally, it was the performance works that collected the Golden Lion award at the last two Venice Biennales (2017 and 2019). Tino Sehgal suggested that the rise of performance art might be related to the capacity of a performance to create a temporary community, thereby allowing people to engage in more physical and substantial forms of communication unmediated by electronic media.[8] In the twenty years since its opening, Tate Modern has observed a major change in the audience's expectations and behavior, and it has updated its policies and expanded its facilities in accordance with the new form of social interaction.

Taking Olafur Eliasson's 2003 *Weather Project* installation in the Turbine Hall at Tate Modern as the representative example of "a profound shift in the expectations and behaviour of audiences in museums," Nicholas Serota stated that the "unanticipated performative aspect" from the audiences led to later exhibitions in the Turbine Hall by artists such as Carsten Höller, Doris Salcedo, Superflex, and Tania Bruguera.[9] In addition, the 2012 launch of the museum's Tank performance spaces was accompanied by the newly commissioned program BMW *Tate Live*, in which performances are live-broadcast on the web for viewers around the world to watch.

Moving a step further, in 2016, Tate Modern opened its new building shaped like a pyramid. The building was designed with the specific goal of providing a space for self-development and learning through participation, rather than mere appreciation and observation, encouraging visitors to contemplate and explore their identity and relationship with the world and the others. Further strengthening the museum's social role, the Tate Exchange programs have carried out various social activities geared towards learning, debating, and creating.
Based on the understanding that knowledge of art should be shared, rather than unilaterally transferred from experts to the general public, Tate's programs have placed a strong emphasis on collaborations and new partnerships with institutions in different fields. Nicholas Serota also wrote, "[A]t a time when the cohesion of society is threatened by visible inequalities in wealth, housing, health, and education, the museum can provide a place in which ideas can be tested and new solutions proposed."[10] Through its reforms over the last twenty years, Tate is leading the push for museums to take on larger social roles as public institutions, a strategy aimed at improving the future of humanity by reconnecting museums with their respective societies.

7. Nicholas Serota, "The 21st Century Tate is a Commonwealth of Ideas," Size Matters! (De)Growth of the 21st Century Art Museum (London: Koenig Books, 2018).

8. Tino Sehgal, "Bring People Together," *Size Matters! (De)Growth of the 21st Century Art Museum* (London: Koenig Books, 2018).

9. ibid., Serota.

10. ibid., Serota.

New Art History and Local Narrative:
Hamburger Bahnhof Museum and L'internationale

11. Claire Bishop, *Radical Museology: Or What's Contemporary in Museums of Contemporary Art?* (Köln: Walther König, 2013).

In response to social changes, various museums have been updating their physical facilities with new spaces and programs for enhanced communication and participation. Some of the most significant changes are taking place in the area of research-based contents. For example, major Western museums such as Tate Modern and Guggenheim have begun to research and collect art from Asia and the Global South. In the summer of 2018, Hamburger Bahnhof Museum für Gegenwart hosted Hello World, an exhibition highlighting non-Western art and trans-culture, intended to move beyond the Western focus of the museum's collection. In terms of methodology, the exhibition was organized to enable each work to serve as the beginning of its own narrative, rather than existing as a chapter in the linear development of art history. More than 200 works from the Nationalgalerie were supplemented with about 150 works loaned from other museums and institutions in Germany, along with 400 artworks, magazines, and documents from international collections. This huge exhibition was developed by thirteen curators within and outside the museum, each of whom independently developed one of thirteen themes. Deviating from certain art movements or styles and exploring the mutual interaction and collaboration between Western and non-Western cultures, the exhibition shed new light on blind spots that have been excluded from conventional art history, thus presenting new directions for the narrative of art in the era of globalization.

Reactions and evaluations of the exhibition were mixed. While many people praised the museum's effort to challenge the Western-centric nature of art history by focusing on non-Western art, other critics disparaged the exhibition's "all-inclusive" global narrative as an extension of cultural imperialism. In her book *Radical Museology: Or What's Contemporary in Museums of Contemporary Art?*, Claire Bishop describes three European museums that have taken more experimental, less architecture-driven approaches to improving political participation: Van Abbemuseum (VAM, Eindhoven, the Netherlands), Museo Nacional Centro de Arte Reina Sofía (MNCARS, Madrid, Spain), and Moderna galerija (MG+MSUM, Ljubljana, Slovenia). For Bishop, the efforts of these three museums provide an alternative to the predominant demand for larger and more expensive events that represent the "one-percenters," rather than the interests and history of marginalized, alienated, and oppressed constituencies.[11]

Notably, all three of these museums are members of L'internationale. As such, an examination of the group's literature can help to reveal their shared orientation. In *The Constituent Museum: Constellations of Knowledge, Politics and Mediation: A Generator of Social Change* (the second publication by L'internationale), John Byrne wrote that museums play a crucial role

in nurturing the social imagination of the future, while also stressing that a new model for fluid, flexible, and cooperative institutionalization is necessary to prevent such concepts from becoming merely symbolic and utopian rhetoric. Byrne further emphasized, "'Becoming Constituent' is not simply a process in which museums attempt to simply 're-brand' existing relationships between art, institutions and publics-they are already sites in which constituencies gather to make sense of, and re-imagine, their local, national and international urgencies and common needs."[12]

In her book, Bishop discusses how Charles Esche, who has been the Director of Van Abbemuseum since 2004, has creatively integrated archives and resources into exhibitions, thus positioning the museum as a narrator of history that focuses on the "social value of retelling histories that lead to other imagined futures, by revisiting marginal or repressed histories in order to open up new vistas."[13] Meanwhile, under Director Manuel Borja-Villel since 2008, Museo Nacional Centro de Arte Reina Sofía has been more critical of Spain's imperialist history, thus locating Spanish history within a much broader international context. For example, rather than explaining Picasso's *Guernica* (1937) in terms of the Cubist art movement, the museum's current display highlights the socio-political and historical context of the painting by displaying it alongside archive materials that had previously received little attention, such as posters, magazines and documentary paintings from the Spanish Civil War. Rejecting the prevalent views of the uniqueness of the avant-garde and the status of artworks as the derivatives of the art movement, Director Borja-Villel instead presents artworks as relational and educational objects capable of psychologically, physically, socially, and politically liberating people. Based on this philosophy, the museum has been supporting anti-government groups in South America, archiving their materials, preserving copies, and forming solidarity with social movements through education programs.[14]

Finally, there is the example of Zdenka Badovinac, director of MG+MSUM (Moderna galerija and Museum of Contemporary Art Metelkova, Ljubljana, Slovenia) since 1993. Since the dissolution of her former nation of Yugoslavia, Badovinac has been focusing on two particular themes: how to represent the new nation state, and the trans-national cultural production of global contemporary art. Seeking new ways to represent the history of Yugoslavia and to contextualize its relationships with Western Europe and the former Soviet Union, the museum's War Time exhibition was organized not chronologically, but thematically, in order to emphasize the Yugoslav Wars of the 1990s. Through such self-examination, MG+MSUM forged a new connection with political activism through archive projects related to Eastern Europe, Bosnia, performance art, and the Museum of Punk. Comparing such attempts to rearrange history and art production into temporary and manifold narratives, rather than trying to reduce the "constellation" (in the sense of Walter Benjamin) of global art into a single

12. John Byrne, "Becoming Constituent," in *The Constituent Museum: Constellations of Knowledge, Politics and Mediation: A Generator of Social Change* (Berlin: Valiz, 2018).

13. ibid., Bishop.

14. ibid.

narrative, Bishop asserts that museums can function as archives of commons, rather than simple storehouses for noble artworks.[15]

15. ibid.

16. Tania Bruguera, "Introduction on Useful Art," published on April 23, 2011, www.taniabruguera.com

Contemporary Museums as the New Public Square

In 2019, Cuban artist Tania Bruguera produced an audience participatory work about the global migration crisis, which was presented at Tate Modern (sponsored by the Hyundai Commission). Bruguera wrote "*Useful Art* is a way of working with aesthetic experiences that focus on the implementation of art in society where art's function is no longer to be a space for 'signaling' problems, but the place from which to create the proposal and implementation of possible solutions."[16] Speaking on behalf of artists pursuing activism, Bruguera's view reflects the growing perception that art should function as a practical and theoretical tool for social and political change, rather than a mere symbolic system. In the work, visitors lie down on the floor of the massive Turbine Hall, and their body heat exposes a portrait of a young Syrian refugee that is concealed in the floor. With the participation of London residents, Bruguera highlighted local activism in support of refugees and human rights, thus placing a key global issue in a more immediate context. The resulting work represents an excellent model for the aforementioned trends of using the museum space to form new relationships and seeking to revise art history by incorporating local narratives.

Even though the voting was postponed, the new definition proposed by ICOM that "museums are democratising, inclusive and polyphonic spaces" represents the current discourse taking place in contemporary museums. In resistance to neo-liberalism, xenophobic nationalism, and the prioritization of economic values, more museums are indeed seeking to become polyphonic spaces where diversity and differences collide and coexist. These changes reflect our anticipation of the new social role of museums as spaces where we can contemplate the future vision, values, and ethics of humanity. Museums of the future must incessantly question, contemplate, and renew the universal human values that fall outside the purview of economic or political concerns. Rather than acting as shrines honoring revered artworks and upholding the mainstream art history, museums are changing into the new public square, characterized by the convergence of multifarious voices and cultures. Today's museums must listen carefully to the stories coming from the square in order to form local narratives and communicate them with the world.

The public's awareness of museum discourses is proportional to the expectations for and interest in the museum's social roles as public institutions. In South Korea, where major art museums are national and government institutions, museums have long been perceived merely as belonging to the realm of government cultural policies. However, there

has been an increasing call for Korean museums to fulfill their social responsibility to imagine and enact the future vision for humanity. In order to do this, South Korean museums must transcend state-led museum policies to participate in the development of global museum discourse, with the aim of contributing to common goals. For a museum to successfully reflect regional characteristics and meet local expectations while satisfying the "global standards", it must begin by stepping out of the isolation in the closed room into the public square, telling its own stories in its own voice.

2. Museum, Square and Theater

Is the Public Square Possible?

Sung Yonghee

Curator, National Museum of Modern and Contemporary Art, Korea

1.Giorgio Agamben "What is the Contemporary," *What is an Apparatus? and Other Essays*, trans. David Kishik, Stefan Pedatella (Stanford: Stanford University Press, 2009), 41.

The Square: Art and Society in Korea 1900-2019 commemorates the 100th anniversary of the March 1st Independence Movement Day and the 50th anniversary of the 1969 opening of the Museum of Modern and Contemporary Art Korea. This exhibition provides an opportunity for us to reflect on the important role that public squares have played in the modern and contemporary history of Korea in relation to the social role of today's art. Sharing the themes of the exhibition at MMCA Seoul, *The Square: Art and Society in Korea 1900-2019*, Part III, <MMCA Performing Arts 2019> introduces three performances that contemplate and question the contemporary public square.

Contemporary public square

What expectations and criticism can be raised about a public square? Likewise, what expectations and criticism can be raised about similar social public spheres, such as museums and theaters?

The three performances in the part III of the exhibition—*Ten Journeys to a Place Where Nothing Happens, The Non-Present Performer, and A Theater for an Individualist*—examine the contemporary public square. The term "contemporary public square" proposes to not only reflect the social and political achievements and roles of the public square in Korean society, but also to examine the changes in today's perspective towards the public square, as well as its internal contradictions and ruptures.

The combination of the temporal expression "contemporary" and the spatial expression "public square" appears rather contradictory, yet this combination suggests that a square not only signifies a specific physical location, but also refers to important occurrences and the consequent alterations in perspectives. "Contemporary public square" in this sense becomes a "phase difference" and a "time difference." Giorgio Agamben defines contemporariness as "a singular relationship with one's own time, [one] which adheres to it and, at the same time, keeps a distance from it. More precisely, it is that relationship with time that adheres to it through a disjunction and an anachronism."[1] Thus, the word "contemporary" acts as a starting point to question whether we can still retain the existing public square and at the same time generate a critical distance to it. Such

contemplations on the contemporary public square will consequently raise questions about other public spaces, such as museums and theaters.

2. Slavoj Žižek, *Blasphemous Thoughts: Islam and Modernity*, trans. Seongmin Bae (Seoul: Geulhangari, 2015), 33.

Disintegrated public squares, museums, and theaters

The "public square," or more precisely, "gathering" in a public square, is always ideological. In general, a gathering in a public square is an act of articulation with a specific purpose; this collective articulation always presumes a listener. What is important is that the listener of this articulation always exists outside of the public square. The setting of the boundary between the "listener who does not want to listen" on the outside, and the "exclusive speaker who articulates for one's self-conviction" on the inside makes a public square a paradoxical place. A public square always creates a clear division between the inside and the outside, and it fails to mediate the two. Although the gathering in a public square advocates solidarity, it is in itself exclusive and contradictory. A public square is a display of power, an exposure of segregation, and a separation of inside and outside. As such, the public square has become another stage (spectacle), and we have become its audience, just like in a theater or museum.

Today, a public square is no longer a space for resistance and struggle against an absolute power; rather, it is a space of social "conflict" where multiple perspectives and interests mix and collide. Once considered a sacred place where massive absurdities–dictatorship, for instance–could be criticized, and justice achieved, a public square today exists as a disintegrated space. Such a non-proprietary aspect of today's public square reveals the inherent conflicts of our society. In this sense, the public square becomes reflective. As it embodies the irreconcilable internal contradictions of any given society, a public square becomes, in and of itself, the (im)possibility of a society, a sign that shows no society can exist as an intact society.

If we consider a public square and a museum as spaces of "impossibility" that contain inherent contradictions and conflicts, it will no longer require an external target to win over or to flaunt in front of, nor will it be necessary to incorporate large masses, posters violently visualizing the message, or speakers projecting harmony and victory. However, the public square, in reality, reveals itself as quite the contrary. The public square is exploited to expose all types of discrimination and hostilities. Moreover, gatherings in public squares are becoming the target of hatred. Liberalists who once believed that all opinions can be articulated, and that different opinions and conflicts are inevitable in any society, can no longer defend their creed. Slavoj Žižek claims that "tolerance is to tolerate the intolerable"[2] and criticizes weak-minded liberalists for antagonizing and fearing certain gatherings and solidarity. Fake liberalists are afraid in advance that their beliefs will be infringed upon and, in turn, attack others' "public squares," as if in self-

defense. If that is the case, can contemporary public squares/museums/
theaters have the courage to resist the lure that liberalism so easily slips into?

Another criticism raised against the contemporary public square is that
many of its consisting elements—even conflict and hatred—are capitalized.
Likewise, compromises also become the target of commodification. Boris
Groys says compromise is indispensable "because it alone can bring peace
between the conflicting parties, and thus preserve the unity of the whole
society."[3] An important factor that he points out is that compromise, unlike
paradox, is established through the mediation of money. By accepting the
truth of the other, one receives an economic compensation. Eventually, the
logic of the public square, such as conflict, compromise, and gathering,
become tightly linked with capitalist returns.

In a capitalist society where we can hardly find a sanctuary that is yet
to be appropriated as a commodity, the most difficult task an artist faces
is to find art that counters such commodification. It is precisely this task
that is taken up by the performances *Ten Journeys to a Place Where Nothing
Happens and The Non-Present Performer*. Their strategy is to adopt a certain
sense of passivity, such as a lack of content, indifference, idleness, fatigue,
ennui, paralysis, and submission to another's will. Alternatively, it could
be to incorporate an attitude of passive activity, similar to that of the title
character from Herman Melville's *Bartleby, the Scrivener*—a potentiality that
will not be carried out—or to keep the boundary between passivity and
activity ambiguous, makes them indiscernible from each other.

The idle public square and its possibility

The public square and the theater bear intriguing similarities. Theaters have
always been an attempt to form or strengthen a social bond, a community
uniting the audience and the stage.[4] However, in today's society, theaters
that try to create a solid audience community by establishing an illusory
universe and a conclusive message based on representation, narrative, and
drama, find themselves unable to function. As its title implies, *A Theater
for an Individualist* refers to this impossibility. This impossibility similarly
applies to a public square. A public square that presumes concepts like "unity",
"solidarity," and "community" no longer exists in reality. Just like theaters
that dream of integration are disappearing, public squares that dream of
integration are also disappearing; museums are also dreaming of integration.

> "There is a promised expectation in a theater (public square). It's
> a forlorn expectation longing for a community. All that remains
> in a theater (public square) is the illusion and the necessity that a
> community (an audience) has created."[5]

3. Boris Groys, *The Communist
Postscript*, trans. Thomas H. Ford
(New York: Verso, 2009), 21.

4. Hans-Thies Lehmann,
Postdramatic Theatre, trans. Karen
Jürs-Munby (Abingdon/New York:
Routledge, 2006), 21.

5. A quote of Hans-Thies Lehmann,
from an excerpt from the interview
between Lehmann and the theater
director Rene Pollesch. (Screened in
Seoul March 27, 2012). The concept
of a square has been juxtaposed
with the concept of theater.

Nonetheless, what possibility does a disaggregated public square and a disintegrated performance have?

"[Today] the audience (participant) finds something missing when coming out from a theater (public square). The theater (public square) betrays [the expectation of a community.] What is promised is not given. Precisely here lies the possibility of the theater (public square)."[6]

Lehmann tries to find this possibility in the minimum condition of a performance to exist, namely in what he calls the "real gathering." For him, "the qualitative gathering based on heavy bodies" stands as the last remaining element of theater after its disintegration- its last possibility. Could this characteristic of a performance, the aesthetic act itself, as well as the act of reception that takes place as a real moment in the here and now, in other words, the physical relationship or the immediacy of the communication, provide the reason of a gathering or activate the politization of a public square?[7] The three performances will deliberate and challenge this possibility in their own way. A Theater for an Individualist will specifically experiment with the concept of the body, which has recently been facing its technologically accelerated transformation, by bringing it into the theater, the space for "heavy bodies."

The contemporary public square will no longer be a place for empathy, solidarity, messages, and outcomes. Rather, it will be a purposeless space of contradiction, politics, and rupture. This void space will enable a volatile community, an idle community, or a community for those who have lost a community. In this space, the audience can free oneself from the responsibilities of participation or the boundaries separating the artwork and become a temporary, yet natural component of the performance. Before we know it, the public square becomes a park, just like in *Ten Journeys to a Place Where Nothing Happens.*

"When you go to a park, people are sitting still. Then they start to laugh, chat, run, and walk. Then they become quiet again. On the grass field of the park, people find their position and naturally adjust the distance between each the other, without the help of any roads, signs, or fences. When a running child trips over, people say 'ouch,' and show their concern, saying 'Is he okay?' If the child springs back up and runs off again, they smile. Everyone is sitting apart but can create a common interest, if necessary. If necessary, they can do something together. Of course, such a situation rarely happens."[8]

6. Hans-Thies Lehmann, ibid. The concept of participants has been juxtaposed with the concept of audience.

7. Hans-Thies Lehmann, op. cit., 17.

8. Boseon Shim, *Although Such Situation Rarely Happens*, VOSTOK magazine Vol.9, (Seoul: VOSTOK Press. 2018), 12.

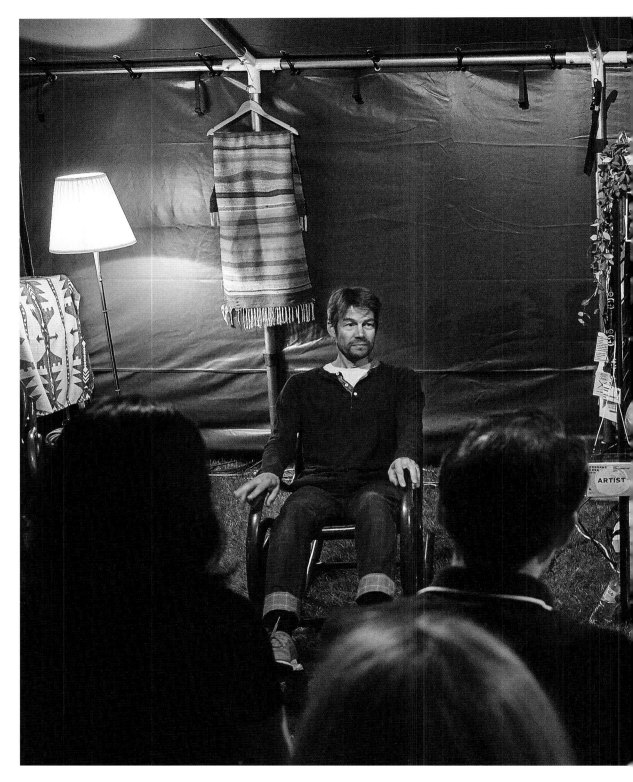

Juha Valkeapää, Taito Hoffrén, *Ten Journeys to a Place Where Nothing Happens*,
Performance, Jongchinbu Madang, 90min.

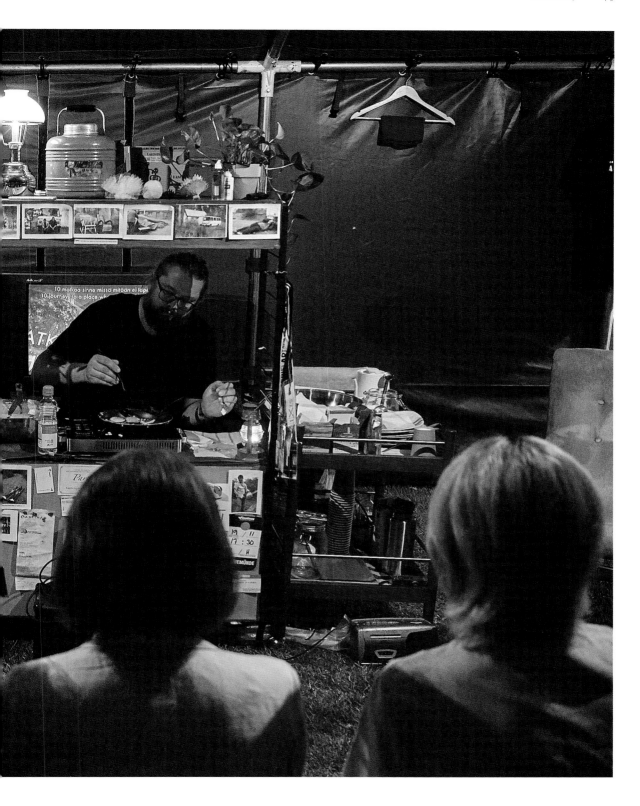

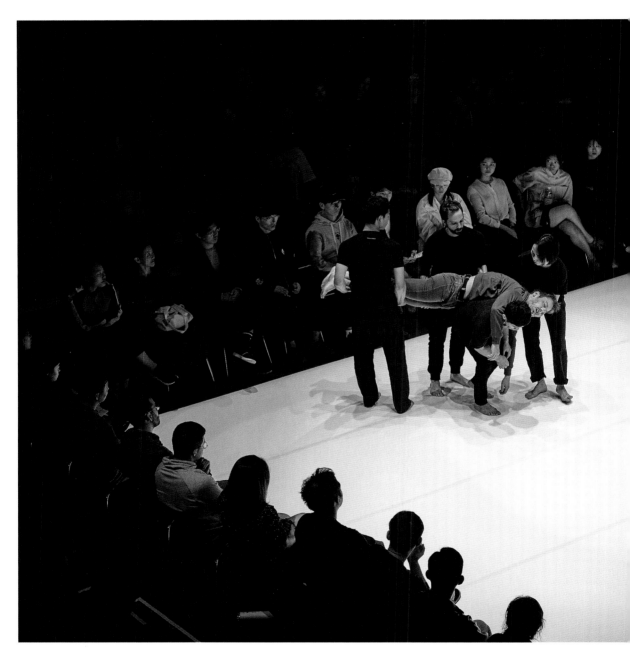

Karel van Laere, *The Non-Present Performer*,
Performance, Multi-Project Hall, 60min.

ROOMTONE, Lee Jangwon, Jeong Seyoung, *A Theatre for an Individualist*,
VR performance, Multi-Project Hall, MMCA Creation.

The Evaporation of the Real and the Creation of a Nonconforming Theater Space

Lee Kyungmi*

Theater Critic

1. Hannah Arendt, "What is freedom?," *The Portable Hannah Arendt*, Ed. Peter Baehr (New York: Penguin Putnam Inc., 2000), 441-447.

According to Jacques Lacan, the Real, which exists outside the Symbolic order as its absolute negation, can never be represented through a symbolic sign or a language despite the strong human desire to do so. It can only be experienced somewhere between frustration, that which occurs at the moment of recognizing such an impossibility, and passion, which is somehow simultaneously reignited. The basis for the Real to have both the power to destroy and to sustain the order of reality stems from this ambivalence.

If this is the case, what is the Real that we desire? For what purpose are we enduring the precarious present? Does a desirable Real even exist anymore? We live in a world today where a community of justice and fairness seems so distant, while society seems to be restlessly reeling from confrontations and conflicts between uncompromising extremes. We stand in the middle of a future that has never arrived, in the middle of a public square that quakes from the despair and anger of those who do not have a place or share in society. These nervous and raucous waves penetrate a theatre's walls and can even be felt inside the theater itself. The theater opens its doors once more and looks at the world outside. It is time for the theater to find a new language, a new perspective from which to respond to the world again.

Betrayed Aspirations, The Disappearing Public Realm

Hannah Arendt claims that freedom cannot remain as an inner feeling to be experienced in the inward space; it can only be achieved when an individual is able to express oneself through speech and action in front of others. This is why it is crucial to politically secure the "public realm"-a space where different people can gather.[1] For Arendt, the existence of a secure public realm functions as a dividing line between totalitarian and democratic societies.

Over the centuries, the theater and public squares are one of the most symbolic public realms that humans have considered to be essential in protecting their rights as members of a community, and have therefore tried to protect through countless crises. Most notably, the ancient Greeks gathered in the Agora to exchange their thoughts on the democratic ideals of the polis and on the value of human beings. They also visited theaters, and through the stories of the mythical world delivered by the chorus in

* Theater scholar and theater critic. Ph.D. in German Language and Literature at Korea University and studied at University of Düsseldorf. Based on the question of 'theatricality,' Lee is currently exploring the 'aesthetics of the space in between,' created when performing arts leaps over the established boundaries of genre. At times, she takes the role as a dramaturg, seeking ways of contact between theory and practice.

the orchestra, they could reflect on the present and the ideal future of the polis and the role of human beings at its center. In these spaces filled with distinctive, collective energy, people made physical contact with each other or encountered artistically mediated forms through which they shared their commonly desired Real, examined the present state of the community, and reflected upon themselves as members of it.

Ever since freedom and equality became two of the most important values to be realized or sought after, and whenever politics has failed to meet the desires of people yearning for a greater democracy, or even tried to suppress such desires, public squares have filled with the voices of angry citizens. Such voices erupted and reached their height during the past 150 years. Over this time, the theater became a political space that created a direct and instantaneous form of communication that revealed the collision between imperative values and the forces interrupting their realization, thereby calling audiences for cathartic solidarity towards a community. It is not an overstatement to say that humanity's struggle for freedom, equality, and justice has gone hand in hand with the struggle to keep public spaces and the theater intact.

Yet, since the beginning of the 21st century, a revolution seems ever-more impossible. Those who once desired common values are leading more and more myopic and self-centered lives, failing to think beyond their own desires and benefits. Meanwhile, we are agitated by the fears, anxiety, despair, and anger that have found no outlet. We are currently witnessing the victory of nationalism over globalism, and the advent of a new Cold War. The tension between nations is reaching new heights every day. To make things worse, politics has become not only lethargic but even blatantly so. The only goal for politicians seems to be winning elections and maintaining the present regime easily aligning themselves with populism. However, what shakes us the most in this given situation is neither despair nor anger, but a sense of loss-the loss of all faith in ourselves and the world. Even more worrying is that despite the initial feeling of outrage and frustration against the injustice and violence that undermine and destroy our everyday life, the repeated exposure to such terrors and disasters makes us easily forget the shock and fear they bring about in us.

In the end, the yearning for the Real beyond the reality that arose in public squares and theaters as an attempt to create a frame for an imperfect reality, proved that our world was functioning "normally." Today, as Arendt would have said, the public realm is disappearing-even in democratic countries. The public square, in particular, has long been shattered, occupied by specific powers or by those who clamor for self-conviction. In other cases, the public square has become a place of suppression where the police erect high fences to monitor citizens or even perpetrate indiscriminate violence upon them. If not, it has become a park or a playground filled with mediocre events.

Slavoj Žižek claims that we should not mistake this frightful, unsettling reality as another repetition of fiction. It is important to discern the Real in what we experience as fiction, and to detect the "rational strategists" behind it.[2] Zygmunt Bauman offers a similar line of thought. The only start of a therapy against the prevalent and liquid fear that is rising and ultimately incapacitating, is "to see through it" and to "see down to its roots."[3] We live in a time where it is imperative to be aware of our senses, and look clearly at the world for what it is. It is time for theaters to yet again seek an answer.

Looking Away!

As its etymological root "theatron"(a place for viewing) suggests, a theater is a place where the act of showing and viewing concurrently occur. It is not a simple space to exhibit something; instead, it is a space for affection, where bodily contact ignites instantaneous communion. People have always gathered in theaters to spatialize not only the visible but also the invisible in numerous languages of their own. In addition, they have shared communal values through the immediacy that can only occur in a theatrical space. When Shakespeare said, "all the world's a stage," he was also suggesting the close connection of the theater and the world, like mirrors of each other. At times, theaters put this mirror up straight, at others, they move it to the left, right or upside down, and sometimes they even shatter the mirror itself. This was an attempt by theaters to spatialize the shape of the world and our senses towards it. Essentially, the history of theaters is a collection of all these things.

However, each of the languages created in this process of writing, erasing, shattering, and turning seem no longer valid today. At every moment of our lives, the evils, clashes, and disasters occurring outside of the theater easily transgress the narrative of anxiety and despair that people inside theaters once presumed. Film screens and television monitors provide a much more dramatic and realistic spectacle of terrifying disasters and horrors that stimulate people's senses. Whatever the theater shows, whichever ideal solution it proposes, for those who are enduring a daily routine of disasters, there is nothing more than a hollow message.

The German philosopher Martin Seel suggests two broad ways of how we perceive an object, our environment, or people. The first is to make a perception based on the qualities inherent in the subject, and the second is to establish a particular perspective of perception after encountering the sudden "appearance" of the subject's unique aspect(s). Referring to the latter as an "aesthetic experience," Seel explains that such an experience becomes stronger when it is impossible to understand the subject in the way we are accustomed to understand it, making this encounter all the more confusing and baffling.[4] Such an experience only occurs when something is not there

2. Slavoj Žižek, *Welcome to the Desert of the Real*, (New York: Verso, 2002), 19.

3. Zygmunt Bauman, *Liquid Fear* (Cambridge: Polity Press, 2007), 177.

that should be there, when something cannot be seen that should be seen, or when something cannot be heard that should be heard. Hans-Thies Lehmann also emphasizes this kind of experience and calls it the "present of true theater (Gegenwart des Theaters)."

> The present is always a departure from the present. To create the present is to deprive it of the present, to break its continuity, and to apply shock to it. To slow down the speed, to escape the norms and create 'incredible' bodies or psychological distance, or to encounter a moment that requires something beyond a simple understanding; all of these aspects show that the present of the theater is produced through interruption, repetition, and retardation.[5]

The "present" Lehmann is referring to is different from the notion of "liveness" that theaters have presented up until now. Nor is Seel's "aesthetic experience" the same as the so-called cathartic experience created through representational mimesis. Rather, it is an experience of shock that is created by twisting and tearing down a familiar subject or discourse, or the experience of absence that occurs when these actions are not taken. This "presence" and "experience" is important because this very "emptiness" –the vacuum created when what used to be there is no longer there, what used be seen cannot be seen, what used to be heard cannot be heard–is the prerequisite for the audience to become an active self, someone who steps out to see, listen, and decide for oneself. In this space of nothingness, the audience starts to open up their senses in search of things to see and hear.

The "theater here/now" refuses to add another rhetoric of enlightenment in tackling the evaporated Real and the consequential chaos. Rather, it announces its emancipation from every simulacre, leaving a space of absence-the absence of subjects to be seen, heard, and act. In this unmediated space of absence, the audience becomes the subject of one's own story and constructs one's own senses towards oneself and the world. The realism of the theater here/now only becomes possible by making the "present" impossible. The audience is the agent that constructs this realism.

Since 2017, the MMCA Performing Arts program has continued to provide a theater that can share this sort of "experience" and "present" with the audience. For instance, the program invites the audience to an ordinary space in the name of a "performance," and shares with them a state of complete halt or absence by doing nothing (Juha Valkeapää, Taito Hoffrén, Ten Journeys to a Place Where Nothing Happens), or proposes that the audience "sense the senselessness" of a "body mass" that has become a mere object, lacking any sort of autonomous self-determination (Karel van Laere, The Non-Present Performer).

4. Martin Seel, *Aesthetics of Appearing*, Trans. John Farrell (Stanford: Stanford University Press, 2005), 46-47.

5. Hans-Thies Lehmann, "Die Gegenwart des Theaters," *Transformationen*. Theater der neunziger Jahre, Erika Fischer-Lichte/ Doris Kolesch/ Christel Weiler (Hg.) (Berlin: Theater der Zeit, 1999), 18.

From a Space for Theater/Exhibition to a Space for Politics

It is the powers of this world that arbitrarily divide and allocate how the mass should talk, act, and exist. These powers separate the visible from the invisible, set apart speech from noise, and draw the boundary between right and wrong. The community of the powerful who have gathered within this constructed frame raises no doubt about their own legitimacy, rationality, or sense of justice. To solidify its unity, the community has created a duplicate community and forms a front line against it, both of which fiercely struggle with each other. As a result, the closer the "match" is between the two rivals, the more consolidated the communities will become and the longer they will perpetuate. This is one strategy to instrumentalize the discord and conflict presently shaking up this world.

Indeed, many theaters today—not to mention theaters of the past—still attempt to control the senses of the audience. In these same theaters, audiences are pushed even further into a state of passivity than in their everyday lives. When the box office opens, audiences who were mingling out front or in the lobby must line up to receive their tickets and enter the theater separately. Then they have to find their seats. Everything is decided from the beginning: the stage that must be watched, the performer who must appear, the music that has to be heard, even the starting and the ending time of the show. Before the performance begins—as if a sacred ritual—the audience must turn off their cell phones, and food and beverages are strictly prohibited. Also, talking with fellow theatergoers is not allowed, and applause is only permitted at designated moments.

Just as the existence of truly "true" politics is predicated on the availability of a lively space that enables the equal coexistence of various perspectives and values, continued conversations and debates, "true" theaters have to escape from the existing convention that binds the audience in a physical and sensational passivity. Theaters must stop repeating their tautology towards the world and about the world. This is why the theater here/now—stripped from its former artsy, embellished rhetoric—purposely scatters the boundaries of how we perceive the world and define the norm; through a crooked perspective, it peers through the cracks of the outside world.

Once everything is summoned to the theater, the present is removed, and a new space and time come to light, in that very moment, the topography of the presence in the theater here/now gains its "publicness" and "politicality." Here, the politicality is different from the politics that turns the theater into a space that represents a certain political agenda, creating emotional bonds amongst the people gathered there. Rather, it is about urging the audience to become an independent agent of the world to which they belong, without having to rely on any political rhetoric or issues.

Jacques Rancière calls this "the distribution of the sensible" and suggests it as a direction that politics and the arts must head towards.

> "Art is not, in the first instance, political because of the messages and sentiments it conveys concerning the state of the world. Neither is it political because of the manner in which it might choose to represent society's structure, or political groups, their conflicts or identities. It is political because of the very distance it takes with respect to these functions, because of the type of space and time that it institutes, and the manner in which it frames this time and space."[6]

Whether it's the theater or any space outside the theater, the very agent of action must be the individual, the audience member, rather than a certain authority or the stage. This is because every audience owns "the power to translate what she perceives in her own way, to link it to the unique intellectual adventure."[7] Until now, such power was overlooked or even erased. The theater here/now, therefore, rejects any boundaries, borders, or necessary sensory modes previously inscribed in the theater. Rather than adding and exhibiting another fiction or illusion in the name of reality, the theater here/now twists, overturns, or even obliterates the fiction. Alternatively, it makes the audience a subject of their own story and actions.

> "To dismiss the fantasies of the word made flesh and the spectator rendered active, to know that words are merely words and spectacles are merely spectacles, can help us arrive at a better understanding of how words and images, stories and performances, can change something of the world we live in."[8]

The speech and body of the theater here/now is neither a tool of enlightenment that tries to create a perfect, emotional consolidation, nor is it a fancy sign that ornaments itself with self-display and self-amusement. The speech and body of the theater here/now summons what is outside the community by carefully examining the fictions that have filled the interior and the exterior of the theater. Most importantly, rather than taking the audience as fools who only see and hear what is shown and told, the body of the here/now puts the audience as the subject of one's own story, capable of connecting the unknown with one's own knowledge. Therefore, the discomfort created by the crooked perspective of this body looking at the world–and its rhetoric–becomes an affirmative, generative matrix that raises the question of where we should be heading in this world of the evaporated Real. When this body meets the audience, its true politics in the age of the absent Real begins.

6. Jacques Rancière, *Aesthetics and Its Discontents*, trans. Steven Corcoran (Cambridge: Polity Press, 2009), 23.

7. Jacques Rancière, *The Emancipated Spectator*, Trans. Gregory Elliott (London: Verso, 2009), 16-17.

8. Jacques Rancière, ibid, 23.

The list of works for the exhibition

1. The Square: Art and Society in Korea 1900-1950

1. Records of the Righteous

Edited by Cho Woosik,
 Illustrations: Hwang Seongha
Illustrated Life of Choi Ikhyun
1932
Woodcut print on paper
Private Collection

Chae Yongshin
Portrait of Choi Ikhyun
1925
Color on silk
101.4 × 52 ㎝
MMCA collection

Chae Yongshin
Portrait of Jeon Woo
1920
Color on silk
95 × 58.7 ㎝
Private Collection

Chae Yongshin
Portrait of Ko Neungseon
1919
Color on silk
76 × 54 ㎝
Private Collection

Chae Yongshin
Portrait of Oh Junseon
1924
Color on silk
74 × 57.5 ㎝
Private Collection

Chae Yongshin
Yongjin Jeongsa Academy
1924
Color on paper
67.5 × 40 ㎝
Private Collection

Yang Gihun
*Bamboo from the Blood of Patriot
 Min Yeonghwan*
1906
Woodcut on paper
97 × 53 ㎝
Art Research Center, MMCA
 collection

Lee Hoe-yeong
Orchid
1920
Ink on paper
140 × 37.4 ㎝
Private Collection

Lee Hoe-yeong
Orchid
1920s
Ink on silk
115 × 32.8 ㎝
Lee Hoe-yeong Memorial Society
 Collection

Lee Hoe-yeong
Orchid
1920s
Ink on silk
114 × 26.8 ㎝
Lee Hoe-yeong Memorial Society
 Collection

Lee Hoe-yeong
Orchid
1920s
Ink on silk
123.8 × 41.9 ㎝
Lee Hoe-yeong Memorial Society
 Collection

Lee Siyeong, Jeong Inbo
Stamped Seals of Lee Hoe-yeong
1946, 1949
Ink on paper
65 × 32.5 ㎝
Lee Hoe-yeong Memorial Society
 Collection

Lee Eunsook
Autobiography of Lee Eunsook
1966
Ink on paper
Lee Hoe-yeong Memorial Society
 Collection

Lee Siyeong
Calligraphy of Lee Siyeong
1946
Ink on paper
29.5 × 98.5 ㎝
Lee Hoe-yeong Memorial Society
 Collection

Weaponry of *Uibyeong*
 ("Righteous Armies")
Late Joseon
Each length 243 ㎝, 128 ㎝, 84 ㎝
Kyung-in Museum of Fine Art
 Collection

Park Gijeong
*Album of Landscapes and "Four
 Gracious Plants"*
Undated
Ink on paper
Each panel 29.5 × 21 ㎝
Chagang Seonbi Museum
 Collection

Park Gijeong
Plum Blossoms in Snow
1933
Ink on silk
145.5 × 384 ㎝
Chagang Seonbi Museum
 Collection

Park Gijeong
Orchids with Exposed Roots
Undated
Ink on paper
130.5 × 33.5 ㎝
Chagang Seonbi Museum
 Collection

Cho Gisoon
Orchid
1941
Ink on paper
136 × 34.3 ㎝
Private Collection

Park Gijeong
*Ten-Panel Folding Screen of Gold-
 painted Five Gracious Plants*
Undated
Gold-painted on paper
Each panel 102.5 × 32 ㎝
Chagang Seonbi Museum
 Collection

Kim Jinwoo
Bamboo
1940
Ink on paper
146 × 230 ㎝
Daegu&Gyeongbuk Branch, Bank
 of Korea Collection

Jeong Daegi
*Eight-Panel Folding Screen of
 Bamboo*
Undated
Ink on paper
Each panel 94.5 × 31 ㎝
Private Collection

Kim Jinman
*Twelve-Panel Folding Screen of
 Twelve Gracious Plants*
Undated
Ink on paper
Each panel 118.5 × 27.5 ㎝
Private Collection

Kim Il
*Eight-Panel Folding Screen of
 Plum Blossoms*
1936
Gold-painted on cotton
Each panel 85 × 30.8 ㎝
Private Collection

Yoon Yong-gu
*Eight-Panel Folding Screen of
 Orchid and Bamboo*
Undated
Ink on paper
Each panel 135.2 × 32.7 ㎝
Suwon Museum Collection

Song Tae-hoe
Plum Blossoms
1938
Ink on paper
99.5 × 320 ㎝
Songgwangsa Museum Collection

Song Tae-hoe
*Ten-Panel Folding Screen of
 Bamboo*
1939
Ink on paper
Each panel 114 × 34.5 ㎝
Jeonju National Museum
 Collection

Song Tae-hoe
Songgwangsa Temple
1915
Ink and color on silk
100.5 × 57 ㎝
Songgwangsa Museum Collection

Lee Ungno
Bamboo
1978
Ink and color on paper
291 × 205.5 ㎝
Lee Ungno Museum Collection

2. Art and Enlightenment

Daesin Ironworks
Printing Press
1950s
Paju Book City Letterpress
 Workshop Collection

Typesetting of the first page of
 the first issue of *Hanseong
 Sunbo* (Korea's first modern
 newspaper, published by the
 government)
2014
Paju Book City Letterpress
 Workshop Collection

First page of the first issue of
 Hanseong Sunbo (Korea's first
 modern newspaper, published
 by the government)
1883.10.31.
Print on paper
Sogang University Loyola Library
 Collection

Primary School Textbook 1
 (revised edition)
1896
National Library of Korea
 Collection

Edited by Jeong Inho
Primary School Textbook 4 (new
 edition)
1908
Hong Seonwung Collection

Home Magazine (Korea's first
 women's magazine)
1906.10.
Hong Seonwung Collection

Shin Chaeho
General Eulji Mundeok
1908
National Museum of Korean
 Contemporary History
 Collection

Edited by Hyeon Chae
 Illustrations: An Jungsik
Yunyeon Pildok (children's
 textbook)
1907
Art Research Center, MMCA
 collection

An Jungsik
"Bamboo from the Blood of
 Patriot Min Yeonghwan" from
 Daehanjaganghoe Monthly (issue
 8)
1907.2.
Hong Seonwung Collection

Bulletin of Daehan Hyeopoe (issue 1)
1908.4.
National Museum of Korean
 Contemporary History
 Collection

Giho Heunghakoe Monthly
1909.7.
Choi Hakjoo Collection

Illustrations: Lee Doyoung
Flower in Prison (novelization of
 The Story of Chunhyang,
 a famous Korean pansori)
1914
Hong Seonwung Collection

Dohwa Imbon 2 (art textbook)
1907
Art Research Center, MMCA
 collection

Dohwa Imbon 4 (art textbook)
1911
Art Research Center, MMCA
 collection
Lee Doyoung

Lee Doyoung
Mopilhwa Imbon 1 (art textbook)
1915
MMCA collection

Kim Gyujin
Orchid Painting Manual 2
1920
Art Research Center, MMCA
 collection

Kim Gyujin
Bamboo Painting Manual
 (new edition)
1920
Art Research Center, MMCA
 collection

Edited by Baek Dooyong
 *Collection of Letters in Cursive
 Script 1 and 2 (new edition)*
1921
Hong Seonwung Collection

Oh Se-chang
*History of Korean Painting
and Calligraphy* 1, 2, 3, and
Appendix
1917
Ink on paper
Seoul Calligraphy Art Museum of
Seoul Arts Center Collection

Oh Se-chang
*Dictionary of Korean Painters and
Calligraphers*
1928
Private Collection

Cho Seokjin
Carp from *Album of Korean
Paintings*, Compiled by
Oh Se-chang
1918
Color on paper
23.7 × 33 ㎝
Seoul National University Museum
Collection

Lee Doyoung
Crabs from *Album of Korean
Paintings*, Compiled by
Oh Se-chang
1929
Color on paper
20.8 × 33 ㎝
Seoul National University Museum
Collection

Kim Yongsu
Pond from *Album of Korean
Paintings*, Compiled by
Oh Se-chang
Undated
Color on paper
23.7 × 35.7 ㎝
Seoul National University Museum
Collection

Cho Jungmuk
Abalone from *Album of Korean
Paintings*, Compiled by
Oh Se-chang
Undated
Ink and color on silk
21.3 × 23 ㎝
Seoul National University Museum
Collection

Cho Jeong-gyu
Cicada from *Album of Korean
Paintings*, Compiled by
Oh Se-chang
Undated
Ink and color on paper
22.1 × 9.1 ㎝
Seoul National University Museum
Collection

Yang Gihun
Wild Geese from *Album of Korean
Paintings*, Compiled by
Oh Se-chang
Undated
Ink on paper
17.6 × 28.3 ㎝
Seoul National University Museum
Collection

Kim Eung-won, An Jungsik,
Oh Se-chang, Yoon Yong-gu,
Lee Doyoung, Jeong Hak-gyo,
Cho Seokjin, Ji Un-young
*Collaborative Painting by Seven
Masters*
1911
Ink and color on paper
17.5 × 128 ㎝
Seoul Calligraphy Art Museum of
Seoul Arts Center Collection

Ko Huidong, Kim Donhui,
Park Hanyoung, Oh Se-chang,
Lee Doyoung, Lee Gi,
Choi Namseon
Album of Poetry Gathering
1925
Ink and color on paper
18 × 12 ㎝
National Library of Korea
Collection

Oh Se-chang
Rubbings of Korean Artifacts
1948
Ink on paper
119.5 × 38.7 ㎝
Seoul Calligraphy Art Museum of
Seoul Arts Center Collection

Lee Doyoung
*Still Life with Bronze Vessels,
Flowers and Fruits*
Undated
Color on paper
104 × 43.4 ㎝
Ewha Womans University Museum
Collection

Yang Gihun
Bird and Cat
Undated
Ink on paper
87.3 × 32.4 ㎝
Museum of Face Collection

Yang Gihun
Bird and Flower
Undated
Ink on paper
87.3 × 32.4 ㎝
Museum of Face Collection

Yang Gihun
Bird and Flower
Undated
Ink on paper
87.3 × 32.4 ㎝
Museum of Face Collection

Yang Gihun
*Ten-Panel Folding Screen of Wild
Geese*
1905
Ink on silk
Each panel 160 × 39.1 ㎝
National Palace Museum of Korea
Collection

Sign placard for Sinmungwan
Publishing Company
ca. 1908
Ink on paper
66.6 × 22 ㎝
Choi Hakjoo Collection

Boy (issue 1)
1908.11.
Choi Hakjoo Collection

Illustrations: Lee Doyoung
Red Jeogori (children's magazine,
issue 2)
1913.1.15.
Pressum Collection

Cover image: An Jungsik
Children's Readings (children's
magazine, issue 7)
1914.3.
Hong Seonwung Collection

Cover image: Ko Huidong
Youth (issue 1)
1914.10.
Institution of Modern Bibliography
Collection

Cover image: Ko Huidong,
 Illustrations: An Jungsik·
 Ko Huidong
Youth (issue 4)
1915.1.
Institution of Modern Bibliography
 Collection

Youth (issue 15)
1918.9.
Choi Hakjoo Collection

Choe Namseon
*Song for the Seoul-Busan
 Railroad Line*
1908
Choi Hakjoo Collection

*Six-Coin Novel Series: Story of
 Simcheong*
1913
Choi Hakjoo Collection

*The Collected Works of Admiral
 Yi Sunsin* 1 and 2
1918
Choi Hakjoo Collection

Choe Namseon
Choe Namseon's Notebook
1923-1930
Choi Hakjoo Collection

Choe Namseon
Notes for the *Encyclopedia* (from
 Choe Namseon's Notebook)
1920s
Choi Hakjoo Collection

*Advertisement of Joseon
 Gwangmunhoe*
ca. 1910
Print on paper
39 × 265
Paju Book City Letterpress
 Workshop Collection

Map of Korea As a Tiger
early 20th century
Color on silk
80.5 × 46.5 ㎝
Korea University Museum
 Collection

jang minseung
Untitled
2019
23min

Page from *Donga Ilbo* newspaper;
 the Japanese flag has been
 removed from the chest of
 Son Gijeong, Korean who
 won the marathon at the 1936
 Olympics in Berlin
1936.8.25.
The Dong-a Ilbo Collection

No Soohyeon
"Pioneering" from *La Kreado*
 (issue 1)
1920.6.
Art Research Center, MMCA
 collection

La Kreado (issue 13)
1921.7.
Institution of Modern Bibliography
 Collection

Rha Hae-seok
"Pioneer" from *La Kreado*
 (issue 13)
1921.7.
Art Research Center, MMCA
 collection

Creation (issue 2)
1919.3.
Institution of Modern Bibliography
 Collection

New Woman (issue 1)
1920.3.
Choi Hakjoo Collection

Cover image: Kim Chanyoung
Student World (issue 1)
1920.7.
Seoul National University Library
 Collection

Cover image: Kim Chanyoung
Student World (vol. 1, no. 5)
1920.12.
Kwon Hyeok-song Collection

Cover image: Ahn Seokju
White Tides (issue 1)
1922.1.
Seoul National University Library
 Collection

Rha Hae-seok
"Dawn" from *Mutual Aid* (issue 1)
1920.9.
Sogang University Loyola Library
 Collection

Hyeondae (tr. Contemporary
 Times, issue 1)
1920.1.
Choi Hakjoo Collection

Cover image: Oh Ilyoung
Joseon Jigwang (tr. Light of
 Korea, issue 1)
1922.11.
Hong Seonwung Collection

Designed by Ahn Seokju
Sinmunye (tr. New Literature,
 issue 2)
1924.3.
Institution of Modern Bibliography
 Collection

Choe Namseon, Designed by
 Ko Huidong
Journey to the South of Korea
1926
Choi Hakjoo Collection

Choe Namseon
Journey to Mt. Baekdu
1927
Choi Hakjoo Collection

Choe Namseon
In Praise of Mt. Geumgang
1928
Choi Hakjoo Collection

An Jaehong, Designed by
 Lee Yeosung
Journey to Mt. Baekdu
1931
Institution of Modern Bibliography
 Collection

Park Taewon, Designed by
 Jeong Hyeon-ung
*A Day in the Life of Kubo the
 Novelist*
1938
Institution of Modern Bibliography
 Collection

Yang Ju-dong, Designed by
 Yim Yong-ryun, Illustrations: Yim
 Yong-ryun· Baek Namsoon
Pulse of Korea
1932
Institution of Modern Bibliography
 Collection

Yim Hwa, Designed by
 Gu Bon-ung
Korea Strait
1938
Institution of Modern Bibliography
 Collection

Edited and Translated by
 Kim Eok, Designed by
 Kim Chanyoung
Dance of Agony (book of poetry)
1921
Private Collection

Kim Sang-yong, Designed by
 Gil Jinseop
Nostalgia
1939
Institution of Modern Bibliography
 Collection

Jeong Jiyong, Designed by Gil
 Jinseop
Lake Baengnokdam
1941
Institution of Modern Bibliography
 Collection

Lee Taejun, Designed by
 Kim Yongjun
Museorok: Essays of Lee Taejun
1941
Institution of Modern Bibliography
 Collection

Lee Yuksa, Designed by
 Gil Jinseop
Collection of Yi Yuksa's Poems
1946
Institution of Modern Bibliography
 Collection

Jeong Jiyong, Designed by
 Kim Yongjun
*Collection of Jeong Jiyong's
 Poems*
1946
Institution of Modern Bibliography
 Collection

Kim Yongjun, Designed by
 Kim Yongjun
Essays of Kim Yongjun
1948
Private Collection

Cover image: Gil Jinseop,
 Illustrations: Kim Yongjun
Munjang (vol. 1, no. 4)
1939.5.
Art Research Center, MMCA
 collection

Cover image: Kim Yongjun,
 Illustrations: Kim Whanki,
 Gil Jinseop
Munjang (vol. 1, no. 5)
1939.6.
Art Research Center, MMCA
 collection

Cover image: Kim Yongjun
Munjang (vol. 1, no. 10)
1939.11.
Art Research Center, MMCA
 collection

Cover image: Kim Yongjun
Munjang (vol. 3, no. 3)
1941.3.
Art Research Center, MMCA
 collection

Park Taewon, Designed by
 Park Munwon
Scenes by a Stream
1947
Institution of Modern Bibliography
 Collection

Lee Taejun, Designed by
 Bae Jeongguk
*The Complete Works of Lee
 Taejun*
1946
Hong Seonwung Collection

Sul Jeongsik, Designed by
 Bae Jeongguk
Bell
1947
Institution of Modern Bibliography
 Collection

Ko Huidong
Self-portrait
1915
Oil on canvas
61 x 46 ㎝
MMCA collection

Rha Hae-seok
Self-portrait
1928
Oil on canvas
62 × 50 ㎝
Suwon I'Park Museum of Art
 Collection

Gil Jinseop
Self-portrait
1932
Oil on canvas
60.8 × 45.7 ㎝
The University Art Museum, Tokyo
 University of the Arts Collection

Pen Varlen
Portrait of Kim Yongjun
1953
Oil on canvas
53 × 70.5 ㎝
MMCA collection

Kim Yongjun
*Hong Myeonghui and
 Kim Yongjun*
1948
Ink and color on paper
63 × 34.5 ㎝
Milal Fine Art Museum Collection

3. Sound of the People

Cover image: Yi Sang
Voices of People (vol. 1, no. 3)
1929.6.
Institution of Modern Bibliography
 Collection

Okada Tatsuo
Formative Pictorial (issue 1)
1928.10.
Machida City Museum of Graphic
 Arts Collection

Ono Tadashige
Death of Three Generations
 Cover page, 1, 11, 13, 24, 30, 37,
 46, 49
1931
Woodcut on paper
Machida City Museum of Graphic
 Arts Collection

Ono Tadashige
Stage Design for Maxim Gorky's
 The hotel by night
1932
Woodcut on paper
14.3 × 20.2 ㎝
Machida City Museum of Graphic
 Arts Collection

Luo Qingzhen
Qingzhen Woodcuts (vol. 3)
1935
Woodcut on paper
16.6 × 13.1 ㎝
Machida City Museum of Graphic
 Arts Collection

Luo Qingzhen
Three Farmer Women from
 Qingzhen Woodcuts (vol. 3)
1935
Woodcut on paper
16.6 × 13.1 ㎝
Machida City Museum of Graphic
 Arts Collection

Luo Qingzhen
Under a Street Light from
 Qingzhen Woodcuts (vol. 3)
1935
Woodcut on paper
12.2 × 10.9 ㎝
Machida City Museum of Graphic
 Arts Collection

Romain Rolland, Kurahara
 Korehito (trans.)
The People's Theater
1917
MMCA collection

Cover image: Ootsuki Genji
Battle Flag (vol. 2, no. 10)
1929.10.
MMCA collection

Cover image: Yanase Masamu
Battle Flag (vol. 3, no. 1)
1930.1.
MMCA collection

Makimoto Kusuro
*Red Flag-Proletarian Children's
 Song Collection*
1930
MMCA collection

Edited by Li Hua
Modern Prints (issue 14)
1935.12.
Woodcut on paper
Machida City Museum of Graphic
 Arts Collection

Edited by Li Hua
Modern Prints (issue 15)
1936.1.
Woodcut on paper
Machida City Museum of Graphic
 Arts Collection

Cover image: Lee Byeonggyu
Yangjeong (issue 7)
1930
Hong Seonwung Collection

Cover image: Lee Byeonggyu
Yangjeong (issue 8)
1931
Hong Seonwung Collection

Cover image: Choe Seokdu
Road at Dawn (book of poems)
1948
Hong Seonwung Collection

Cover image: Ahn Seokju
Korean Farmers (vol. 3, no. 8)
1927.8.
Hong Seonwung Collection

Lee Gwangsu, Joo Yohan, Kim
 Donghwan, Cover image:
 Ahn Seokju
*Collection of Poems by Three
 Poets*
1929
Art Research Center, MMCA
 collection

Lee Jeong
Landscape with Utility Poles 1
ca. 1947
Woodcut on paper
11 × 16 ㎝
Private Collection

Lee Jeong
Landscape with Utility Poles 2
ca. 1947
Woodcut on paper
13.3 × 14.5 ㎝
Private Collection

Lee Jeong
Print of cover design for *Sky,
 Wind, and Stars* by Yun Dongju
1948
Woodcut on paper
18.3 × 24 ㎝
Private Collection

Lee Jeong
At Daybreak
1948
Woodcut on paper
9.2 × 15.2 ㎝
Private Collection

Lee Jeong
Nightscape
Undated
Woodcut on paper
32.1 × 16.8 ㎝
Private Collection

Jung Hasu
Lee Sang-choon's illustrations for
 the novel *Nitrogenous Fertilizer
 Factory* (reproduced by
 Jeong Hasu)
2019
Woodcut on paper
Each size 60 × 79 ㎝
Courtesy of the Artist

Jung Hasu
Illustrations for "Korea's
 New Theater Movement"
 from *Theater Movements*
 (reproduced by Jeong Hasu)
2019
Rubber print on paper
Each size 45 × 40 ㎝
Courtesy of the Artist

New Boy
1929.12.-1934.4.(20)
Lee Juhong Literary House
 Collection

World of Stars
1930.10.-1935.2.(10)
Lee Juhong Literary House
 Collection

*Fire Star: Proletarian Children's
 Song Collection*
1931
Lee Juhong Literary House
 Collection

The Public (issue 1)
1933.4.
Institution of Modern Bibliography
 Collection

Cover image: Lee Juhong
Criticism (August 1938)
1938.8.
Lee Juhong Literary House
 Collection

Cover image: Lee Juhong
Criticism (October 1939)
1938.10.
Lee Juhong Literary House
 Collection

Eastern Light (December 1931)
1931.12.
Sogang University Loyola Library
 Collection

Cover image: Ahn Seokju
Eastern Light (January 1932)
1932.1.
Sogang University Loyola Library
 Collection

Kurt Runge
Unsoung Pai Tells
1950
Art Research Center, MMCA
 collection

Park Youngchik's copy of
 Webster's Dictionary
Undated
Art Research Center, MMCA
 collection

Photo of Park Youngchik
1920s
Art Research Center, MMCA
 collection

Photo of members of Heungsadan
 ("Young Korean Academy") at
 Eulmildae, Pyongyang
ca. 1918
Art Research Center, MMCA
 collection

Photo of members of Heungsadan
 ("Young Korean Academy") at
 Eulmildae, Pyongyang
ca. 1918
Art Research Center, MMCA
 collection

Park Youngchik's faculty ID from
 Seoul National University
1951
Art Research Center, MMCA
 collection

Permit to reenter the United
 States, issued to Park
 Youngchik
1936
Art Research Center, MMCA
 collection

Operating permit for *A Century of
 Progress* exhibition
1934
Art Research Center, MMCA
 collection

Uraki
1930.6.
Institution of Modern Bibliography
 Collection

Pen Varlen
Kalinino
1969
Etching on paper
50.8 × 84.2 ㎝
Private Collection

Pen Varlen
Yuzhno-Sakhalinsk
1967
Etching on paper
32 × 49.5 ㎝
Private Collection

Pen Varlen
Nakhodka Bay in the Evening
1968
Oil on canvas
100.5 × 79.5 ㎝
Private Collection

Pen Varlen
Family
1986
Oil on canvas
68 × 134 ㎝
Private Collection

Park Youngchik (Charles Park)
Untitled
Undated
Oil on plywood
24.5 × 19.5 ㎝
MMCA collection

Park Youngchik (Charles Park)
Portrait of a Woman
1950s
Oil on canvas
39.4 × 28.7 ㎝
MMCA collection

Yim Yong-ryun (Gilbert Phah Yim)
Crucifixion
1929
Pencil on paper
37 × 32.5 ㎝
Private Collection

Yim Yong-ryun (Gilbert Phah Yim)
Landscape of Herblay
1930
Oil on hardboard
24.2 × 33 ㎝
MMCA collection

Pai Unsoung
Self-portrait in Hat
1930s
Oil on canvas
54 × 45 ㎝
Jeon Chang-gon Collection

Pai Unsoung
Self-portrait
1930s
Oil on canvas
60.5 × 51 ㎝
Jeon Chang-gon Collection

Jeong Jeum-sik
Landscape of Harbin
1945
Pen and watercolor on paper
16.2 × 21.5 ㎝
Private Collection

Jeong Jeum-sik
Landscape of Harbin
1945
Pen and watercolor on paper
12.5 × 19.5 ㎝
Private Collection

Jeong Jeum-sik
Landscape of Harbin
1945
Pen and watercolor on paper
14 × 18.5 ㎝
Private Collection

Jeong Jeum-sik
Landscape of Harbin
1945
Pen and watercolor on paper
13 × 15 ㎝
Private Collection

Jeong Jeum-sik
Landscape of Harbin
1945
Pen and watercolor on paper
14 × 18 ㎝
Private Collection

Jeong Jeum-sik
Landscape of Harbin
1945
Pen and watercolor on paper
19 × 13.5 ㎝
Private Collection

Na Woongyu, Edited by Mun Il
Arirang (film script, 1 and 2)
1930
Arirang Association Collection

Directed by Lee Gyu-seol
Flyer for *Bird in a Cage*
1926
Arirang Association Collection

Flyer for Junganggwan movie
 theater
1924
Han Sang Eon Cinema Institute
 Collection

Chyokeug Weekly (no. 54)
1928.8.18.
Han Sang Eon Cinema Institute
 Collection

Chyokeug Weekly (no. 56)
1928.8.28.
Han Sang Eon Cinema Institute
 Collection

Chyokeug Weekly (no. 67)
1928.10.26.
Han Sang Eon Cinema Institute
 Collection

Edited by Lee Gyu-young,
 Designed by Mun Il
Dansung Weekly (no. 300)
1929
Han Sang Eon Cinema Institute
 Collection

Green Star (issue 1)
1919.11.
Choi Hakjoo Collection

Lee Jongmyeong, Directed by
 Kim Yu-young, Cover image:
 Yim Hwa
Wandering (film script)
1928
Han Sang Eon Cinema Institute
 Collection

Flyer for *Floating Weeds* at
 Joseon Theater
1928.4.5.
Han Sang Eon Cinema Institute
 Collection

Flyer for *Dark Street* at Joseon
 Theater
1928.6.28.
Han Sang Eon Cinema Institute
 Collection

Edited by Park Sichun
*Selected Korean Folk Music:
 Guitar Accompaniment*
1941
Han Sang Eon Cinema Institute
 Collection

Edited by Mun Il
*Short Music Pieces of Korean
 Cinema*
1929
Arirang Association Collection

Lyrics of the Soundtrack *Arirang*
 (sung by Kim Yeonsil)
Undated
Arirang Association Collection

Vacuum tube radio
Japanese colonial era
22.5 × 50 × 22.7 ㎝
Busan Museum Collection

Photo of musicians of
 Nipponophone Company
1913
Han Sang Eon Cinema Institute
 Collection

Directed by Lee Myeongwoo,
 Hong Gae-myeong
Film poster for *Story of Hong
 Gildong* and *Story of Janghwa
 and Hongryeon*
1936
Busan Museum Collection

Directed by Ahn Seokju
Film poster for *Rural Life*
1942
Modern Design Museum

Poster for Choi Seunghee's new
 dance performance
1930s
Modern Design Museum
 Collection

Poster for Choi Seunghee's new
 dance performance
1930s
Modern Design Museum
 Collection

Poster for *Night of Operetta of
 Polydor Records*
1930s
Modern Design Museum
 Collection

Poster for Kim Yeonsil musical
 troupe
1940s
Modern Design Museum
 Collection

Poster for Hyeophwa musical
 troupe
1930s
Modern Design Museum
 Collection

Won Woojeon
Stage design drawings
1930s-40s
Arko Arts Archive Collection

Shin Gosong, Illustrations:
 Jeong Hyeon-ung
Snow White
1946
Institution of Modern Bibliography
 Collection

Kim Youngsu
Blood Vessel
1949
Institution of Modern Bibliography
 Collection

Theater Curtains (issue 2)
1938.3.
Institution of Modern Bibliography
 Collection

4. Mind of Korea

Lee Yeosung
History of Korean Traditional
 Clothing
1947
Art Research Center, MMCA
 collection

Lee Yeosung
Gyeokgu (a Korean game similar
 to polo)
1930s
Color on silk
92 × 86 ㎝
Korea Racing Authority Equine
 Museum Collection

Lee Qoede
Portrait of Lee Yeosung
1940s
Oil on canvas
90.8 × 72.8 ㎝
Private Collection

Lee Qoede
Self-portrait
late 1940s
Oil on canvas
72 × 60 ㎝
Private Collection

Lee Qoede
Portrait of a Woman
1943
Oil on canvas
70 × 60 ㎝
Private Collection

Lee Qoede
Horses
1943
Oil on canvas
60.8 × 59.5 ㎝
Private Collection

Kim Jongchan
Lotus
1941
Oil on canvas
33 × 46 ㎝
MMCA collection

Jin Hwan
Heavenly Peaches and Children
1940s
Crayon on hemp cloth
31 × 93.5 ㎝
MMCA collection

Choi Jaideok
Poplar Trees by the Han River
1940s
Oil on canvas
46 × 66 ㎝
Private Collection

Choi Jaideok
Lookout Hut on Stilts
1946
Oil on canvas
20 × 78.5 ㎝
Private Collection

Lee Insung
Sweet-briars
1944
Oil on canvas
228.5 × 146 ㎝
Private Collection

Kim Whanki
Fruits
ca. 1954
Oil on canvas
90 × 90 ㎝
Private Collection

Kim Whanki
White Porcelain Jars
late 1950s
Oil on canvas
100 × 80.6 ㎝
Private Collection

Kim Whanki
Jar
1958
Oil on canvas
49 × 61 ㎝
Private Collection

Kim Eung-hyeon
An Ode to White Porcelain
1999
Ink on paper
45 × 140 ㎝
Private Collection

Kim Whanki
Jar and Plum Blossom
1958
Oil on hardboard
39.5 × 56 ㎝
Private Collection

Jin Hwan
A Pond
1942
Oil on canvas
24.5 × 66.4 ㎝
MMCA collection

An Seungkak
Refugees
1942
Oil on canvas
72 × 90 ㎝
MMCA collection

Lee Jungseob
Drawing
1941
Pencil on paper
23.3 × 26.6 ㎝
Private Collection

Lee Jungseob
A Boy
1944-45
Pencil on paper
26.4 × 18.5 ㎝
MMCA collection

Lee Jungseob
Three People
1944-45
Pencil on paper
18.2 × 28 ㎝
MMCA collection

Lim Gunhong
Birds in a Cage
1947
Oil on paper
21 × 13.5 ㎝
Private Collection

Kim Mansul
The Liberation
1947
Bronze
70 × 30 × 30 ㎝
MMCA collection

Lim Gunhong
Traveler
1940s
Oil on paper
60 × 45.4 ㎝
Private Collection

Lee Qoede
Announcing Liberation
1948
Oil on canvas
181 × 222.5 ㎝
Private Collection

Lee Qoede
People IV
late 1940s
Oil on canvas
177 × 216 ㎝
Private Collection

Suh Seok
People
1990s
Ink and color on paper
91 × 63 ㎝
MMCA collection

Suh Seok
People
1990s
Ink on paper
173.3 × 183.3 ㎝
MMCA collection

Lee Ungno
*Composition: Paintings from
 Prison*
1968
Ink and color on paper
173.3 × 183.3 ㎝
Lee Ungno Museum Collection

Kim Chong Yung
Sketch for *Monument for
 Declaration of Independence*
 (March 1, 1919)
1963
Watercolor on paper
53 × 37 ㎝
Kim Chong Yung Museum
 Collection

Kim Chong Yung
Part of the Sculpture *Monument
 for Declaration of Independence*
 (March 1, 1919)
1963
Bronze
22 × 38 × 45 ㎝
Kim Chong Yung Museum
 Collection

Hong Seonwung
*Centennial Anniversary of the
 March 1st Movement*
2019
Woodcut on paper
68 × 187 ㎝
Courtesy of the Artist

Lee Ungno
People
1985
Ink on paper
268 × 223 ㎝
Lee Ungno Museum Collection

**2. The Square: Art and Society
 in Korea 1950-2019**

1. Blackened Sun

Jungju An
Ten Single Shots
2013
Six-channel video, B&W, sound
8min. 56sec.
MMCA collection

Jaewook Lee
Red Line #9
2018
Archival pigment print
Dimensions variable
Courtesy of the artist

Kang Yo-bae
The Camellia Has Fallen
1991
Acrylic on canvas
130.6 × 162.1 ㎝
Hakgojae Gallery Collection

Kang Yo-bae
The Beginning
1989
Pen and black ink on paper
38.7 × 53.2 ㎝
Hakgojae Gallery Collection

Kang Yo-bae
Jeju Island
1989
Pen and black ink on paper
38.7 × 53.2 ㎝
Hakgojae Gallery Collection

Kang Yo-bae
*The Woman Divers'
 Demonstration Against the
 Japanese Administration*
1989
Pen and black ink on paper
38.7 × 53.2 ㎝
Hakgojae Gallery Collection

Kang Yo-bae
*The Refugees Coming Down from
 the Mountain*
1989
Pen and black ink on paper
54.4 × 79.3 ㎝
Hakgojae Gallery Collection

Kang Yo-bae
Starvation
1990
Conte on paper
53.2 × 38.7 ㎝
Hakgojae Gallery Collection

Kang Yo-bae
The Liberation
1990
Conte on paper
39 × 55 ㎝
Hakgojae Gallery Collection

Kang Yo-bae
Drought
1991
Conte on paper
34.4 × 51.2 ㎝
Hakgojae Gallery Collection

Kang Yo-bae
A Father Burying His Child
1991
Conte on paper
38.7 × 54 ㎝
Hakgojae Gallery Collection

Kang Yo-bae
*The Demonstration - No Western
 Sweets Stuffs!*
1991
Conte on paper
38.7 × 54 ㎝
Hakgojae Gallery Collection

Kang Yo-bae
Firing
1991
Conte on paper
68 × 52.5 ㎝
Hakgojae Gallery Collection

Kang Yo-bae
A Murderee
1991
Conte on paper
56 × 76 ㎝
Hakgojae Gallery Collection

Kang Yo-bae
The Plaza on the General Strike
1991
Charcoal on paper
43.5 × 77.8 ㎝
Hakgojae Gallery Collection

Kang Yo-bae
Detention
1991
Conte on paper
60 × 97.7 ㎝
Hakgojae Gallery Collection

Kang Yo-bae
Plunder
1991
Conte on paper
50 × 84 ㎝
Hakgojae Gallery Collection

Kang Yo-bae
The Torchlight Parade
1991
Charcoal on paper
76 × 55.3 ㎝
Hakgojae Gallery Collection

Kang Yo-bae
Entering the Mountain
1991
Charcoal on paper
49 × 76 ㎝
Hakgojae Gallery Collection

Kang Yo-bae
Signal Fires
1991
Charcoal on paper
50 × 130.6 ㎝
Hakgojae Gallery Collection

Kang Yo-bae
Attack
1991
Charcoal on paper
55.3 × 152 ㎝
Hakgojae Gallery Collection

Kang Yo-bae
Fabrication
1991
Charcoal on paper
55.3 × 76 ㎝
Hakgojae Gallery Collection

Lee Cheul-yi
Massacre
1951
Oil on plywood
23.8 × 33 ㎝
MMCA collection

Im Heungsoon
Sung Si(Symptom and Sign)
2011
Single-channel video
24min. 24sec.
MMCA collection

Kim Song-hwan
Korean War Sketch - June 28,
1950 Advance of North Korean
Army
1950
Watercolor on paper
16.6 × 20.5 ㎝
MMCA collection

Kim Song-hwan
Korean War Sketch - June
28, 1950 Gunshot from
Jeongneung
1950
Watercolor on paper
19.1 × 25.7 ㎝
MMCA collection

Kim Song-hwan
Korean War Sketch - June 28,
1950 Pale Faces
1950
Watercolor on paper
18.8 × 26.5 ㎝
MMCA collection

Kim Song-hwan
Korean War Sketch - June 28,
1950 The Death of a South
Korean Soldier
1950
Watercolor on paper
17.6 × 24 ㎝
MMCA collection

Kim Song-hwan
Korean War Sketch - June 29,
1950 The Bombing of a South
Korean Fighter
1950
Watercolor on paper
19.5 × 26.4 ㎝
MMCA collection

Kim Song-hwan
Korean War Sketch - June
30,1950 Dead Bodies in
the Yard of Seoul National
University Hospital (Euljiro4-ga)
1950
Watercolor on paper
26.5 × 19.5 ㎝
MMCA collection

Kim Song-hwan
Korean War Sketch - July, 1950
Red Hunt of Bomber B29
1950
Watercolor on paper
18.9 × 13.4 ㎝
MMCA collection

Kim Song-hwan
Korean War Sketch - July 20,
1950 Disposed Bodies at the
Park
1950
Watercolor on paper
17.5 × 25.6 ㎝
MMCA collection

Kim Song-hwan
Korean War Sketch - September,
1950 US Flight Bombing of
Gaeseong Station
1950
Watercolor on paper
18.2 × 12.8 ㎝
MMCA collection

Kim Song-hwan
Korean War Sketch - September
12, 1950 A Hiding Place: Jingol
Inn in Gaeseong
1950
Watercolor on paper
20.1 × 27.5 ㎝
MMCA collection

Jeon Seontaek
Returning to Hometown
1981
Oil on canvas
136 × 230 ㎝
MMCA collection

Park Sangok
Children in the Rear
1958
Oil on canvas
65 × 90 ㎝
MMCA collection

Kim Jae-hong
Father-iron Curtain 1
2004
Acrylic on canvas
162 × 331 ㎝
MMCA collection

Pen Varlen
The Panmunjeom (JSA) for
Ceasefire Talks in September
1953
1954
Oil on canvas
28.1 × 47 ㎝
MMCA collection

Pen Varlen
Repatriation of North Korean
Prisoners of War at Panmunjom
(JSA)
1953
Oil on canvas
51.5 × 71 ㎝
MMCA collection

Lee Seung-taek
History and Time
1958
Wire, painted on plaster
153 × 144 × 23 ㎝
MMCA collection

Park Ko-Suk
Landscape in Bumildong
1951
Oil on canvas
39.3 × 51.4 ㎝
MMCA collection

Kang Unseob
The Night Sky with a Meteor
Early 1950s
Crayon on paper
37.5 × 27 ㎝
MMCA collection

Kim Ku Lim
Death of the Sun II
1964
Oil and object on wood panel
91 × 75.3 ㎝
MMCA collection

Heryun Kim
Yellow River
2009
Oil on canvas
150 × 200 ㎝
SPACE K Collection

Heryun Kim
November
2009
Oil on canvas
150 × 200 ㎝
SPACE K Collection

Heryun Kim
The Barbed Wire
2009
Oil on canvas
150 × 200 ㎝
SPACE K Collection

Heryun Kim
Imjingang
2009
Oil on canvas
150 × 200 ㎝
SPACE K Collection

Heryun Kim
Forbidden Land
2009
Oil on canvas
150 × 200 ㎝
SPACE K Collection

Heryun Kim
Forbidden Sky
2009
Oil on canvas
150 × 200 ㎝
SPACE K Collection

Park Sookeun
Baby
1960
Oil and pencil on silver paper
16 × 6 ㎝
MMCA collection

Lee Jungseob
Children
Undated
Oil on tinfoil
9 × 15.1 ㎝
MMCA collection

Lee Jungseob
Family
Undated
Oil on tinfoil
8.5 × 15 ㎝
MMCA collection

Lee Jungseob
Fighting Fowls
1955
Oil on cardboard
28.5 × 40.5 ㎝
MMCA collection

Lee Jungseob
A Couple
1953
Oil on paper
40 × 28 ㎝
MMCA collection

Lee Jungseob
Children, Fish and Crab
Early 1950s
Watercolor on paper
25.8 × 19 ㎝
MMCA collection

Lee Jungseob
Fishes and Children
Early 1950s
Ink on tinfoil
15 × 9 ㎝
MMCA collection

Lee Jungseob
Landscape of Jeongneung, Seoul
1956
Oil, crayon and pencil on paper
43.5 × 29.3 ㎝
MMCA collection

Park Sookeun
Roofed House at Changsin-dong
1956
Pencil and color pencil on paper
23.1 × 29 ㎝
MMCA collection

Park Sookeun
Grandfather and Grandson
1960
Oil on canvas
146 × 98 ㎝
MMCA collection

Park Sookeun
Girl
1960
Charcoal on paper
57 × 44 ㎝
MMCA collection

Park Sookeun
Birds
1960
Oil on board
10 × 15 ㎝
MMCA collection

Park Sookeun
Roadside Vendors
1962
Oil on canvas
25 × 15 ㎝
MMCA collection

Limb Eung Sik
Job Hunting
1953
Gelatin silver print
50.5 × 40 ㎝
MMCA collection

Sung Dookyung
*In Front of the Bando Hotel on a
 Snowy Day*
1953-1966 (2019)
Digital inkjet print
105 × 125cm (print), 17 × 13.6cm
 (each image)
Ed. 3/10.
Courtesy of the bereaved

Joo Myungduk
*Mixed Names (Holt Orphanage)-
 Biracial Orphan, Photographed
 in 1956*
1986
Gelatin silver print
27.9 × 35.5 ㎝
MMCA collection

Lee Hyungrok
*The Shoe Vendor in the Street,
 Namdaemun Market, Seoul*
1950s/2008
Gelatin silver print
49.3 × 59.5 ㎝
MMCA collection

Chung Bumtai
Series of Seoul Image
1955-1971
Gelatin silver print
45 × 50 ㎝ (15)
MMCA collection

Han Youngsoo
*Bando Hotel, Euljiro 1-ga, Seoul,
 Korea*
1956-1963/2018
Gelatin silver print
50.3 × 40.3 ㎝
MMCA collection

Han Youngsoo
Meongdong, Seoul, Korea
1958/2018
Gelatin silver print
50.3 × 40.3 ㎝
MMCA collection

2. Han-gil (One Path)

Lee Kyusang
Composition
1959
Oil on polywood
65 × 52 ㎝
MMCA collection

Chung Kyu
Church
1955
Oil on canvas
55 × 60 ㎝
MMCA collection

Yoo Young-Kuk
Work
1957
Oil on canvas, dok
MMCA collection

Kim Youngjung
Machinism and Humanitarianism
1964
Pig Iron
133 × 50 × 121 ㎝
MMCA collection

Kim Chong Yung
Legend
1958
Steel
77 × 70 × 65 ㎝
Kim Chong Yung Museum

Oh Jong-uk
Widow No. 2
1960
Steel
72 × 15.5 × 31㎝ (2)
MMCA collection

Kim Whanki
*Where, In What From, Shall We
 Meet Again*
1970
Oil on cotton
205 × 153 ㎝
Private Collection

Kim Whanki
Two Moons
1961
Oil on canvas
130 × 193 ㎝
MMCA collection

Unknown
*Moon Jar-Collection of
 Kim Whanki*
Early 18th century
Porcelain
44.5(h) ㎝
Private Collection

Unknown
*Celadon Vase-Collection of
 Kim Whanki*
The end of the 12th century
Celadon
41.3(h) ㎝.
Private Collection

Chang Uc-chin
Untitled
1975
Marker pen on paper
25 × 35 ㎝
Chang Ucchin Museum of Art
 Yangju City Collection

Chang Uc-chin
Untitled
1975
Marker pen on paper
24.5 × 35 ㎝
Chang Ucchin Museum of Art
 Yangju City Collection

Chang Uc-chin
White and Blue porcelain
1979
Color on White porcelain
24 × 24 × 19.5 ㎝
Han Hyang Lim Onggi Museum

Chang Uc-chin
White and Blue porcelain
1983
Color on White porcelain
19 × 19 × 18.5 ㎝
Han Hyang Lim Onggi Museum

Chang Uc-chin
*A Grayish-blue-powdered
 Celadon*
1977
Buncheong ware
6 × 6 × 7 ㎝
Han Hyang Lim Onggi Museum

Yoo Young-Kuk
Painting on Porcelain
1970s
Color on White porcelain
23 × 23 × 12 ㎝
Gana Foundation for Arts and
 Culture Collection

Lee Sookja
Work
1980
Color on paper
146.5 × 113.2 ㎝
MMCA collection

Marty Gross
Korean Folk Potter
1974/2019
Single-channel, sound
30min.
Courtesy of the artist

Unknown
The *Onggi*
Undated
Onggi
Dimensions variable
Private Collection

Youn Myeong Ro
Tattoo 64-I
1964
Oil on canvas
116 × 91 ㎝
MMCA collection

Kim Hyungdae
Restoration B
1961
Oil on canvas
162 × 112 ㎝
MMCA collection

Kim Chonghak
Work 603
1963
Oil on canvas
95.2 × 144 ㎝
MMCA collection

Kim Tschang-yeul
Rite
1965
Oil on canvas
162 × 130 ㎝
MMCA collection

Park Rehyun
Work
1960
Color on paper
174 × 129.3 ㎝
MMCA collection

Kim Byungki
*View the Nam Mountain with
 Leisure*
1965
Oil on canvas
128 × 71 ㎝
MMCA collection

Song Youngbang
Heaven and Earth
1967
Ink and color on paper
110 × 101 ㎝
MMCA collection

Suh Seok
Twilight on Address No. 0
1955
Ink and color on paper
99 × 94 ㎝
MMCA collection

Suh Seok
Midday
1958-1959
Ink on paper
180 × 80 ㎝
Courtesy of the artist

Choon Choi
Autopsy of the Future
2018
Mixed media
Dimensions variable
Courtesy of the artist

Kim Jiwon
Untitled
1995
Acrylic on canvas
60 × 50 ㎝
Courtesy of the artist

Kim Jiwon
Untitled
1992
Acrylic on canvas
60 × 50 ㎝
Courtesy of the artist

Kim Jiwon
Untitled
1995
Acrylic on canvas
60 × 50 ㎝
Courtesy of the artist

Kim Jiwon
Untitled
1992
Oil on canvas
55 × 45 ㎝
Courtesy of the artist

Kim Jiwon
Untitled
1992
Acrylic on canvas
53 × 45 ㎝
Courtesy of the artist

Kim Jiwon
Untitled
1991
Acrylic on canvas
20 × 25 ㎝
Courtesy of the artist

Kim Jiwon
Untitled
1991
Acrylic on canvas
50 × 40 ㎝
Courtesy of the artist

Korea's First Radio: Goldstar
 A-501 Registered Cultural
 Property No.559-2
1959
National Folk Museum of Korea

Samsung A01a0037 (SW T442L)
 TV
1974
970 × 510 × 685 ㎝
National Folk Museum of Korea

Kim Hanyong
Jinro Brewery Co., Ltd.(Model:
 Han Yoojeong)
1970s
Digital Print, Wood Frame
85 × 65 cm
The Museum of Photography,
 Seoul Collection

Kim Hanyong
Taihan Electric Wire Co., Ltd.
 (Model: Hong Semi)
1970s
Digital Print, Wood Frame
85 × 65 cm
The Museum of Photography,
 Seoul Collection

Kim Hanyong
Hyundai Motor Company
 Poster Advertising Cotina
 (photographed and produced
 with the company's employee in
 a public relations department)
1970s
Digital Print, Wood Frame
85 × 65 ㎝
The Museum of Photography,
 Seoul Collection

Kim Hanyong
New Ramen Poster
 (photographed and produced
 with the company's employee)
1970s
Digital Print, Wood Frame
85 × 65 cm
The Museum of Photography,
 Seoul Collection

Kim Hanyong
Photographed for Oriental
 Brewery Company
 Calendar 1964 (model:
 Choi Mooryong (male),
 Kim Jimi (female)) featured by
 Lee Byungsoo, designed by
 Min Chulhong
1964
Digital Print Wood Frame
85 × 65 cm
The Museum of Photography,
 Seoul Collection

Kim Hanyong
Gold Star Co.,Ltd. Poster (model:
 Yum Hyesuk, featured, text, and
 design by Moon Dalboo)
1970s
Digital Print
Wood Frame
85 × 65 cm
The Museum of Photography,
 Seoul Collection.

3. Gray Caves

Ha, Chong Hyun
White Paper on Urban Planning
1970
Oil on canvas
80 × 80 ㎝
MMCA collection

Choi Myoungyoung
Pen 69-Y
1969
Oil on canvas
161.5 × 129.5 ㎝
MMCA collection

Suh Seung-Won
Simultaneity 67-1
1967
Oil on canvas
160.5 × 131 ㎝
MMCA collection

Kim Tschang-yeul
Untitled
Late 1960s
Oil on canvas
20.5 × 20.7 ㎝
MMCA collection

Kim Chungsook
Half Moon
1976
Marble
30 × 96 × 46 ㎝
MMCA collection

Chung Changsup
Tak No. 86088
1986
Paper on canvas
330 × 190 ㎝
MMCA collection

Shim Moon-Seup
Wood Deity 8611
1986
Wood and steel
114 × 44 × 38 ㎝
39.3 × 128 × 34 ㎝
MMCA collection

Choi Byungso
Untitled
2014
Pen and pencil on newspaper
700 × 80 × 1 ㎝
MMCA collection

Kwon Young Woo
Untitled
1980
Punched paper
163 × 131 ㎝
MMCA collection

Lee Dongyoub
Situation
1974
Oil on canvas
162 × 130 ㎝
MMCA collection

Yun Hyong-Keun
Umber Blue 82-86-32
1982
Oil on canvas
189 × 300 ㎝
MMCA collection

Ha, Chong Hyun
Conjunction 74-98
1974
Oil on hemp cloth
225 × 97 ㎝
MMCA collection

Park Seo Bo
Ecriture No. 43-78-79-81
1981
Oil and graphite on canvas
193.5 × 259.5 ㎝
MMCA collection

Song Soo Nam
Tree
1985
Ink on paper
94 × 138 ㎝
MMCA collection

Quac Insik
Work 63
1963
Glass on panel
72 × 100.5 ㎝
MMCA collection

Quac Insik
Thing and Thing
1975
Korean paper
85 × 85 ㎝
MMCA collection

Lee Ufan
From Line
1974
Stone pigment on canvas
194 × 259 ㎝
MMCA collection

Kwak Duckjun
DUCK in DUCK
1997
Single channel video
10min.
MMCA collection

Kwak Duckjun
Meter Series
1970/2003
Meter, stone
125 × 38 × 58 ㎝
MMCA collection

Kwak Duckjun
Twelve Clocks
2001 (Reproduced in 2003)
Clocks
32 × 32 × 4.5 ㎝ (12)
MMCA collection

Le Thanh (Lê Thanh)
*Clique of International
 Reactionaries Black Plots.
 (Against Communist Humanity)*
Undated
Watercolor on paper
78 × 55 ㎝
Fukuoka Asian Art Museum
 Collection

Nguyen Dinh Lan (Nguyễn Đình
 Lân)
U.S. Power
1972
Watercolor on paper
66 × 53.5 ㎝
Fukuoka Asian Art Museum
 Collection

Nguyen Dung (Nguyễn Dũng)
VN, a Battle, a Victory.
1975
Watercolor on paper
54 × 79 ㎝
Fukuoka Asian Art Museum
 Collection

Tran Tuy (Trần Túy)
*We Swear an Oath to Protect our
 Father Country.*
1972
Watercolor on paper
64 × 44.5 ㎝
Fukuoka Asian Art Museum
 Collection

Mian Ijaz-ul-Hassan
Thah
1973
Oil on canvas
121.5 × 183.3 ㎝
Fukuoka Asian Art Museum
 Collection

Le Thanh Tru (Lê Thanh Trừ)
*Transporting Ammunition (Tải
 đạn)*
1975
Lacquered wood
59 × 84 ㎝
Vietnam National Fine Arts
 Museum Collection

Nguyen Vinh Nguyen (Nguyễn
 Vĩnh Nguyên)
*This is the land of our ancestor
 (Đất này của tổ tiên ta)*
1970
Lacquered wood
70 × 113.5 ㎝
Vietnam National Fine Arts
 Museum Collection

Le Quoc Loc (Lê Quốc Lộc)
*Passing the mountain slope (Qua
 dốc miếu)*
1974
Lacquered wood
39 × 159.5 ㎝
Vietnam National Fine Arts
 Museum Collection

Hoang Tram (Hoàng Trầm)
*Female militia fighters of the Ngu
 Thuy troop (Dân quân gái Ngư
 Thuỷ)*
1974
Lacquered wood
90 × 120 ㎝
Vietnam National Fine Arts
 Museum Collection

Le Thanh Tru (Lê Thanh Trừ)
The soldiers are back (Bộ đội về)
1973
Lacquered wood
60 × 120 ㎝
Vietnam National Fine Arts
 Museum Collection

Tran Huu Te (Trần Hữu Tê)
*Reading newspapers for the
 veterans (Đọc báo cho thương
 binh)*
1975
Silk painting
60 × 91.5 ㎝
Vietnam National Fine Arts
 Museum Collection

Dao Duc (Đào Đức)
*Resting on the side of the Vinh
 Linh trench (Bên chiến hào Vĩnh
 Linh)*
1970-1971
Silk painting
47 × 59 ㎝
Vietnam National Fine Arts
 Museum Collection

Nguyen the Hung (Nguyễn Thế
 Hùng)
*There are no invaders left in our
 country (Quê ta sạch bóng quân
 xâm lược)*
1973
Propaganda posters (paper)
43 × 61 ㎝
Vietnam National Fine Arts
 Museum Collection

Thai Son (Thái Sơn)
*Here! The target of Nixon! (Đây!
 Mục tiêu của Nich Xơn)*
1972
Propaganda posters (paper)
52.5 × 38 ㎝
Vietnam National Fine Arts
 Museum Collection

Chang HwaJin
Modern Taste (at the Corner)
2019
Tile image on canvas
360 × 632 × 316 ㎝
Courtesy of the artist

Unknown
Portrait
The Joseon Dynasty era
Color on Korean paper
24 × 46.5 ㎝
Suncheon City Deep Rooted Tree
 Museum Collection

Park Youngsook
Untitled
undated
Print on paper
28 × 20 (48.8 × 41 × 4) ㎝
Private Collection

Lee Seung-taek
Untitled
1976
Rope, book and canvas mounted
 on wood
64.3 × 49.5 × 5.5 ㎝
Courtesy of the artist

Lee Seung-taek
Untitled
1980
Rope, book on canvas
40 × 40 ㎝
Courtesy of the artist

Lee Ungno
Composition
1968
Ink and soy source on korean
 paper
130 × 33 ㎝
Lee Ungno Museum Collection

Lee Ungno
Composition
1968
Ink and soy source on korean
 paper
131 × 40 ㎝
Lee Ungno Museum Collection

Lee Ungno
Composition
1968
Soy source on korean paper
130 × 34 ㎝
Lee Ungno Museum Collection

Lee Ungno
Self-portrait
1958
Ink on korean paper
37 × 41 ㎝
Lee Ungno Museum Collection

Lee Ungno
People
1967-1968
Porridge papers with rice
38 × 35 × 17.5 ㎝
Gana Foundation for Arts and
 Culture Collection

Lee Ungno
People
1967-1968
Porridge papers with rice
17 × 25 × 15 ㎝
Gana Foundation for Arts and
 Culture Collection

Lee Ungno
Crowd
1986
Ink on paper
211 × 270 ㎝
MMCA collection

Yun Isang
Images
1968
a handwritten note
33.5 × 26.5 ㎝
Tongyeong City Museum

Theaterraum : der
 philosophierende Körper
 (Im, Hyoungjin)
Isang Yun-Colloid : 28538
2019
Courtesy of the artist

Theaterraum Der
 Philosophierende Körper
 (Im, Hyoungjin)
Con anima : sospirando
2019
80min.
Courtesy of the artist

Theaterraum Der
 Philosophierende Körper
 (Im, Hyoungjin)
Con espressione
2019
52min.
Courtesy of the artist

Theaterraum Der
 Philosophierende Körper
 (Im, Hyoungjin)
Con spirito
2019
Courtesy of the artist

Theaterraum Der
 Philosophierende Körper
 (Im, Hyoungjin)
Pizzicato: glissando
2019
Courtesy of the artist

Theaterraum Der
 Philosophierende Körper
 (Im, Hyoungjin)
Performance-colloid 2019
2019
Courtesy of the artist

Unknown
*Four Guardian Deities: The White
 Tiger*
Undated (Estimated 50 years ago)
Color on paper
150.7 × 88 ㎝
Preservation

Unknown
*Four Guardian Deities: The Red
 Phoenix*
Undated (Estimated 50 years ago)
Color on paper
164 × 99.5 ㎝
Preservation

Park Chan-kyong
Flying
2005
Single channel video with sound
13min.
Kukje Gallery Collection

4. Painful Sparks

Kim Ku Lim
From Phenomenon to Traces:
 Tying the Art Museum
1969
Digital Print
106 × 105 ㎝
Courtesy of the artist

Kim Ku Lim
Body Painting
1969
C-print
59.5 × 102 ㎝, 103 × 60 ㎝, 103 ×
 67.5 ㎝
Courtesy of the artist

Kim Ku Lim
Installation
1975
Metal Chair, Fabric, Traces,
 Painted with Oil Paint
Dimensions variable
Courtesy of the artist

Kim Ku Lim
Duster
1974
Silkscreen on Table cloth
120 × 74 × 70 ㎝
Courtesy of the artist

Kim Ku Lim
The Meaning of 1/24 Second
1969
Single-channel video, color, silent
10min.
MMCA collection

Lee Seung-taek
Wind (Blue)
1971
Color on rope, Artwork total size
 (Rope, cloth joining parts only)
Dimensions variable
Courtesy of the artist

Lee Seung-taek
Untitled
Before 1982
Paper (from antique book), rope
81 × 24.5 × 5 ㎝,
 67.5 × 24 × 5.5 ㎝,
 52.5 × 24.5 × 4.8 ㎝,
 68.3 × 25.3 × 5.7 ㎝,
 52.5 × 24 × 4.7 ㎝,
 32.5 × 19 × 5.7 ㎝,
 29 × 28.7 × 5.2 ㎝
Courtesy of the artist

Lee Kun-yong
Logic of Place, 1
C-print
50 × 50 (53 × 53) ㎝
Pace Gallery Collection

Lee Kun-yong
Logic of Hands, 1
C-print, 85 × 85 (89 × 89) ㎝
Pace Gallery Collection

Lee Kun-yong
Records of Performances, Slides
Dimensions variable
Pace Gallery Collection

Lee Kun-yong
The Method of Drawing 76-2
 (Drawn with the Artist's Back
 toward the Plywood
The Method of Drawing 76-6
 (Drawn with Both Arms)
1976
Marker pen on plywood
71.3 × 118 ㎝ (3)
MMCA collection

Sung Neung Kyoung
Newspaper
1974
Newspaper on panel
64 × 87 × 5 ㎝ (4)
Courtesy of the artist

Sung Neung Kyoung
Apple
1976
Marker pen on b&w photo
19 × 24 ㎝ (17)
Courtesy of the artist

Sung Neung Kyoung
A Frame of Photography
1975
Photograph, frame, photo album
41.5 × 51 ㎝
Courtesy of the artist

Sung Neung Kyoung
A Photo Album
1975
Photo album
32.3 × 28 ㎝
Courtesy of the artist

Burn-soo Song
Take Cover I, II, III
1974
Serigraph on paper
103 × 103 ㎝ (3)
MMCA collection

Lee Taehyun
Command1
1967/2001
Gas mask, knapsack
140 × 70 × 14 ㎝
Courtesy of the artist

Kang Kukjin
Amusement of Visual Sense
1967
Glass bottle, desk, etc
165 × 155 ㎝
MMCA collection

Yeo Un
Work 74
1974
Paper collage on window frame
73 × 115 × 2.5 ㎝
MMCA collection

Moon Bokcheol
Situation
1968
Oil and objet on canvas
120 × 93 × 17 ㎝
MMCA collection

Kim Han
Interior 3
1967
Oil on cnavas
162 × 131 ㎝
MMCA collection

Lee Seungjio
Nucleus No. G-99
1968
Oil on canvas
162 × 130.5 ㎝
MMCA collection

Kim Hong Joo
Door
1978
Oil on door frame
146 × 64 ㎝ (2)
MMCA collection

Lee Sukju
Daily Life
1985
Acrylic on canvas
97 × 129.7 ㎝
MMCA collection

Jung Kangja
Kiss Me
1967/2001
Mixed media
120 × 200 × 50 ㎝
Arario Gallery Collection

Choi Byungsoo and 35 Students
 and Artists
A drawing of Labor Liberation
1989
Acrylic on cloth
2100 × 1700 ㎝
Courtesy of the artist

Choi Byungsoo
Save Han-yeol
1987
Paint on Non-woven, Acrylic
900 × 650 ㎝
MMCA collection

Sneaker of Lee Han-yeol, a patric
 martyr for Democracy
ca. 1987/ Restored in 2015
Lee Han Yeol Memorial Museum

KIA Brisa
1978
Samsung Trasportation Museum

Bae Youngwhan
Pop Song 3: Farewell to My Youth
2002
Video installation above pavement
 engraved with lyrics to "March
 for Our Beloved", Dimensions
 variable, 18min.
Courtesy of the artist

Lee Sangil
The Old Mangwol-dong
1985-1995
Gelatin silver print on fiber-base
35.5 × 27.6 ㎝ (8), 50.5 × 40.5 ㎝
 (33) , 60.4 × 50.6 ㎝ (9)
MMCA collection

Lee Jong-gu
Earth-At Oziri (Oziri People)
1988
Acrylic and paper collage on
 paper
200 × 170 ㎝
MMCA collection

Kim Jung Heun
Land I Should Cultivate
1987
Oil on canvas
94.5 × 195 ㎝
Seoul Museum of Art Collection
 Gift of Lee Ho-jae, GanaArt,
 2003

Shin Hak Chul
*Modern History of Korea-
 Synthesis*
1983
Oil on canvas
390 × 130 ㎝
Leeum, Samsung Museum of Art
 Collection

Park Saeng-Kwang
Jeon, Bong-Jun
1985
Color on paper
360 × 510 ㎝
MMCA collection

Do Ho Suh
Floor
1997-2000
PVC, glass plate, phenolic sheets,
 Polyurethane resin
8 × 100 × 100 ㎝ (8)
Glass plate included
MMCA collection

Shin Hak Chul
Connivance 802
1980
Collage on canvas
60.6 × 80.3 ㎝
MMCA collection

Ahn Chang Hong
Family Photograph
1982
Oil on paper
115 × 76 ㎝
MMCA collection

Lim Ok-Sang
Rabbit and Wolf
1985
Ink and color on embossed paper
85.5 × 106 ㎝
MMCA collection

Park Buldong
Foreign Words
1987
Photograph collage on paper
36 × 49.5 ㎝
MMCA collection

Hwang Jaihyoung
Briquet Press
1986
Acrylic and paper clay on window
 frame and steel mesh
92.5 × 59 ㎝
MMCA collection

Joo Jaehwan
Wonwangseang
1991
Print on paper
52 × 76 ㎝
MMCA collection

Ahn Kyuchul
Chung-dong Landscape
1986
Color on plaster
24 × 46 × 42 ㎝
MMCA collection

Lee Giyeon
Back Against the Wall
1984
Color on Korean paper, paper
 collage, Indian ink
120.5 × 93 ㎝
Courtesy of the artist

Oh Yoon
Dance with Korean Drum
1985
Color on Tent cloth
206 × 201 ㎝
Gana Foundation for Arts and
 Culture Collection

Oh Yoon
Song of a Sword
1980s
Color on Tent cloth
204.5 × 200.5 ㎝
Gana Foundation for Arts and
 Culture Collection

Oh Yoon
Dance II
1985
Color on Tent cloth
208.3 × 195.5 ㎝
Gana Foundation for Arts and
 Culture Collection

Oh Yoon
Folk Customed Play Gangjaeng-i
 Darijaeng-i Water Demon
1984
Linoleum cut
60 × 50 ㎝
The Korean Aesthetics Institute
 Collection

Lim Ok-Sang
Newspaper
1980
Oil on canvas, newspaper collage
138 × 300 ㎝
Gana Foundation for Arts and
 Culture Collection

Oh Yoon
Construction Manager
1984
Mixed media
47.5 × 39.5 × 16 ㎝
The Korean Aesthetics Institute
 Collection

Oh Yoon
Ajimae Big-Handed
1984
Mixed media
42.2 × 37.5 × 18.5 ㎝
The Korean Aesthetics Institute
 Collection

Oh Yoon
Construction Governor
1984
Mixed media
36.5 × 25.5 × 8.5 ㎝
The Korean Aesthetics Institute
 Collection

Oh Yoon
Secretary of Assemblyman
1984
Mixed media
42.7 × 27.5 × 9 ㎝
The Korean Aesthetics Institute
 Collection

Hahn, Ai-kyu
Making Kimchi
1989
China clay, Chamotte, Ash glaze
31 × 50 × 27 ㎝
Seoul Museum of Art Collection.
 Gift of Lee Ho-jae, GanaArt,
 2002

Hahn, Ai-kyu
Woman inside a Closet
1989
China clay, Color glaze
33 × 22 × 12.5 ㎝
Seoul Museum of Art Collection.
 Gift of Lee Ho-jae, GanaArt,
 2002

Yun Suk Nam
Massacre without Faces
1987
Pencil and color on paper
48 × 62.5 (70 × 84.7) ㎝
Courtesy of the artist

Yun Suk Nam
Maljuggeoli Market
1988
Pencil and color on paper
53 × 77.5 (75.5 × 100) ㎝
Courtesy of the artist

Jung Jungyeob
Sewing a Blanket
1988
Ink on Paper
75 × 49 ㎝
Courtesy of the artist

Jung Jungyeob
Body Ache
1991
Acrylic on cotton, paper
130 × 104 ㎝
Courtesy of the artist

Hong Sung Dam
Bathtub: Mother, I Can See
 Hometown's Blue Sea!
1996
Mixed media on canvas
193 × 122 ㎝
Seoul Museum of Art Collection
 Gift of Lee Ho-jae, GanaArt,
 2002

Lee Myoung-bok
That Afternoon
1983
Acrylic on canvas
180 × 226 ㎝
Seoul Museum of Art Collection

5. Blue Desert

Ham Jin
Encounter
2005
Polymer clay, scrap material
3 × 1350 × 1.5 ㎝
Fukuoka Asian Art Museum

Bahc Yiso
Exotic-Minority-Oriental
1990
Photograph, Enamel paint
each 76 × 61 ㎝
Courtesy of the bereaved

Do Ho Suh
Untitled
1990
Mixed media
240 × 240 × 100 ㎝
Courtesy of the artist

Kim Chan-dong
The Floating Signifier
1990
Mixed media
300 × 200 × 200 ㎝
Courtesy of the artist

Choi Jeonghwa
My Beautiful 21st Century
1993/2019
Mixed media
250 × 34 × 190 ㎝, 220 × 30 ×
 170 ㎝
Courtesy of the artist

Choi Jeonghwa
Made in Korea
1991/2019
Mixed media
460 × 220 ㎝, 40 × 40 × 80 ㎝ (10)
Courtesy of the artist

Lee Bul
Study for Plexus
1996
Pen on paper
57.2 × 72.7 ㎝ (With frame)
Arario Gallery Collection

Lee Bul
Cyborg Drawing: No.1
1997
Pen on paper
57.2 × 72.8 ㎝ (With frame)
Arario Gallery Collection

Lee Bul
*Study for Inez finds herself alone
 IV*
1996
Pen on paper
57.2 × 72.10 ㎝ (With frame)
Arario Gallery Collection

Lee Bul
*Study for Inez finds herself alone
 III*
1996
Pen on paper
57.2 × 72.11 ㎝ (With frame)
Arario Gallery Collection

Lee Bul
Study for the Wall
MoMA 'Project' installation
1996
Pen on paper
Arario Gallery Collection

Lee Bul
Study for the Wall
MoMA 'Project' installation
1996
Pen on paper
Arario Gallery Collection

Lee Bul
Cyborg W5
1999
Painting on plastic
150 × 55 × 90 ㎝
MMCA collection

Lee Bul
Live Forever
2001
Fiberglass capsule with acoustid
 foam, leather, electronic
 equipment
96.5 × 152.4 × 254 ㎝
MMCA collection

Ko Nack-bum
Torso
1988
Acrylic on plastic
65 × 40 × 22 ㎝
Private Collection

Kim Wol Sik
Delievery Carrier
2017
Single-chnnel video, color, no
 sound, recycled paper, 6min.
 25sec. Variable installation
Seoul Museum of Art Collection

Haegue Yang
*Sol LeWitt Upside Down - Five
 Unit Cross, Expanded 48 Times*
2017
Aluminum venetian blinds,
 powder-coated aluminum
 hanging structure, steel wire
 rope, LED tubes, cable
145 × 283 × 283 ㎝
Kukje Gallery Collection

ium
The Highway
1997
Single-channel video, color,
 sound, 8min. 46sec.
MMCA collection

Minouk Lim
New Town Ghost
2005
Single-channel video, color,
 sound, 10min. 59sec.
MMCA collection

Song Sanghee
Shoes / 243.0Mhz
2010-2011
Single-channel video, radio,
 motor, video 35min, radio sound
 45min. (radio 10 × 35 × 55 ㎝)
MMCA collection

Hong Kyoung Tack
Funkchestra(Funk+Orchestra)
2001-2005
Oil and acrylic on canvas
130 × 163 ㎝ (12)
MMCA collection

Koo Sungsoo
Magical Reality - Wedding Hall
2005
C-print
180 × 220 ㎝
MMCA collection

Dongwook Lee
Dolphin Safe
2003
Mixed media, can
5 × 10 × 10 ㎝
MMCA collection

Dongwook Lee
Vacation Assignment
2003
Bottle, Mixed media
5 × 5 × 5 ㎝ (7), 13 × 8 × 8 ㎝
MMCA collection

Dongwook Lee
I Wished
2004
Mixed media, vinyl, 5 × 15 × 5 ㎝
MMCA collection

Nikki S. Lee
The Hip Hop project 1
2001
Digital C-print
74.8 × 100.2 ㎝
MMCA collection

Oh Heinkuhn
*Ajumma Wearing a Pearl
 Necklace*
1997
Gelatin silver print
45.5 × 45.5 ㎝
MMCA collection

Oh Heinkuhn
*Ajumma Wearing Floral-patterned
 Scarf*
1997
Gelatin silver print
45.5 × 45.5 ㎝
MMCA collection

Lee Sunmin
Sang-yeop and Han-sol
Inkjet print
118 × 143.5 ㎝
MMCA collection

Lee Sunmin
Su-jeong and Ji-yeong
Inkjet print
118 × 143.5 ㎝
MMCA collection

Donghyun Son
Logotype CocaCola
2006
Color on paper
130 × 162 ㎝ (2)
MMCA collection

Lee Dongi
Atomouse eating noodles
2003
Acrylic on canvas
130 × 160 ㎝
MMCA collection

Jung Jungyeob
Peum
2017
Color on mirror
100 × 40 ㎝
Courtesy of the artist

Jung Jungyeob
Kku
2017
Color on mirror
69× 39 ㎝
Courtesy of the artist

Jung Jungyeob
Ditt
2018
Color on mirror
66 × 33.5 ㎝
Courtesy of the artist

Jung Jungyeob
Pib
2017
Color on mirror
82.5 × 37.5 ㎝
Courtesy of the artist

Jung Jungyeob
Heul
2017
Color on mirror
112.5 × 41.5 ㎝
Courtesy of the artist

6. Arid Sea

Lee Manik
The Han River Boat Parade
1989
Silkscreen
45 × 65.4 ㎝
MMCA collection

Lee Manik
Viewing the Sun
1989
Silkscreen
45 × 65.4 ㎝
MMCA collection

Lee Manik
Road in the Early Morning
1989
Silkscreen
45 × 65.4 ㎝
MMCA collection

Lee Manik
Procession of Dragon Drum
1989
Silkscreen
45 × 65.4 ㎝
MMCA collection

Lee Manik
Light of Genesis
1989
Silkscreen
45 × 65.4 ㎝
MMCA collection

Lee Manik
Welcome
1989
Silkscreen
45 × 65.4 ㎝
MMCA collection

Lee Manik
Great Day
1989
Silkscreen
45 × 65.4 ㎝
MMCA collection

Lee Manik
Prayer of Blessings
1989
Silkscreen
45 × 65.4 ㎝
MMCA collection

Lee Manik
Chaos
1989
Silkscreen
45 × 65.4 ㎝
MMCA collection

Lee Manik
Beyond All Barriers
1989
Silkscreen
45 × 65.4 ㎝
MMCA collection

Lee Manik
Silence
1989
Silkscreen
45 × 65.4 ㎝
MMCA collection

Lee Manik
Sprout
1989
Silkscreen
45 × 65.4 ㎝
MMCA collection

Lee Manik
Harmony
1989
Silkscreen
45 × 65.4 ㎝
MMCA collection

Lee Manik
One World
1989
Silkscreen
45 × 65.4 ㎝
MMCA collection

Lee Manik
Friendship
1989
Silkscreen
45 × 65.4 ㎝
MMCA collection

Lee Manik
Ojak Bridge
1989
Silkscreen
45 × 65.4 ㎝
MMCA collection

Lee Manik
Light and Sound
1989
Silkscreen
45 × 65.4 ㎝
MMCA collection

Lee Manik
Parting Ship
1989
Silkscreen
45 × 65.4 ㎝
MMCA collection

Lee Manik
Prayer
1989
Silkscreen
45 × 65.4 ㎝
MMCA collection

Lee Manik
Farewell
1989
Silkscreen
45 × 65.4 ㎝
MMCA collection

Kim Ki-Chan
Dowhadong, Seoul
July. 1988
Gelatin silver print
27.9 × 35.6 ㎝
MMCA collection

Kim Ki-Chan
Jungrimdong, Seoul
November. 1988
Gelatin silver print
27.9 × 35.6 ㎝
MMCA collection

Koo Bohnchang
One's Eyes 1980 Series
1985-1989/2010
C-print
30 × 45 ㎝ (10)
MMCA collection

Kang Hong-goo
Greenbelt: Sehando
2000-2002
Digital print (Dust Lamda 130
 laser print)
80 × 220 ㎝
MMCA collection

Chung Chuha
A Pleasant Day
2003-2007/2008
Digital inkjet color print
151 × 210 ㎝
MMCA collection

mixrice
A Song Connected from 'A Stage'
2009
Single-channel video, one
 monitor, on divix player, scripts,
 eight pigment prints, props,
 7min. 30sec. photo 45.5 × 69 ㎝
 (5), 59 × 89 ㎝ (3)
MMCA collection

I Wonseok
An Exhausting Day
2006
Fiberglass, stainless
20 × 45 × 45 ㎝
MMCA collection

Bahc Yiso
Entrance of History
1987
Acrylic on canvas
181.4 × 187 ㎝
MMCA collection

Bahc Yiso
Blackhole Yes
2001
Acrylic on paper
Dimensions variable
MMCA collection

Jong Soung Kimm
*Olympic Weightlifting Stadium
 Model*
2014
Mokchon kim jung sik foundation

Kim Swoo Geun
*Jamsil Olympic Main Stadium
 Model*
2011
MMCA Art Research Center

Olivier Debre
KAL
1986
Acrylic on canvas
203 × 213 ㎝
MMCA collection

Yoo Geun-Taek
Long Fence
2000
Ink on paper
162 × 130 ㎝ (4)
MMCA collection

Park Yoonyoung
Pickton Lake
2005
Ink and color on silk
210 × 520 ㎝
MMCA collection

Kim Youngchul
IMF Story 1 (Middle age unemployment)
1998
Digital print
84.1 × 118.9 ㎝
Courtesy of the artist

Kim Youngchul
IMF Story 2 (Youth unemployment)
1998
Digital print
84.1 × 118.9 ㎝
Courtesy of the artist

Kim Youngchul
IMF Story 3 (Mature unemployment)
1998
Digital print
84.1 × 118.9 ㎝
Courtesy of the artist

Lee Yunyop
No More Cort
2019
Woodcut on paper
29.5 × 43.5 ㎝
Courtesy of the artist

Lee Yun-yop
No More Non-regular Workers
2019
Woodcut on paper
45 × 55 ㎝
Courtesy of the artist

Lee Yun-yop
Cort
2010
Woodcut on paper
38 × 58 ㎝
Courtesy of the artist

Lee Yun-yop
Cort: I want to work
2009
Woodcut on paper
67 × 37 ㎝
Courtesy of the artist

Kimsooja
Bottari, 1
Used Korean bedcover, used clothing of artist's son
53.34 × 57.15 × 53.34 ㎝
Kukje Gallery Collection

Kimsooja
Mind and World
1991
Mixed media on cotton fabric
443 × 282 × 150 ㎝
Courtesy of the artist

Meekyoung Shin
Venus
1998
Soap, color pigment, varnish
227 × 85 × 60 ㎝
MMCA collection

Meekyoung Shin
Translation Series
2006-2013
Soap
36.5 × 21.5 × 21.5, 56 × 21 × 21,
 57 × 29.5 × 30, 69 × 48 × 48,
 54 × 30.5 × 30.5, 54 × 31 × 31,
 55 × 61 × 61, 39 × 23 × 23,
 30 × 16 × 16, 55 × 30 × 30,
 52.5 × 29 × 29, 32 × 19 × 19,
 84.5 × 34 × 34, 48 × 36 × 36,
 42 × 40 × 40, 39.5 × 24 × 24 ㎝
MMCA collection

Yoo Eui Jeong
Anachronism
2012
Ceramics
79 × 79 × 165 ㎝
Courtesy of the artist

Im Heungsoon
Factory Complex
2014
HD video, inkjet print
SIngle Channel 95min.
 photo 41 × 100 ㎝
Courtesy of the artist

siren eun young jung
Act of Affect
2013
Single-channel video, color,
 sound, 15min. 36sec.
Courtesy of the artist

Sung Hwan Kim (in musical
 collaboration with David Michael
 DiGregorio a.k.a. dogr)
Temper Clay
2012
Single-channel video, color,
 sound, 23min. 41sec.
Courtesy of the artist

Kim Sora & Gimhongsok
Chronic Historical Interpretation Syndrome
2003
Mixed media
500 × 280 × 280 ㎝
Gyeonggi Museum of Modern Art
 Collection

7. White Bird

Lee Wonho
Elegantly
2019
6 channel video installation
20min.
Courtesy of the artist

Oh Jaewoo
Downsized Square
2019
Video installation
10min.
Courtesy of the artist

Nho, Won-Hee
Tree
1982
Oil on Paper
77 × 432 ㎝
Seoul Museum of Art Collection

Weaving Life, Weaving Nature
Yellow Light
2019
wood, yarn, light,
 Mixed media, high 360 ㎝
 diameter 90 ㎝ (5)
Courtesy of the artist

Part-time Suite
March Dance in the 42㎡ Club, 1
Performance, Stage installation
Courtesy of the artist

BARE
Dream Cells
2018
Mixed media
Dimensions variable
Courtesy of the artist

Hong Bo-Mi
Today's Museum
2019
2 channel video
Dimensions variable
Courtesy of the artist

Hong Bo-Mi
Drawing of Museum
2019
6 channel video, Drawing on
 paper
Dimensions variable
Courtesy of the artist

Everyday Practice
*There is No Reason Anyone
 Should Die Because They Were
 on that Ship*
2014
Metalic fence, ribbon, photograph,
 Dimensions variable
Courtesy of the artist
Excerpt from Bak Mingyu's
 "The Country of the Blind"
 (Munhakdongne Publishing
 Corp., 2014)

Nikolai Sergeevich Shin
Mourning
1980
Oil on canvas
200 × 290 ㎝
MMCA collection

Nikolai Sergeevich Shin
Mother and Son
1984
Oil on canvas
150 × 200 ㎝
MMCA collection

Nikolai Sergeevich Shin
Mourning
1984
Oil on canvas
140 × 200 ㎝
MMCA collection

Nikolai Sergeevich Shin
Encounter
1984
Oil on canvas
200 × 150 ㎝
MMCA collection

Nikolai Sergeevich Shin
Prayer
1984
Oil on canvas
200 × 150 ㎝
MMCA collection

Nikolai Sergeevich Shin
Mourning
1984
Oil on panel
190 × 190 ㎝
MMCA collection

Nikolai Sergeevich Shin
Reminiscence
1989
Oil on canvas
100 × 100 ㎝
MMCA collection

Bill Viola
Observance
2002
Plasma monitor, HD video
120.7 × 72.4 × 10.2 ㎝
MMCA collection

Christian Boltanski
Monument-Comfort Women
1997
Mixed media
125 × 58 × 36 ㎝ (16)
MMCA collection

Chansook Choi
Wornded Recollection III
2016
2 channel video, monitor, clothes,
 sound
7min.
Courtesy of the artist

Kim Soyoung (a.k.a Jeong Kim)
Heart of Snow-AfterLife
2016
Single-channel video, color,
 sound
16min. 56sec.
MMCA collection

Song Hyun Sook
*Brushstrokes-Diagram(Painted
 on the impression of the Sewol-
 ship tragedy on 16 April,
 2014)+8 brushstroke*
2014
Tempera on canvas
170 × 240, 170 × 130 ㎝
MMCA collection

jang minseung
*voiceless-pitch-dark, a withered
 field*
2014
Single-channel video, six silk
 screen on papers, six pebbles,
 25min, silk screen
29 × 42 × 8 ㎝ (6)
MMCA collection

jang minseung
voiceless-snow we saw
2014
Single-channel video, color, silent
89min. 51sec.
MMCA collection

Back Seungwoo
Blow Up
2005-2007/ 2012
Digital pigment print
49.5 × 59.5 ㎝ (40)
MMCA collection

Pen Varlen
*Geumgangsan Mountain in North
 Korea(Manmulsang)*
1959
Etching on paper
49 × 64 ㎝
MMCA collection

Pen Varlen
North Korean Landscape
1959
Etching on paper
49.3 × 64.5 ㎝
MMCA collection

Pen Varlen
The Amnok Riverside
1960
Etching on paper
MMCA collection

Ham Kyungah
I'm Sorry
2009-2010
Embroidering on fabric
148 × 226.5 ㎝
MMCA collection

Ham Kyungah
I'm Hurt
2009-2010
Embroidering on fabric
162.5 × 212 ㎝
MMCA collection

Koh Sankeum
The New York Times
2000
Acrylic and imitation pearls on
 panel
60 × 60 ㎝ (5)
MMCA collection

Jaewook Lee
Inner safety II #1
2019
Archival pigment print
122 × 92 ㎝
Courtesy of the artist

Jaewook Lee
Inner safety II #2
2019
Archival pigment print
122 × 92 ㎝
Courtesy of the artist

Che Onejoon
International Friendship
2013
Archive installation
Dimensions variable
Courtesy of the artist

Seems Like Community
*Gaeseong Industrial Complex
 (Cinderella)*
2018
Mixed media
Dimensions variable
Courtesy of the artist

Noh Suntag
Red House I #BFK001
2005
Archival inkjet pigment print
110 × 160 ㎝
Courtesy of the artist

Noh Suntag
Red House II #BFK006
2005
Archival inkjet pigment print
75 × 110 ㎝
Courtesy of the artist

Noh Suntag
Red House II #BFK026
2005
Archival inkjet pigment print
75 × 110 ㎝
Courtesy of the artist

Noh Suntag
Red House II #CHK3101
2017
Archival inkjet pigment print
110 × 160 ㎝
Courtesy of the artist

Sun Mu
Hand in Hand
2017
Oil on canvas
130 × 194 ㎝
Seoul Museum of Art Collection

Sun Mu
My hometown
2007
Oil on canvas
130 × 194 ㎝
Private Collection

Sun Mu
Blossom
2019
Wire, plastic flower, paint, cotton
Dimensions variable
Courtesy of the artist

Everyday Practice
Life
Wood structure, laser cutting,
 gear
170 × 70 × 270 ㎝
Courtesy of the artist

3. The Square: Art and Society in Korea 2019

1. I and the Other

Yokomizo Shizuka
Stranger 2
1999
C-print
124.5 × 105 ㎝
MMCA collection

Yokomizo Shizuka
Stranger 13
1999
C-print
124.5 × 105 ㎝
MMCA collection

Yokomizo Shizuka
Stranger 23
1999
C-print
124.5 × 105 ㎝
MMCA collection

Joo Hwang
Departure #0462
2016
C-print
105 × 70 ㎝
Courtesy of the artist

Joo Hwang
Departure #1024 London
2016
C-print
105 × 70 ㎝
Courtesy of the artist

Joo Hwang
Departure #2577 Taipei
2016
C-print
105 × 70 ㎝
Courtesy of the artist

Oh Heinkuhn
Rose, August 2017
2017
C-print
130 × 100 ㎝
Courtesy of the artist

Oh Heinkuhn
Sue, April 2016
2016
C-print
113 × 85 ㎝
Courtesy of the artist

Oh Heinkuhn
J, December 2016
2016
C-print
103 × 150 ㎝
Courtesy of the artist

Oh Heinkuhn
Jo, July 2016
2016
C-print
125 × 96 ㎝
Courtesy of the artist

Oh Heinkuhn
Min, May 2017
2017
C-print
144 × 109 ㎝
Courtesy of the artist

Oh Heinkuhn
Sowha, July 2017
2017
C-print
103 × 147 ㎝
Courtesy of the artist

Oh Heinkuhn
Jiwoo, July 2016
2016
C-print
122 × 94 ㎝
Courtesy of the artist

Song Sung-jin
Camp16 BlockE
2018
Pigment print
150 × 100 ㎝
Courtesy of the artist

Song Sung-jin
One Pyeong House Between Tides
2018
Mixed installation of 3.3㎡ house,
 multi-channel video, daily log,
 photographs
Dimensions variable
Courtesy of the artist

Kim Heecheon
Sleigh Ride Chill
Single-channel video, color,
 sound
17min. 27sec.
MMCA collection

Ham Yangah
The Sleep
2016
Two-channel video installation,
 color, sound
8min
MMCA collection

Ham Yangah
Undefined Panorama 1.0
2018-2019
Single-channel video, color,
 sound
7min
Courtesy of the artist

Ham Yangah
Hunger
2019
Single-channel video, color,
 sound
7min
Courtesy of the artist

Eric Baudelaire
Letters to Max
2014
Single-channel video and 74
 letters
103min. 12sec.
MMCA collection

Nalini Malani
The Tables Have Turned
2008
Thirty-two turn tables, reversed
 painted Mylar cylinders, halogen
 lights, sound
20min
MMCA collection

Chung Seoyoung
East West South North
2007
Steel, wheel
Dimensions variable
MMCA collection

Hong Seung-Hye
BAR
2019
Furniture, graphic
Courtesy of the artist

Hong Jinhwon
I think it's time I stopped the show
2019
QR code on pigment print
60 × 80 ㎝
Courtesy of the artist

Shingseungback Kimyonghun
Mind
2019
Mechanical ocean drum,
　microcontroller, sea simulation,
　facial emotion recognition
　network camera, computer and
　smartphone
Dimensions variable
Courtesy of the artist

2. Museum, Square and Theater

Juha Valkeapää, Taito Hoffrén
*Ten Journeys to a Place Where
　Nothing Happens*
Performance
90min.

Karel van Laere
The Non-Present Performer
Performance
60min.

ROOMTONE, Lee Jangwon,
　Jeong Seyoung
A Theatre for an Individualist
VR performance
MMCA Creation.

The list of artists for the exhibition

1. The Square: Art and Society in Korea 1900-1950

Gang Ho
Ko Huidong
Gu Bon-ung
Gil Jinseop
Kim Gyujin
Kim Donhui
Kim Mansul
Kim Bokjin
Kim Yongsu
Kim Yongjun
Kim Eung-won
Kim Eung-hyeon
Kim Il
Kim Chong Yung
Kim Jongchan
Kim Jinman
Kim Jinwoo
Kim Chanyoung
Kim Whanki
Na Woongyu
Rha Hae-seok
No Soohyeon
Luo Qingzhen
Li Hua
Mun Il
Park Gijeong
Park Munwon
Park Youngchik (Charles Park)
Park Hanyoung
Pai Unsoung
Bae Jeongguk
Baek Namsoon
Pen Varlen
Suh Seok
Song Tae-hoe
Ahn Seokju
An Seungkak
An Jungsik
Yanase Masamu
Yang Gihun
Ono Tadashige
Oh Se-chang
Oh Ilyoung
Ootsuki Genji
Okada Tatsuo
Won Woojeon
Yoon Yong-gu
Lee Gyu-seol
Lee Gi
Lee Doyoung
Lee Byeonggyu
Yi Sang
Lee Sang-choon
Lee Siyeong
Lee Yeosung
Lee Eunsook
Lee Ungno
Lee Insung

Lee Jeong
Lee Juhong
Lee Jungseob
Lee Qoede
Lee Hoe-yeong
Lim Gunhong
Yim Yong-ryun (Gilbert Phah Yim)
Yim Hwa
jang minseung
Jeong Daegi
Jeong Jeum-sik
Jung Habo
Jung Hasu
Jeong Hak-gyo
Jeong Hyeon-ung
Cho Gisoon
Cho Seokjin
Cho Jeong-gyu
Cho Jungmuk
Ji Un-young
Jin Hwan
Chae Yongshin
Choe Namseon
Choe Seokdu
Choi Jaideok
Hong Gae-myeong
Hong Seonwung
Hwang Seongha

2. The Square: Art and Society in Korea 1950-2019

Kang Kukjin
Kang Yo-bae
Kang Unseob
Kang Hong-goo
Kho Nak Beom
Koh Sankeum
Kwon Joonho
Kwak Duck Jun
Quac Insik
Koo Bohnchang
Koo Sung Soo
Kwon Young Woo
Gum Nuri
Kim Kyo Man
Kim Ku Lim
Kim Ki-Chan
Kim Byungki
Kim Song-hwan
Sung Hwan Kim
Kim Sora
Soyoung Kim
Kim Swoo Geun
Kimsooja
Kim Young Jung
Kim Young-chul
Kim Wol Sik
Kim Jae-hong
Kim Chungsook
Kim Jung Heun
Jong Soung Kimm
Kim Chong Yung
Kim Chong Hak
Kim Ji Won
Kim Chan-dong
Kim Tschang-Yeul
Kim Han
Kim Han Yong
Kim Hyun
Kim Hyung-Dae
Heryun Kim
Gimhongsok
Kim Hong Joo
Kim Whanki
Na Jae-Oh
Nho Suntag
Nho, Won-Hee
Nikki S. Lee
Dao Duc (Đào Đức)
Le Quoc Loc (Lê Quốc Lộc)
Le Thanh (Lê Thanh)
Le Thanh Tru (Lê Thanh Trừ)
Marty Gross
Moon Bokcheol
Mian Ijaz-ul-Hassan
mixrice
BARE
Park Ko-Suk
Park Re-hyun

Park Buldong
Park Sangok
Park Saeng-Kwang
Park Seo-Bo
Park Soo Keun
Park, Young-Sook
Park, Yoonyoung
Bahc Yiso
Park Chan-kyong
Bae Youngwhan
Back Seung Woo
Pen Varlen
Bill Viola
Do Ho Suh
Suh Se Ok
Suh Seung-Won
Sung Neungkyung
Sung Dookyung
Donghyun Son
Burn-soo Song
Song Sanghee
Song Soo Nam
Song Yeong Bang
Meekyoung Shin
Shin Hak Chul
Shim Moon-Seup
Ahn Kyuchul
Ahn Sang-soo
Jungju An
Ahn Chang Hong
Yang Seung Choon
Haegue Yang
Yeo Un
Oh Yoon
Oh Jong-uk
Oh Heinkuhn
Olivier Debre
Yoo Geun-Taek
Yoo Young-Kuk
Yoo Eui Jeong
Yoon Kwangcho
Youn Myeong Ro
Yun Suk Nam
Yun Isang
Yun Hyong-Keun
Nguyen Dinh Lan (Nguyễn Đình Lân)
Nguyen Vinh Nguyen (Nguyễn Vĩnh Nguyên)
Nguyen Dung (Nguyễn Dũng)
Nguyen the Hung (Nguyễn Thế Hùng)
Lee Kun-yong
Lee Kyusang
Lee Giyeon
Lee Dongi
Lee Dong-youb
Dongwook Lee
Lee Manik
Lee Myoung-Bok
Lee Bul

Lee Sangil
Lee Sang Chol
Lee Sukju
Lee Sunmin
Lee Sook Ja
Lee Seung Jio
Lee Seung-taek
Lee Ufan
I Wonseok
Lee Wonho
Lee, Yun-Yop
ium
Lee Ungno
Lee Jong-gu
Lee Jungseob
Lee Cheul-yi
Lee Tae Hyun
Lee Hyungrok
Minouk Lim
Lim Ok-Sang
Limb Eung Sik
Im Heung-soon
Chang Ucchin
Chang Hwa Jin
Jeon Seon Taek
Jaewook Lee
Jung Kang Ja
Chung Kyu
Chung Bum-Tai
siren eun young jung
Jung Jungyeob
Chung Chuha
Chung Chang Sup
Cho Young-jae
Joo Myung Duck
Joo Jaehwan
Tran Huu Te (Trần Hữu Tê)
Choi Byung so
Choi Byungsoo and 35 Students
 and Artists
Choi Jeong Hwa
Choon Choi
Tran Tuy (Trần Túy)
Thai Son (Thái Sơn)
Theaterraum: des
 Philosophierende Körper
 (Im, Hyoungjin)
Ha, Chong Hyun
Hahn, Ai-kyu
Han Youngsoo
Ham Jin
Hoang Tram (Hoàng Trầm)
Hong Kyoung Tack
Hong Sungdam
Hwang Jai-Hyoung
seems like community
Sun Mu
Song Hyun Sook
Nikolai Sergeevich Shin
Oh Jaewoo
Everyday Practice

jang minseung
Weaving Life, Weaving Nature
Che Onejoon
Chansook Choi
Christian Boltanski
Part-time Suite
Ham Kyungah
Hong Bo-Mi

**3. The Square: Art and Society
 in Korea 2019**

Chung Seoyoung
Eric Baudelaire
Ham Yangah
Hong Jinhwon
Hong Seung-Hye
Joo Hwang
Kim Heecheon
Nalini Malani
Oh Heinkuhn
Shinseungback Kimyonghun
Song Sung-jin
Yokomizo Shizuka
Juha Valkeapää
Taito Hoffrén
Karel van Laere
ROOMTONE
Lee Jangwon
Jeong Seyoung

Glossary

abstract art

A term which can be used to describe any non-figurative painting or sculpture. Abstract art is also called non-representational art or non-objective art, and throughout the 20th century has constituted an important current in the development of Modernist art. In Korea. In the 1950s so called "Cubist images," which separated the object into numerous overlapping shapes, were often described as Abstractionist, but only with the emergence of *Informel* painting in the late 1950s could the term "abstract" be strictly used to describe the creation of works that did not reference any exterior subject matter. The abstract movements of geometric abstractionism and *dansaekhwa* dominated the art establishment in Korea in the late-1970s. By the 1980s, however, with the rising interest in the politically focused figurative art of *Minjung*, abstraction was often criticized as aestheticist, elitist, and Western-centric.

abstract expressionism

An art movement in the United States that lasted from the late 1940s to the early 1960s. Koreans encountered abstract expressionist artwork and information on the genre through illustrations painted with primary colors that were featured in magazines such as Life and Art News as well the Eight American Contemporary Artists exhibition. The large canvases, free brushwork, and expressive colors common to the genre drew the attention of young Korean artists, and this led to a popularization of *Informel*.

alternative space

A non-profit exhibition space, intended to be free from the elitist authoritarianism and rigid traditionalism of art museums, and the naked commercialism of sales galleries. Numerous alternative spaces emerged in Korea between the 1990s and the early 2000s and contributed to the development of a vibrant national contemporary scene that supported diverse experimental innovative approaches to art making. The number of spaces disappeared drastically around 2010 as many closed due to financial difficulties, or lost their initial focus on experimentation and became bureaucratically institutionalized.

Art *Informel*

The French critic Michel Tapie first used the term in 1950 to describe a European genre of gestural, expressionist abstract painting that emerged in the 1940s and 1950s and was closely related to the Abstract Expressionist movement in the USA. In Korea, the term *Informel* was used by several young abstract painters who came to prominence in the late 1950s. While this young generation of artists were initially stylistically influenced by Western art after the Korea War, their artistic approaches soon began to focus on on the less visually grounded conceptual characteristics of avant-garde art, in which practitioners opposed established power structures and pursued a progressive reformation of the conservative art world. The movement continued until the mid-1960s, and its international orientation provided an strong impetus for Korea to become part of the global art world.

brush and ink	A term referring to the most basic and instrumental tools of Eastern-style painting. A diverse range of brushwork and inkwork techniques have developed around these two tools. Literati painters and Southern School painters held the aesthetics of the brush and ink to be of the highest value.
Dansaekhwa	A genre of monochrome abstract paintings by a group of Korean artists working from the 1970s onward. For these artists, the repetition of monotonous painterly or drawing acts possessed a meditative meaning, and relative to this aspect of their work they hoped to emphasize the spiritual and the physical qualities of the materials in play. This conceptual approach arguably served to differentially locate these Korean artists in distinction to their counterpart "monochrome" painters in the west, who largely concerned themselves with issues of visuality and flatness.
figurative art	Figurative art refers to a style that depicts objects, both real and imaginary, in a realistic manner. It became popularized within Western Art in parallel with the emergence of Modernist abstract art during the early 20th century. In the Korean art community, discourses on figurative art began when the Western Art division of National Art Exhibition (or *Gukjeon*) was separated into the figurative, semi-abstract, and abstract categories in 1961
geolgae painting	A *Minjung* Art style of the 1980s that borrows from the Buddhist tradition of painted banners. These paintings were large banners designed to be put up at popular political rallies and demonstrations. The paintings are noteworthy for their provocative nature, as reflected in the bold colors that express the nature and purpose of the gatherings.
Gyeongseong Exposition	A large-scale exposition first held in Seoul in 1907. The exposition was organized by the Resident-General, who was installed by the Empire of Japan to oversee the vassal Korean Empire, and managed by the Ministry of Agriculture, Industry, and Commerce. The exposition was held from September 1 to November 15, 1907.
ink and wash painting	The term ink and wash painting refers to a monotone painting created using ink. Ink and wash paintings use depth of ink to depict light and volume. Since ink was considered the best medium to express the inner spirit of a painter, traditional literati artists across East Asia preferred painting in this medium.

ink painting movement	A series of exhibitions and projects from the early to mid-1980s that Song Su-nam, a professor of Eastern-style painting at the Hongik University, and his junior colleagues and students planned and participated in. While there is not a unified style, the movement experimented continuously with the idea of Eastern spirituality as somehow embodied within the traditional format of ink painting, as well as attempting to extend the expressive potential of the medium. The painters under the movement were the people who promoted the term "Korean painting (*hangukwa*)."
Joseon Art Exhibition	A government-run art exhibition organized by the Office of the Governor-General of *Joseon* during the Japanese colonial rule of Korea. A total of 23 exhibitions, which were also known as *Seonjeon* or *Joseonmijeon*, were held from 1922 to 1944. The exhibition served as the sole platform for aspiring artists in the modern era to achieve recognition, and the exhibition held considerable influence over the art community.
Korean folk painting	A historical genre of practical paintings such as those of wild pears or on folding screens, created by diverse national groups or individuals in accordance with their local lifestyle conventions. During the Joseon dynasty, these paintings were called *japhwa*, *sophwa*, or *byeolhwa*. In 1937, the term *minhwa*, acquired the meaning of paintings originating from the people, painted by the people, and traded between people.
Korean Painting	A type of painting created during the 20th century that uses traditional Korean materials, techniques, and styles. The term emerged from the criticism that traditional-style paintings were called Eastern-style paintings in Korea, in contrast to China, where they were called national-style paintings, and Japan, where they were called Japanese-style paintings.
literati painting (*muninhwa*)	A painting produced by a member of the literati, elite amateur painters, often scholars or bureaucrats by profession, to express their thoughts and emotions and acquire cultural or moral refinement. Literati artists attempted to emphasize the depiction of the true nature of a subject, rather than the depiction of intricate details or the creation of highly technical work.

local color	A term referring to sentiments relating to the countryside, farming communities, regional communities, local customs, and home. The term became popular within the Japanese literary community in the early 20th century. The concept then became an important theme in the art community when the Japanese judges of the Joseon Art Exhibition in the 1920s decided to emphasize the expression of local color as an assessment criterion. The popularity of local color during the Japanese occupation continued to hold influence until the 1970s, which led to the appearance of artists, like Park Su-geun, who worked on the depiction of idyllic rural subject matter.
Minjung Art	An artistic movement that came to prominence alongside Korea's democratization movement in the 1980s. *Minjung* artists often sought to directly confront and critically portray the violent repression of the military dictatorship, and represent the experiences of the laborers, farmers and students who comprised the democratization movement. As such, *Minjung* artists attempted to use their art to help achieve the social change sought through the democratization movement. In contrast to abstraction, which constituted the mainstream of 1970s art in Korea, *Minjung* Art is notable for using representational and figurative forms of expression.
monochrome art	A genre of Korean abstract painting that consists of a single tone of color with varied brightness and chroma. The term also refers to a range of American modernist paintings from the 1960s to the 1970s, created to explore the values of aesthetic purity, flatness, and reductionism. In Korea, the critic Lee Il first used the now popularized art historical term *dansaekhwa* to describe single-tone, flat, abstract paintings created by a loose movement of Korean artists in the 1970s.
National Art Exhibition	A government-hosted exhibition held 30 times from 1949 to 1981, also known by the shorter name *Gukjeon*. Following national independence, the exhibition was the primary means for young and emergent Korean artists to achieve recognition. The influence of the exhibition declined as a result of the emergence of non-figurative art during the 1970s, the increased opportunities for artists to participate in overseas exhibitions, and the rise of private exhibitions and galleries.

small group
movement

A term describing the tendency of many artists in the 1980s to work in small groups, in which the application of many diverse methods, attitudes and values in mediums such as painting, sculpture and installation was common. These groups associated with neither the established modernist abstract art community or the *Minjung* Art community, which formed the primary two ideologically and formally opposed movements of the 1980s. Instead, artists within these small groups focused on individual approaches to production based on situational contingency, and deliberately declined to develop into larger organizations, unlike the artists of previous generations.

tal modernism

In its literal sense, tal modernism describes any art form or attitude deviating from modernism. In Korean art, it was a critical term that art critic Seo Seong-rok used to explain contemporary Korean art in his writings during the late 1980s. Seo called the works from artist collectives such as Meta-Vox and *Nanjido* (*Nanji* Island) "*tal* modern." His rationale was that those works, in distinction to more formally focused works in the modernist tradition, were more actively engaged in the issues of environment, culture, and communication. However, Seo argued that, because these works did not seek to overcome the modernist inclination toward materiality, nor directly reflect upon the issues of contemporary late-industrial society, they should be defined as tal modernism (deviating from modernism), rather than postmodernism.

* The terms and definitions in this glossary are taken from *Online Multilingual Dictionary of Korean Art Terms* (https://gokams.or.kr:442/visual-art/art-terms) by Korea Arts Management Service.

Installation View

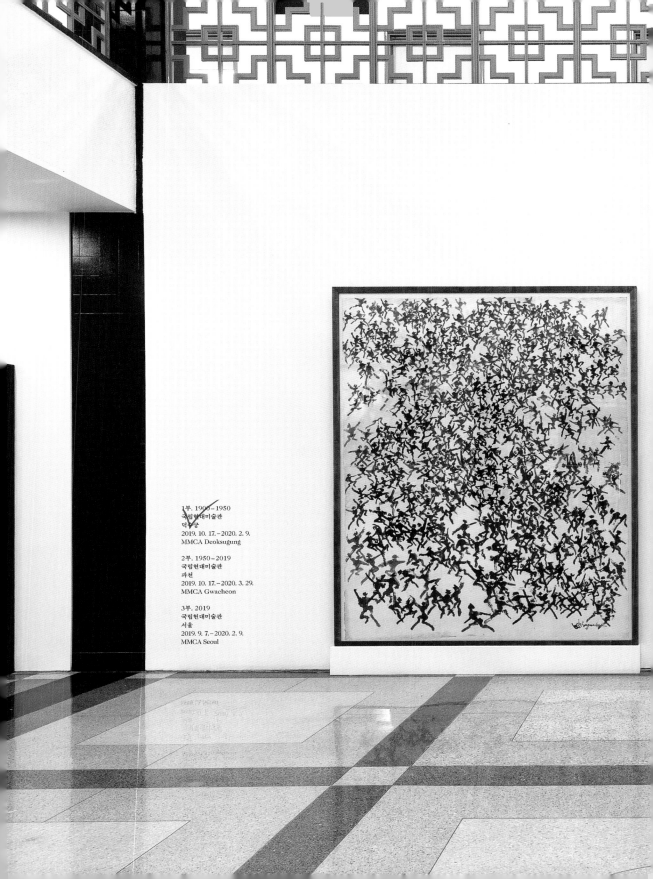

1부. 1900–1950
국립현대미술관
덕수궁
2019. 10. 17.–2020. 2. 9.
MMCA Deoksugung

2부. 1950–2019
국립현대미술관
과천
2019. 10. 17.–2020. 3. 29.
MMCA Gwacheon

3부. 2019
국립현대미술관
서울
2019. 9. 7.–2020. 2. 9.
MMCA Seoul

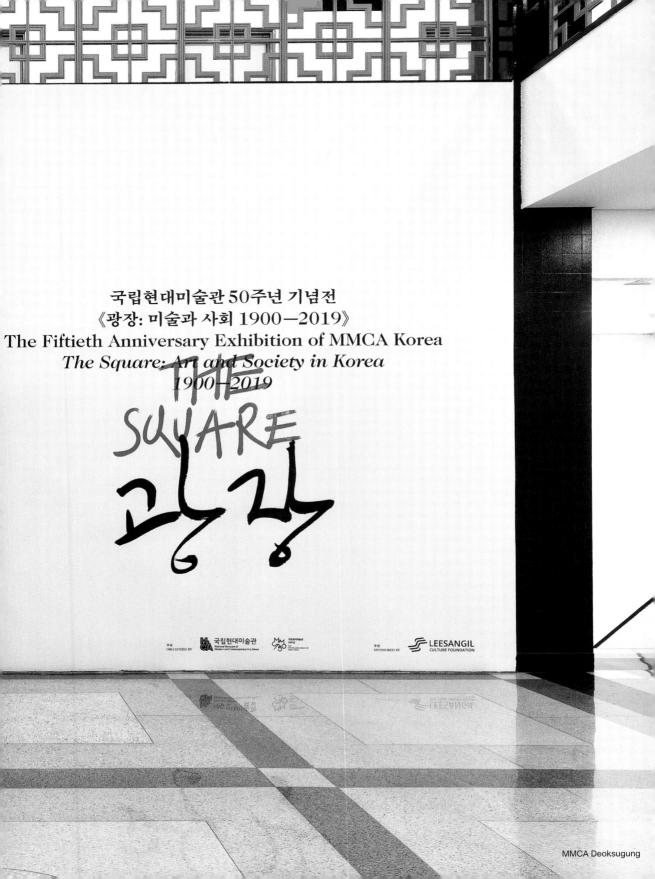

국립현대미술관 50주년 기념전
《광장: 미술과 사회 1900—2019》
The Fiftieth Anniversary Exhibition of MMCA Korea
The Square: Art and Society in Korea
1900—2019

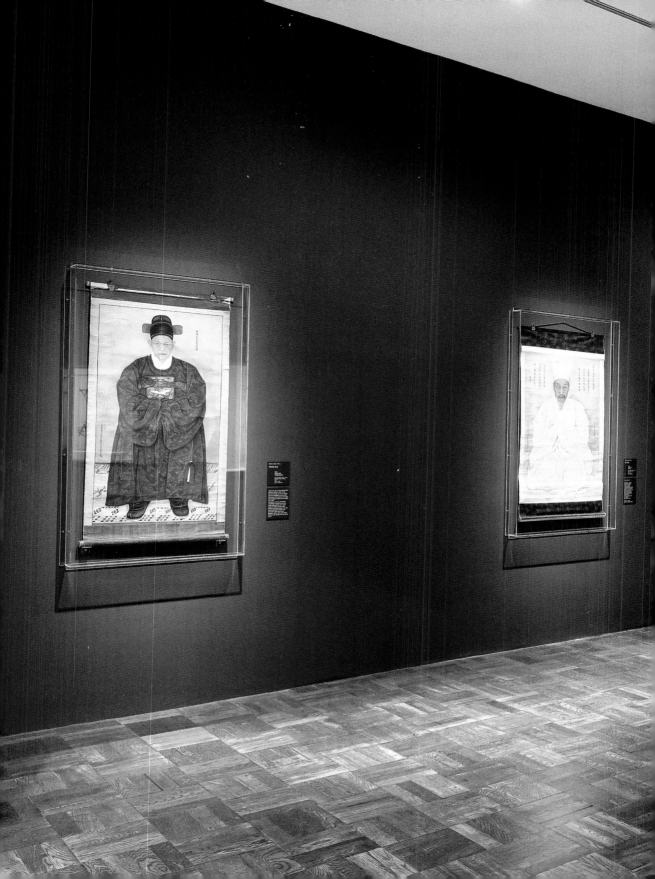

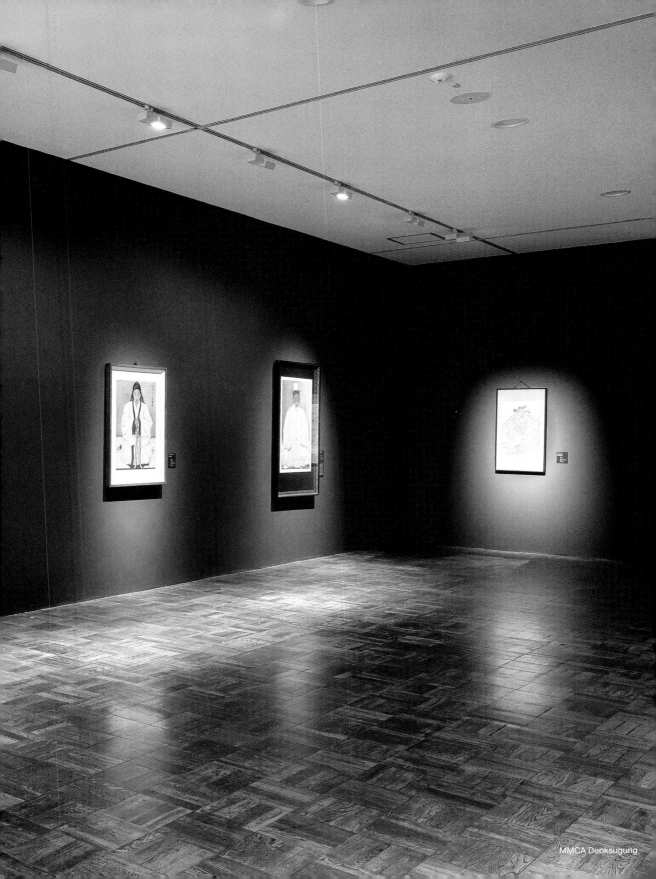

MMCA Deoksugung

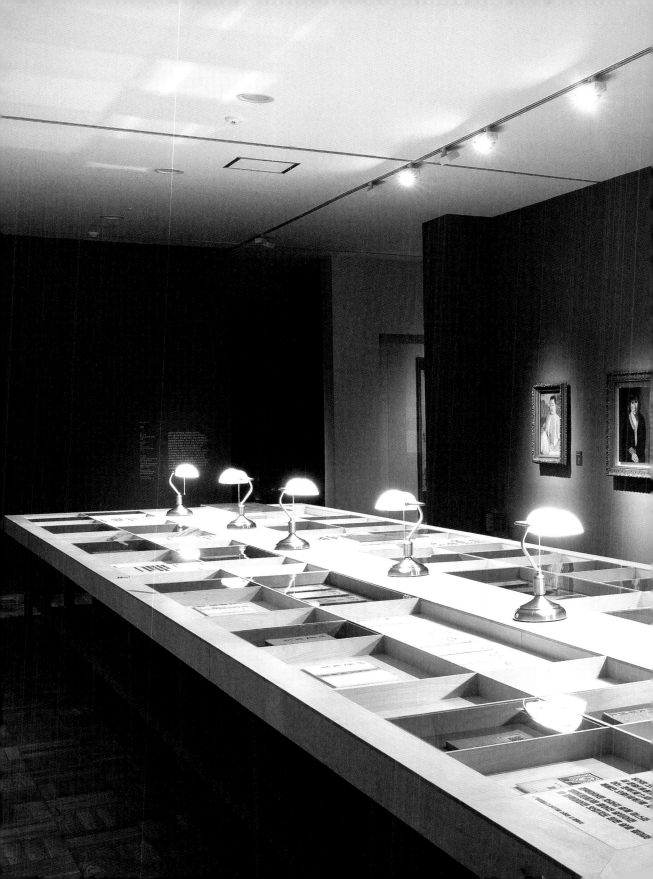

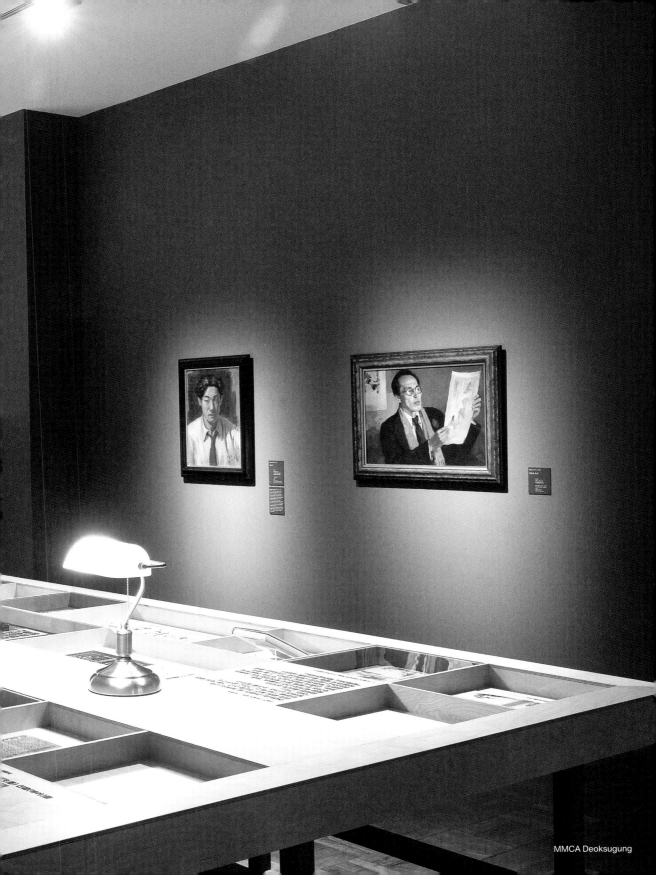

MMCA Deoksugung

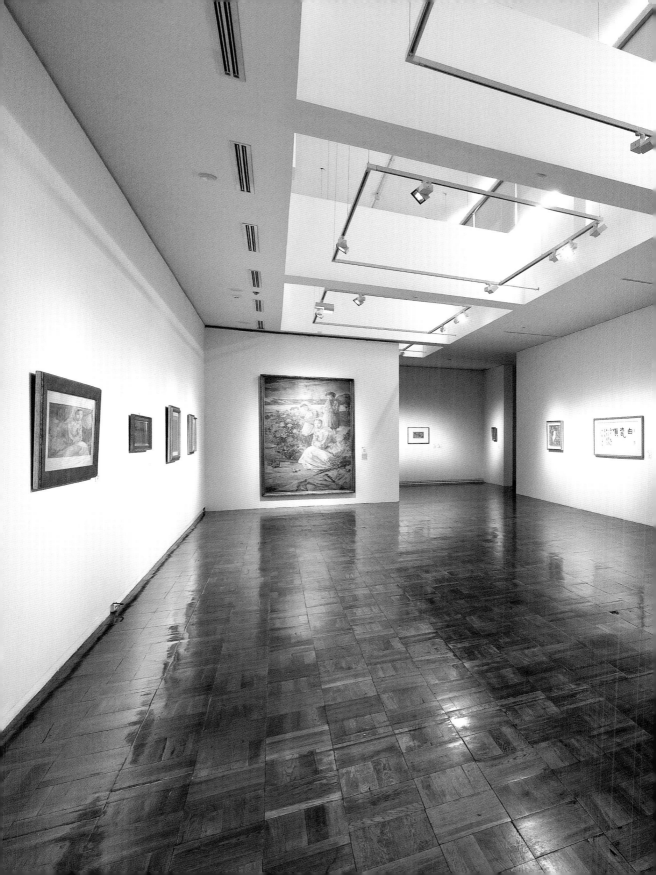

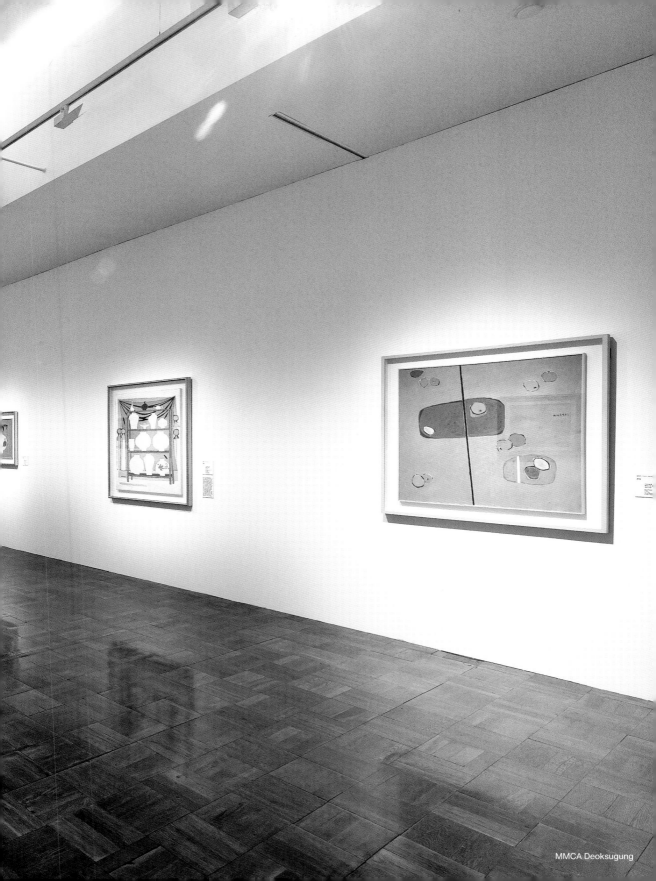

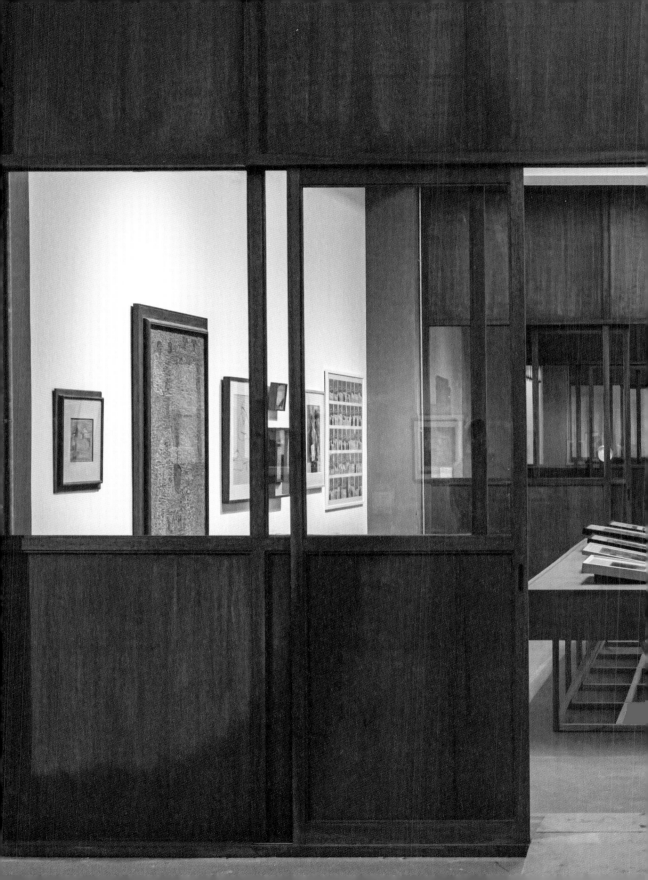

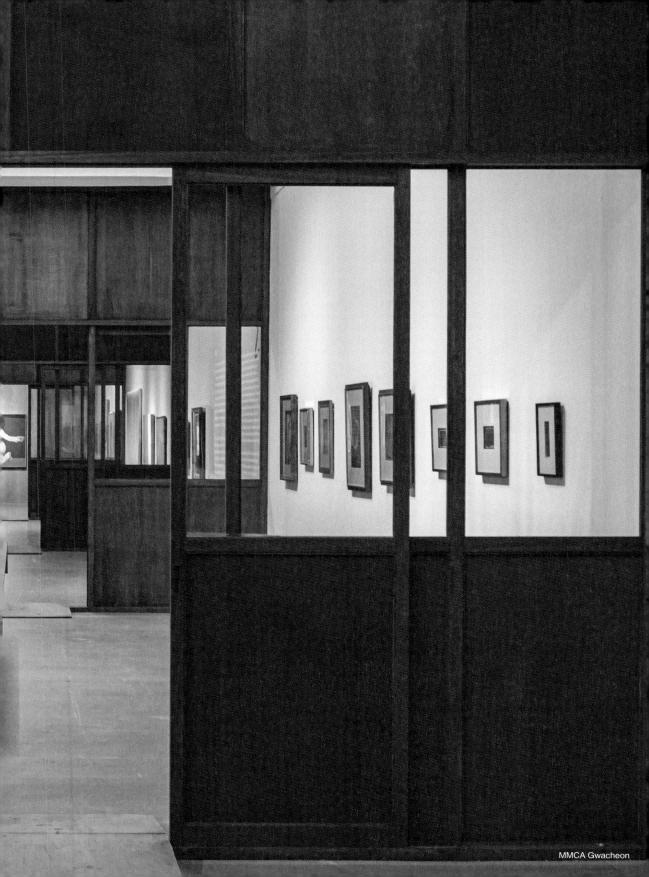

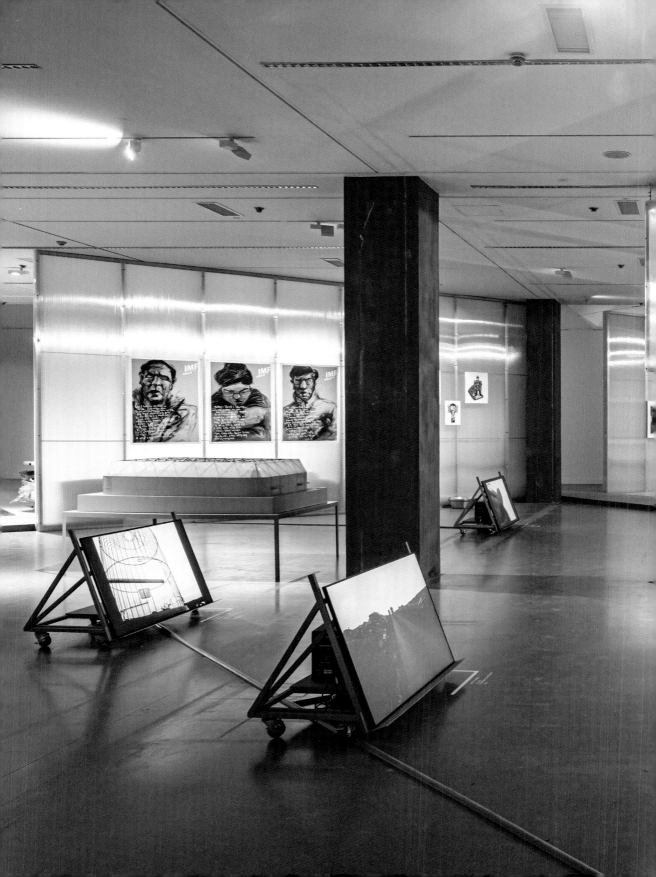

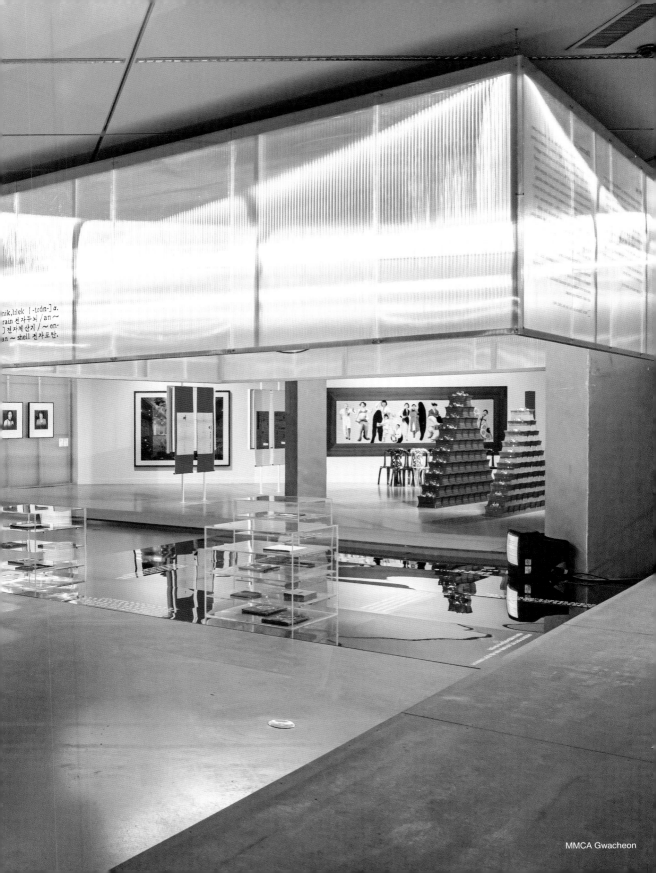

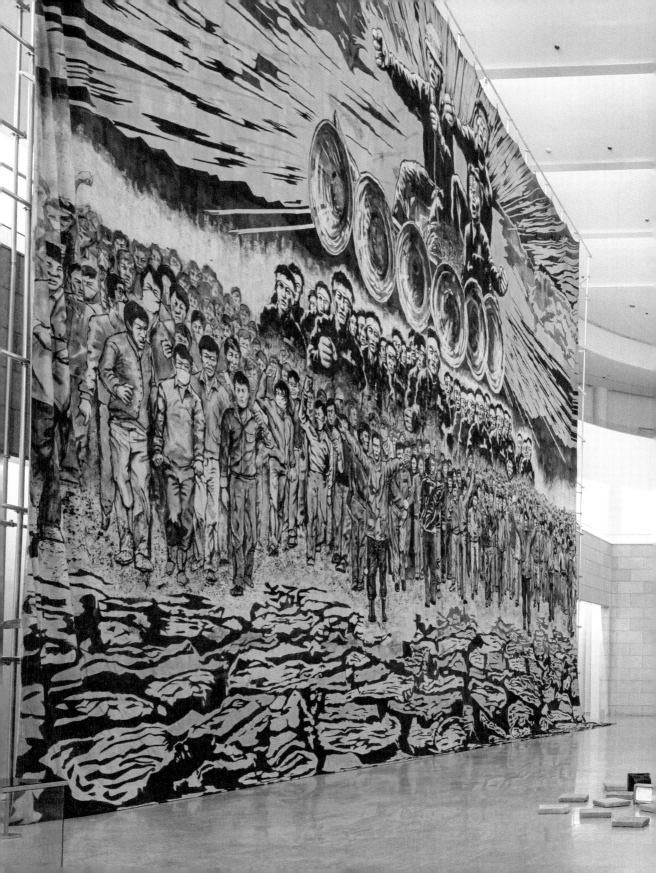

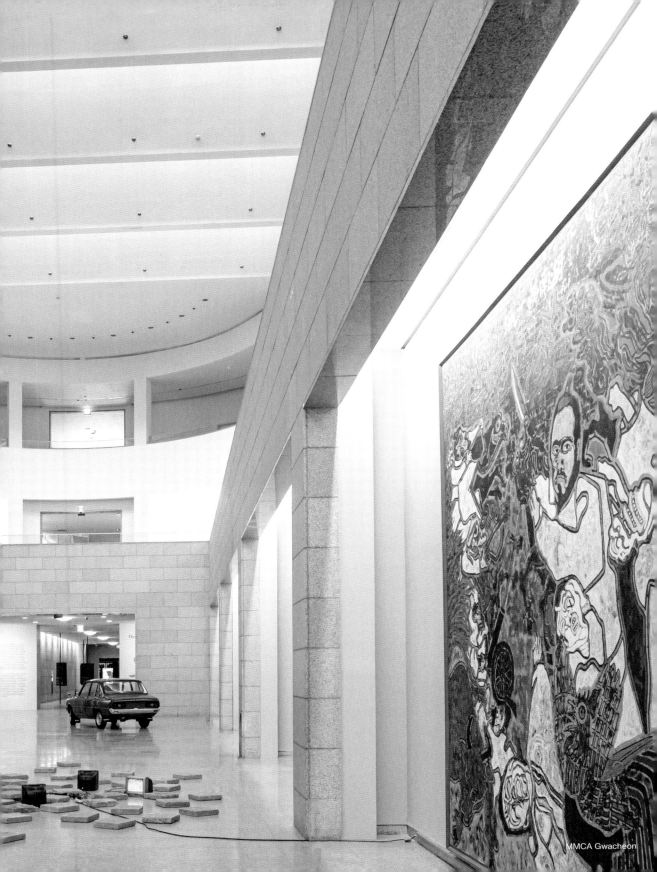

MMCA Gwacheon

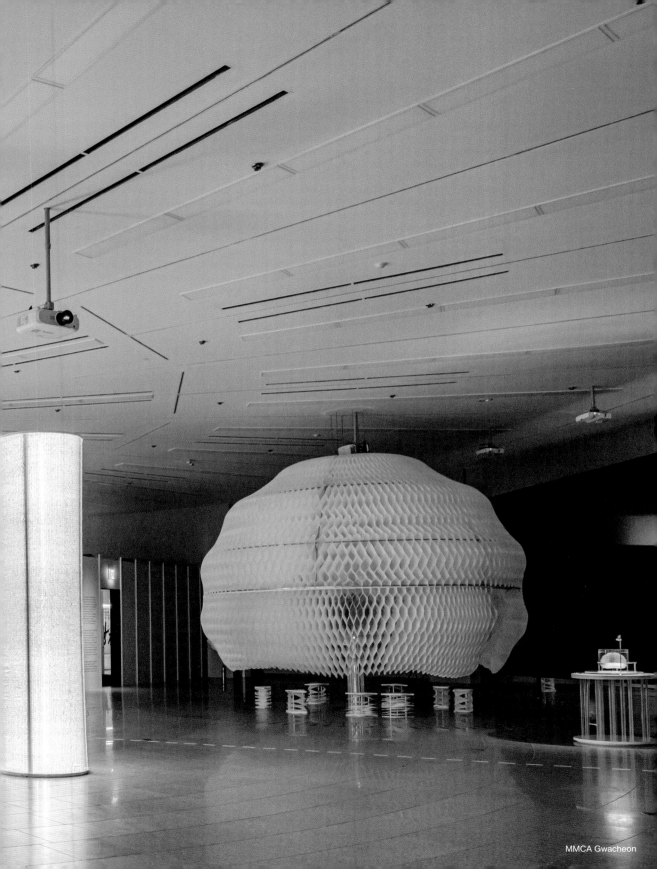

MMCA Gwacheon

MMCA Seoul

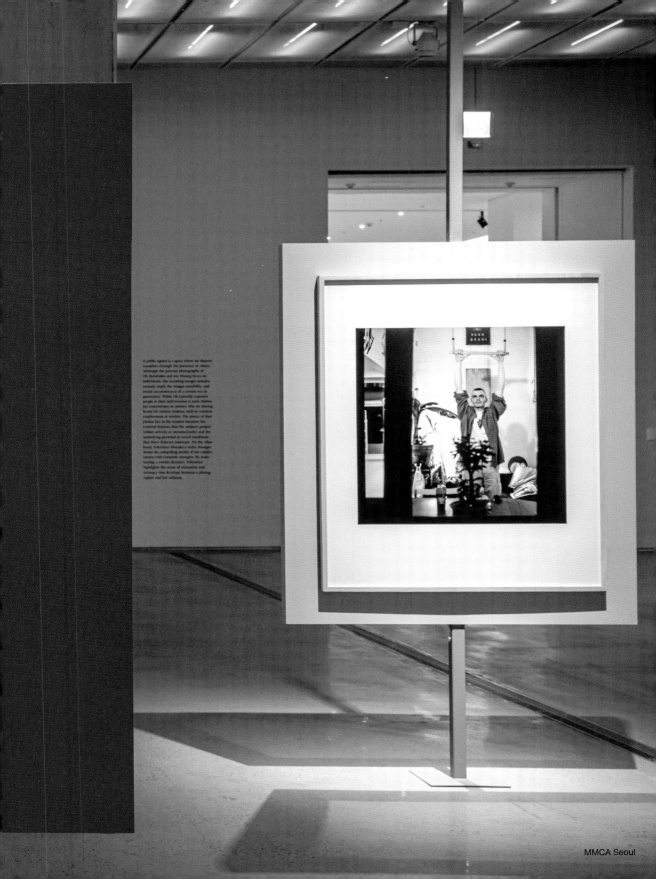

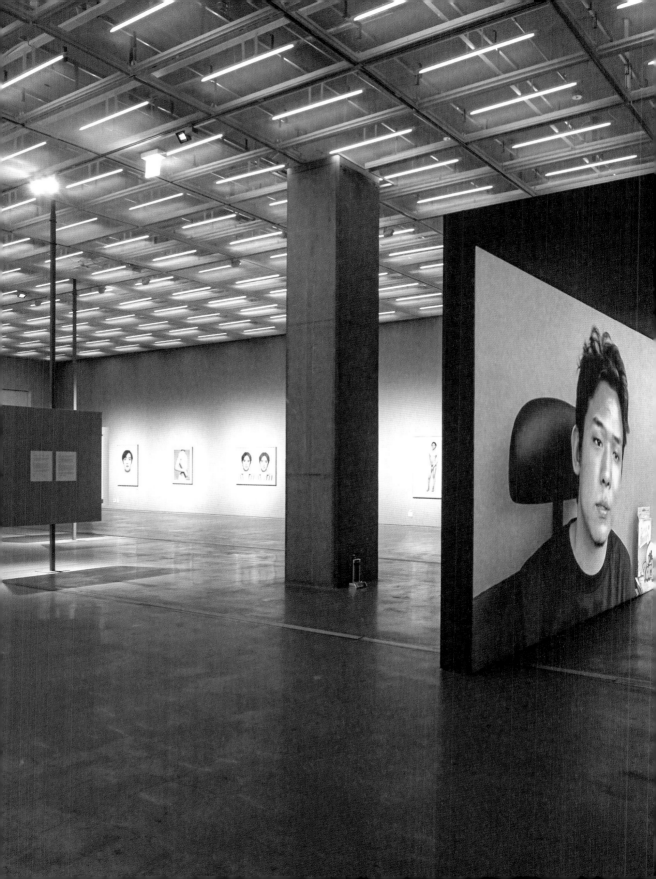

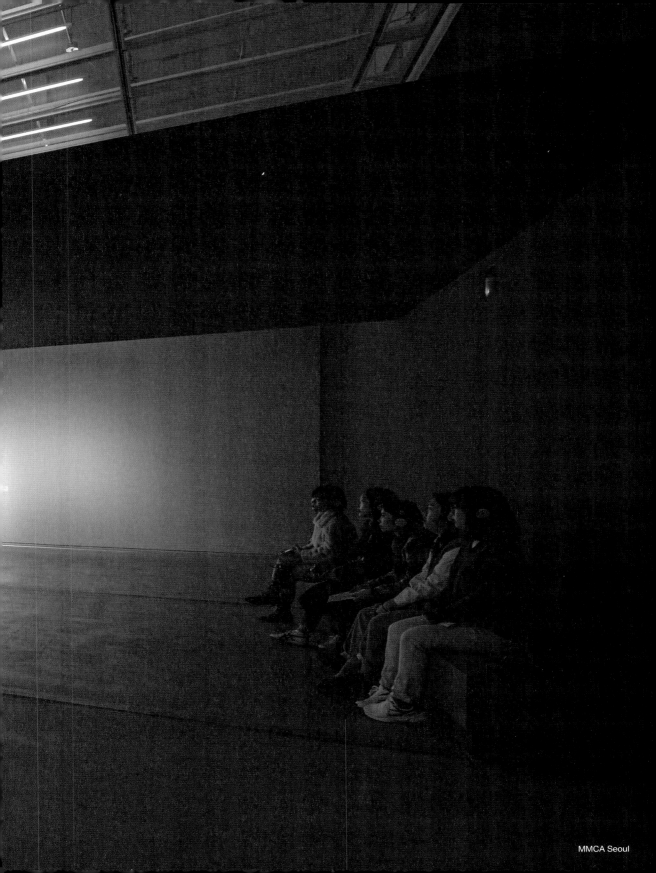

The Fiftieth Anniversary Exhibition of MMCA Korea
The Square: Art and Society in Korea 1900-2019

Publisher
Youn Bummo

Production Director
Kang Seungwan

Essay
Youn Bummo
Kang Seungwan
Part I: Kim Mee Young, Kim Inhye, Kim Hyunsook, Choi Youl, Hong Jisuk
Part II: Kwon Boduerae, Kang Soojung, Kim Won, Kim Hak-lyang, Shin Chunghoon, Yoon Sorim,
 Lee Hyunju, Chung Dahyoung
Part III: Sung Yonghee, Yang Hyosil, Lee Kyungmi, Lee Sabine, Lim Jade Keunhye

Translated by
Part I: Park Myongsook, Phillip Robert Maher, Kim Namin
Part II: Seoul Selection
Part III: Park Myongsook, Phillip Robert Maher, Kim Shinu

Translation Reviewed by
Emily Hyosu Kang

Catalog Editing & Design
VOSTOK Press

Published by
National Museum of Modern and Contemporary Art Foundation, Korea
30 Samcheong-ro, Sogyeok-dong, Jongno-gu, Seoul
T +82-2-3701-9500,
www.mmca.go.kr

ISBN 979-11-967771-2-8

This catalog is printed on Hansol Paper.

Cover: **INSPER M** Rough-SuperWhite 240g/m²
Body: **INSPER M** Rough-SuperWhite 100g/m²